1000 Artisan Textiles

QUARRY

First published in the United States of America by
Quarry Books, a member of
Quayside Publishing Group
100 Cummings Center
Suite 406-L
Beverly, Massachusetts 01915-6101
Telephone: (978) 282-9590
Fax: (978) 283-2742
www.quarrybooks.com
Visit www.Craftside.Typepad.com for a behind-the-scenes peek at our crafty world!

ISBN-13: 978-1-59253-609-2
ISBN-10: 1-59253-609-3

10 9 8 7 6 5

Design: Sandra Salamony
Front cover, column 1: image 0945, image 0292, image 0523, image courtesy of Gina Pierce; column 2: image 0001, image 0127; column 3: image courtesy of Judy Wise, image courtesy of STRONGFELT works of Lisa Klakulak, image 0745; column 4: image 0966, image 0995; column 5: image 0131, image 0460, image 0006
Back cover, left to right: image 0790, image 0300, image 0798 (top), image 0420 (bottom), image 0375, image 0121

Printed in China

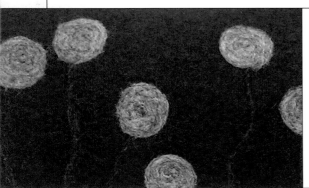

Left to right: image 0395, image 0290,
image 0994, image 0688

1000
Artisan Textiles

BEVERLY MASSACHUSETTS

contemporary
fiber art, quilts,
and wearables

Sandra Salamony
& Gina M. Brown

QUARRY BOOKS

Row 1: image 0321, image 0946;
row 2: image 0463; row 3: image 0388,
image 0165

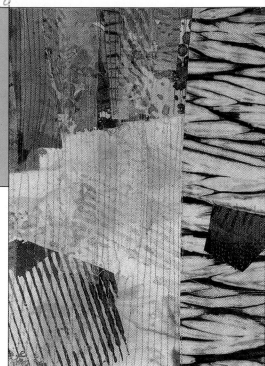

Contents

Introduction

My sister (and co-author), Gina, and I are not twins. But people often thought we were, because when we were young my mother would occasionally dress us in identical clothes. Even more extreme were the special events when she would join us in mother-and-daughter (and-daughter) outfits.

Though these outfits were often handmade with love (and they made "the Salamony girls" instantly recognizable), they were essentially uniforms. As a result, my sister and I now take special pleasure in showcasing the one-of-a-kind, artisan-created, fine textiles featured here! Every piece, whether meant for your home or your wardrobe, reflects a strong personal style: simple and charming, modern and striking, complex and highly detailed. And speaking of details, we've occasionally included enlarged views so you can see the artistry up close.

The generous scope of the chapters—Wearable Art & Couture, Fashion Accessories, Soft Furnishings & Vessels, Tapestries & Display Art, and Art Quilts—reflects the broad arena in which textiles are found in our lives. Pieces were chosen to inspire readers to re-imagine the surfaces of their own creations: to manipulate by embroidery, dyeing, stitching; to re-examine their color palettes; to experiment with unpredictable techniques that can cause happy accidents.

Left to right: image 0210, image 0741, image 0550, image 0404

For example, when you review the chapter on Art Quilts, you'll notice immediately the evolution that these pieces reflect. Though their roots began with homespun bed covers, the often surprising mixed-media techniques incorporated into these quilts have elevated these creations into pure art.

We now live in a golden age for artists who create one-of-a-kind pieces, and the Internet affords home-based artisans the opportunity to exhibit and sell their wares on a global scale. This "global scale" is also made evident in that artists from six continents are represented inside.

I'd collected art for another "1,000 book" for Quarry in the past, so I knew that Gina and I would be bombarded with hundreds and hundreds of submissions by very talented artisans…but I wasn't prepared for how excited I'd be each morning to see the new pieces that came in. As one of the submitting artists said, "it must be like Christmas every day." And she was right. My sister and I hope that this book will provide you with the same overwhelming experience of a gift-filled morning, the inspiration to grow in your own work, and the impetus to never let your (or your home's) clothes be predictable.

—Sandra Salamony

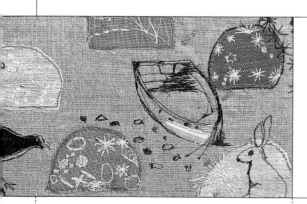

ROW 1: IMAGE 0084, IMAGE COURTESY OF KC LOWE, NUNOFELT
ORIGINALS; ROW 2: IMAGE COURTESY OF STRONGFELT WORKS OF
LISA KLAKULAK (PHOTO BY JOHN LUCAS), IMAGE 0080; ROW 3: IMAGE
COURTESY OF MEGAN WARNER (PHOTO BY STEPHANIE MATTHEWS),
IMAGE COURTESY OF ANNE FLORA, FLORAWORKS

Wearable Art & Couture

0001–0121

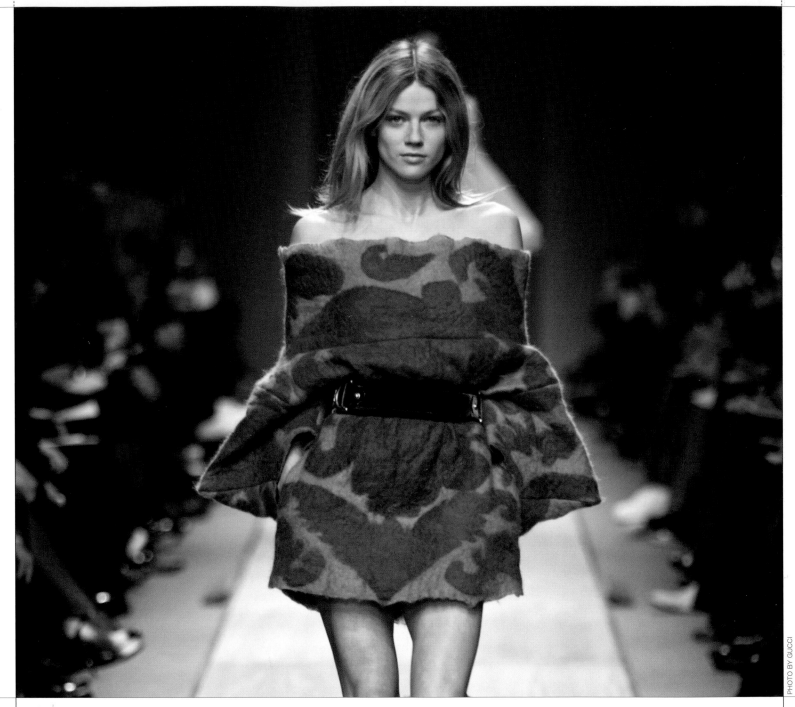

0001 | Liz Clay coat fabric produced for Stella McCartney, UK

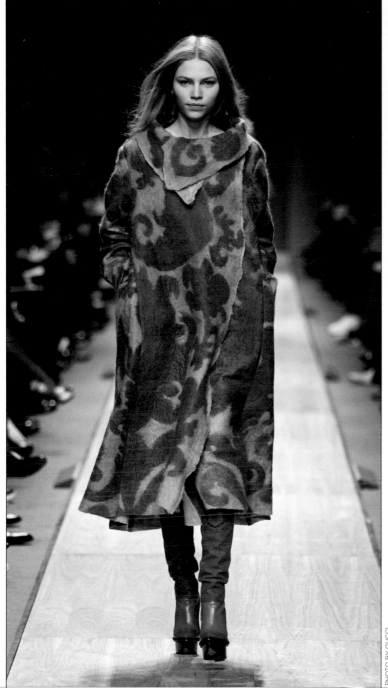

0002 | Liz Clay coat fabric produced for Stella McCartney, UK

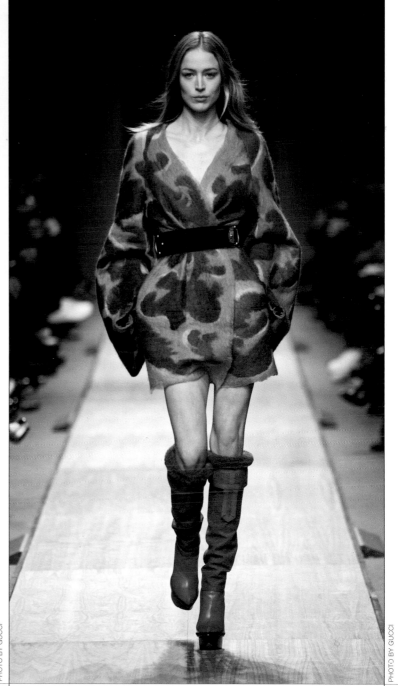

0003 | Liz Clay coat fabric produced for Stella McCartney, UK

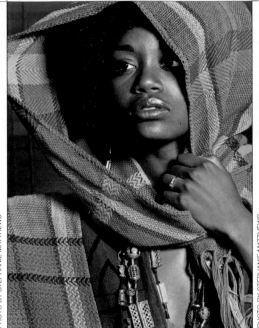

0004 | LaVerne Kemp Handwovens, USA

0005 | LaVerne Kemp Handwovens, USA

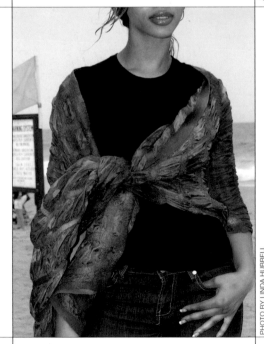

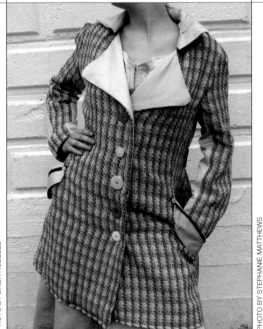

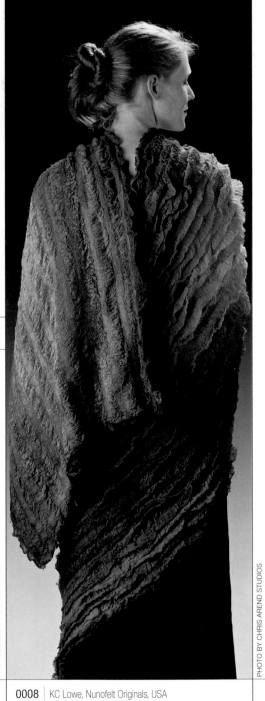

0006 | Deborah Faye Watson, USA

0007 | Megan Warner, USA

0008 | KC Lowe, Nunofelt Originals, USA

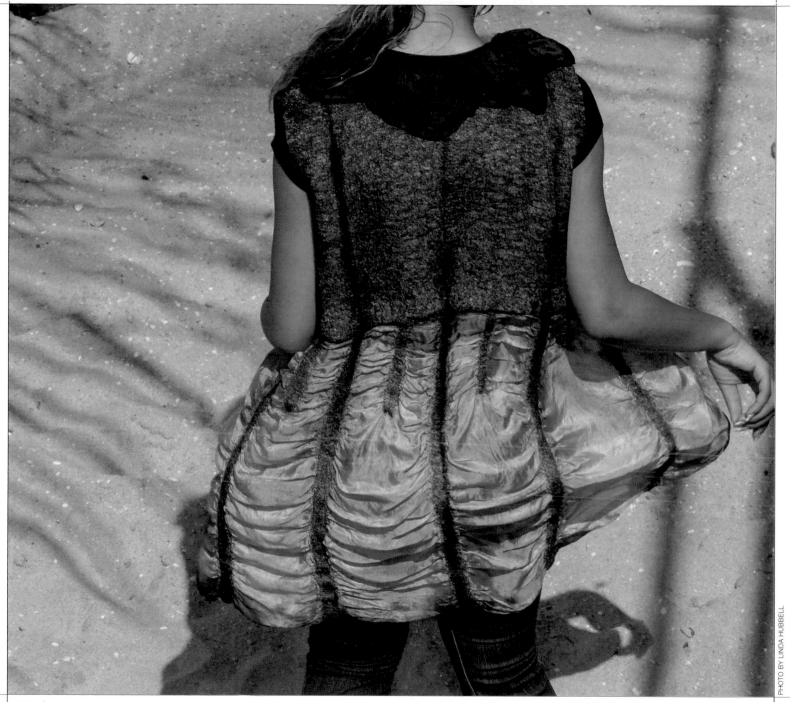

0009 | Deborah Faye Watson, USA

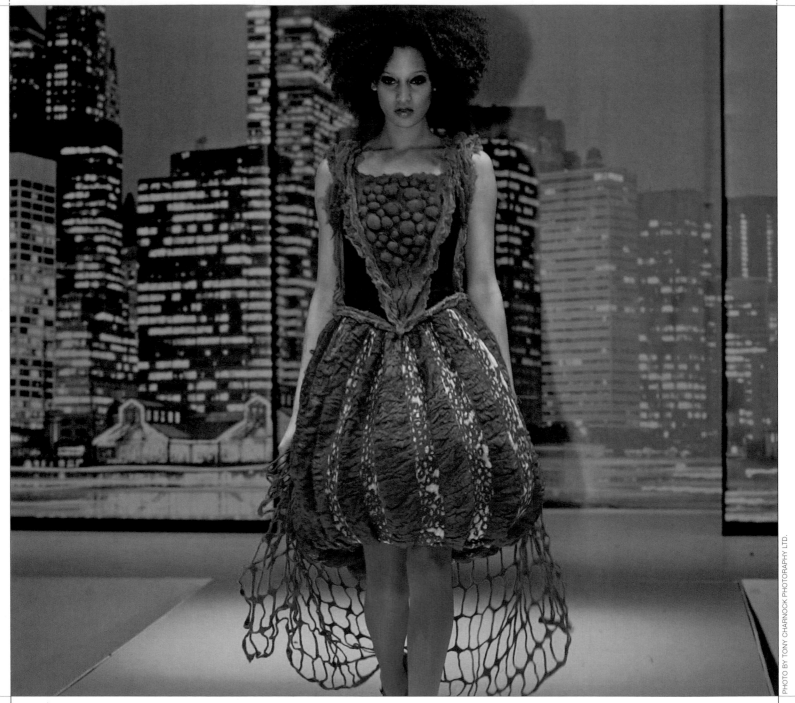

0010 | Caroline Merrell Turner, UK

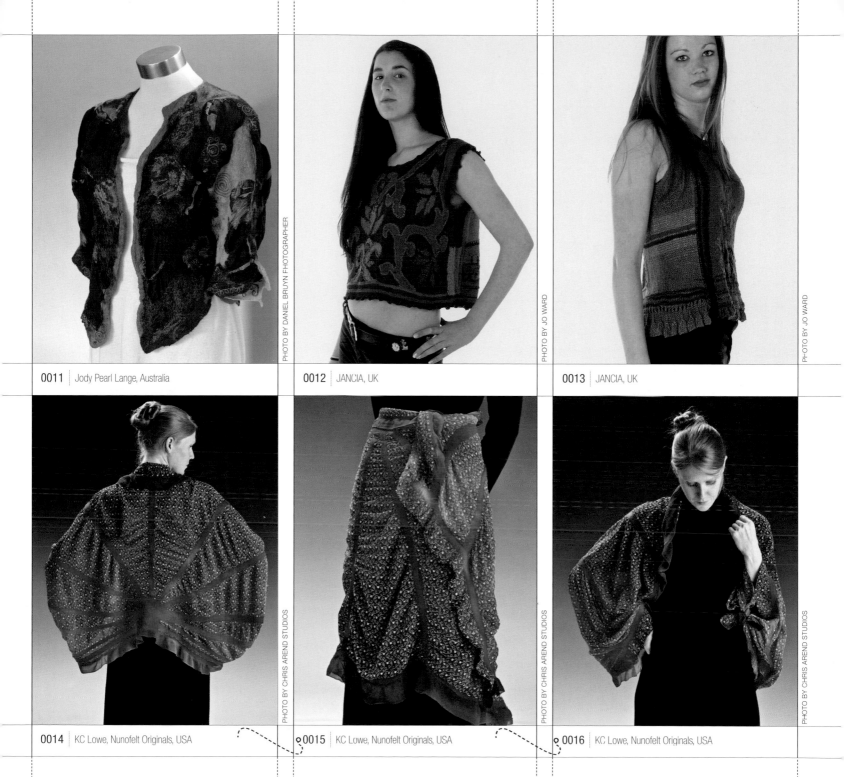

0011 | Jody Pearl Lange, Australia

PHOTO BY DANIEL BRUYN FHOTOGRAPHER

0012 | JANCIA, UK

PHOTO BY JO WARD

0013 | JANCIA, UK

PHOTO BY JO WARD

0014 | KC Lowe, Nunofelt Originals, USA

PHOTO BY CHRIS AREND STUDIOS

0015 | KC Lowe, Nunofelt Originals, USA

PHOTO BY CHRIS AREND STUDIOS

0016 | KC Lowe, Nunofelt Originals, USA

PHOTO BY CHRIS AREND STUDIOS

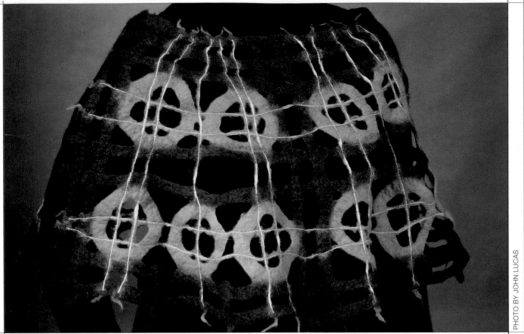

0017 | STRONGFELT works of Lisa Klakulak, USA

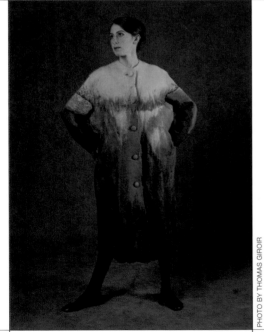

0018 | Roz Spier, USA

0019 | Roz Spier, USA

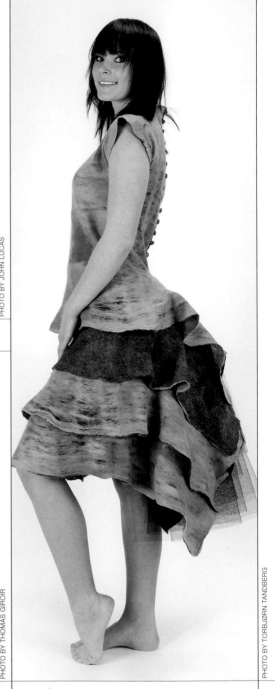

0020 | Torill Haugsvaer Wilberg, Norway

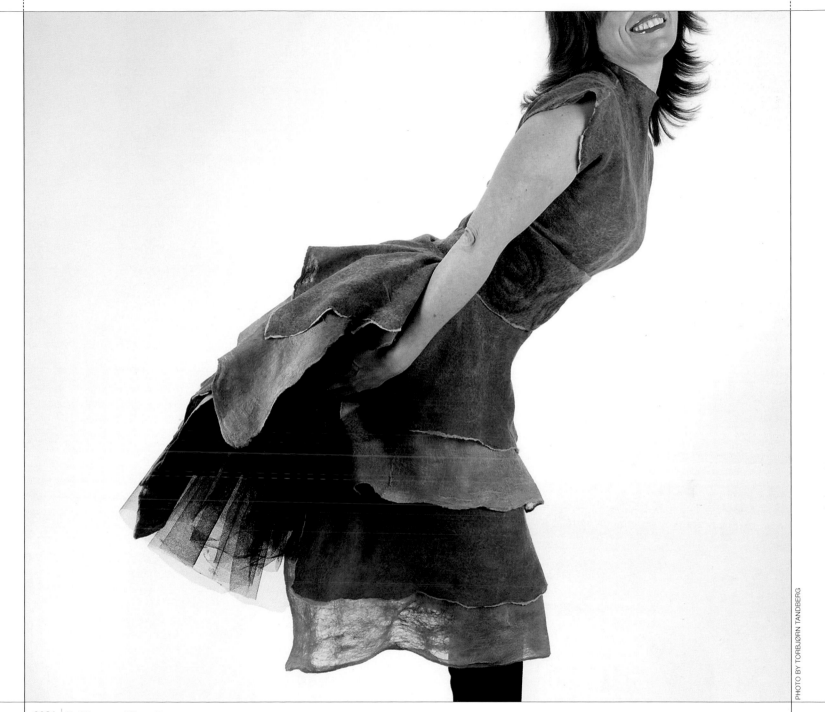

0021 | Torill Haugsvaer Wilberg, Norway

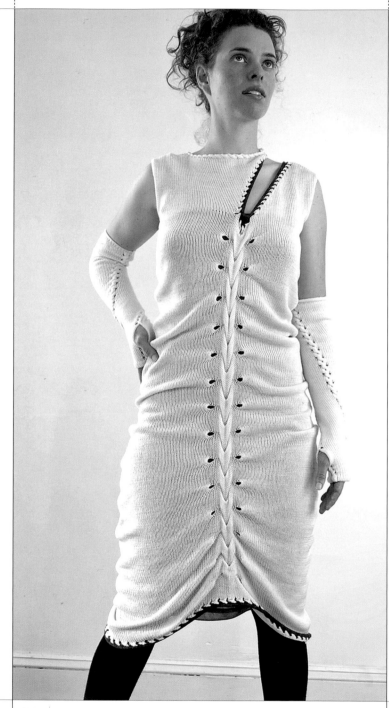

0022 | Lillian Jackson Textile Design, USA

0023 | Lillian Jackson Textile Design, USA

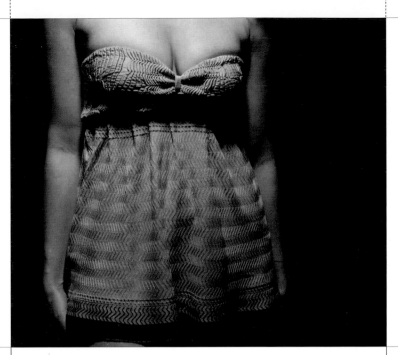

0024 | Delphinc Marie Thwaites, UK

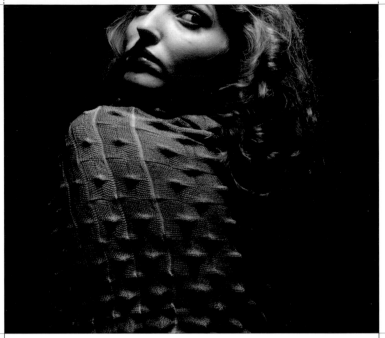

0025 | Delphine-Marie Thwaites, UK

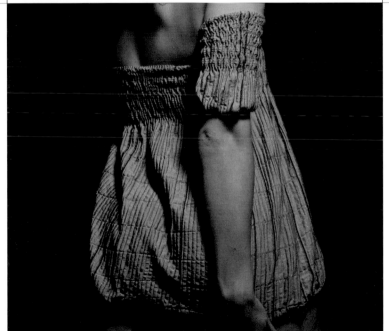

0026 | Delphine-Marie Thwaites, UK

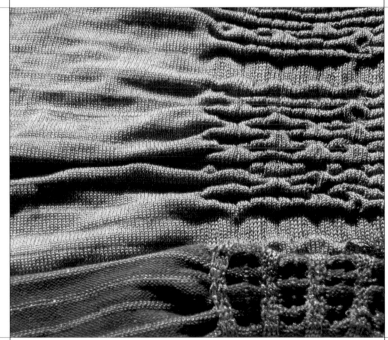

0027 | Delphine-Marie Thwaites, UK

WEARABLE ART & COUTURE | 19

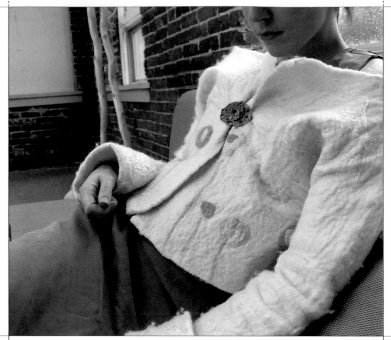

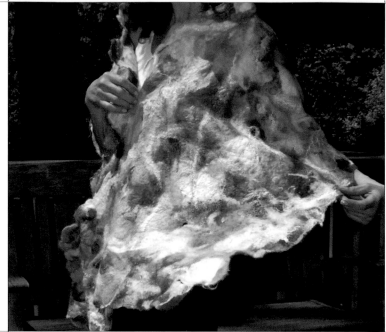

0028 | LeBrie Rich, PenFelt, USA

0029 | Regina Moss Designs, USA

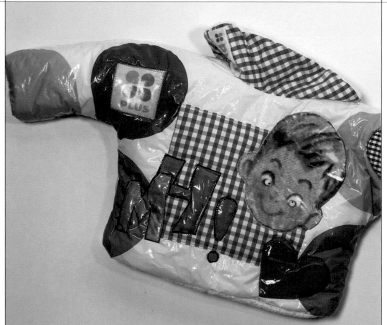

0030 | Barbara Schneider, dipl. des., Germany

0031 | Barbara Schneider, dipl. des., Germany

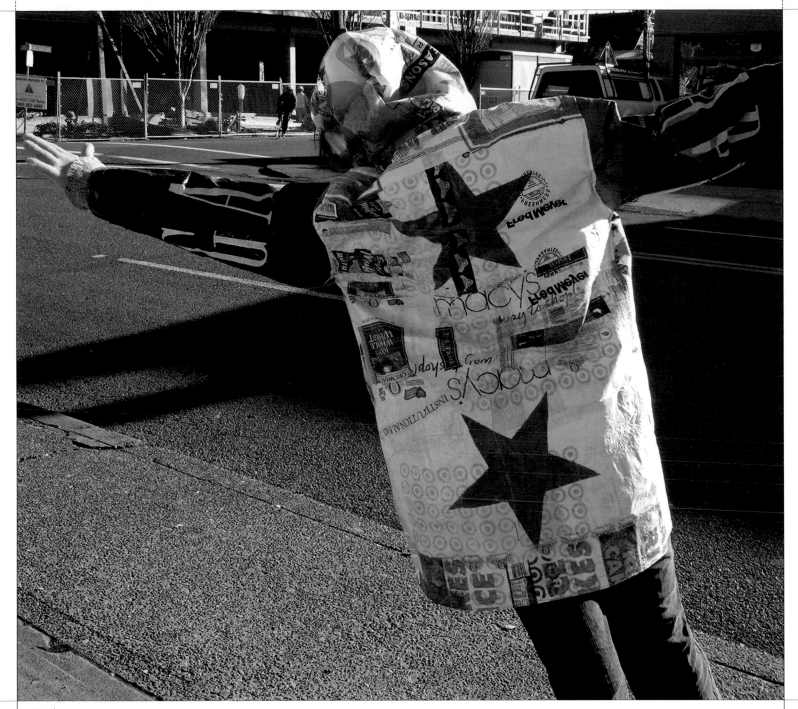

0032 | LeBrie Rich, PenFelt, USA

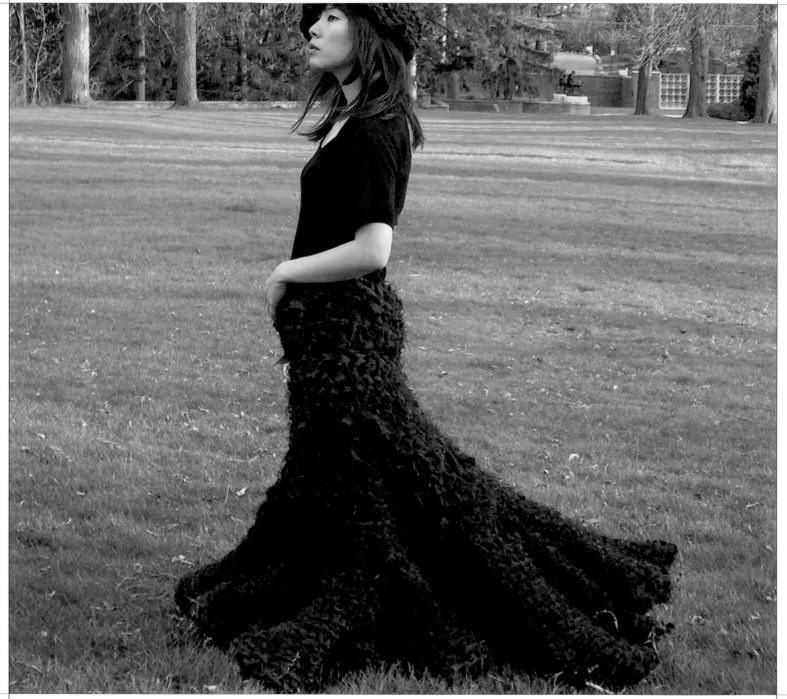

0033 | Ema Ishii, USA

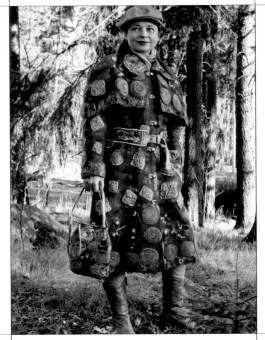

0034 | Helena Sergeyeva, Yozhyk's Felt, Sweden

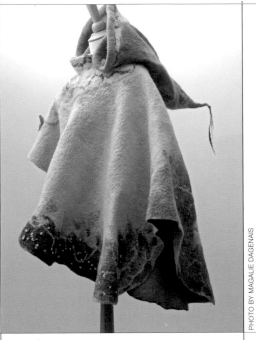

0035 | Diane Gonthier, Canada

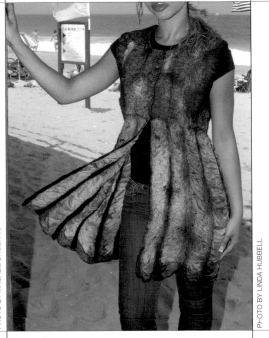

0036 | Deborah Faye Watson, USA

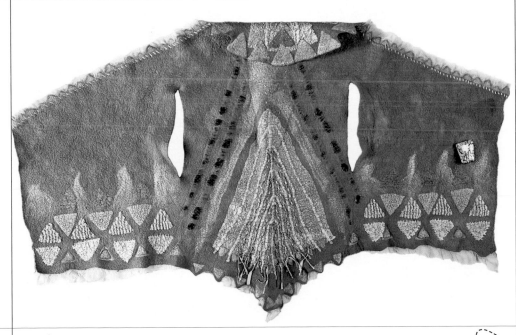

0037 | Rachel Castle, UK

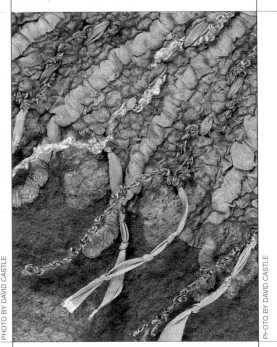

0038 | Rachel Castle, UK

0039 | Ulrieke Benner, Art You Wear in Felt & Silk, Canada

0040 | Anne Flora, USA

0041 | Anne Flora, USA

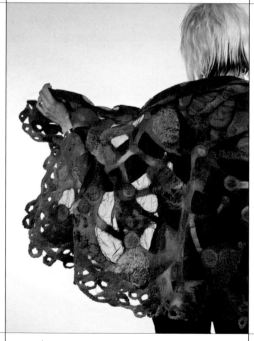

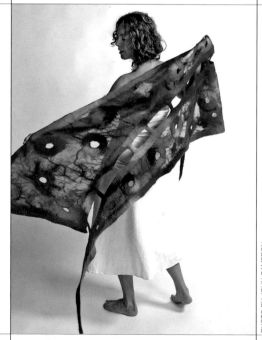

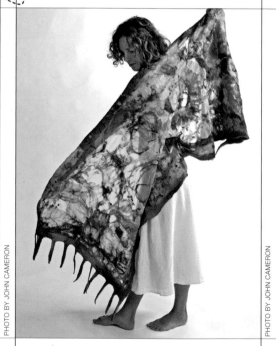

0042 | Elizabeth Armstrong, Australia

0043 | Ulrieke Benner, Art You Wear in Felt & Silk, Canada

0044 | Ulrieke Benner, Art You Wear in Felt & Silk, Canada

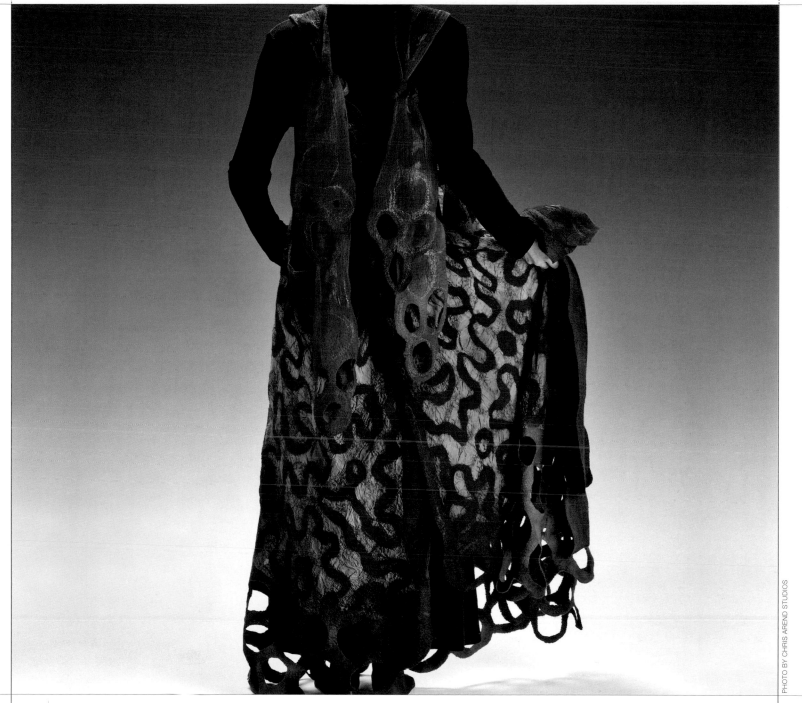

0045 | KC Lowe, Nunofelt Originals, USA

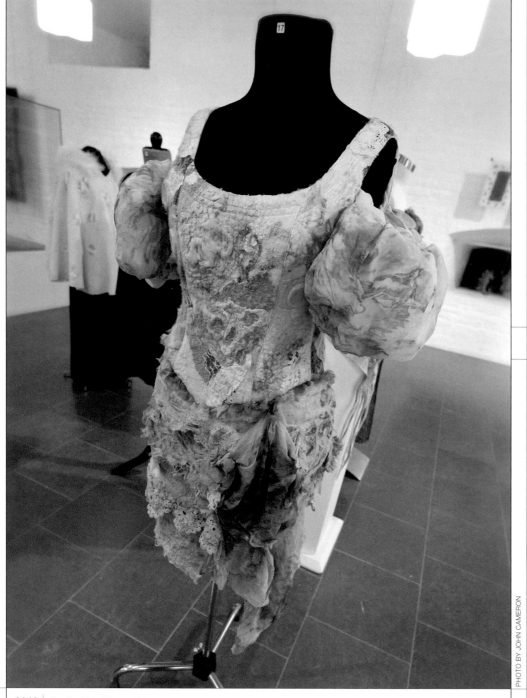

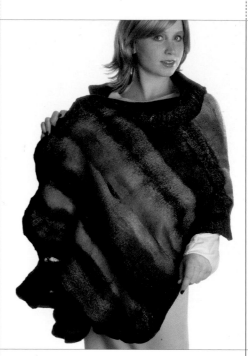

0047 | Jenne Giles, Harlequin Feltworks, USA

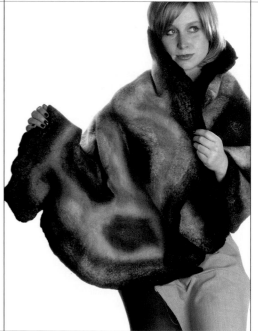

PHOTO BY JOHN CAMERON

0046 | Caroline Merrell Turner, UK

0048 | Jenne Giles, Harlequin Feltworks, USA

0049 | Linda Veilleux, USA

0050 | Sandra Adams, USA

0051 | Ulrieke Benner, Art You Wear in Felt & Silk, Canada

0052 | Heidi Greb, Germany

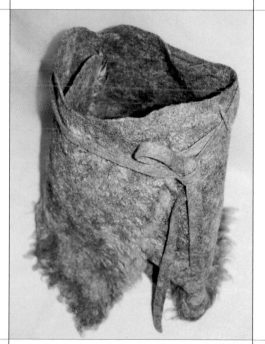

0053 | Heidi Greb, Germany

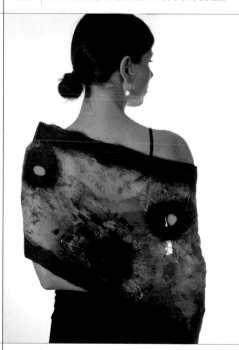

0054 | Ulrieke Benner, Art You Wear in Felt & Silk, Canada

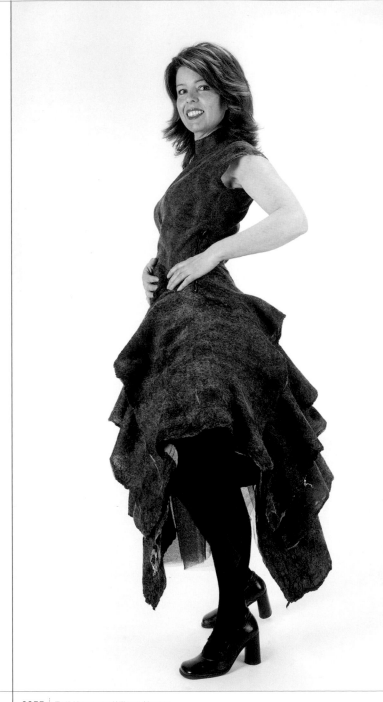

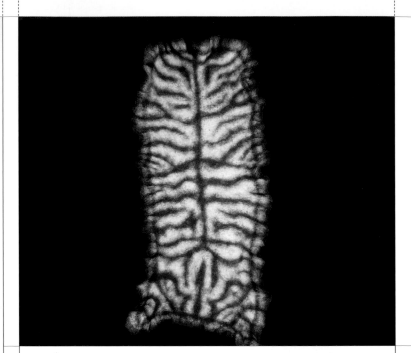

0056 | Jenne Giles, Harlequin Feltworks, USA

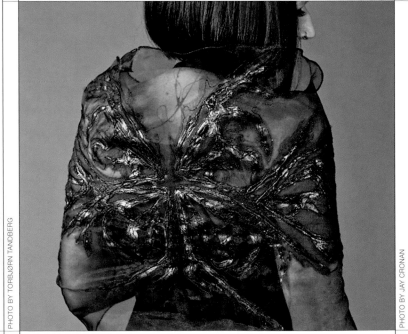

0055 | Torill Haugsvaer Wilberg, Norway

0057 | Svenja, Australia

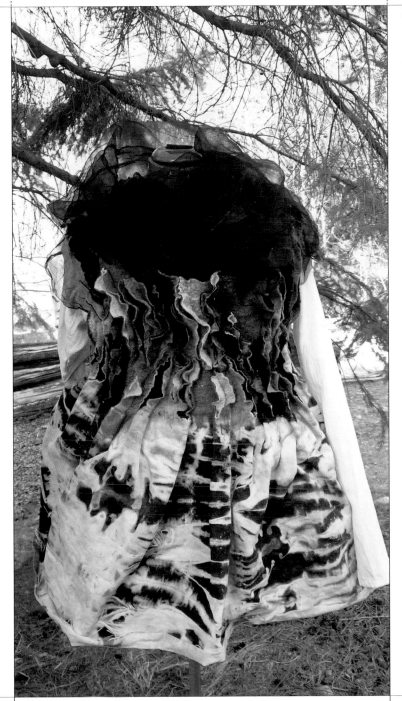

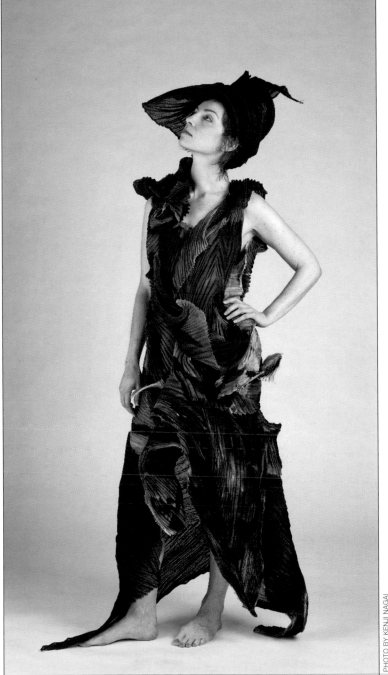

0058 | Marjolein Dallinga, Bloomfelt.com, Canada

0059 | Yvonne Wakabayashi, Canada

PHOTO BY KENJI NAGAI

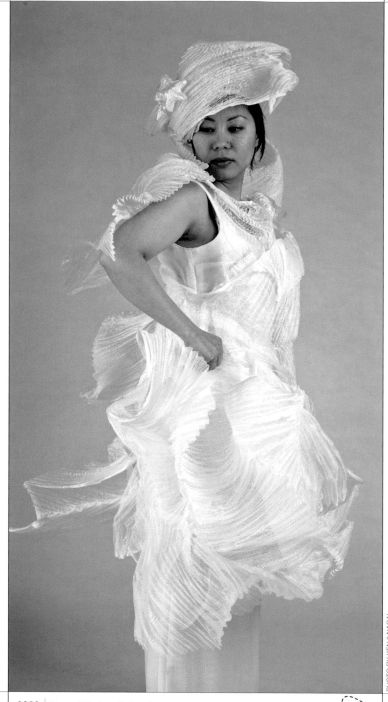

0060 | Yvonne Wakabayashi, Canada

0061 | Yvonne Wakabayashi, Canada

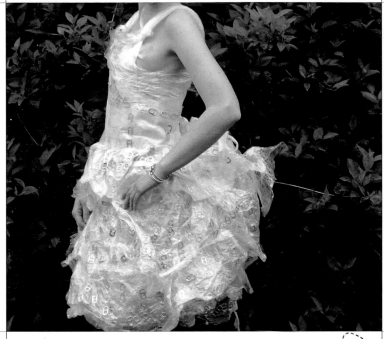

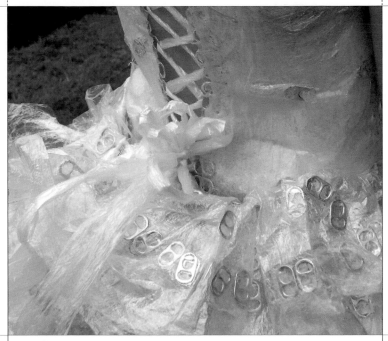

0062 | Megan Warner, USA

9 0063 | Megan Warner, USA

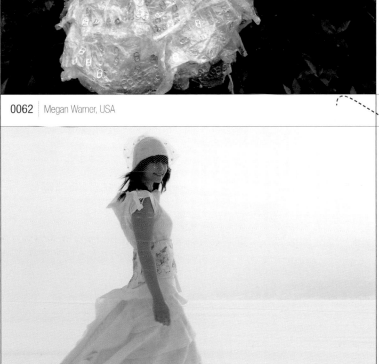

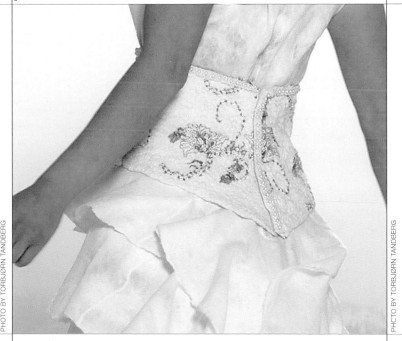

0064 | Torill Haugsvaer Wilberg, Norway

9 0065 | Torill Haugsvaer Wilberg, Norway

PHOTO BY TORBJØRN TANDBERG

PHOTO BY TORBJØRN TANDBERG

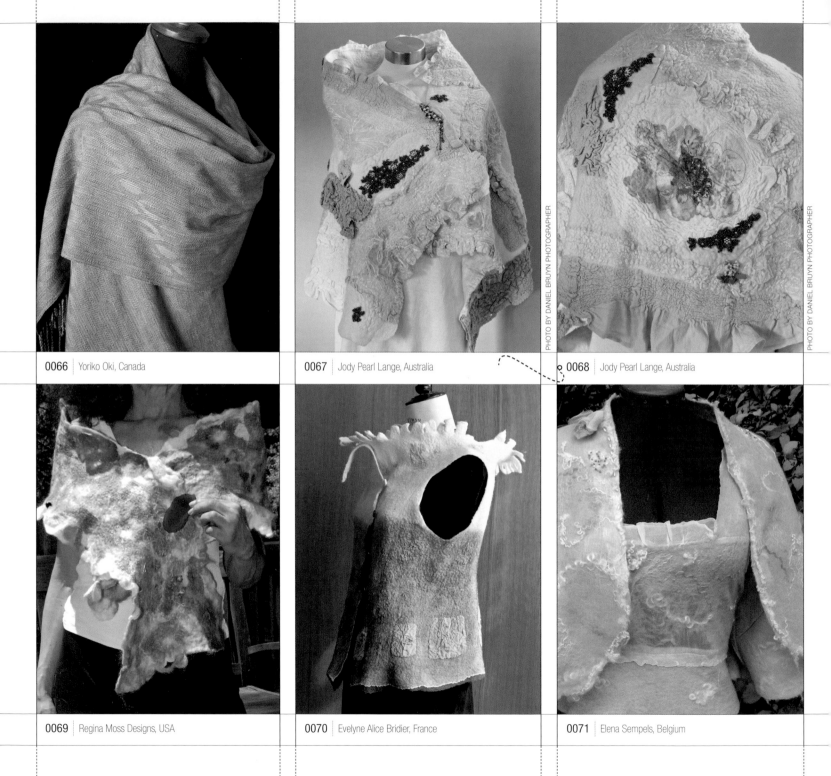

0066 | Yoriko Oki, Canada

0067 | Jody Pearl Lange, Australia

0068 | Jody Pearl Lange, Australia

0069 | Regina Moss Designs, USA

0070 | Evelyne Alice Bridier, France

0071 | Elena Sempels, Belgium

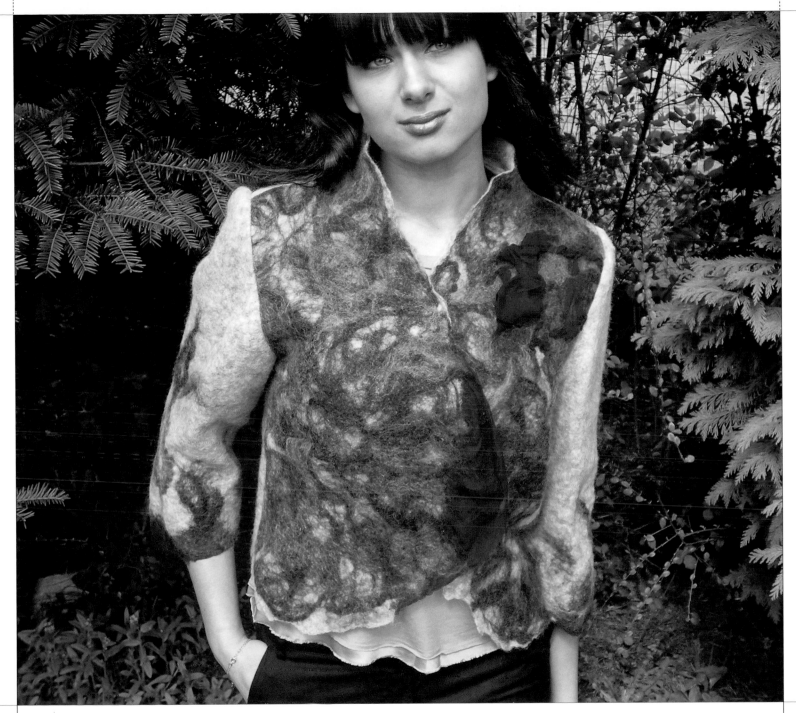

0072 | Elena Sempels, Belgium

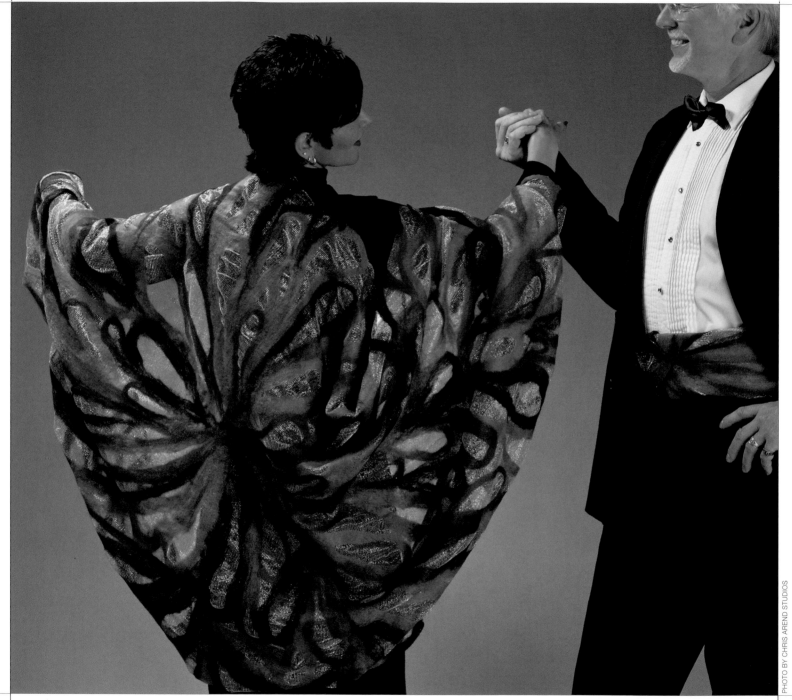

0073 | KC Lowe, Nunofelt Originals, USA

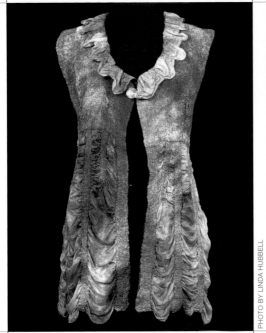

0074 | Deborah Faye Watson, USA

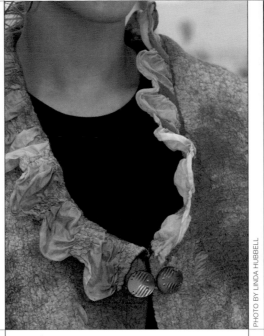

0075 | Deborah Faye Watson, USA

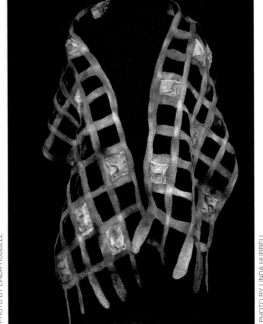

0076 | Deborah Faye Watson, USA

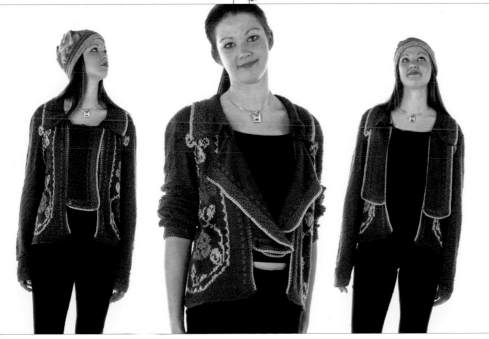

0077 | JANCIA, UK

0078 | Anne J. Hand, USA

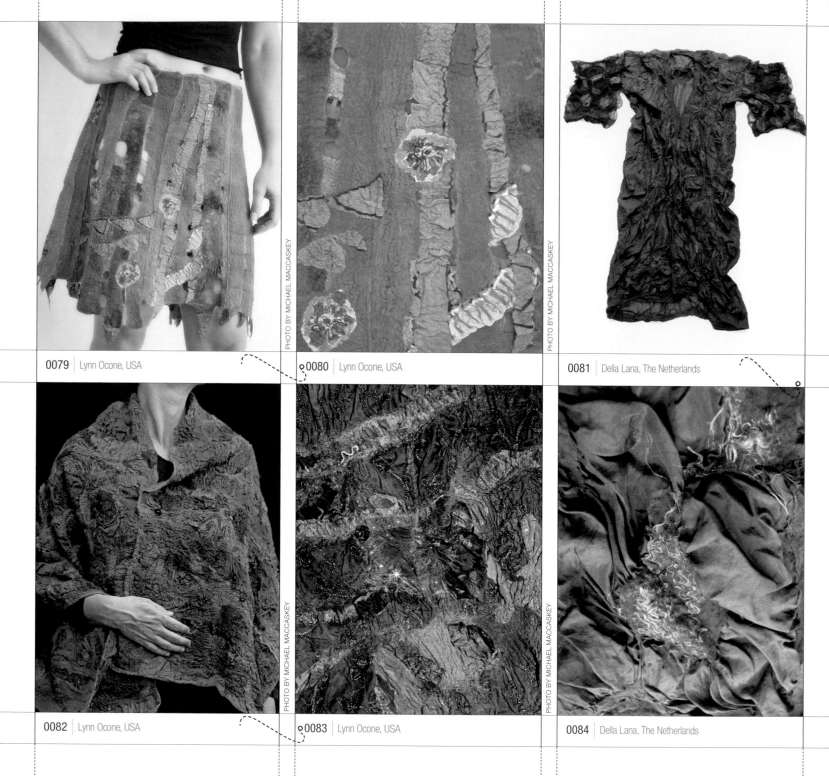

0079 | Lynn Ocone, USA

PHOTO BY MICHAEL MACCASKEY

0080 | Lynn Ocone, USA

PHOTO BY MICHAEL MACCASKEY

0081 | Della Lana, The Netherlands

0082 | Lynn Ocone, USA

PHOTO BY MICHAEL MACCASKEY

0083 | Lynn Ocone, USA

PHOTO BY MICHAEL MACCASKEY

0084 | Della Lana, The Netherlands

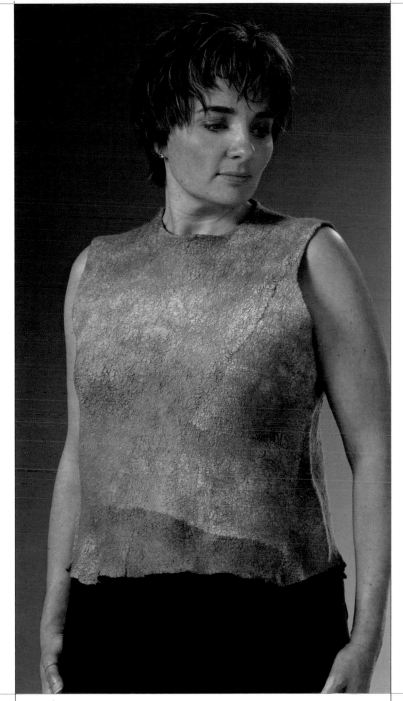

0085 | Linda Veilleux, USA

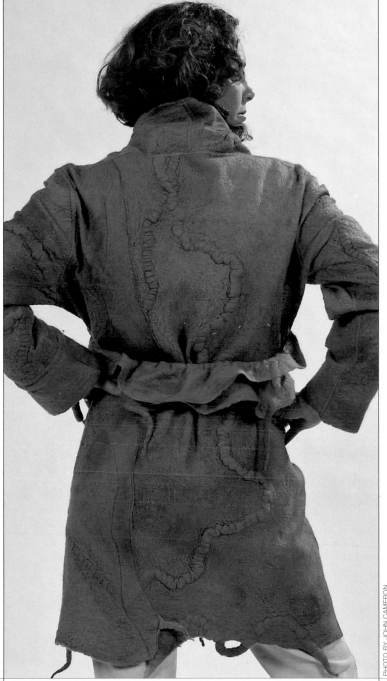

0086 | Ulrieke Benner, Art You Wear in Felt & Silk, Canada

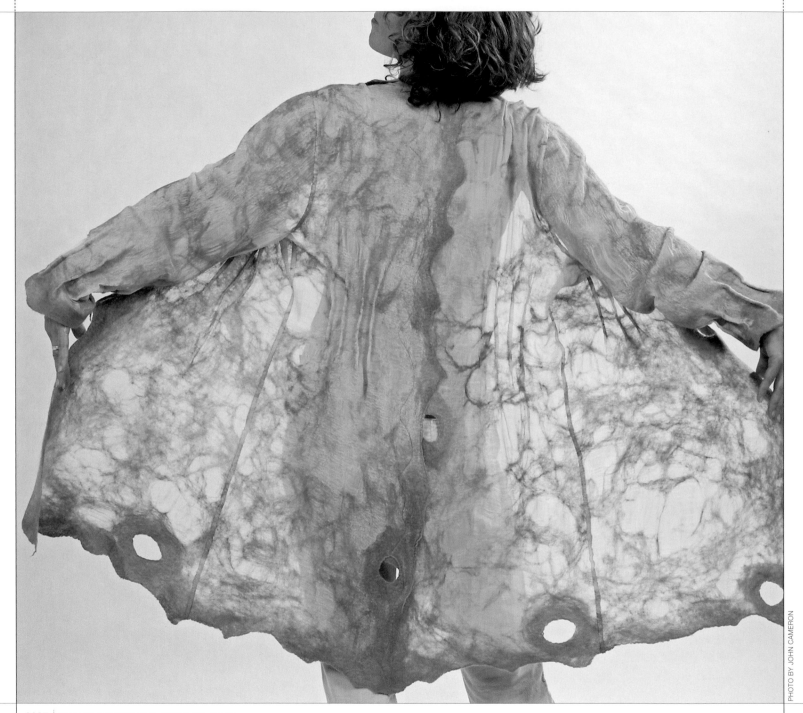

0087 | Ulrieke Benner, Art You Wear in Felt & Silk, Canada

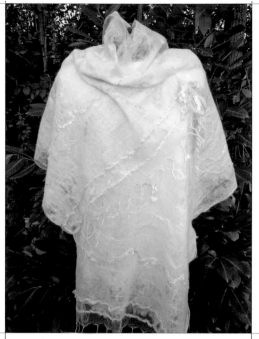

0088 | Elena Sempels, Belgium

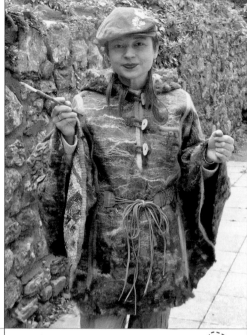

0089 | Helena Sergeyeva, Yozhyk's Felt, Sweden

0090 | Helena Sergeyeva, Yozhyk's Felt, Sweden

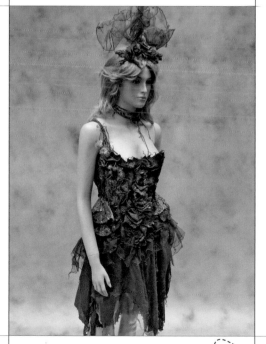

0091 | Svenja, Australia

0092 | Svenja, Australia

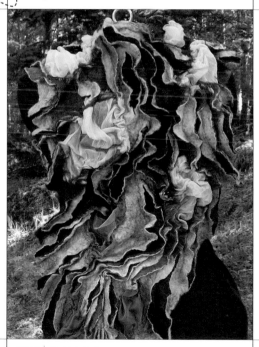

0093 | Marjolein Dallinga, Bloomfelt.com, Canada

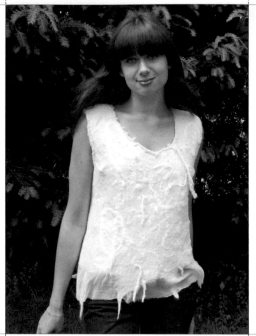

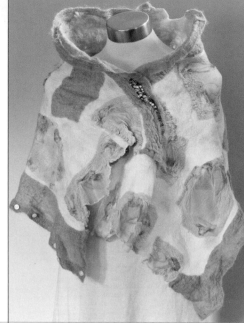

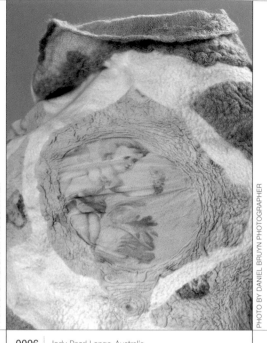

0094 | Elena Sempels, Belgium

0095 | Jody Pearl Lange, Australia

0096 | Jody Pearl Lange, Australia

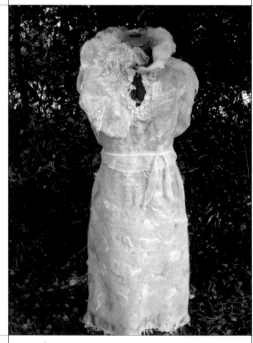

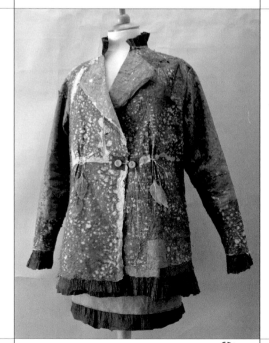

0097 | Elena Sempels, Belgium

0098 | Rosalind Aylmer, Canada

0099 | Rosalind Aylmer, Canada

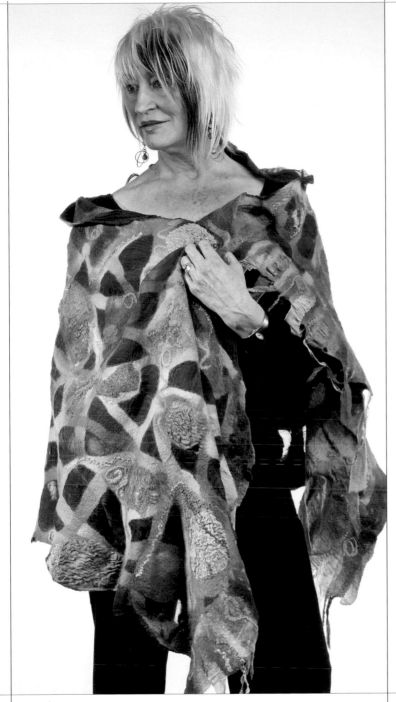

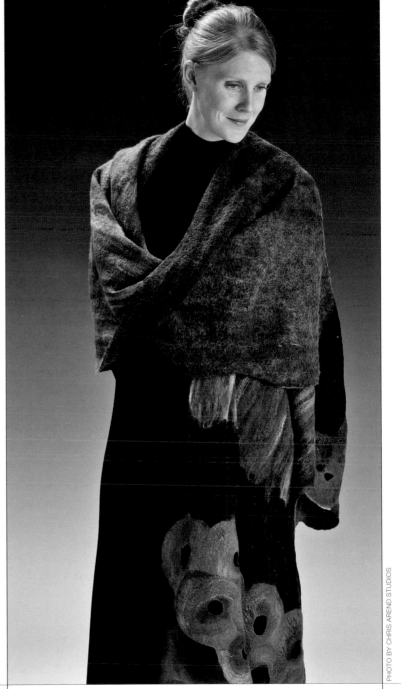

0100 | Elizabeth Armstrong, Australia

0101 | KC Lowe, Nunofelt Originals, USA

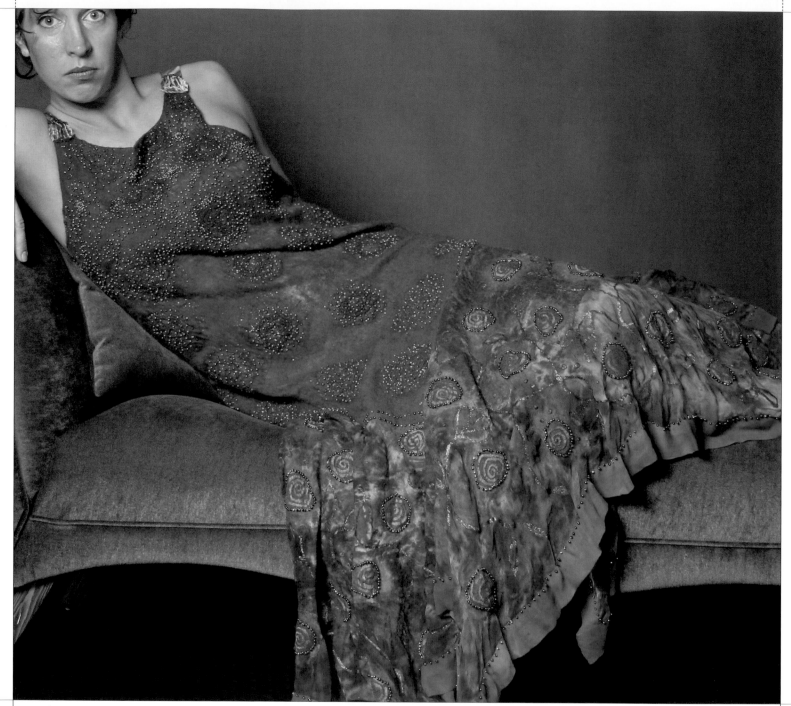

0102 | Anne Flora, USA

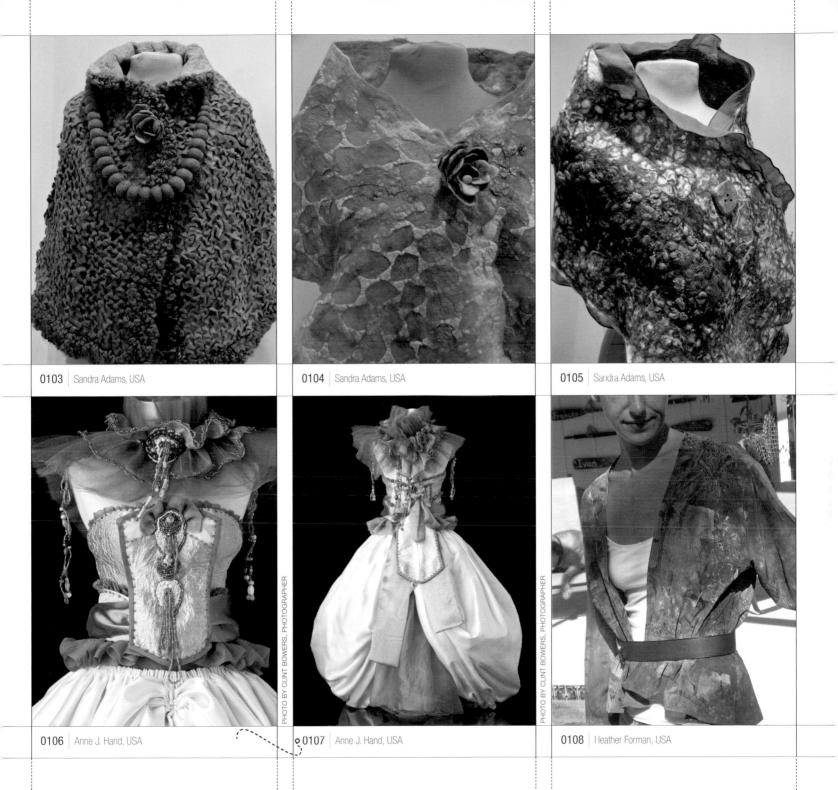

0103 | Sandra Adams, USA

0104 | Sandra Adams, USA

0105 | Sandra Adams, USA

0106 | Anne J. Hand, USA

PHOTO BY CLINT BOWERS, PHOTOGRAPHER

0107 | Anne J. Hand, USA

PHOTO BY CLINT BOWERS, PHOTOGRAPHER

0108 | Heather Forman, USA

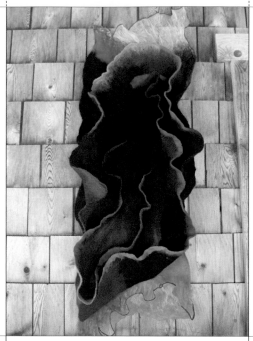

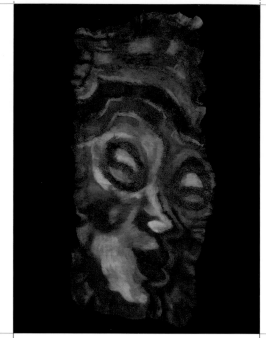

0109 | Marjolein Dallinga, Bloomfelt.com, Canada

0110 | Marjolein Dallinga, Bloomfelt.com, Canada

0111 | Jenne Giles, Harlequin Feltworks, USA

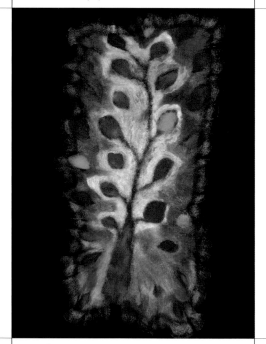
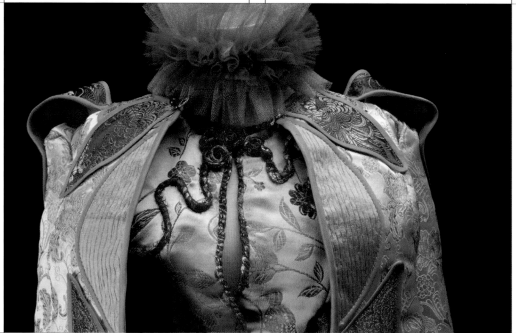

0112 | Jenne Giles, Harlequin Feltworks, USA

0113 | Anne J. Hand, USA

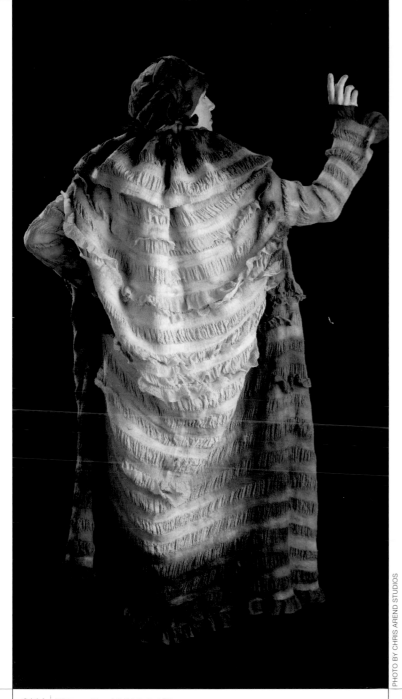

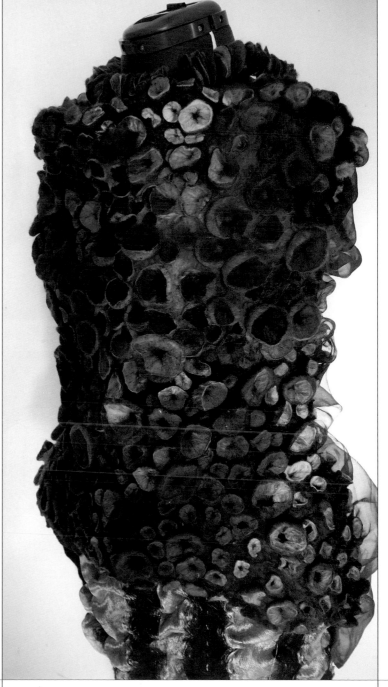

0114 | KC Lowe, Nunofelt Originals, USA

0115 | Marjolein Dallinga, Bloomfelt.com, Canada

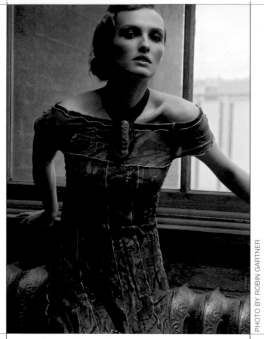

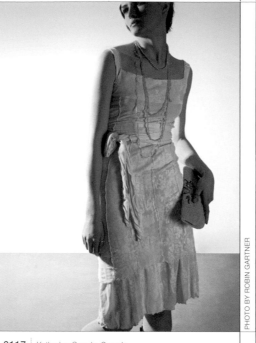

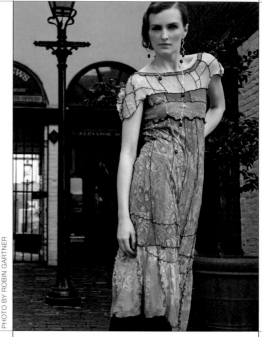

0116 | Katherine Soucie, Canada

0117 | Katherine Soucie, Canada

0118 | Katherine Soucie, Canada

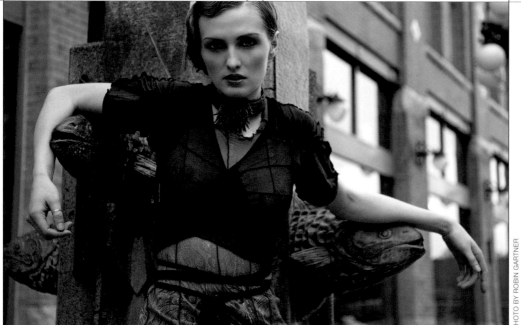

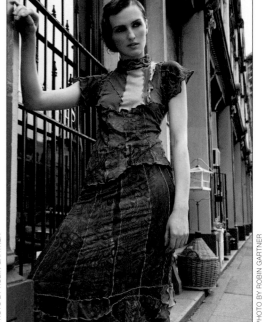

0119 | Katherine Soucie, Canada

0120 | Katherine Soucie, Canada

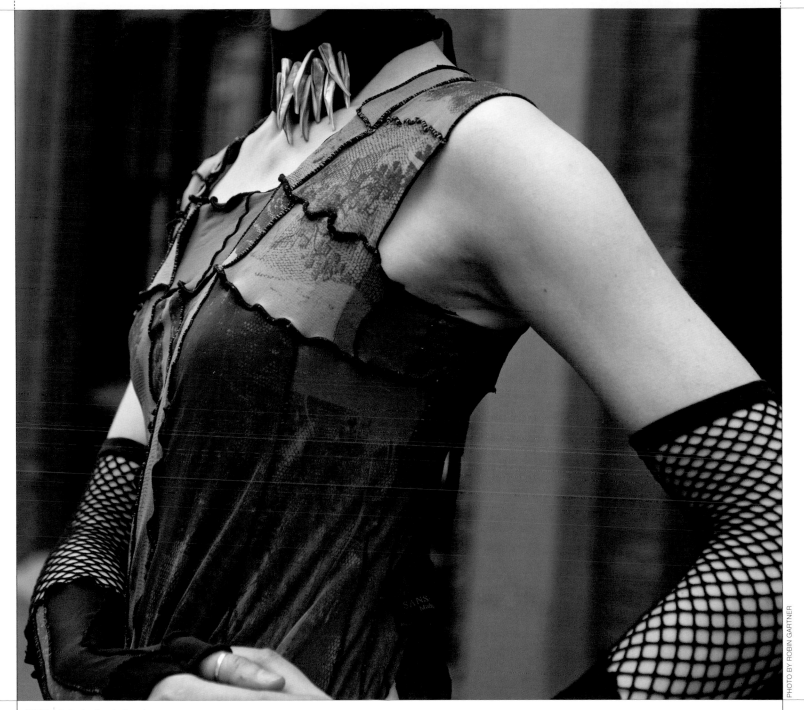

0121 | Katherine Soucie, Canada

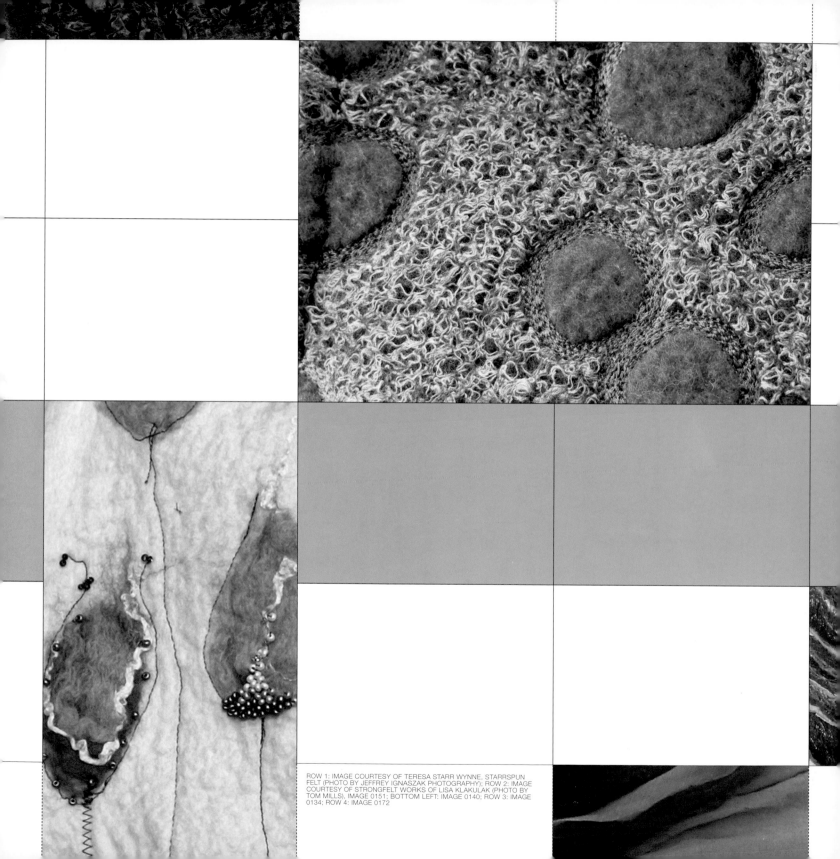

ROW 1: IMAGE COURTESY OF TERESA STARR WYNNE, STARRSPUN
FELT (PHOTO BY JEFFREY IGNASZAK PHOTOGRAPHY); ROW 2: IMAGE
COURTESY OF STRONGFELT WORKS OF LISA KLAKULAK (PHOTO BY
TOM MILLS), IMAGE 0151; BOTTOM LEFT: IMAGE 0140; ROW 3: IMAGE
0134; ROW 4: IMAGE 0172

CHAPTER 2

fashion Accessories

0122–0297

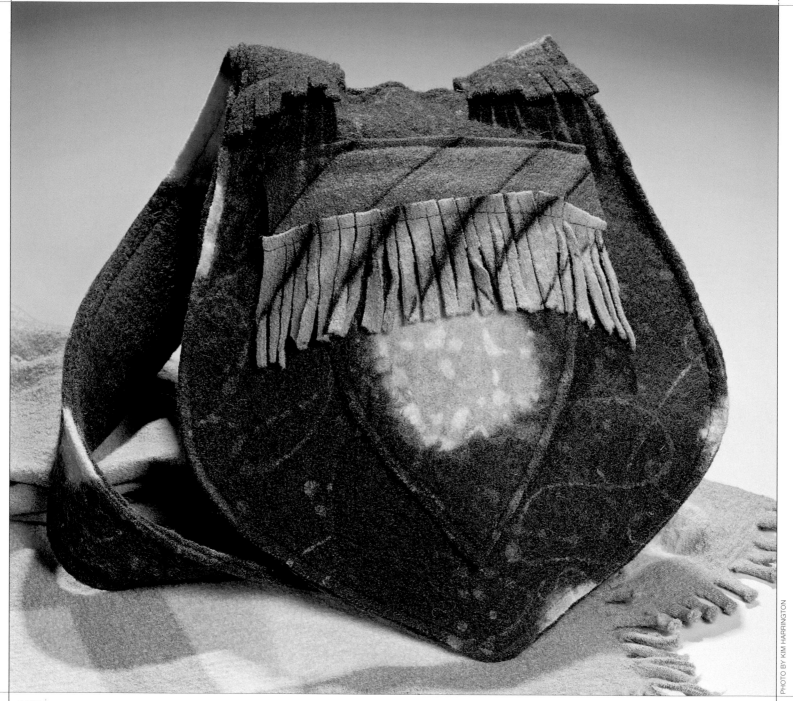

0122 | Bonnie Wells, Material Grace, USA

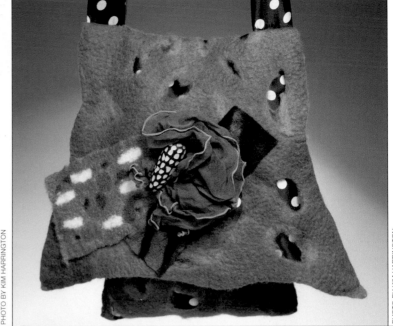

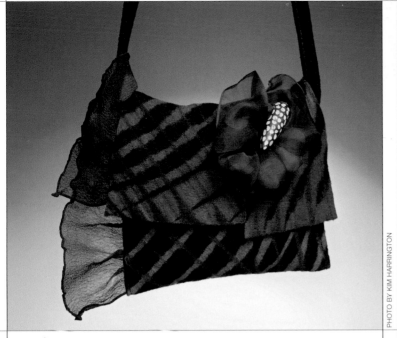

0123 | Bonnie Wells, Material Grace, USA

0124 | Bonnie Wells, Material Grace, USA

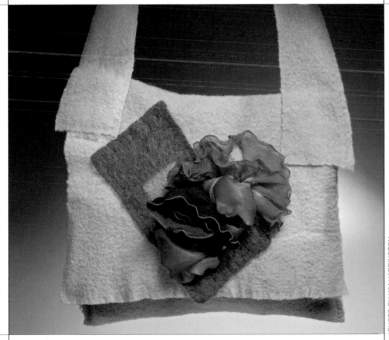

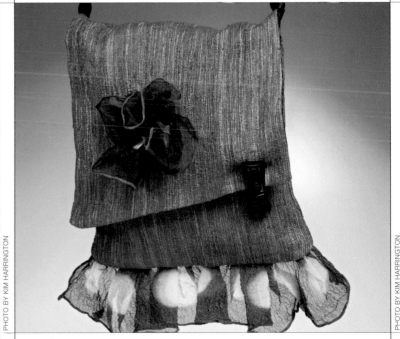

0125 | Bonnie Wells, Material Grace, USA

0126 | Bonnie Wells, Material Grace, USA

0127 | Breanna Rockstad-Kincaid, USA

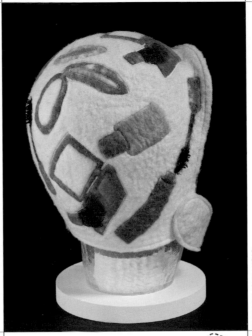

0128 | STRONGFELT works of Lisa Klakulak, USA

0129 | STRONGFELT works of Lisa Klakulak, USA

0130 | STRONGFELT works of Lisa Klakulak, USA

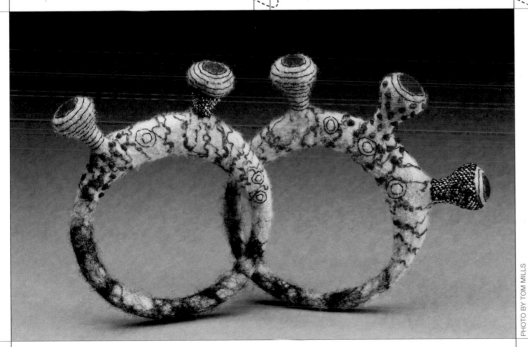

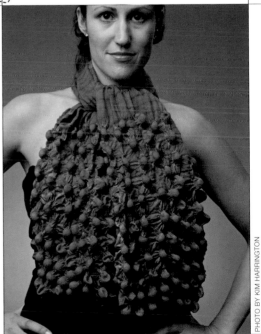

0131 | STRONGFELT works of Lisa Klakulak, USA

0132 | Bonnie Wells, Material Grace, USA

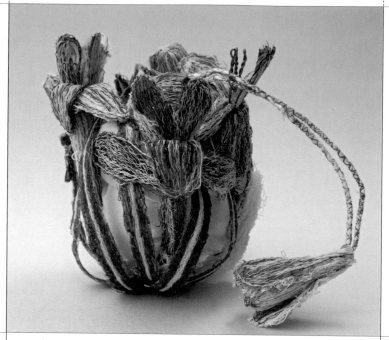

0133 | Lindsay Taylor, UK

0134 | Riny Smits, The Netherlands

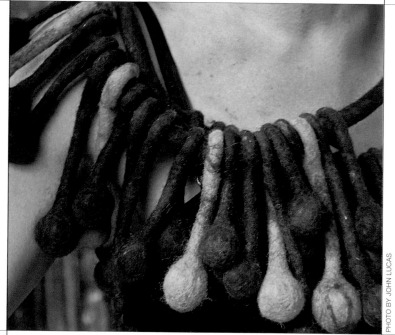

0135 | Breanna Rockstad-Kincaid, USA

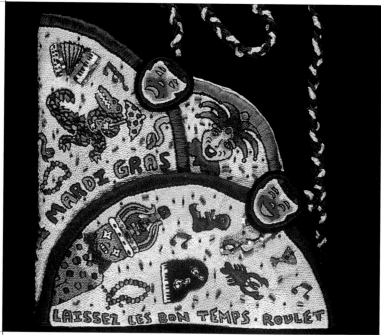

PHOTO BY JOHN LUCAS

0136 | Caroline Marcum Dahl, USA

0137 | Sandra Yasmin Fuchshofen, Germany

0138 | LeBric Rich, Penfelt, USA

0139 | Dawn Edwards, USA

0140 | Mariana Ciliberto, Florcita, The Netherlands

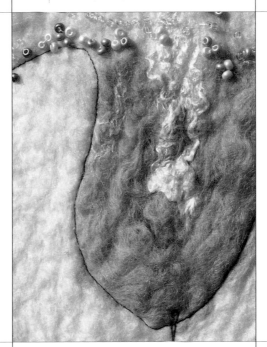

0141 | Mariana Ciliberto, Florcita, The Netherlands

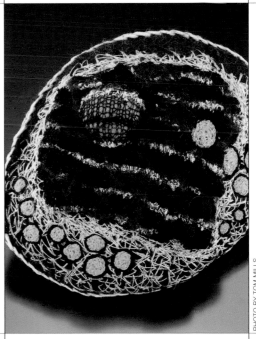

0142 | STRONGFELT works of Lisa Klakulak, USA

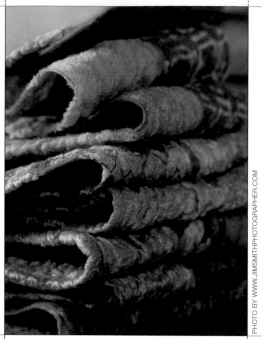

0143 | Gill Brooks, Australia

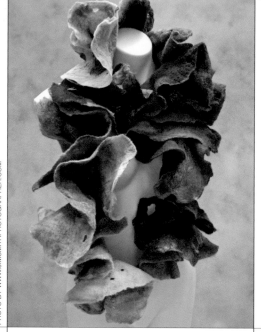

0144 | Svenja, Australia

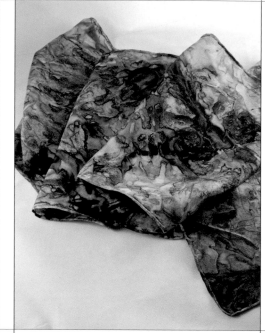

0145 | Sue Bleiweiss, USA

0146 | KC Lowe, Nunofelt Originals, USA

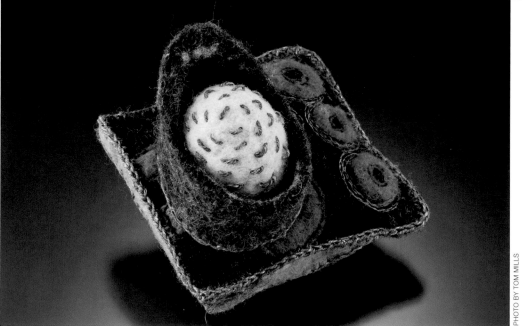

0147 | STRONGFELT works of Lisa Klakulak, USA

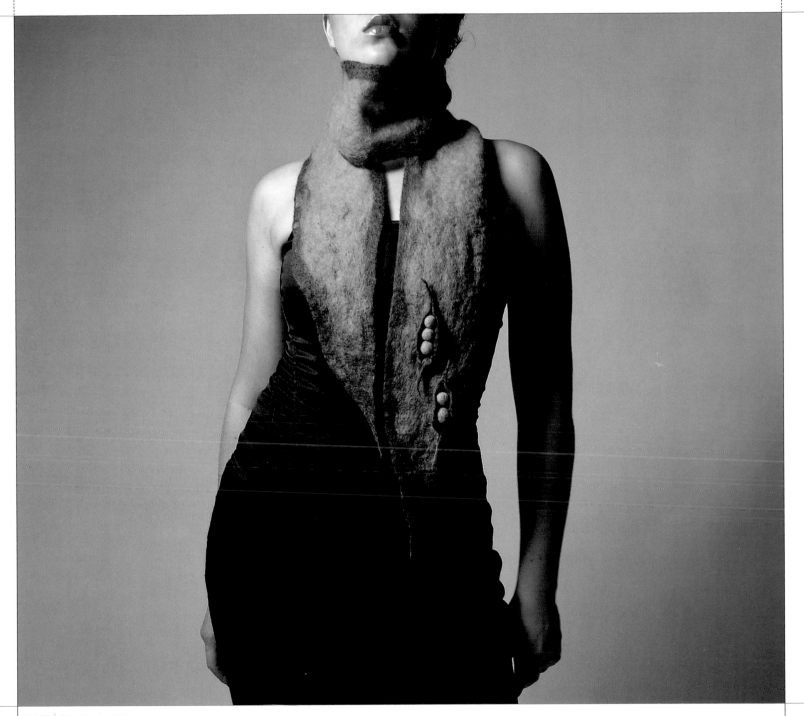

0148 | Elena Bondar, USA

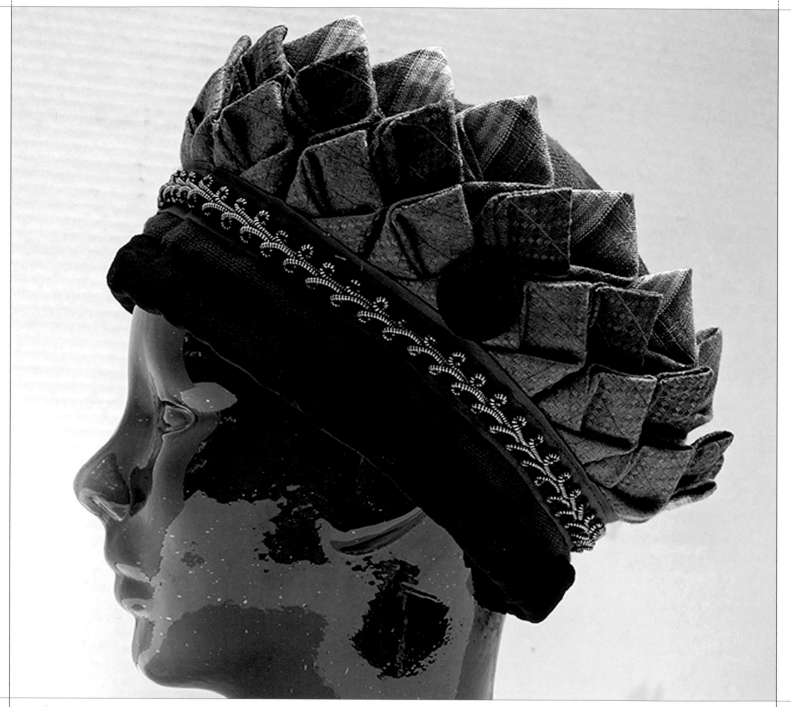

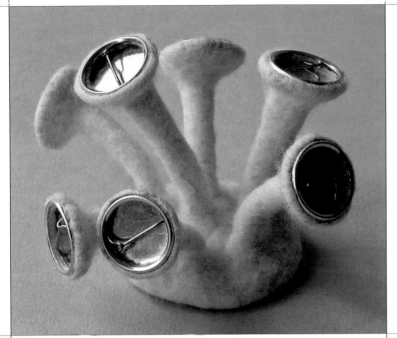

0150 | Brigit Daamen, The Netherlands

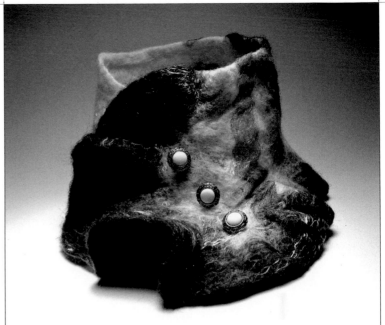

0151 | Elena Bondar, USA

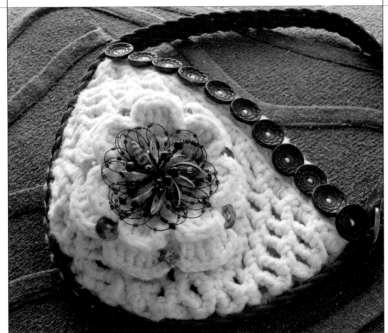

0152 | Christine Boyle, Northern Ireland

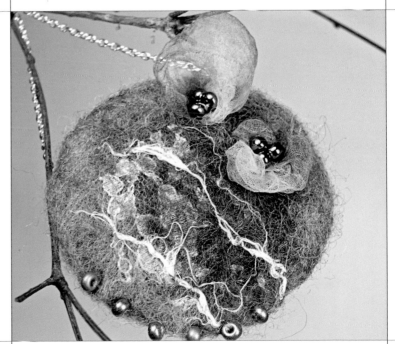

0153 | Elena Bondar, USA

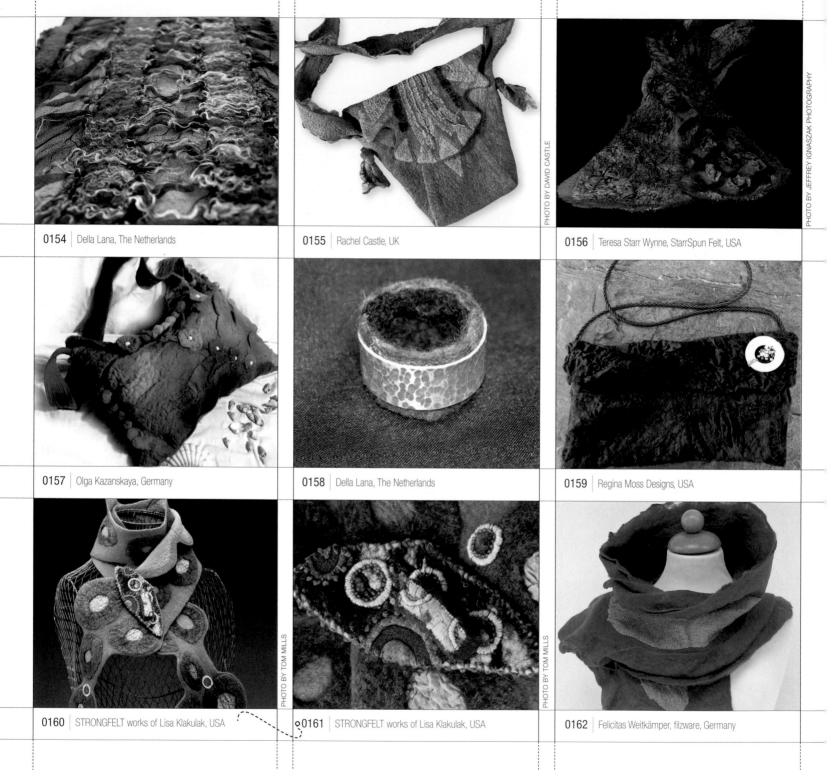

0154 | Della Lana, The Netherlands

0155 | Rachel Castle, UK

0156 | Teresa Starr Wynne, StarrSpun Felt, USA

0157 | Olga Kazanskaya, Germany

0158 | Della Lana, The Netherlands

0159 | Regina Moss Designs, USA

0160 | STRONGFELT works of Lisa Klakulak, USA

0161 | STRONGFELT works of Lisa Klakulak, USA

0162 | Felicitas Weitkämper, filzware, Germany

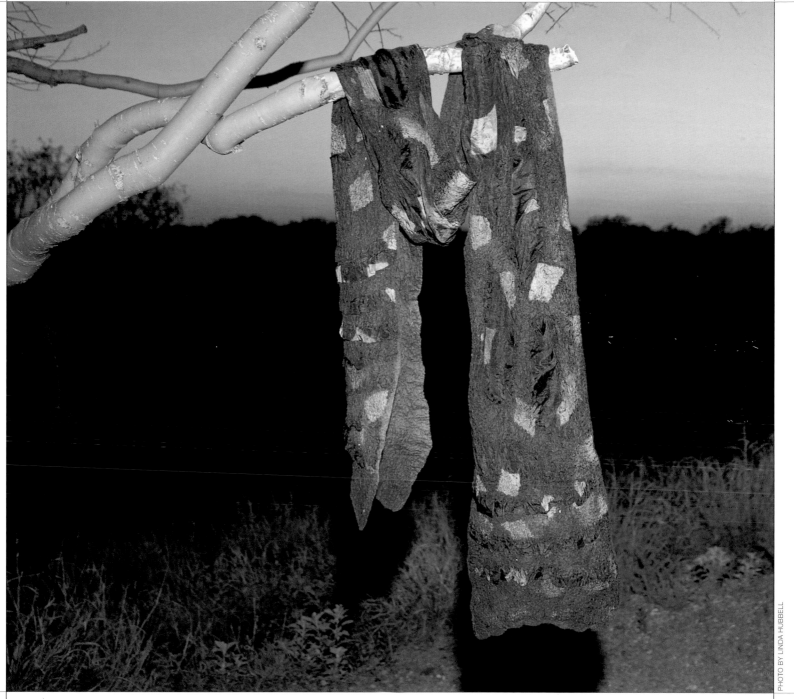

0163 | Deborah Faye Watson, USA

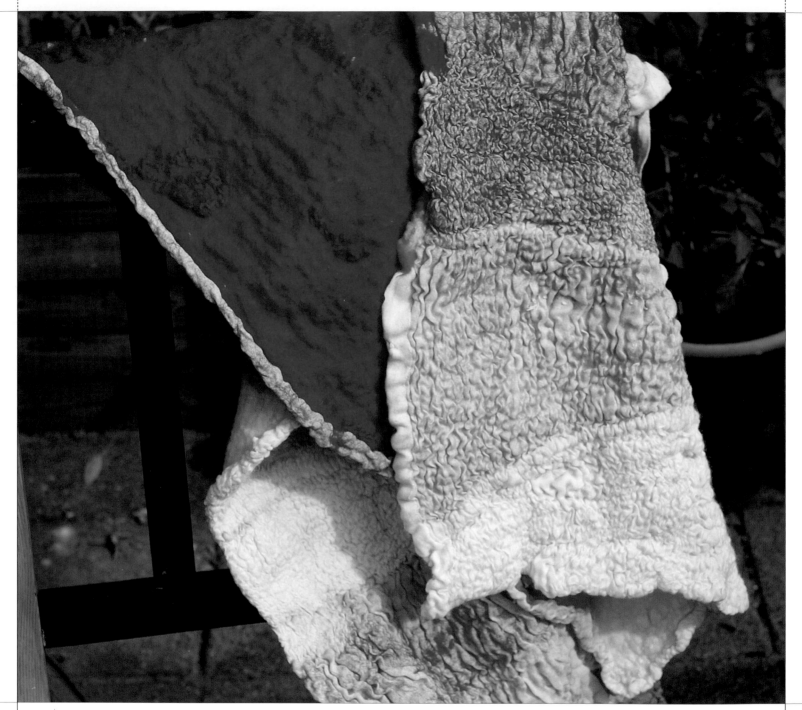

0164 | Mariana Ciliberto, Florcita, The Netherlands

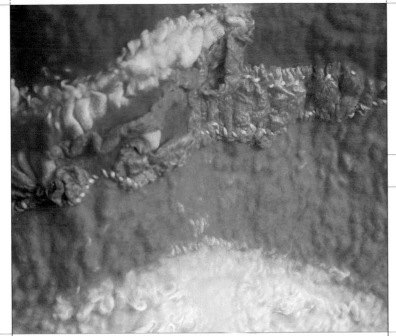

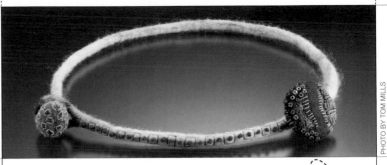

0166 | STRONGFELT works of Lisa Klakulak, USA

0165 | Mariana Ciliberto, Florcita, The Netherlands

0167 | STRONGFELT works of Lisa Klakulak, USA

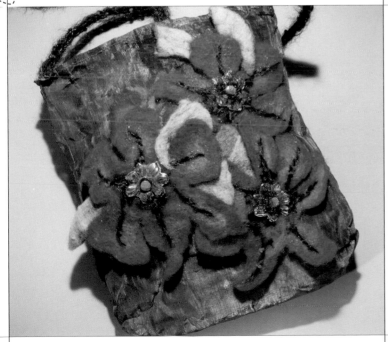

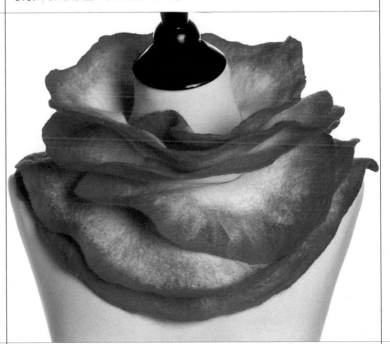

0168 | Barbara G. Kile, USA

0169 | Jenne Giles, Harlequin Feltworks, USA

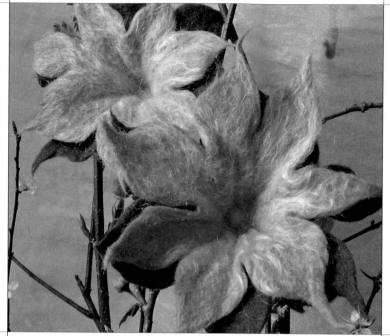

0170 | Sandra Yasmin Fuchshofen, Germany

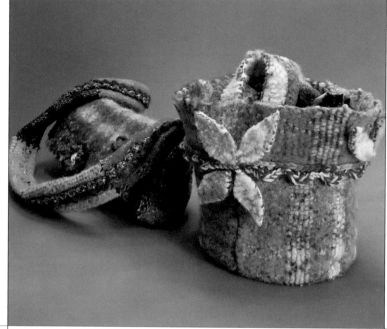

0171 | Claire Boulat, USA

0172 | Felicitas Weitkämper, filzware, Germany

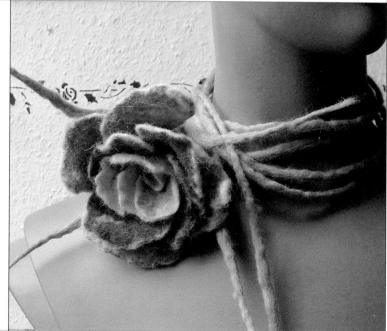

0173 | Sandra Yasmin Fuchshofen, Germany

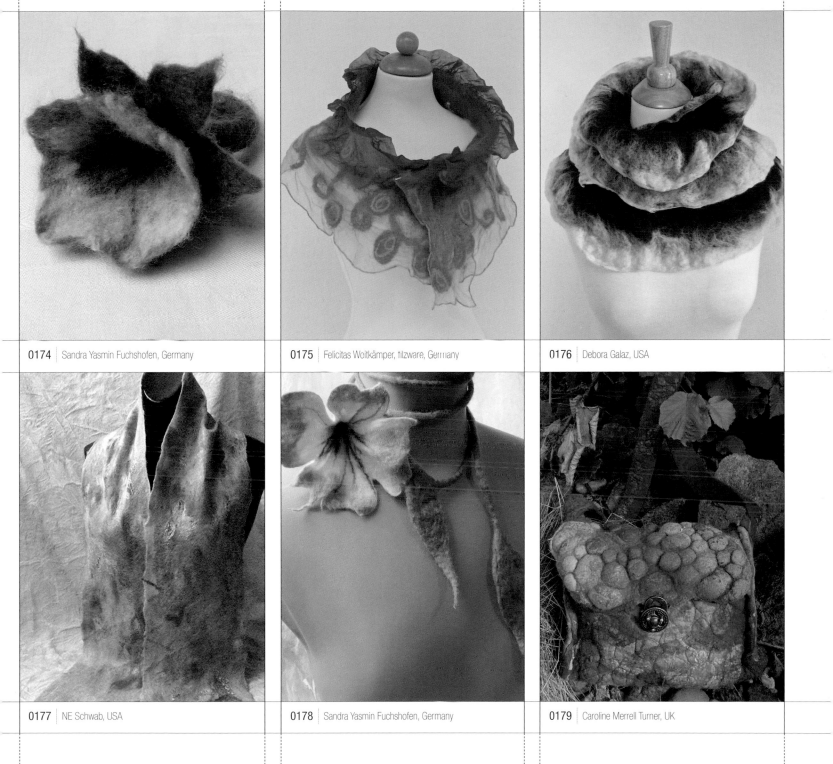

0174 | Sandra Yasmin Fuchshofen, Germany

0175 | Felicitas Woitkämper, filzware, Germany

0176 | Debora Galaz, USA

0177 | NE Schwab, USA

0178 | Sandra Yasmin Fuchshofen, Germany

0179 | Caroline Merrell Turner, UK

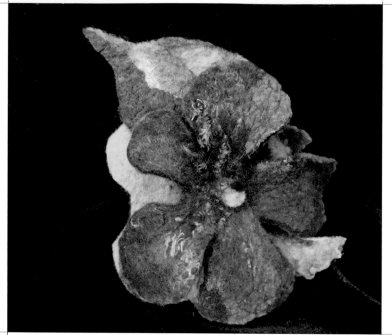

0180 | Ginny Huber, USA

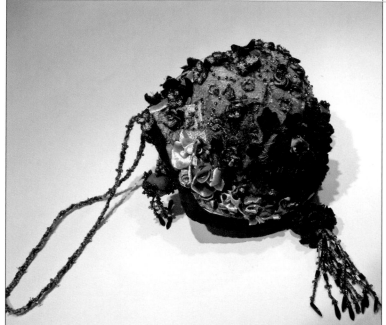

0181 | Victoria J. Davis, Canada

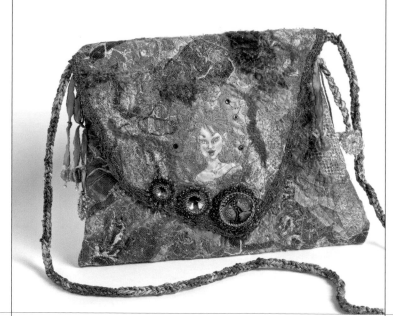

0182 | Patti Medaris Culea, PMC Designs, USA

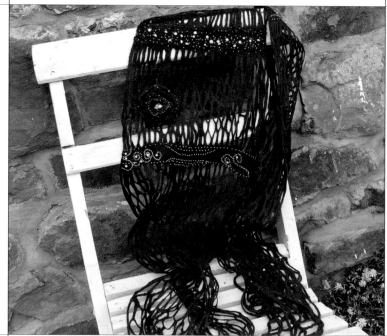

0183 | Olga Kazanskaya, Germany

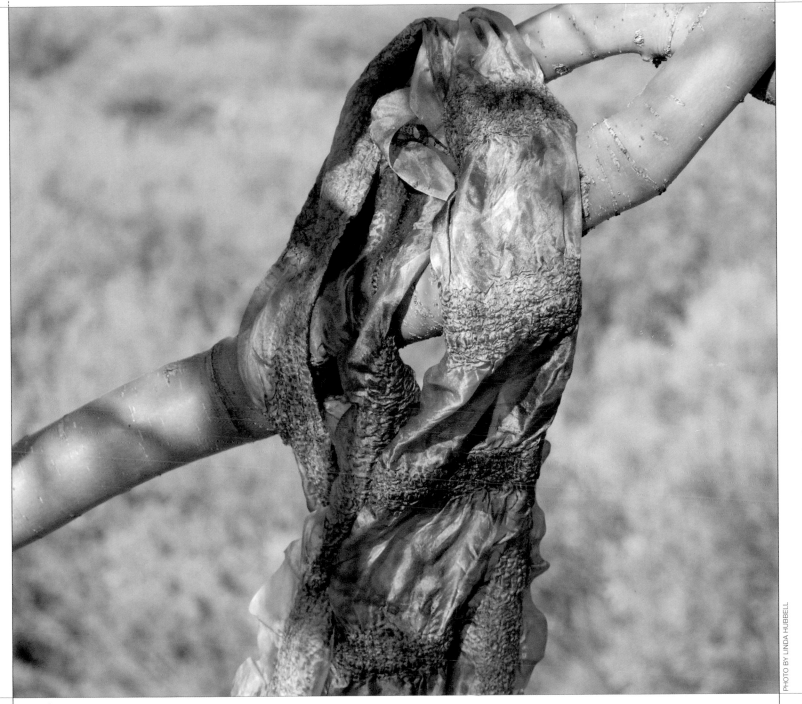

0184 | Deborah Faye Watson, USA

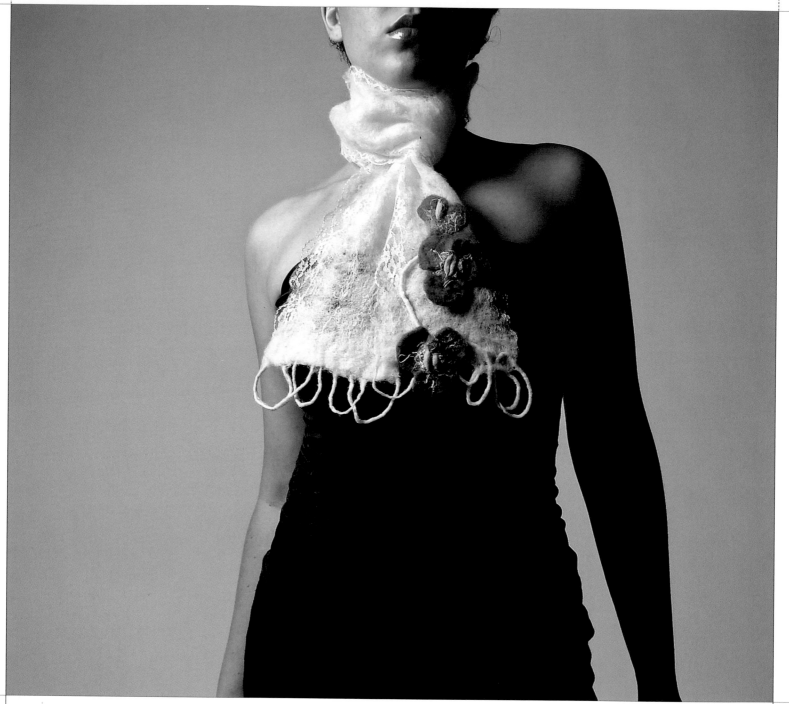

0185 | Elena Bondar, USA

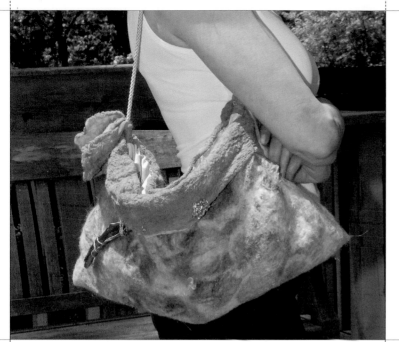

0186 | Regina Moss Designs, USA

0187 | Olga Kazanskaya, Germany

0188 | Sandra Yasmin Fuchshofen, Germany

0189 | LeBrie Rich, PenFelt, USA

0190 | Barbara G. Kile, USA

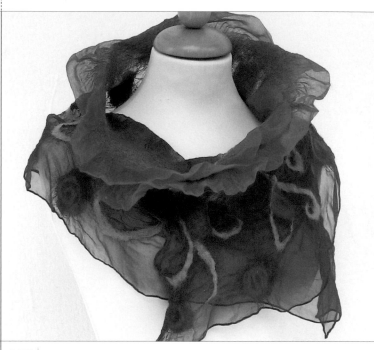

0191 | Felicitas Weitkämper, filzware, Germany

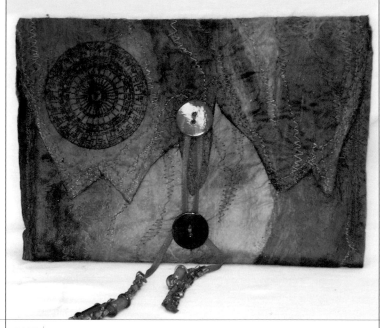

0192 | Jacquie Stone, USA

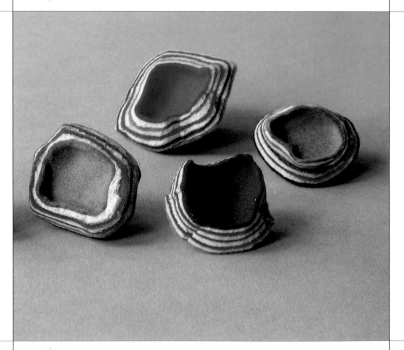

0193 | Brigit Daamen, The Netherlands

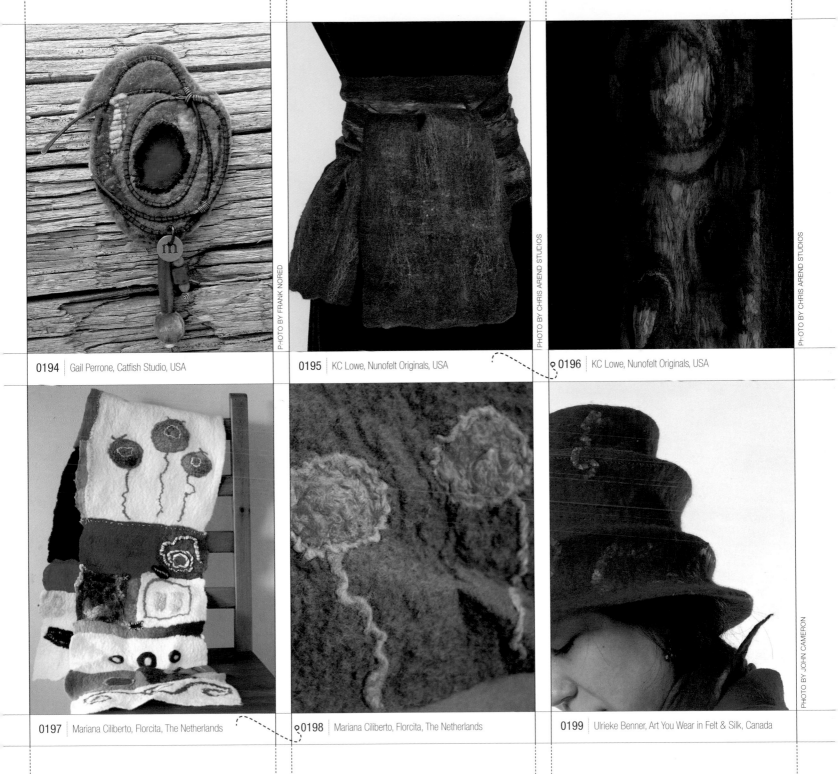

0194 | Gail Perrone, Catfish Studio, USA

PHOTO BY FRANK NORED

0195 | KC Lowe, Nunofelt Originals, USA

PHOTO BY CHRIS AREND STUDIOS

0196 | KC Lowe, Nunofelt Originals, USA

PHOTO BY CHRIS AREND STUDIOS

0197 | Mariana Ciliberto, Florcita, The Netherlands

0198 | Mariana Ciliberto, Florcita, The Netherlands

0199 | Ulrieke Benner, Art You Wear in Felt & Silk, Canada

PHOTO BY JOHN CAMERON

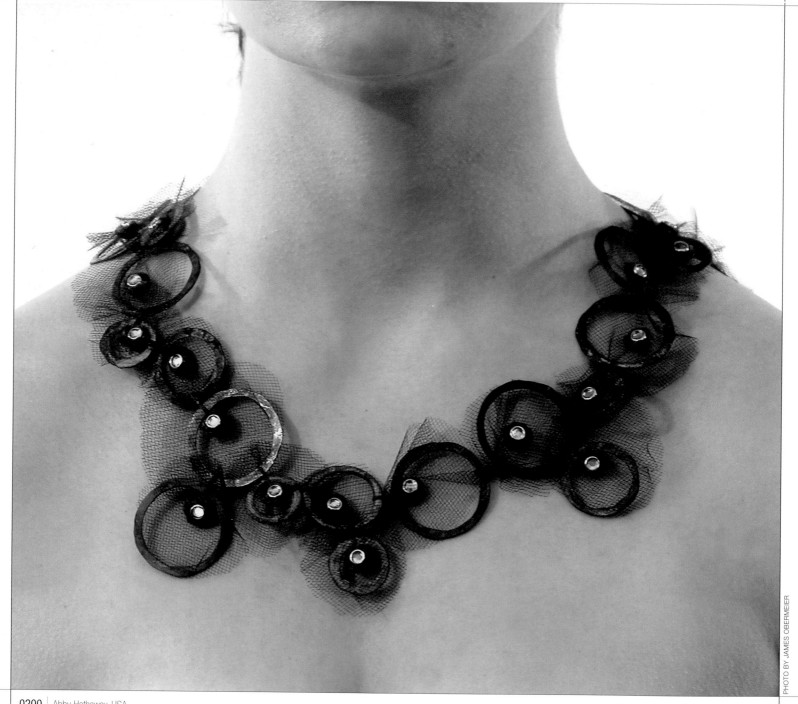

0200 | Abby Hathaway, USA

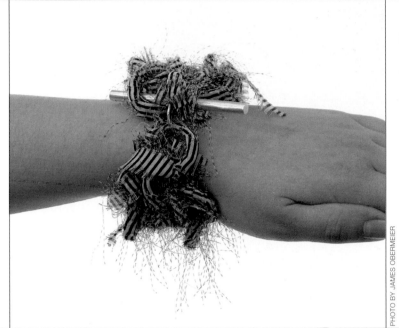

0201 | Abby Hathaway, USA

0202 | STRONGFELT works of Lisa Klakulak, USA

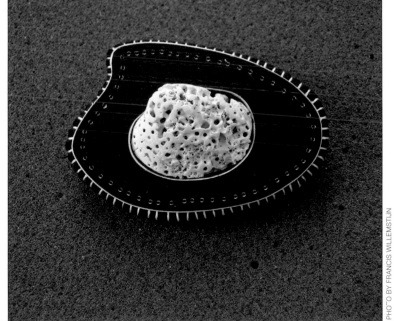

0203 | Ginny Huber, USA

0204 | Ingeborg Vandamme, The Netherlands

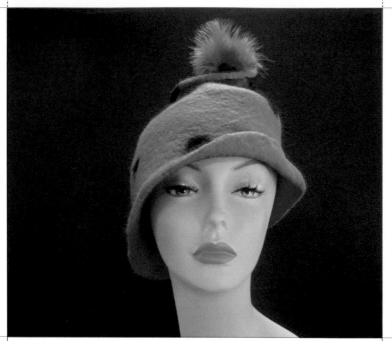

0205 | Sarah Harrington Lajoie, Attitude Hats, USA

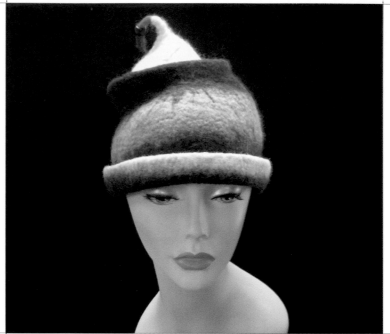

0206 | Sarah Harrington Lajoie, Attitude Hats, USA

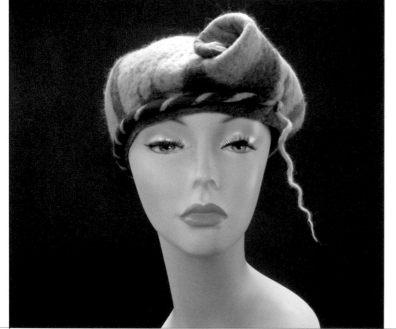

0207 | Sarah Harrington Lajoie, Attitude Hats, USA

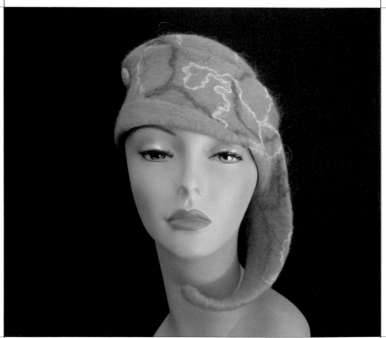

0208 | Sarah Harrington Lajoie, Attitude Hats, USA

0209 | STRONGFELT works of Lisa Klakulak, USA

0210 | STRONGFELT works of Lisa Klakulak, USA

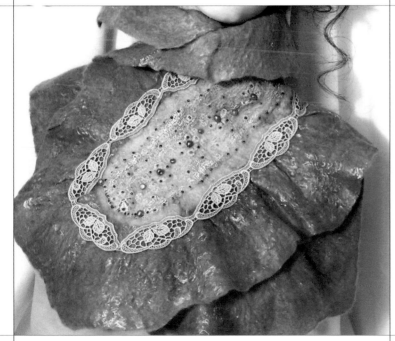

0211 | Olga Kazanskaya, Germany

0212 | Heather Crossley, Australia

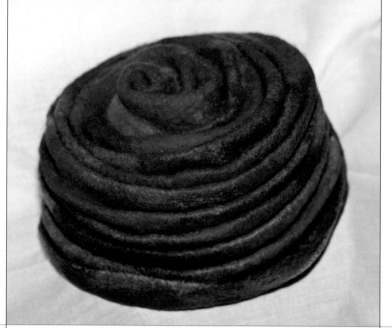

0213 | Dawn Edwards, USA

0214 | Dawn Edwards, USA

0215 | Maggie French, USA

0216 | Barbara G. Kile, USA

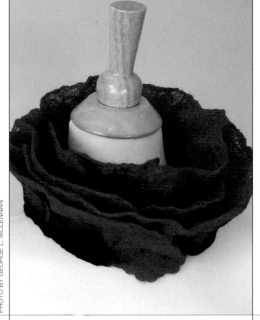

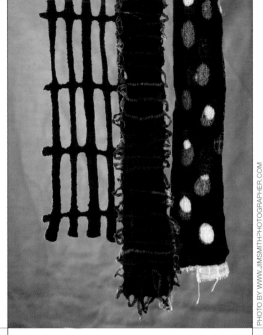

| 0217 | Debra M. Lee, USA |

| 0218 | Debora Galaz, USA |

| 0219 | Gill Brooks, Australia |

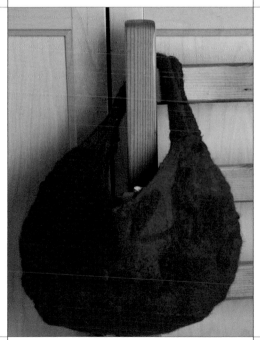

| 0220 | Mariana Ciliberto, Florcita, The Netherlands |

| 0221 | Mariana Ciliberto, Florcita, The Netherlands |

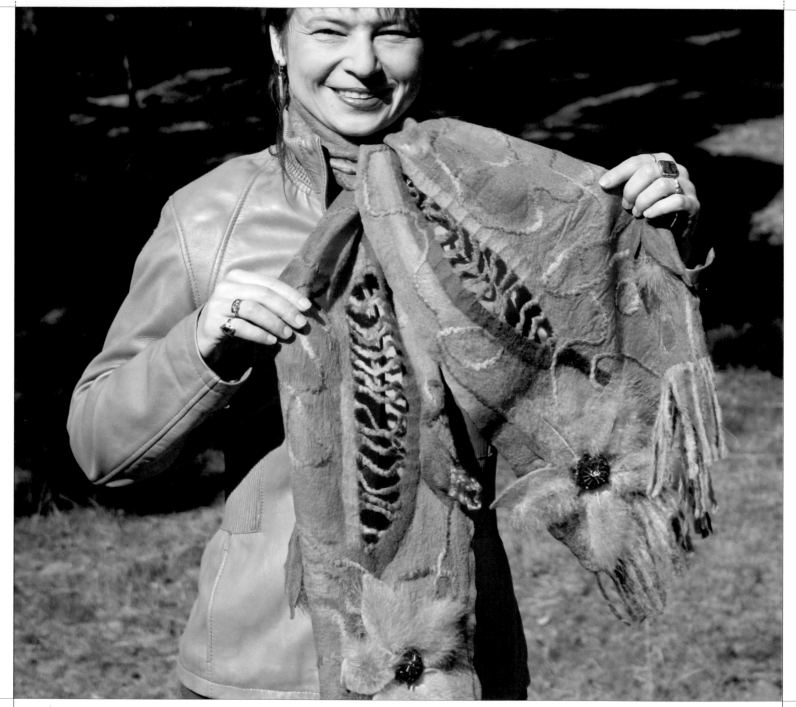

0222 | Helena Sergeyeva, Yozhyk's Felt, Sweden

0223 | Niki Newkirk, USA

0224 | Niki Newkirk, USA

0225 | Niki Newkirk, USA

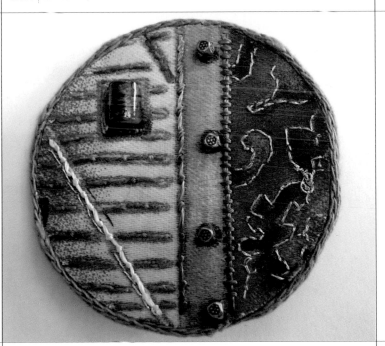

0226 | Dana Biddle, South Africa

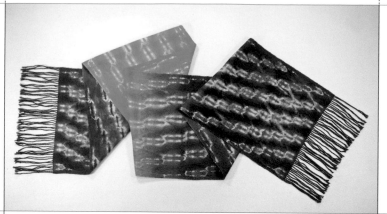

0227 | Linda Senechal, USA

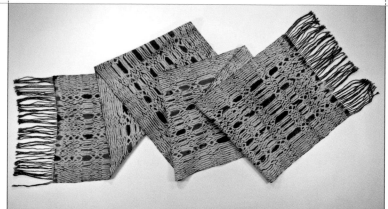

0228 | Linda Senechal, USA

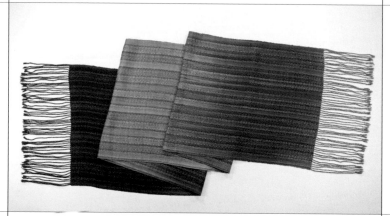

0229 | Linda Senechal, USA

0230 | Linda Senechal, USA

0231 | Claire Boulat, USA

0232 | Christine Witham, UK

0233 | Marjolein Dallinga, Bloomfelt.com, Canada

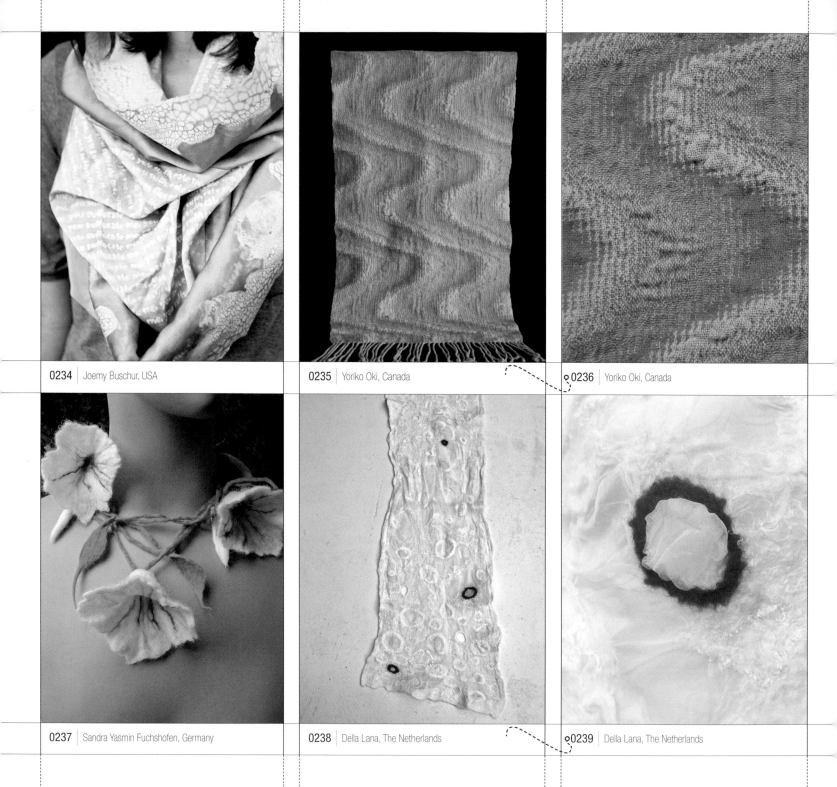

0234 | Joemy Buschur, USA

0235 | Yoriko Oki, Canada

0236 | Yoriko Oki, Canada

0237 | Sandra Yasmin Fuchshofen, Germany

0238 | Della Lana, The Netherlands

0239 | Della Lana, The Netherlands

0240 | Della Lana, The Netherlands

0241 | Carol Ingram, USA

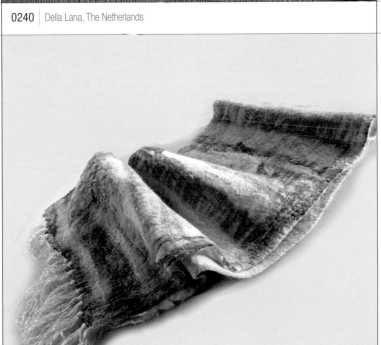

0242 | Olga Kazanskaya, Germany

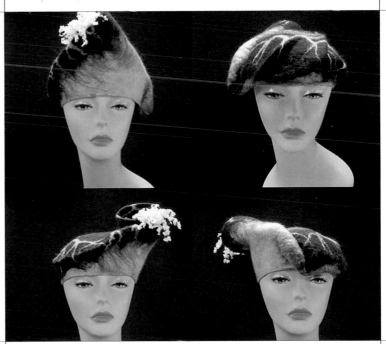

0243 | Sarah Harrington Lajoie, Attitude Hats, USA

0244 | Elena Sempels, Belgium

0245 | Teresa Starr Wynne, StarrSpun Felt, USA

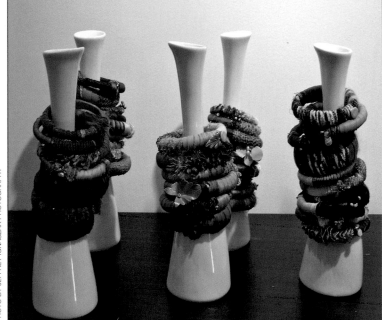

0246 | Sandra Adams, USA

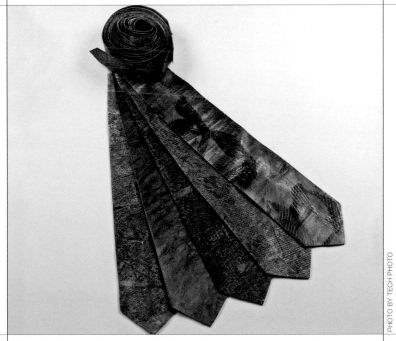

0247 | Miriam W. Jacobs, USA

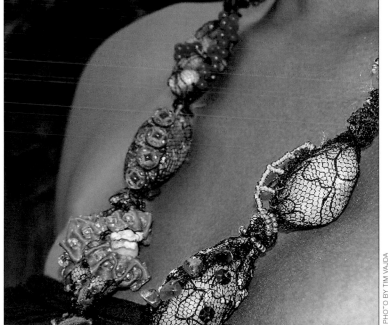

0248 | LaVerne Kemp Handwovens, USA

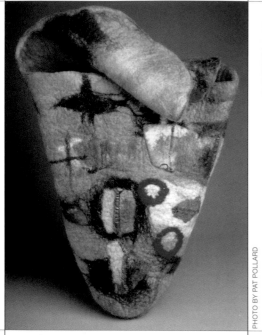

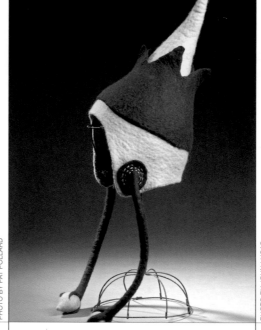

PHOTO BY PAT POLLARD

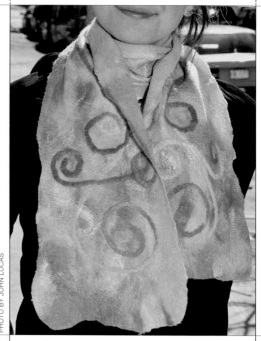

PHOTO BY JOHN LUCAS

0249 | Gail Perrone, Catfish Studio, USA

0250 | Breanna Rockstad-Kincaid, USA

0251 | NE Schwab, USA

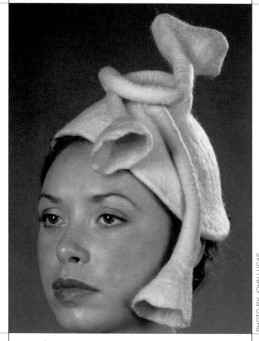

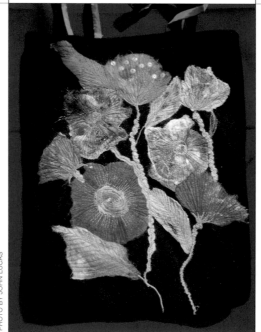

PHOTO BY JOHN LUCAS

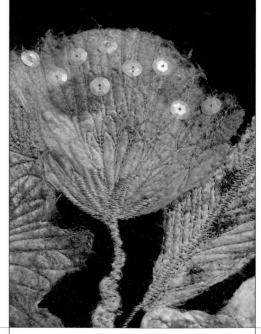

0252 | Breanna Rockstad-Kincaid, USA

0253 | Kath Danswan, UK

0254 | Kath Danswan, UK

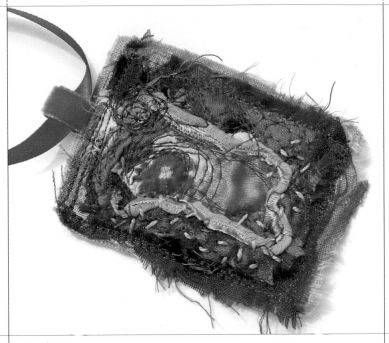

0255 | Heloise, UK

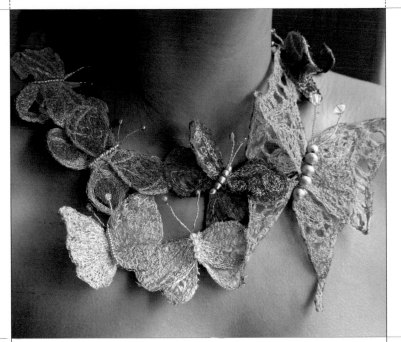

0256 | Lindsay Taylor, UK

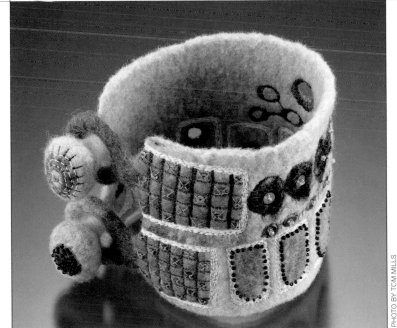

0257 | STRONGFELT works of Lisa Klakulak, USA

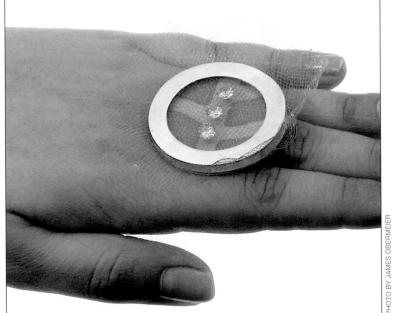

0258 | Abby Hathaway, USA

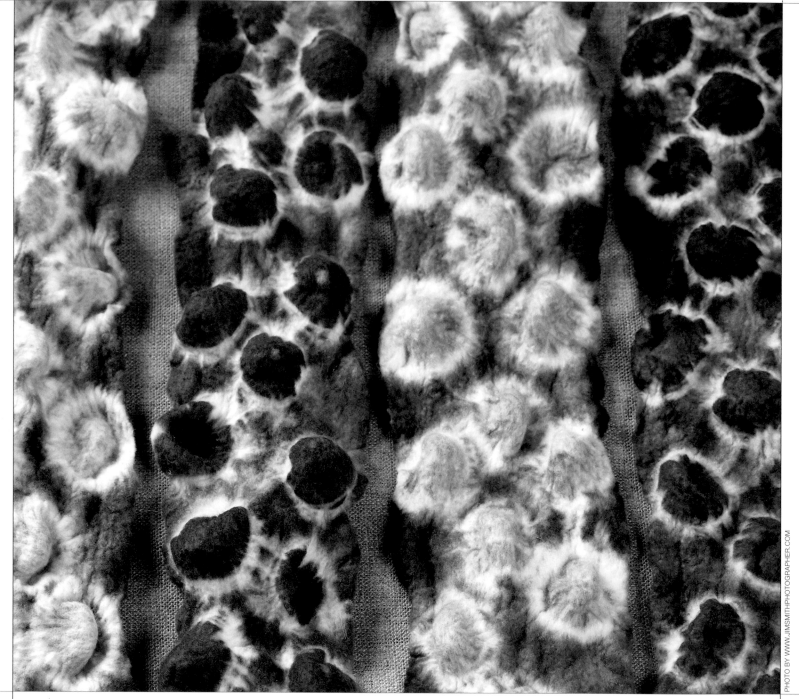

0259 | Gill Brooks, Australia

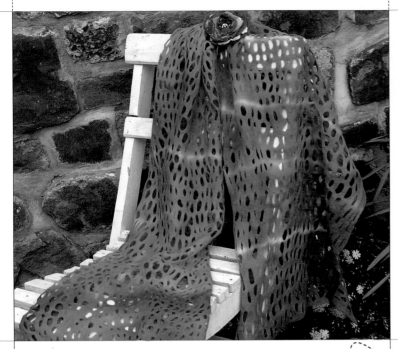

0260 | Olga Kazanskaya, Germany

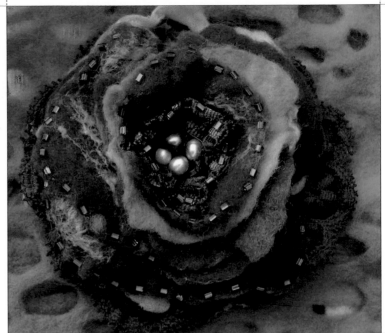

0261 | Olga Kazanskaya, Germany

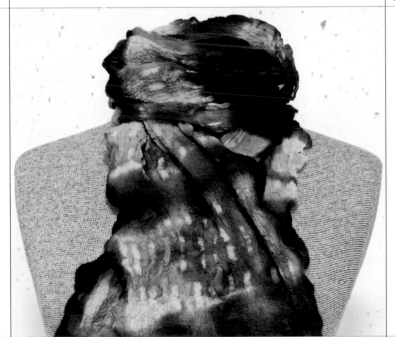

0262 | Robin L. Haller, USA

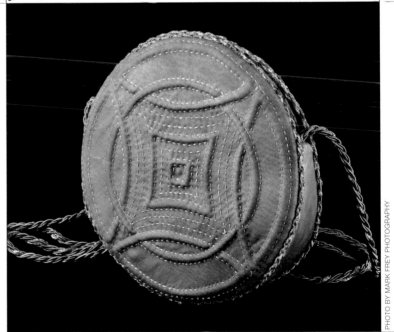

0263 | Jeri L. Flom, USA

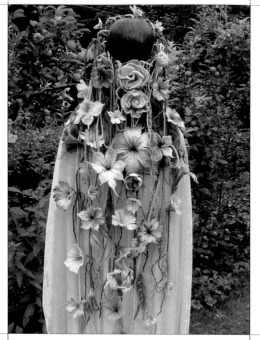

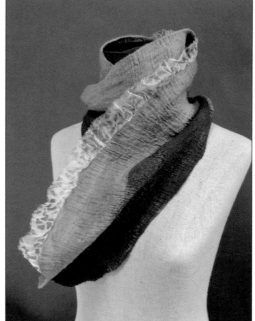

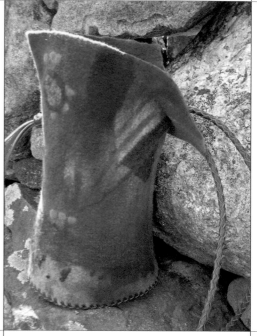

0264 | Sandra Yasmin Fuchshofen, Germany

0265 | LeBrie Rich, PenFelt, USA

0266 | Heather Kerner, Spiralworks Fiber Studio, USA

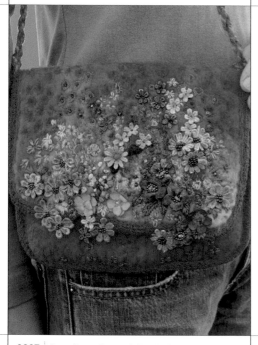

0267 | Penny Eamer, Teamwork Handicrafts, Australia

0268 | Della Lana, The Netherlands

0269 | Della Lana, The Netherlands

0270 | Anno Flora, USA

0271 | Sandra Adams, USA

0272 | Carol Coleman, UK

0273 | Heather Kerner, Spiralworks Fiber Studio, USA

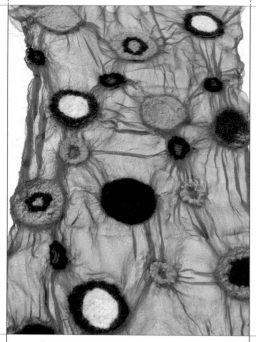

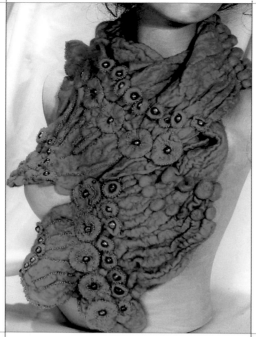

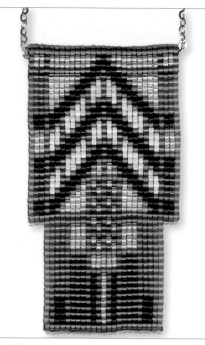

0274 | Della Lana, The Netherlands

0275 | Olga Kazanskaya, Germany

0276 | Jenny Vrieze, Weaving & Design, USA

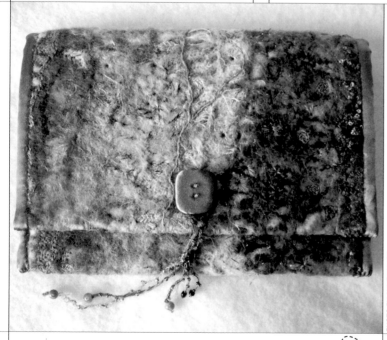

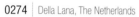

PHOTO BY ANNE LAINCE

PHOTO BY ANNE LAINCE

0277 | Carol McGill, Australlia

0278 | Carol McGill, Australlia

0279 | LeBrie Rich, PenFelt, USA

0280 | Heather Kerner, Spiralworks Fiber Studio, USA

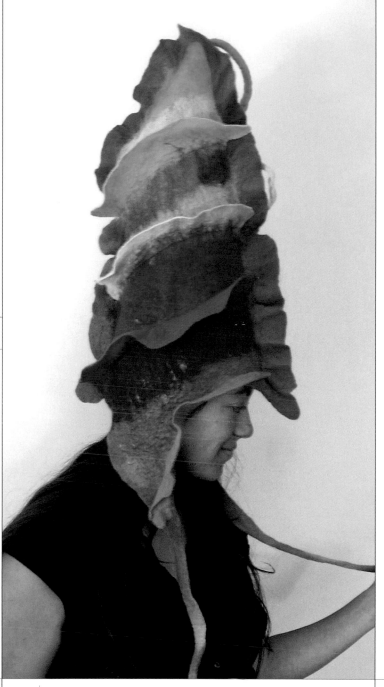

0281 | Debora Galaz, USA

0282 | Brigitte Amarger, France

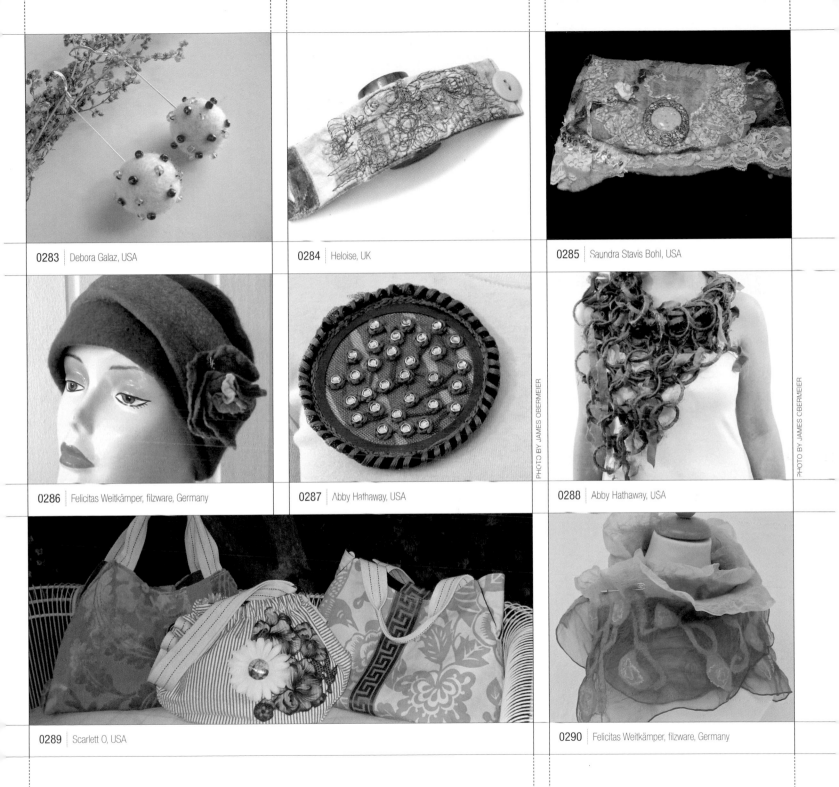

0283 | Debora Galaz, USA

0284 | Heloise, UK

0285 | Saundra Stavis Bohl, USA

0286 | Felicitas Weitkämper, filzware, Germany

0287 | Abby Hathaway, USA

0288 | Abby Hathaway, USA

PHOTO BY JAMES OBERMEIER

0289 | Scarlett O, USA

0290 | Felicitas Weitkämper, filzware, Germany

PHOTO BY JAMES OBERMEIER

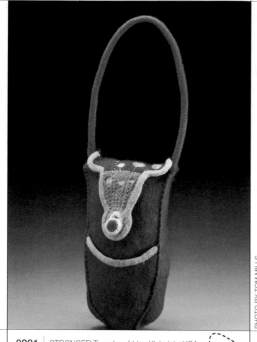

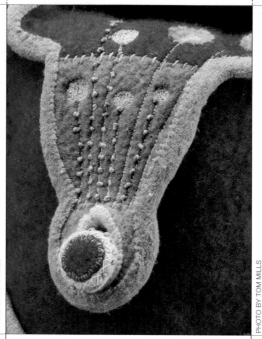

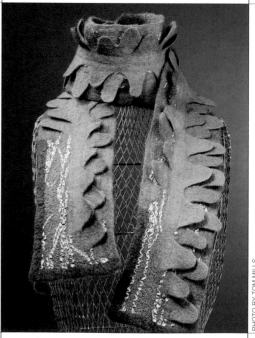

0291 | STRONGFELT works of Lisa Klakulak, USA

0292 | STRONGFELT works of Lisa Klakulak, USA

0293 | STRONGFELT works of Lisa Klakulak, USA

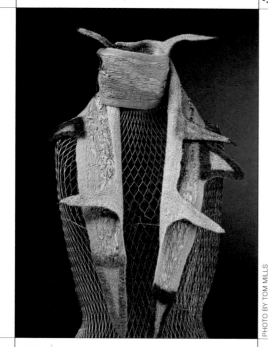

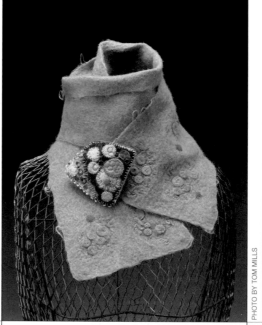

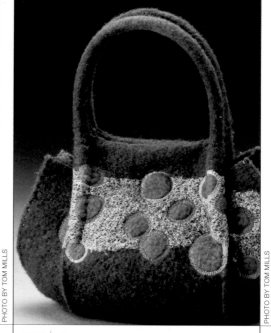

0294 | STRONGFELT works of Lisa Klakulak, USA

0295 | STRONGFELT works of Lisa Klakulak, USA

0296 | STRONGFELT works of Lisa Klakulak, USA

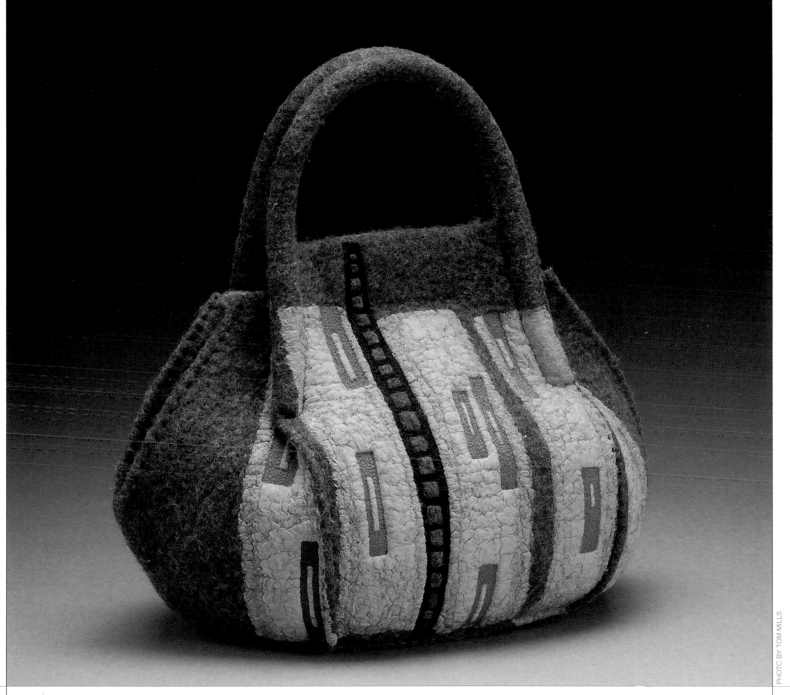

0297 | STRONGFELT works of Lisa Klakulak, USA

ROW 1: IMAGE COURTESY OF CERES M. RANGOS (PHOTO BY MARK MAY), IMAGE 0387; ROW 2: IMAGE 0365, IMAGE 0303; ROW 3: IMAGE 0353, IMAGE 0390

ſoft Furnishings & Vesssels

0298—0403

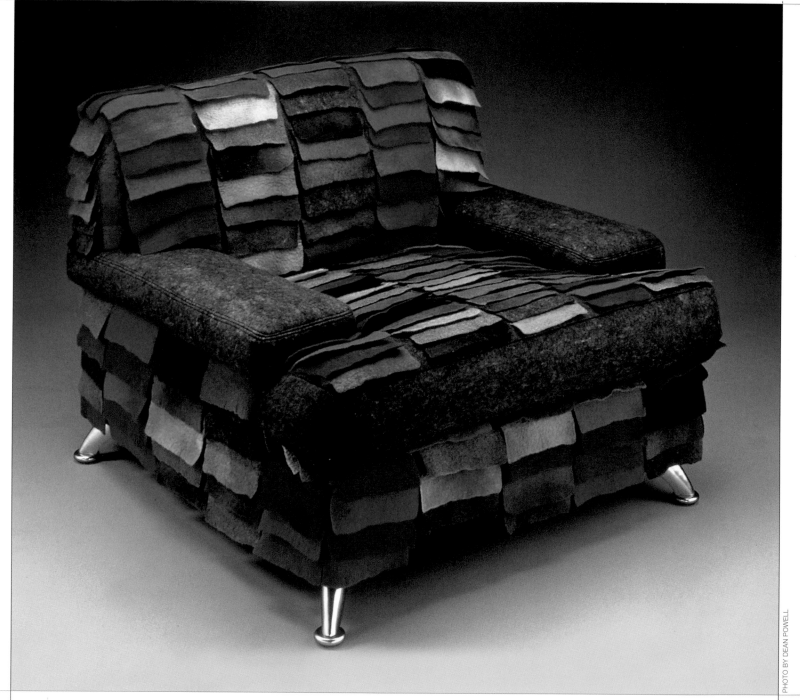

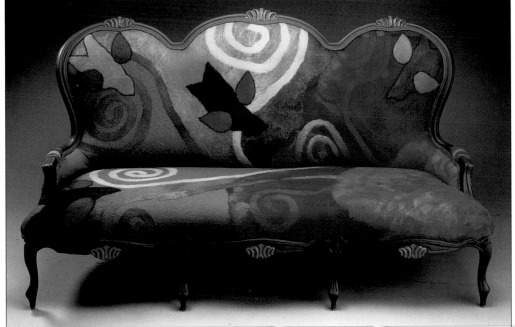

0299 | Nicole Chazaud Telaar, Festive Fibers, USA

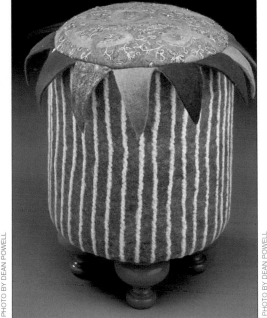

0300 | Nicole Chazaud Telaar, Festive Fibers, USA

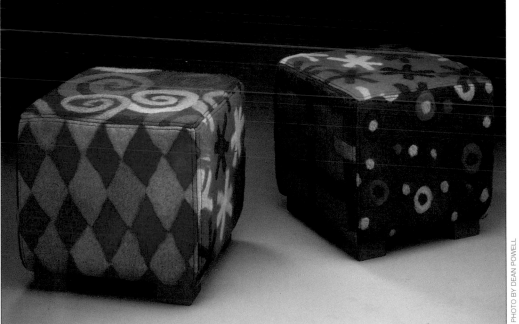

0301 | Nicole Chazaud Telaar, Festive Fibers, USA

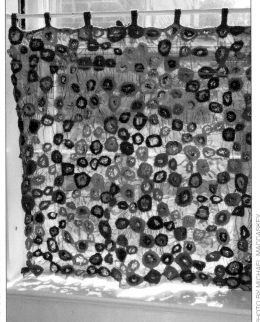

0302 | Lynn Ocone, USA

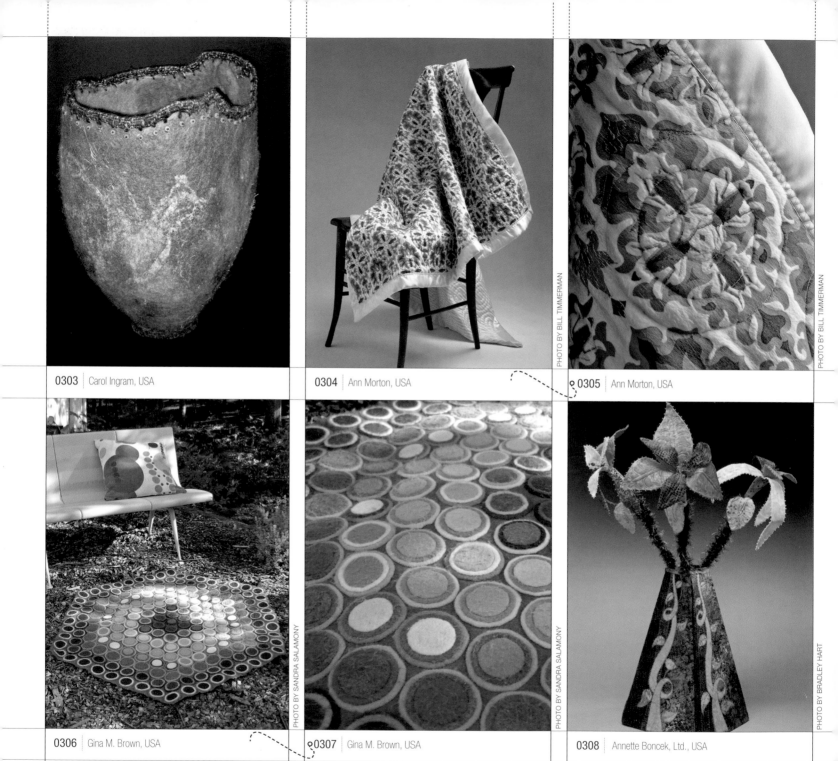

0303 | Carol Ingram, USA

0304 | Ann Morton, USA

PHOTO BY BILL TIMMERMAN

0305 | Ann Morton, USA

PHOTO BY BILL TIMMERMAN

0306 | Gina M. Brown, USA

PHOTO BY SANDRA SALAMONY

0307 | Gina M. Brown, USA

PHOTO BY SANDRA SALAMONY

0308 | Annette Boncek, Ltd., USA

PHOTO BY BRADLEY HART

0309 | Gina Pierce, UK

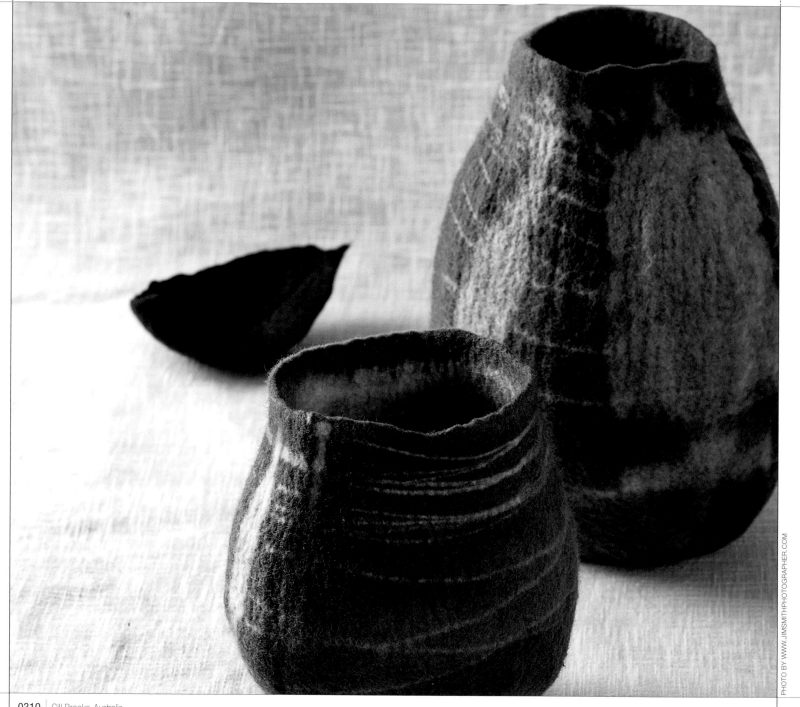

0310 | Gill Brooks, Australia

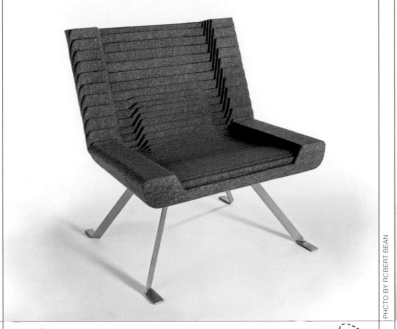

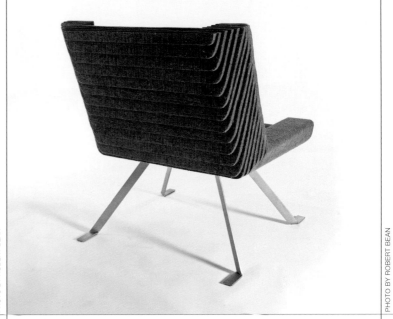

0311 | Ben K. Mickus, USA

0312 | Ben K. Mickus, USA

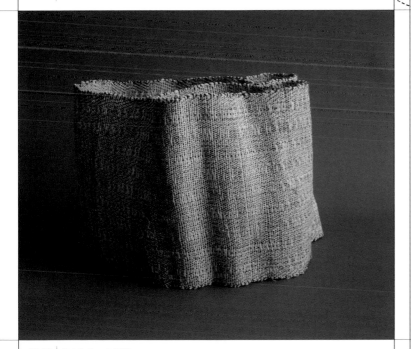

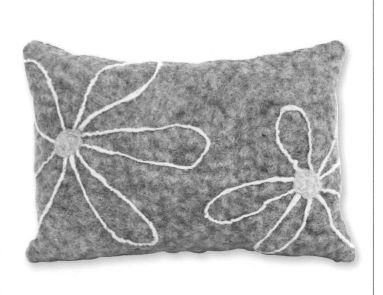

0313 | Natalie Boyett, USA

0314 | Felted Style, USA

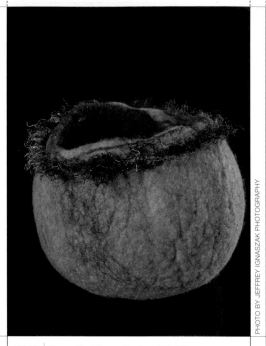

0315 | Teresa Starr Wynne, StarrSpun Felt, USA

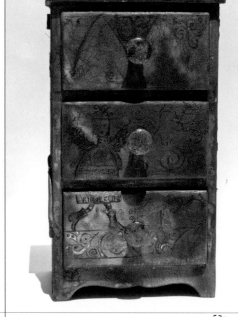

0316 | Jacqueline Lams, USA

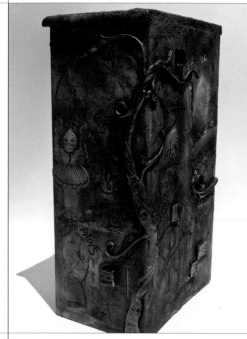

0317 | Jacqueline Lams, USA

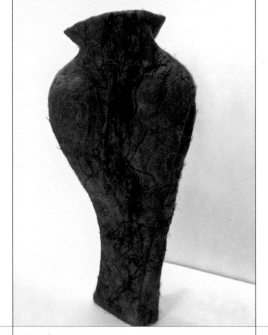

0318 | Debra A. Hartranft, USA

0319 | STRONGFELT works of Lisa Klakulak, USA

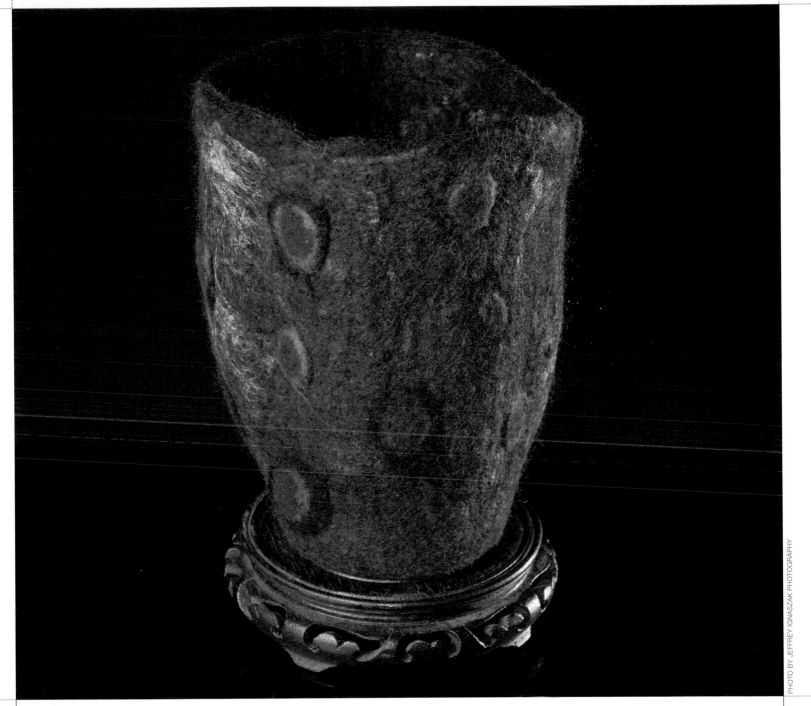

0320 | Teresa Starr Wynne, StarrSpun Felt, USA

0321 | Debra A. Hartranft, USA

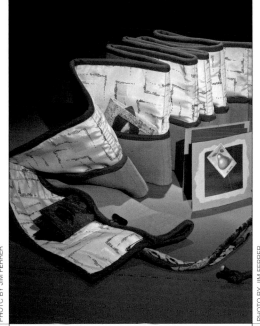

PHOTO BY JIM FERRER

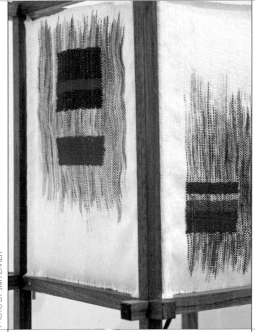

PHOTO BY JIM FERRER

0322 | Susanne C. Scott, USA

0323 | Susanne C. Scott, USA

0324 | Martine Peters, USA

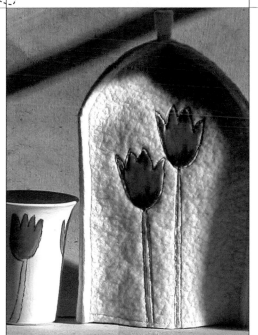

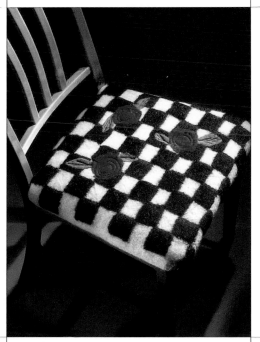

0325 | Patty Benson, USA

0326 | Julia Manitius, Canada

0327 | Barbara G. Kile, USA

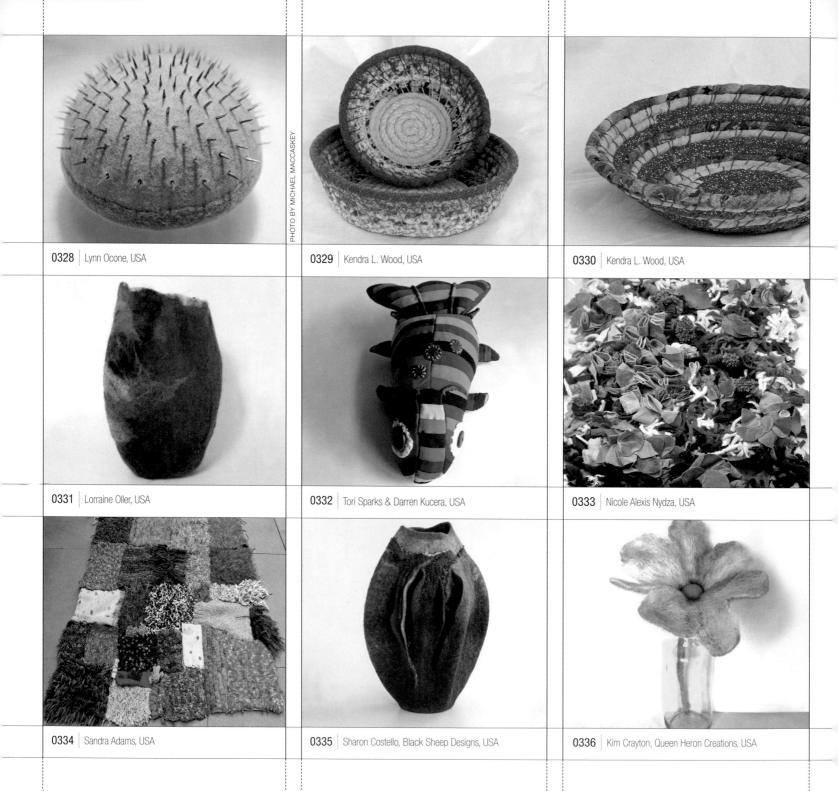

PHOTO BY MICHAEL MACCASKEY

0328 | Lynn Ocone, USA

0329 | Kendra L. Wood, USA

0330 | Kendra L. Wood, USA

0331 | Lorraine Oller, USA

0332 | Tori Sparks & Darren Kucera, USA

0333 | Nicole Alexis Nydza, USA

0334 | Sandra Adams, USA

0335 | Sharon Costello, Black Sheep Designs, USA

0336 | Kim Crayton, Queen Heron Creations, USA

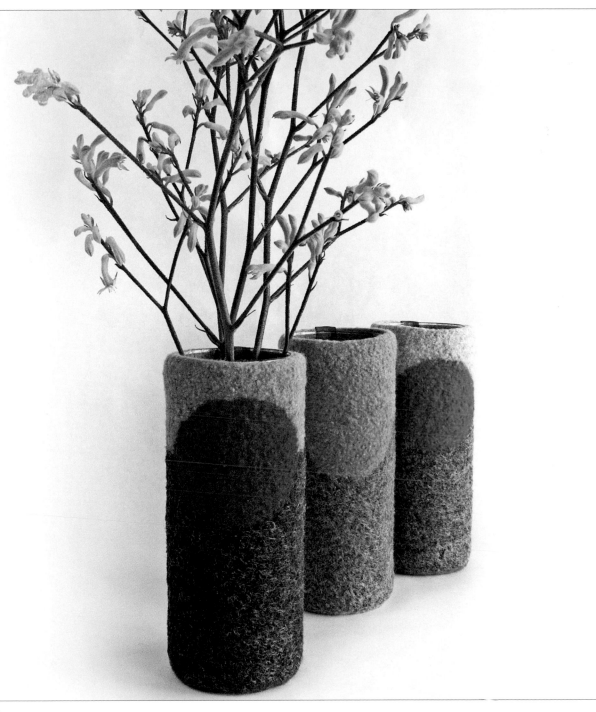

0337 | Patty Benson, USA

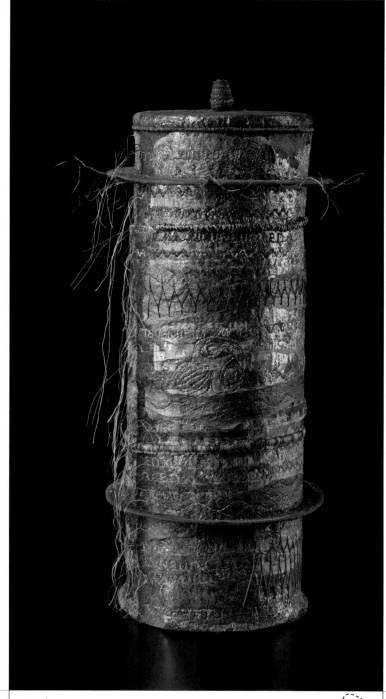

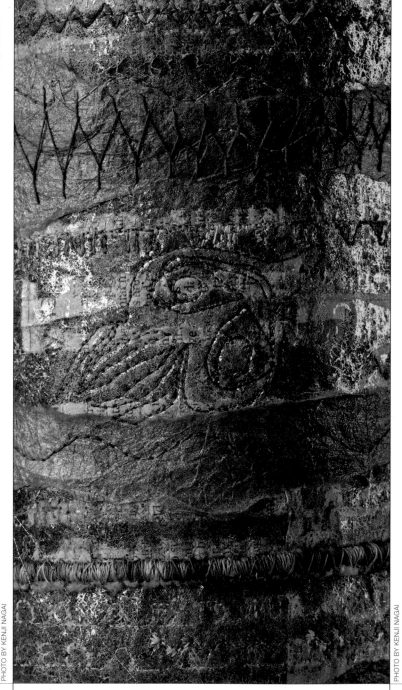

0338 | Anni Hunt, Canada

0339 | Anni Hunt, Canada

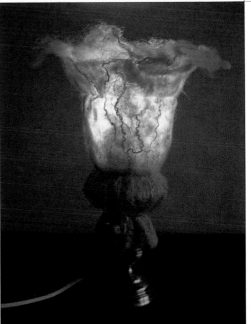

0340 | Regina Moss Designs, USA

0341 | Elena Sempels, Belgium

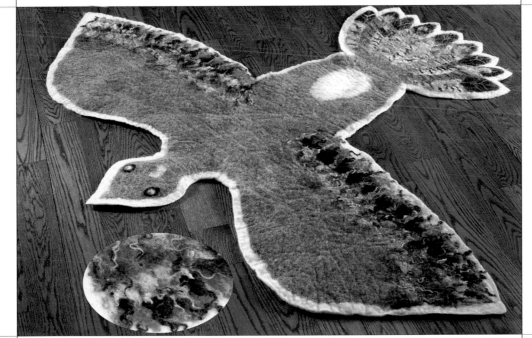

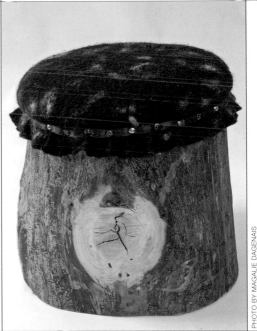

0342 | Diane Gonthier, Canada

0343 | Diane Gonthier, Canada

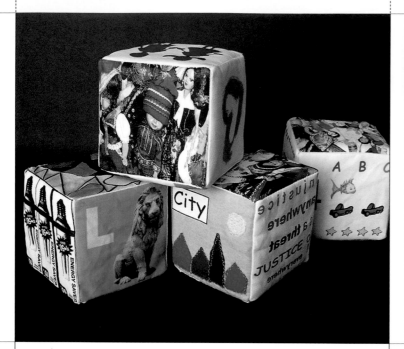

0344 | Barbara Schneider, dipl. des., Germany

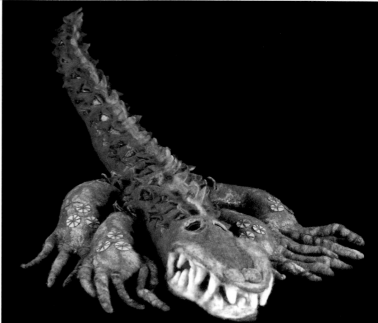

0345 | Barbara G. Kile, USA

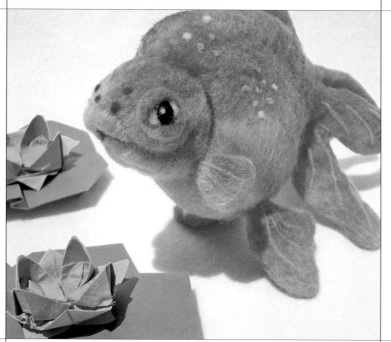

0346 | Felted Chicken, USA

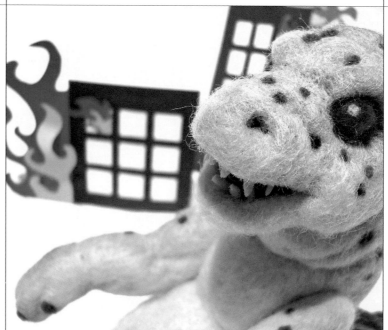

0347 | Felted Chicken, USA

0348 | Heather Forman, USA

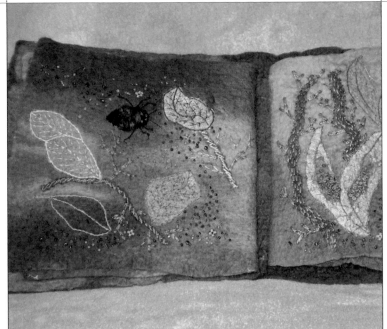

0349 | Joei Bassell, USA

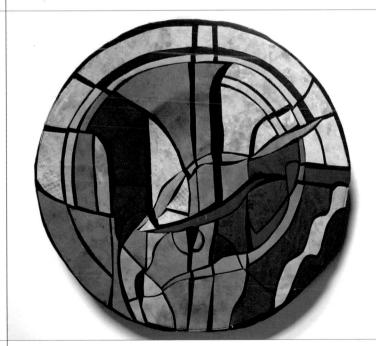

0350 | Debra A. Hartranft, USA

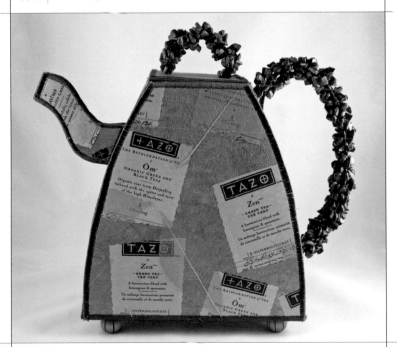

0351 | Sue Bleiweiss, USA

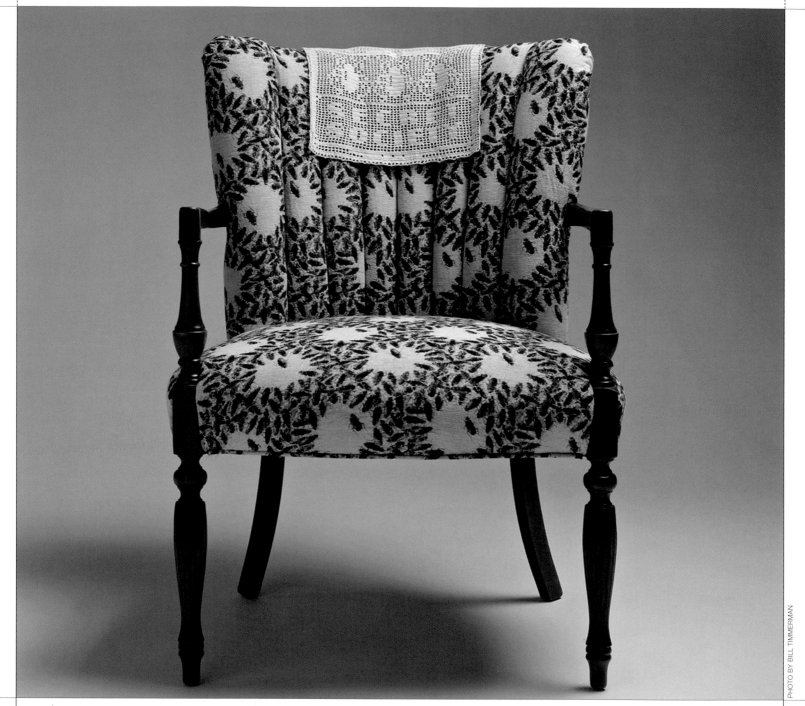

0352 | Ann Morton, USA

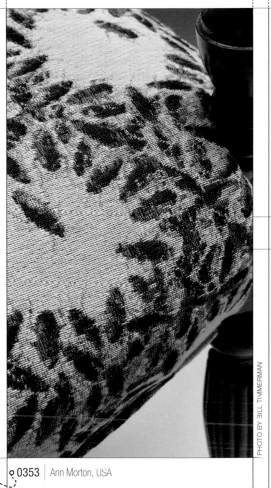

0354 | Felted Style, USA

0355 | Felted Style, USA

○ 0353 | Ann Morton, USA

0356 | Felted Style, USA

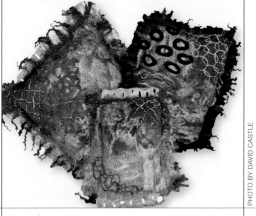

0357 | Rachel Castle, UK

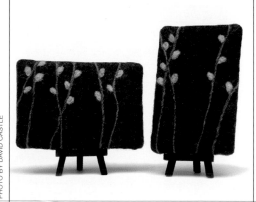

0358 | Felted Style, USA

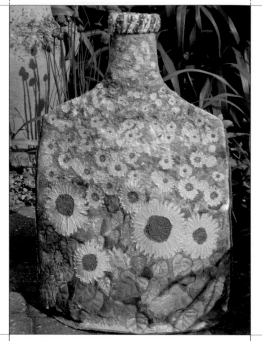

0359 | Naomi Renouf, UK

0360 | Patty Benson, USA

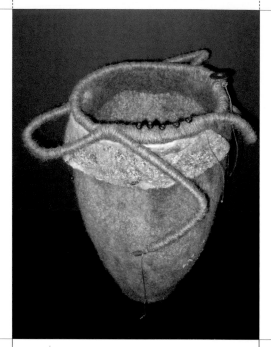

0361 | Carol Ingram, USA

0362 | Judy Wise, USA

0363 | Gina M. Brown, USA

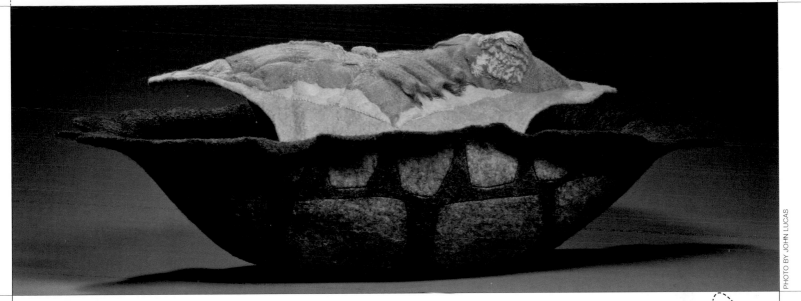

0364 | STRONGFELT works of Lisa Klakulak, USA

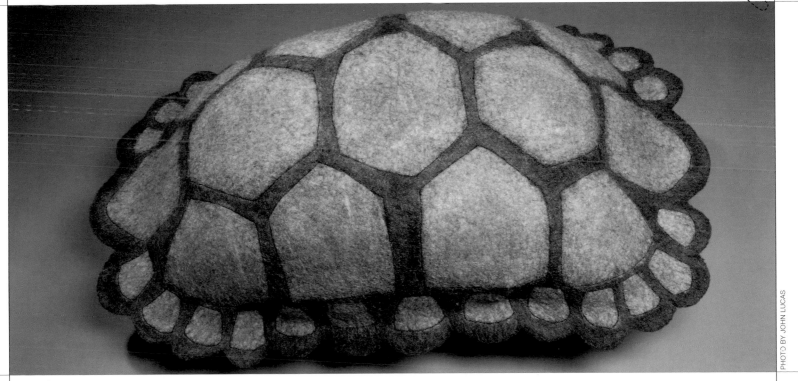

0365 | STRONGFELT works of Lisa Klakulak, USA

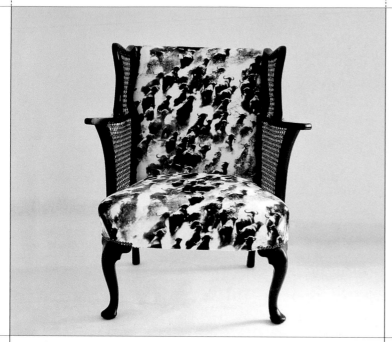

0366 | Eleanornadimi.com, UK

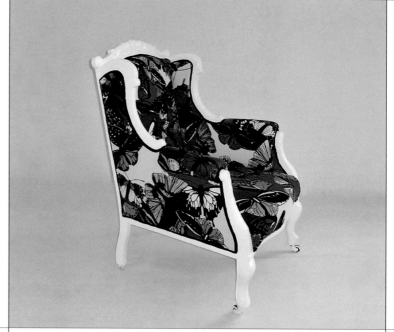

0367 | Eleanornadimi.com, UK

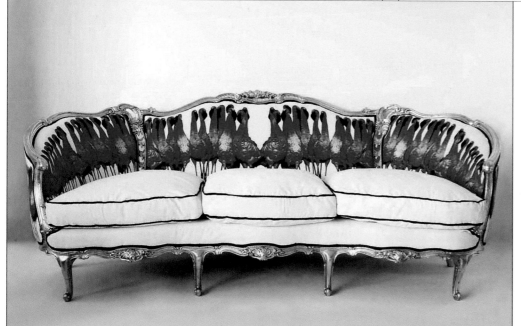

0368 | Eleanornadimi.com, UK

0369 | Regina Moss Designs, USA

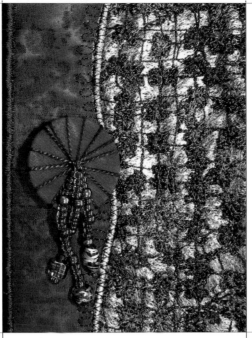

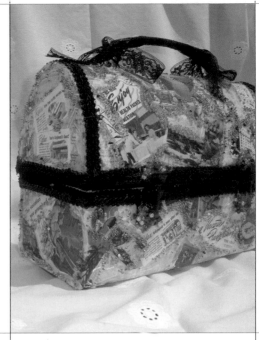

0370 | Creative Textile + Quilting Arts, USA

0371 | Creative Textile + Quilting Arts, USA

0372 | Nora Cannon, USA

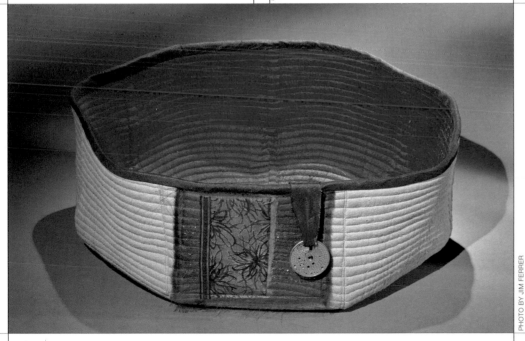

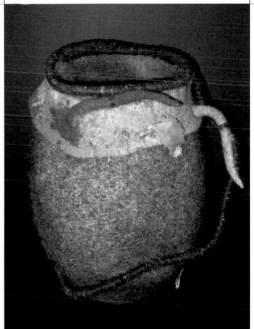

PHOTO BY JIM FERRER

0373 | Susanne C. Scott, USA

0374 | Carol Ingram, USA

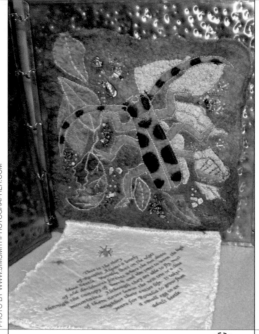

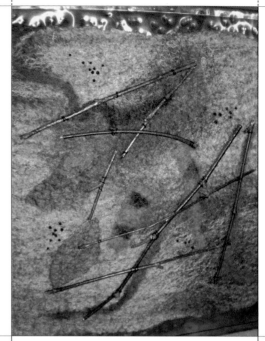

0375 | Gill Brooks, Australia

0376 | Joei Bassett, USA

0377 | Joei Bassett, USA

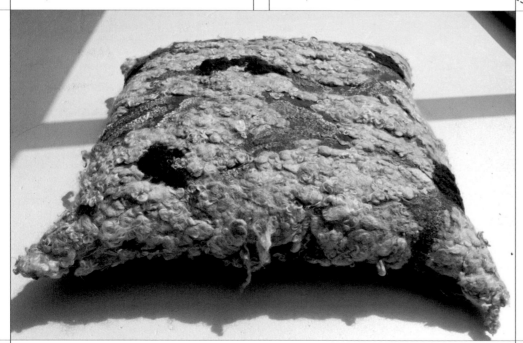

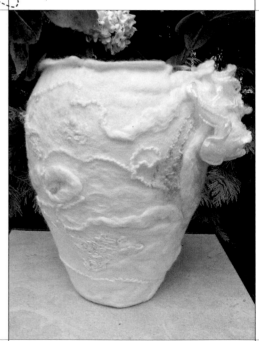

0378 | Della Lana, The Netherlands

0379 | Elena Sempels, Belgium

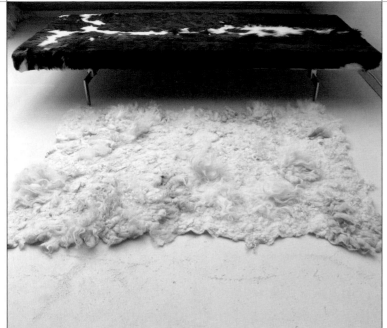

0380 | Della Lana, The Netherlands

0381 | Sandra Adams, USA

0382 | Heather Forman, USA

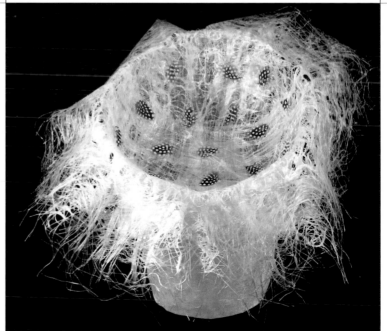

0383 | Jane Ogren, USA

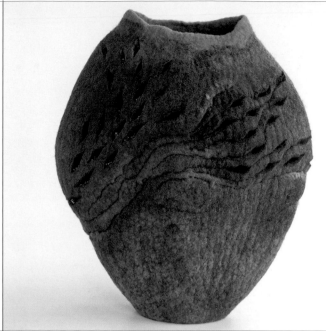

0384 | Sharon Costello, Black Sheep Designs, USA

ochi 0385 | Sharon Costello, Black Sheep Designs, USA

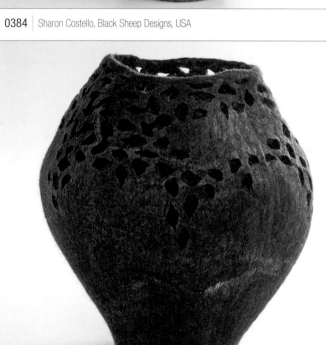

0386 | Sharon Costello, Black Sheep Designs, USA

ochi 0387 | Sharon Costello, Black Sheep Designs, USA

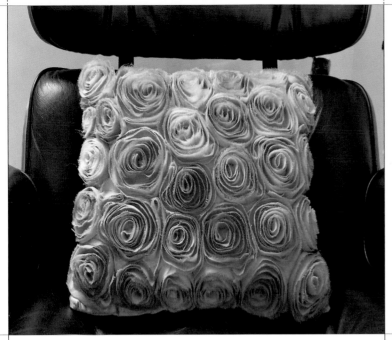

0388 | Sandra Adams, USA

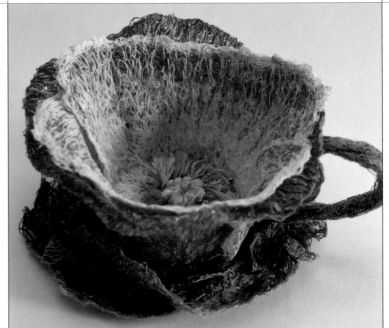

0389 | Lindsay Taylor, UK

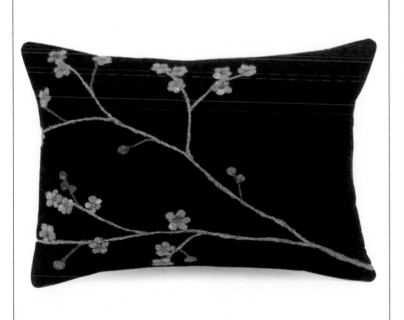

0390 | Felted Style, USA

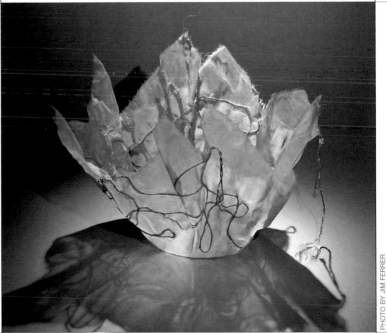

0391 | Susanne C. Scott, USA

PHOTO BY JIM FERRER

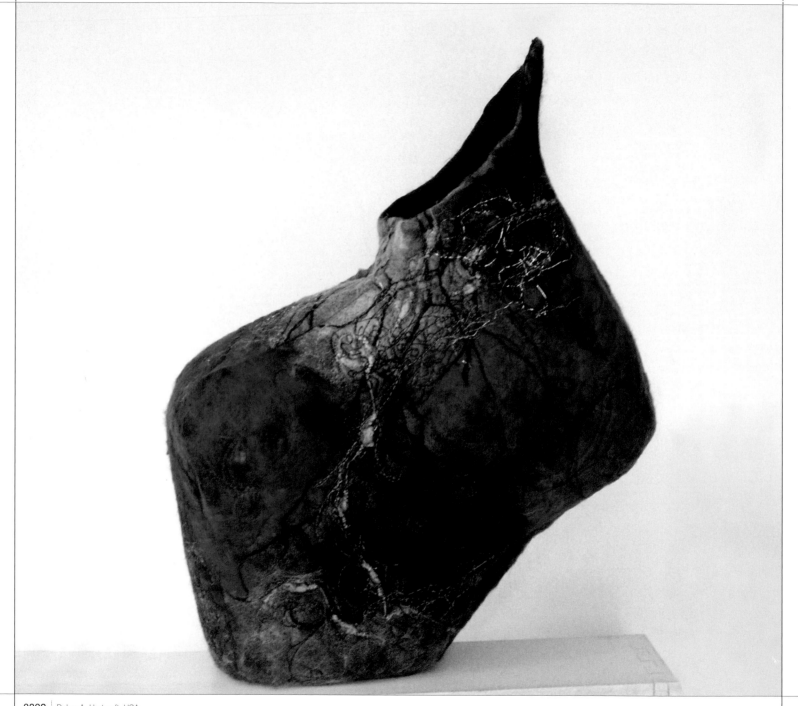

0392 | Debra A. Hartranft, USA

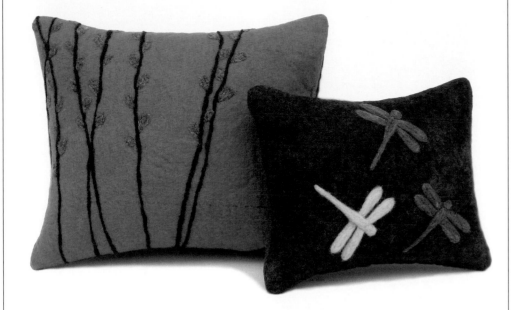

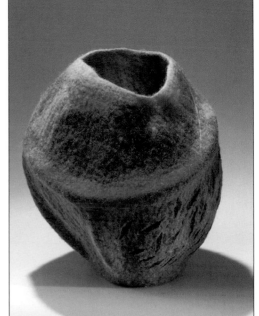

0393 | Felted Style, USA

0394 | Barbara G. Kile, USA

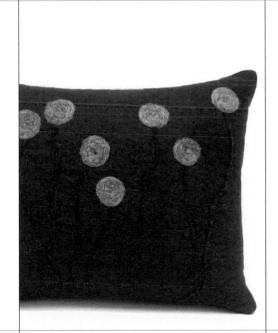

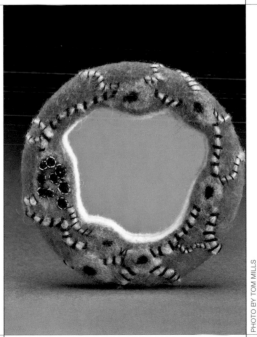

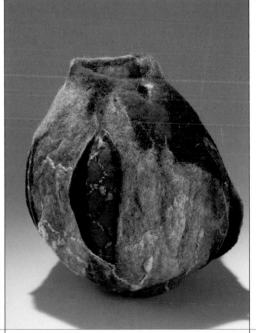

0395 | Felted Style, USA

0396 | STRONGFELT works of Lisa Klakulak, USA

PHOTO BY TOM MILLS

0397 | Barbara G. Kile, USA

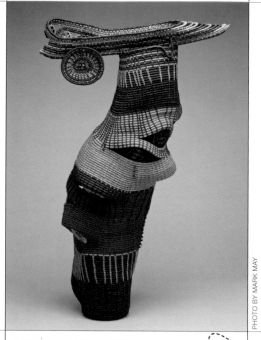

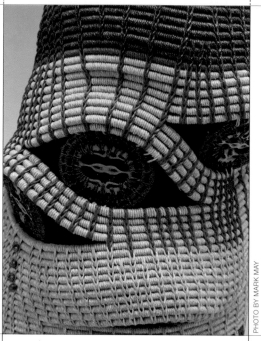

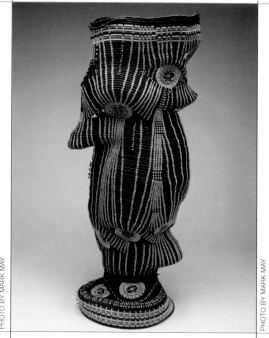

0398 | Ceres M. Rangos, USA

0399 | Ceres M. Rangos, USA

0400 | Ceres M. Rangos, USA

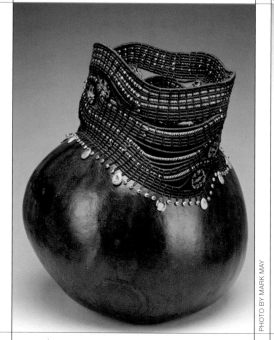

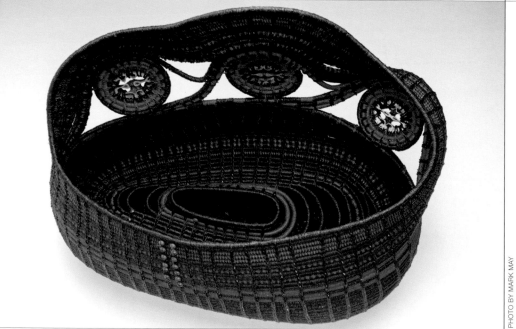

0401 | Ceres M. Rangos, USA

0402 | Ceres M. Rangos, USA

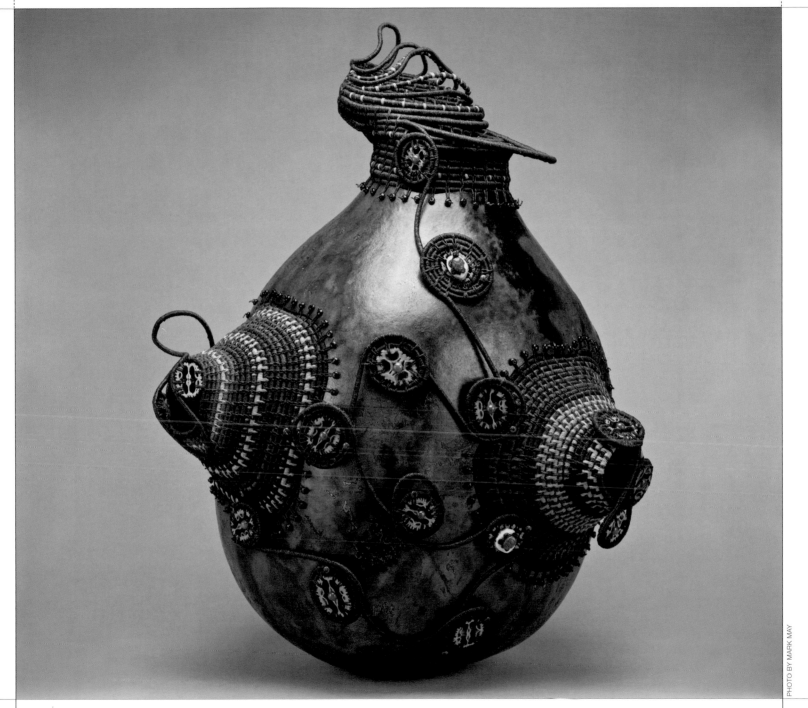

0403 | Ceres M. Rangos, USA

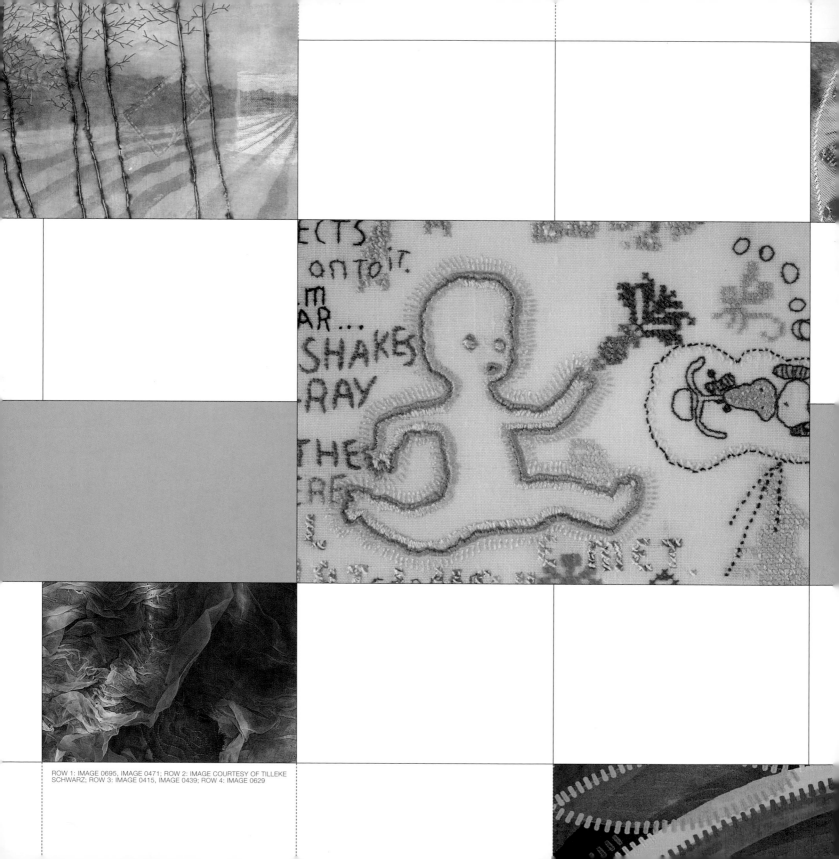

CHAPTER 4

Tapestries & Display Art

0404–0697

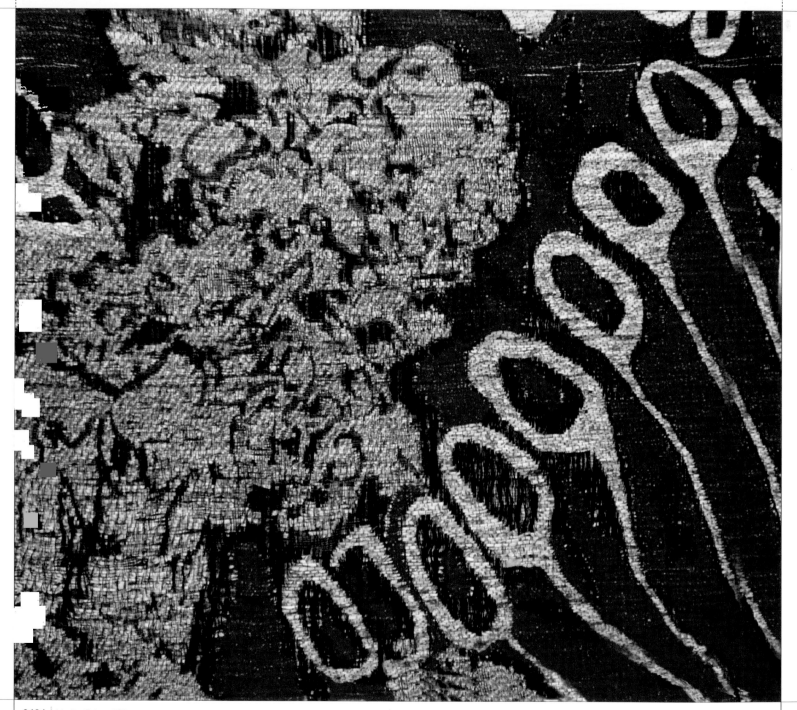

0404 | Martine Peters, USA

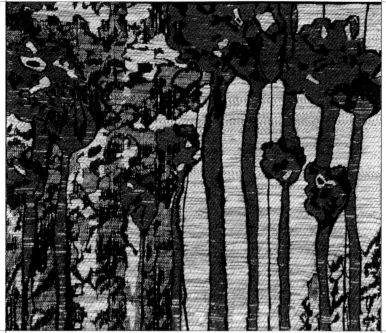

0405 | Martine Peters, USA

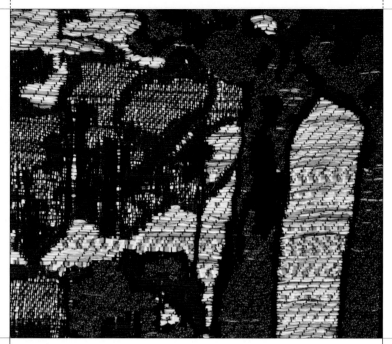

0406 | Martine Peters, USA

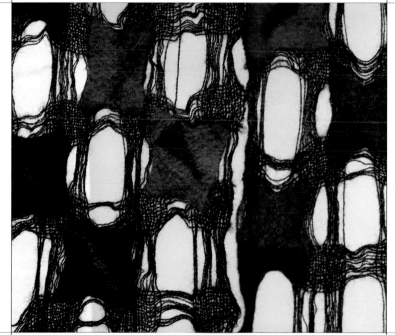

0407 | Martine Peters, USA

0408 | Rowen Schussheim-Anderson, USA

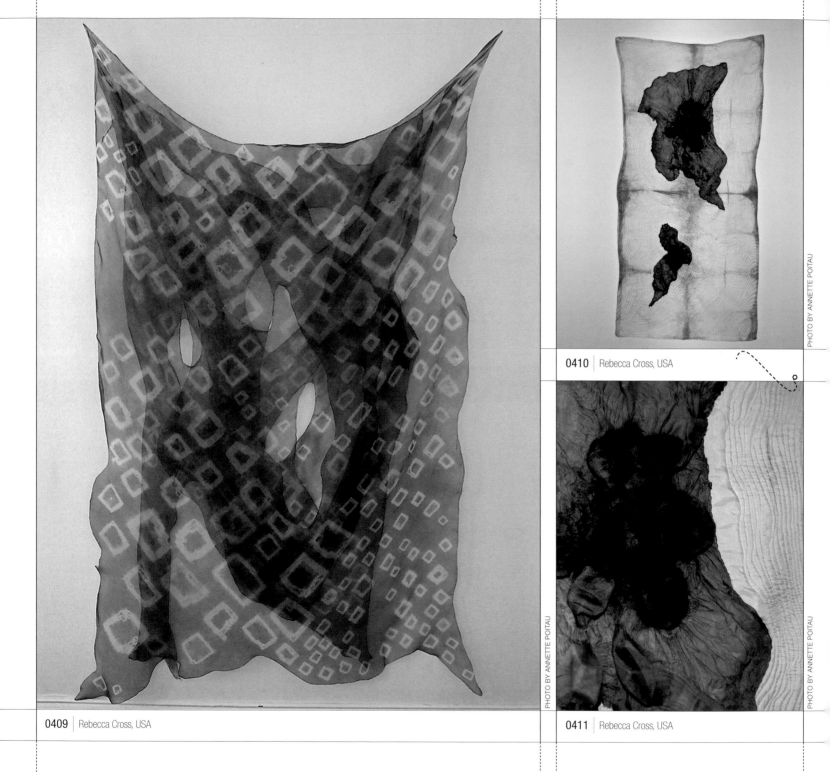

0409 | Rebecca Cross, USA

0410 | Rebecca Cross, USA

PHOTO BY ANNETTE POITAU

0411 | Rebecca Cross, USA

PHOTO BY ANNETTE POITAU

PHOTO BY ANNETTE POITAU

0412 | Rebecca Cross, USA

○ 0413 | Rebecca Cross, USA

0414 | Rebecca Cross, USA

○ 0415 | Rebecca Cross, USA

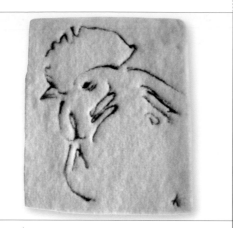

0416 | Ali Brown, UK

0417 | Ali Brown, UK

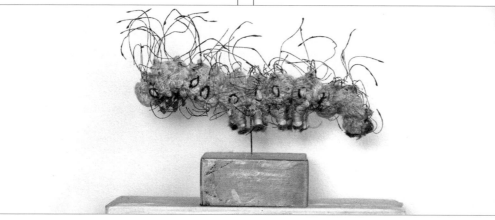

0418 | S.E.M. van Dijk, The Netherlands

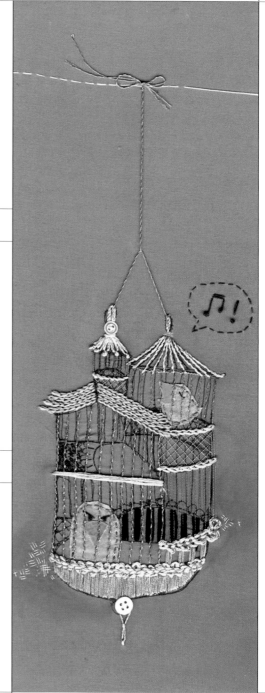

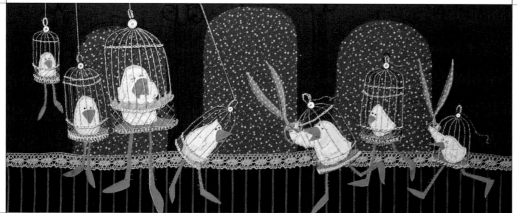

0419 | Kristie Carlisle Duncan, USA

0420 | Kristie Carlisle Duncan, USA

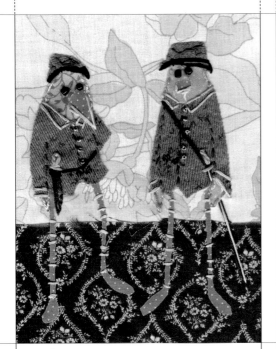

0421 | Kristie Carlisle Duncan, USA

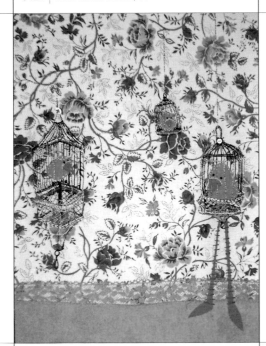

0422 | Kristie Carlisle Duncan, USA

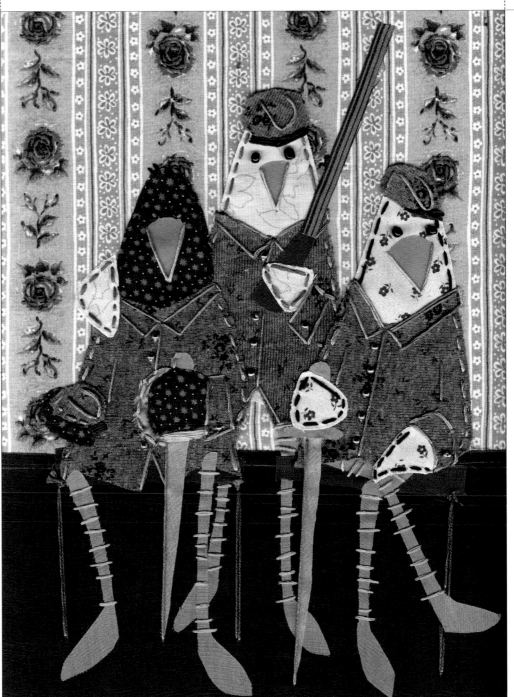

0423 | Kristie Carlisle Duncan, USA

0424 | Lotta-Pia Kallio, Finland

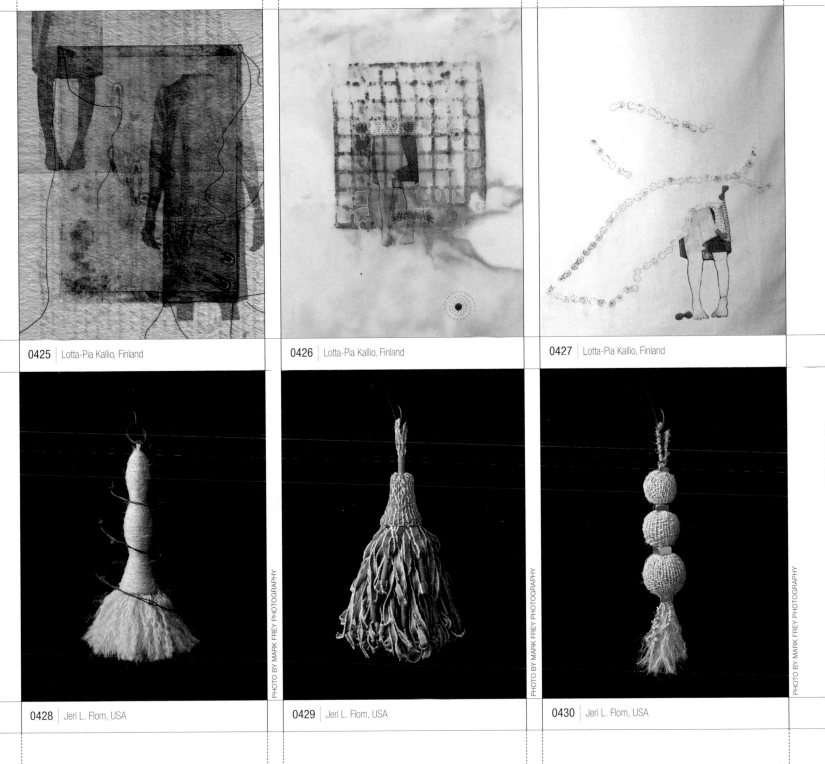

0425 | Lotta-Pia Kallio, Finland

0426 | Lotta-Pia Kallio, Finland

0427 | Lotta-Pia Kallio, Finland

0428 | Jeri L. Flom, USA

0429 | Jeri L. Flom, USA

0430 | Jeri L. Flom, USA

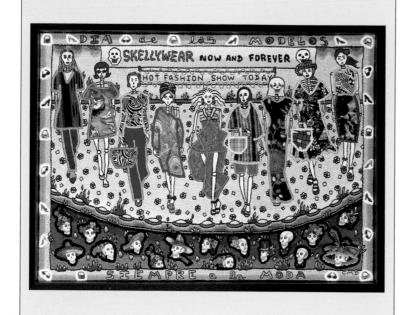

0431 | Caroline Marcum Dahl, USA

0432 | Caroline Marcum Dahl, USA

0433 | Caroline Marcum Dahl, USA

0434 | Caroline Marcum Dahl, USA

0435 | Caroline Marcum Dahl, USA

0436 | Caroline Marcum Dahl, USA

0437 | Caroline Marcum Dahl, USA

0438 | Caroline Marcum Dahl, USA

0440 | Emily Felderman, USA

0441 | Emily Felderman, USA

0442 | Emily Felderman, USA

0443 | Emily Felderman, USA

0444 | Jean Fortune Kaplan, USA

0445 | Wen Redmond, USA

0446 | Wen Redmond, USA

0447 Wen Redmond, USA

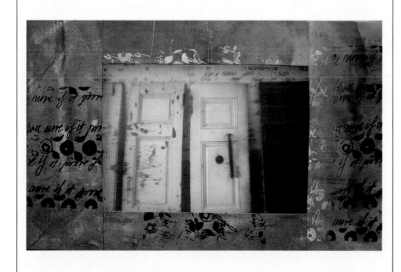

0448 Wen Redmond, USA

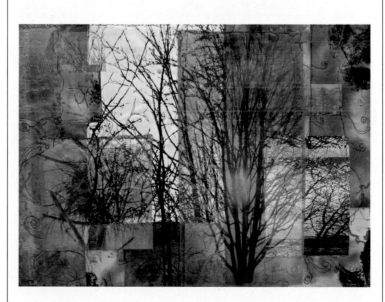

0449 Wen Redmond, USA

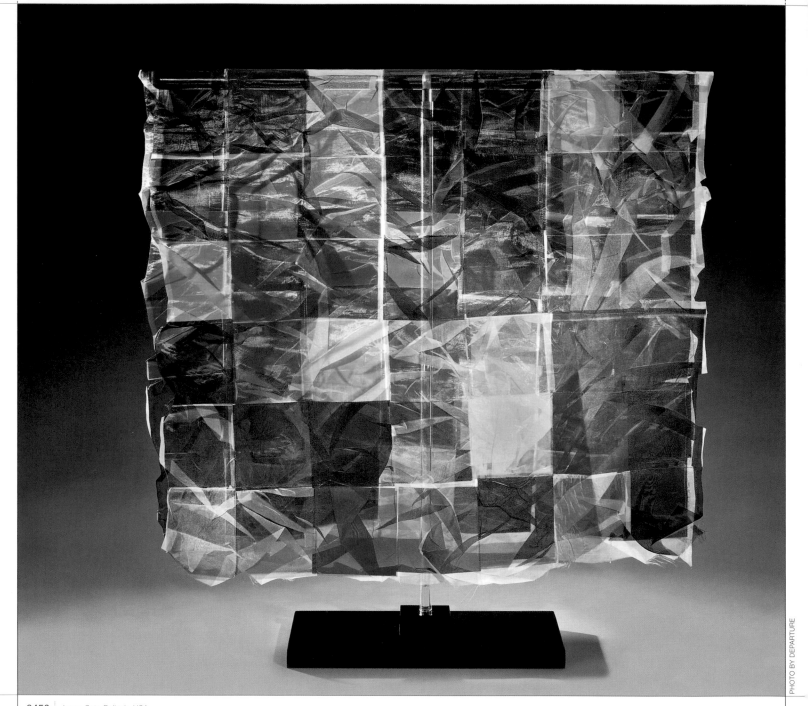

0450 | Junco Sato Pollack, USA

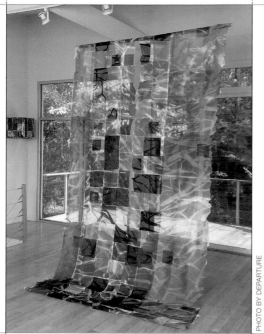

0451 Junco Sato Pollack, USA

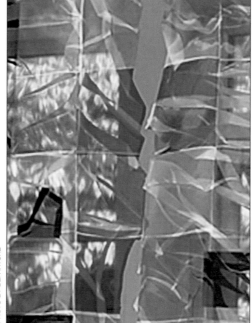

0452 Junco Sato Pollack, USA

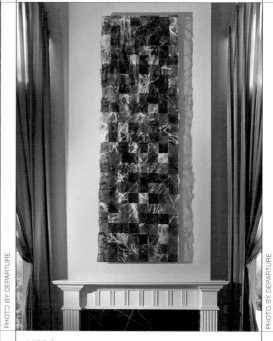

0453 Junco Sato Pollack, USA

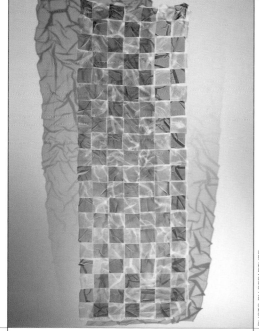

0454 Junco Sato Pollack, USA

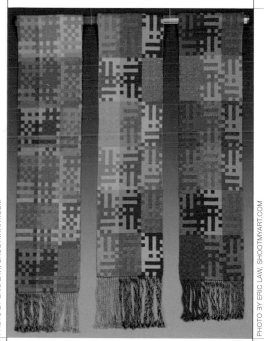

0455 Bonnie J. Kay, USA

0456 Bonnie J. Kay, USA

0457 | Tilleke Schwarz, The Netherlands

0458 | Tilleke Schwarz, The Netherlands

0459 | Tilleke Schwarz, The Netherlands

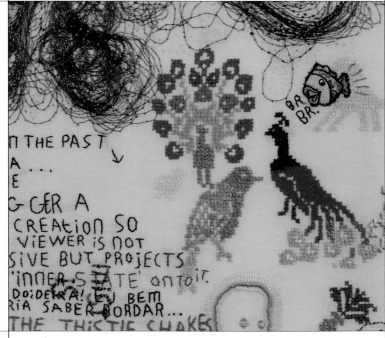

0460 | Tilleke Schwarz, The Netherlands

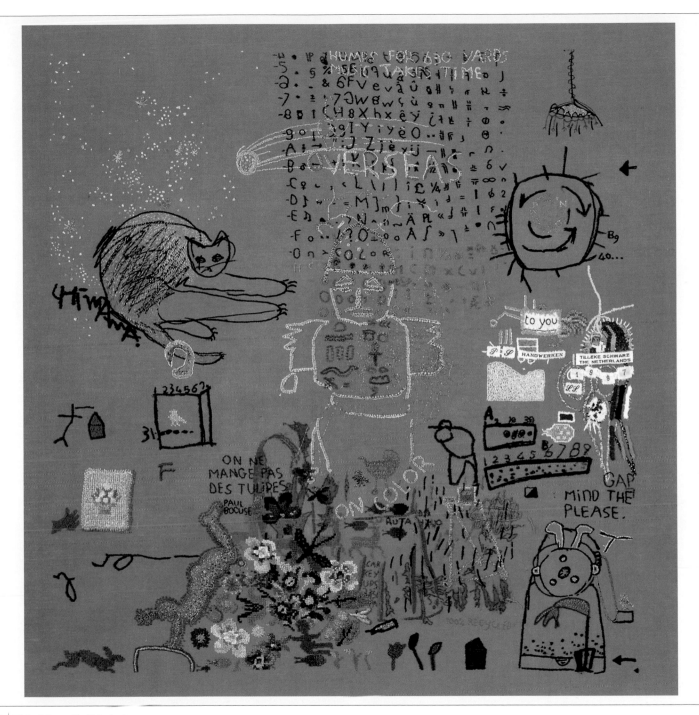

0461 | Tilleke Schwarz, The Netherlands

0462 | Anni Hunt, Canada

0463 | Anni Hunt, Canada

0464 | Erica Licea-Kane, USA

0465 | Erica Licea-Kane, USA

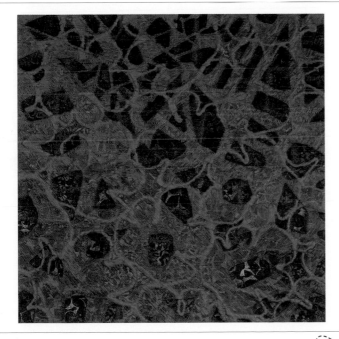

0466 | Erica Licea-Kane, USA

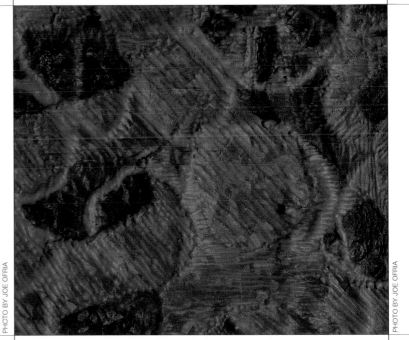

0467 | Erica Licea-Kane, USA

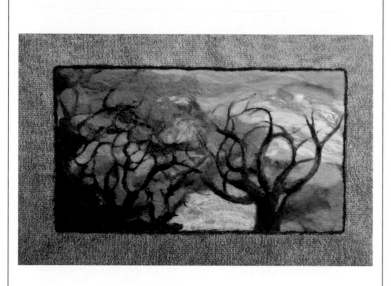

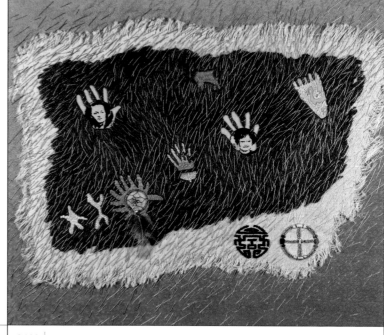

0468 | Susan Krahn, USA

0469 | Katherine L. Colwell, USA

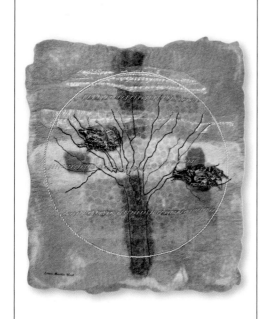

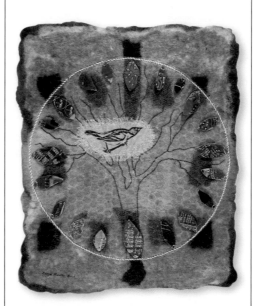

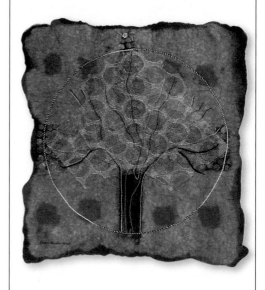

0470 | Erma Martin Yost, USA

0471 | Erma Martin Yost, USA

0472 | Erma Martin Yost, USA

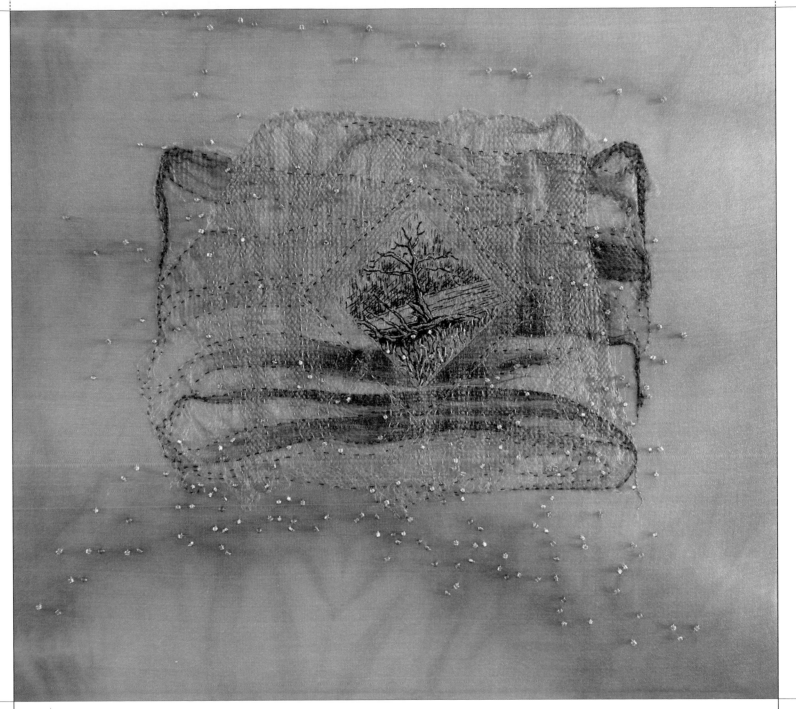

0473 | Katherine L. Colwell, USA

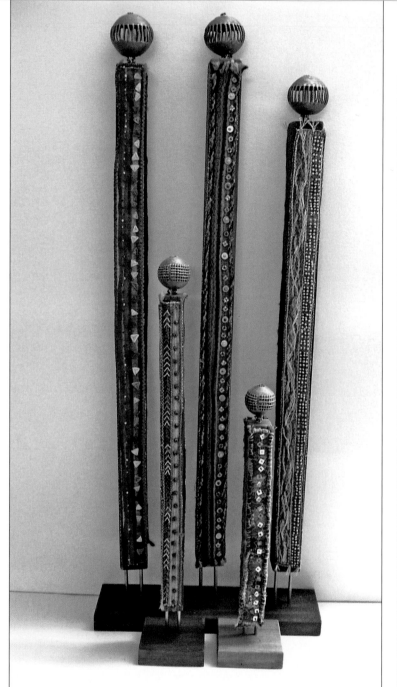

0474 | Dana Biddle, South Africa

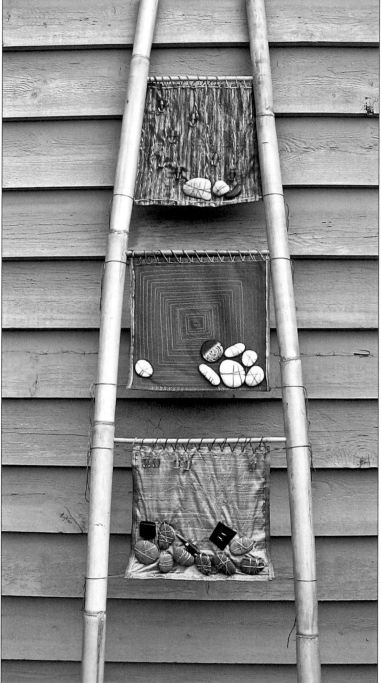

0475 | Jacquie Stone, USA

0476 | Dana Biddle, South Africa

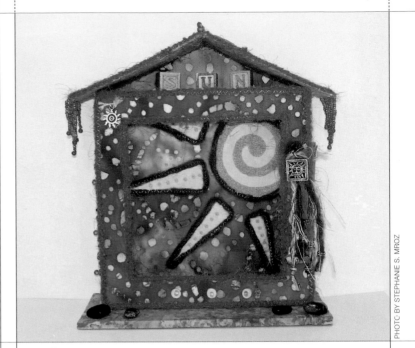

0477 | Sidney Savage Inch, USA

0478 | Jacquie Stone, USA

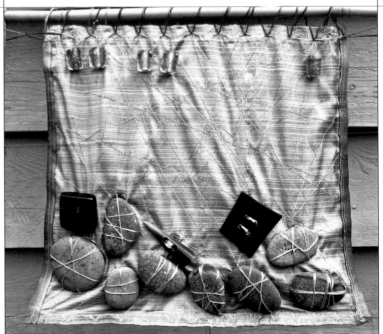

0479 | Jacquie Stone, USA

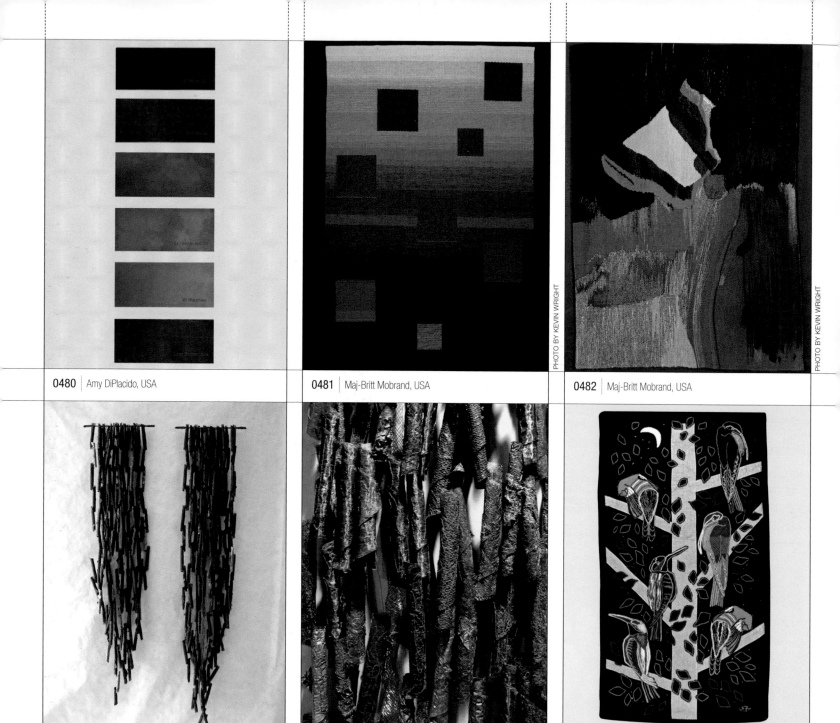

0480 | Amy DiPlacido, USA

0481 | Maj-Britt Mobrand, USA

0482 | Maj-Britt Mobrand, USA

PHOTO BY KEVIN WRIGHT

PHOTO BY KEVIN WRIGHT

0483 | Riny Smits, The Netherlands

0484 | Riny Smits, The Netherlands

0485 | Sherri Roberts, Galil Threadworks, USA

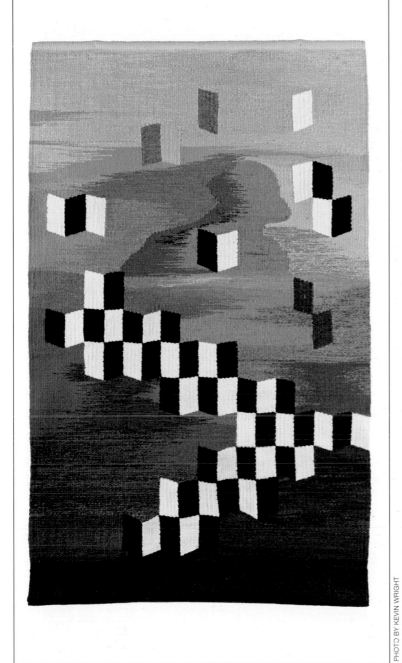

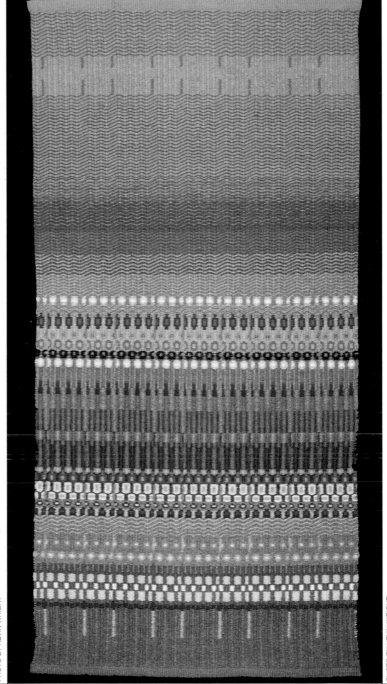

0486 | Maj-Britt Mobrand, USA

0487 | Maj-Britt Mobrand, USA

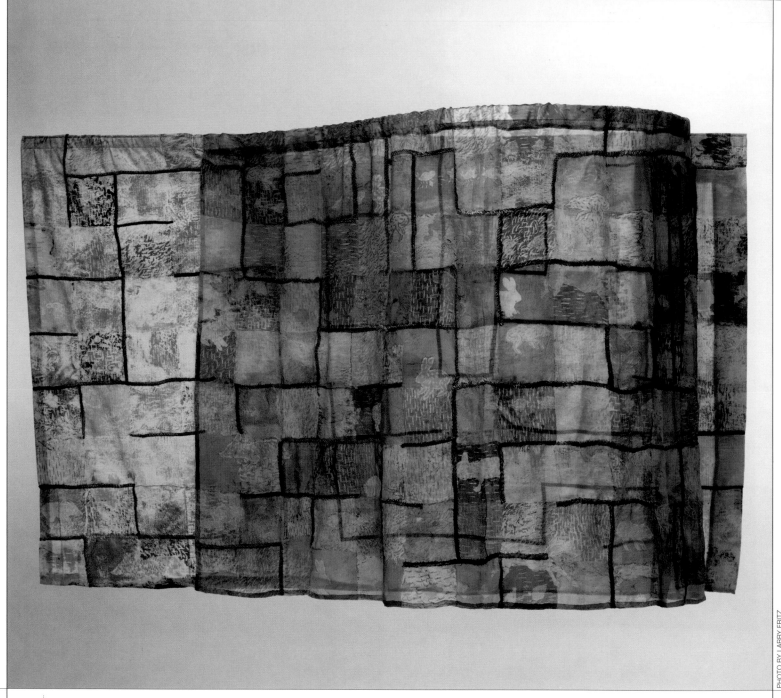

0488 | Akemi Nakano Cohn, USA

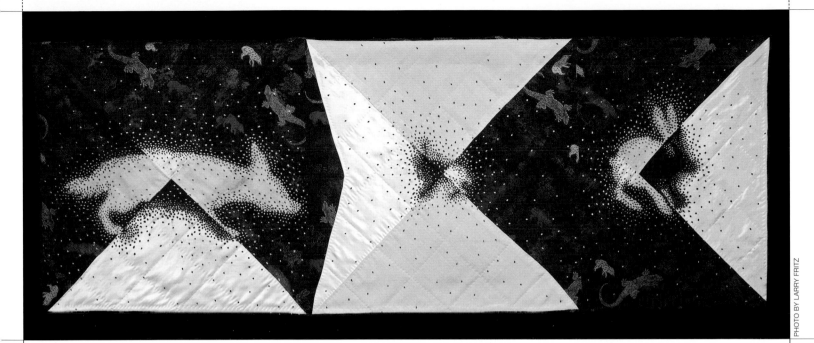

0489 | Akemi Nakano Cohn, USA

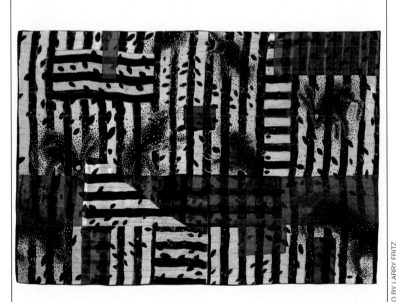

0490 | Akemi Nakano Cohn, USA

0491 | Akemi Nakano Cohn, USA

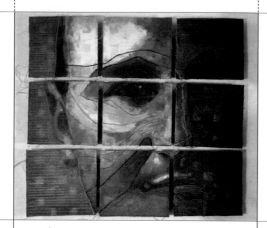

0492 | Jane Ogren, USA

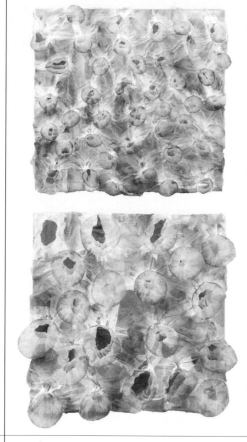

0493 | Jane Ogren, USA

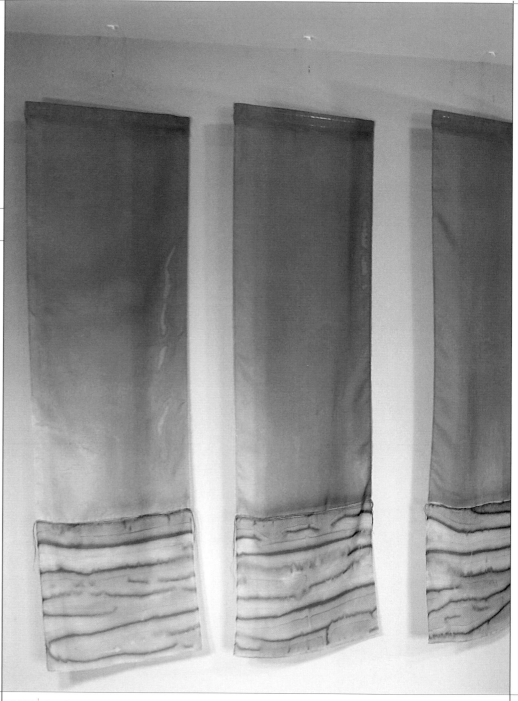

0494 | Jane Ogren, USA

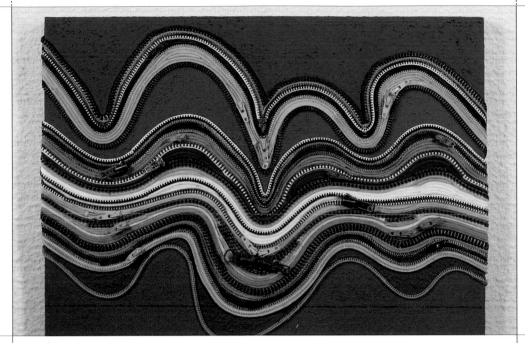

0495 | Jane Ogren, USA

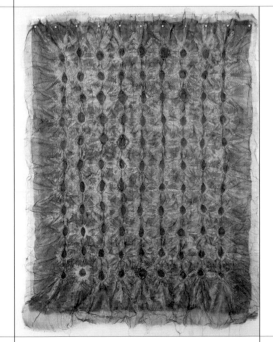

0496 | Jane Ogren, USA

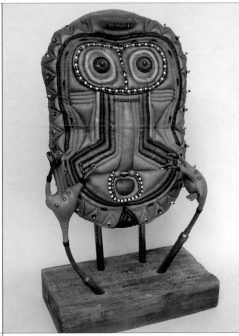

0497 | Jane Ogren, USA

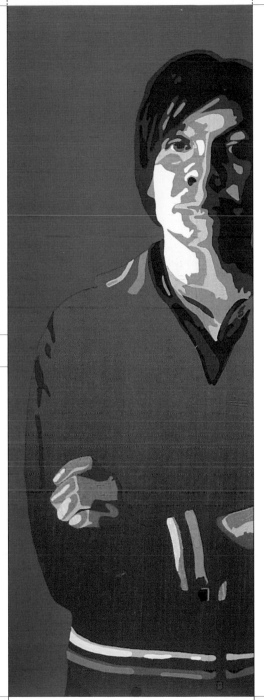

0498 | Jane Ogren, USA

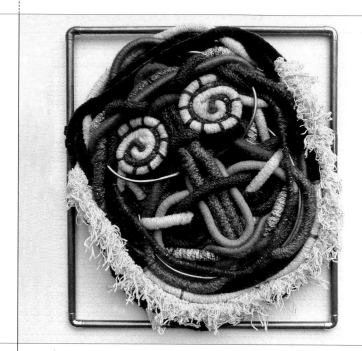

0499 | Jane Ogren, USA

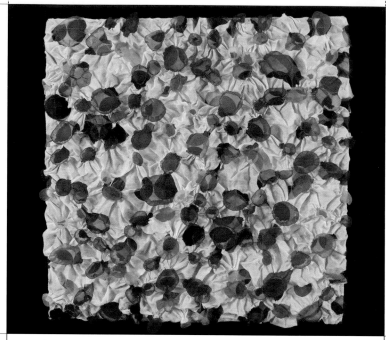

0500 | Jane Ogren, USA

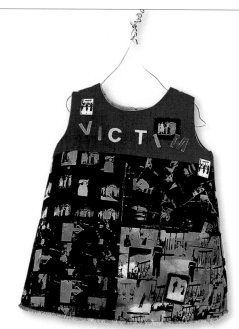

0501 | Barbara Schneider, dipl. des., Germany

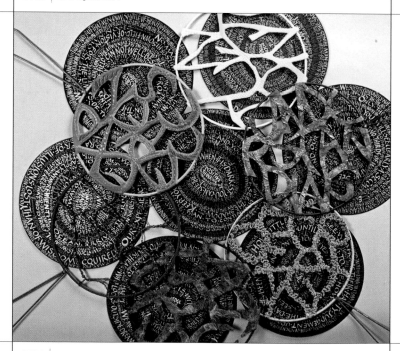

0502 | Tricia Smout, Australia

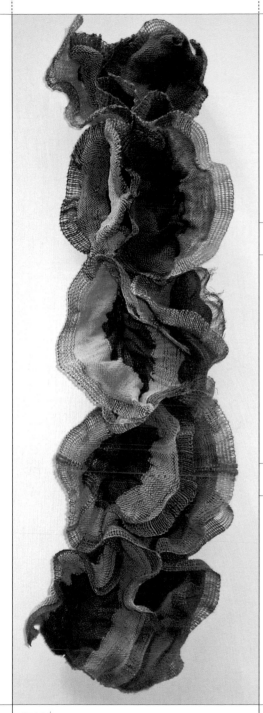

0503 | Erika Sojkova Grime, UK

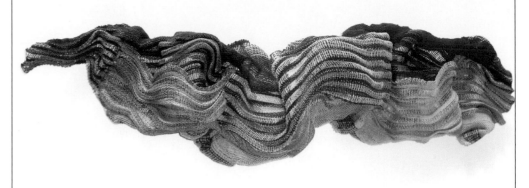

504 | Erika Sojkova Grime, UK

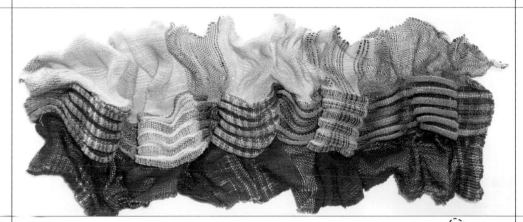

0505 | Erika Sojkova Grime, UK

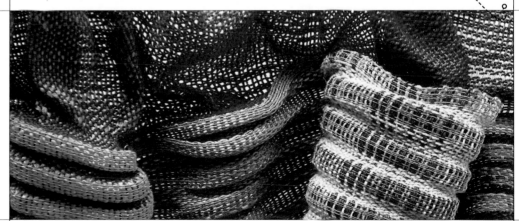

0506 | Erika Sojkova Grime, UK

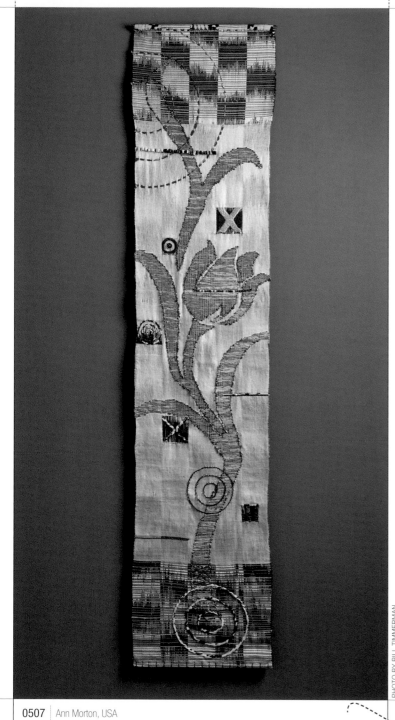

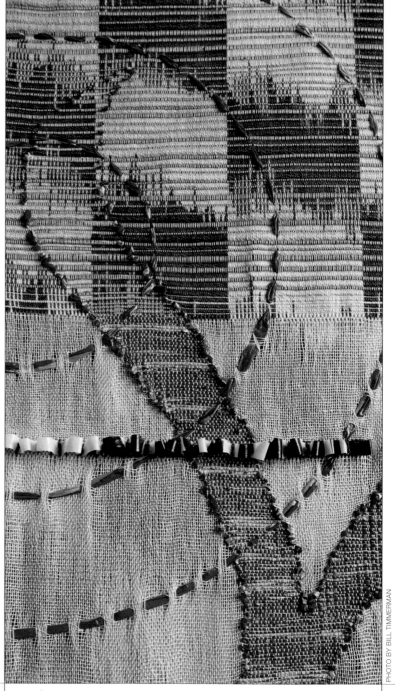

0507 | Ann Morton, USA

०0508 | Ann Morton, USA

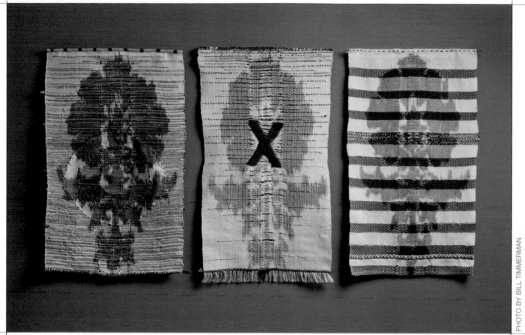

0509 | Ann Morton, USA

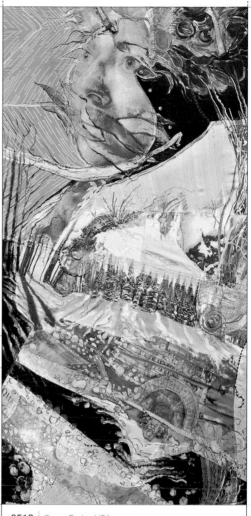

0512 | Susan Fecho, USA

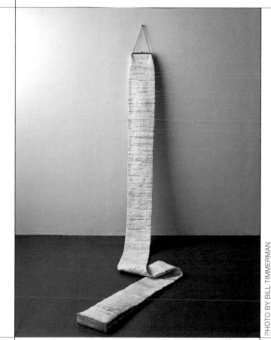

0510 | Ann Morton, USA

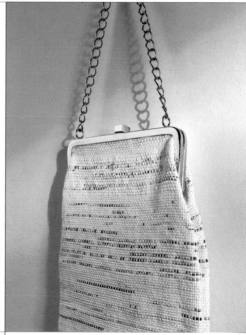

⚲0511 | Ann Morton, USA

0513 | Janie F. Woodbridge, USA

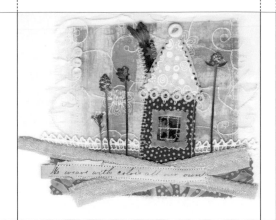

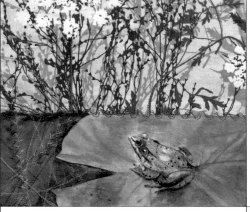

0514 | Tracie Lyn Huskamp, The Red Door Studio, USA

0515 | Tracie Lyn Huskamp, The Red Door Studio, USA

0516 | Mariana Ciliberto, Florcita, The Netherlands

0517 | Marylin Huskamp, USA

0518 | Daniela Tommasi, Australia

0519 | Mariana Ciliberto, Florcita, The Netherlands

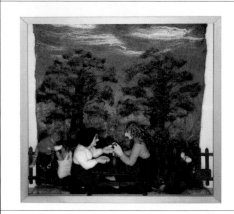

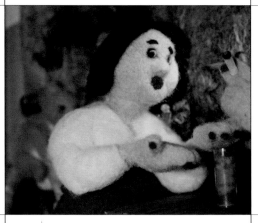

0520 | Helena Sergeyeva, Yozhyk's Felt, Sweden

0521 | Helena Sergeyeva, Yozhyk's Felt, Sweden

0522 | Linda Kittmer, Canada

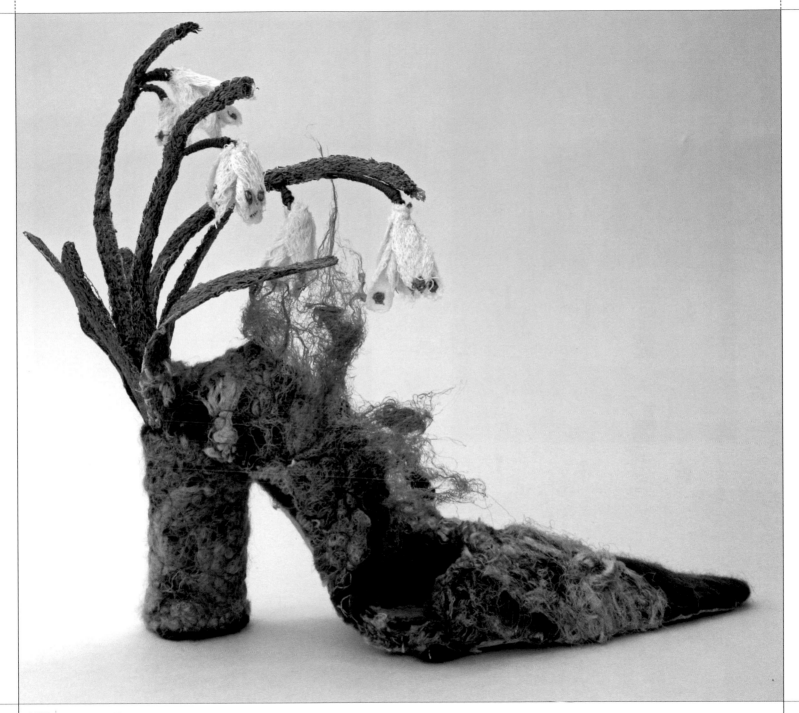

0523 | Lindsay Taylor, UK

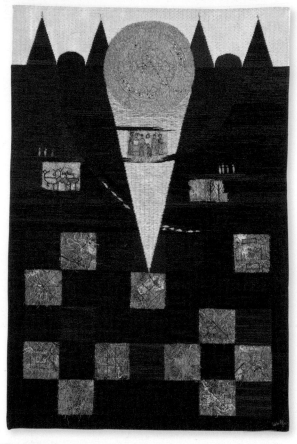

0524 | Joan Wolfer, USA

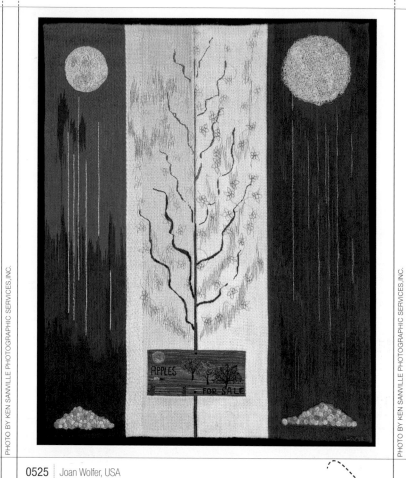

0525 | Joan Wolfer, USA

0526 | Joan Wolfer, USA

0527 | Joan Wolfer, USA

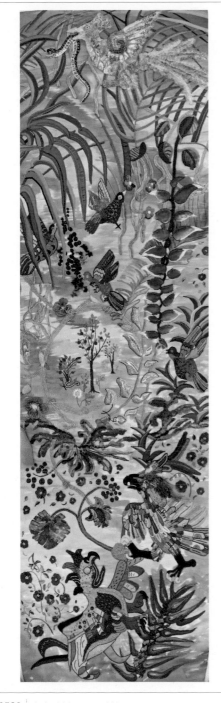

0529 | Maria-Theresa Fernandes, UK

0530 | Maria-Theresa Fernandes, UK

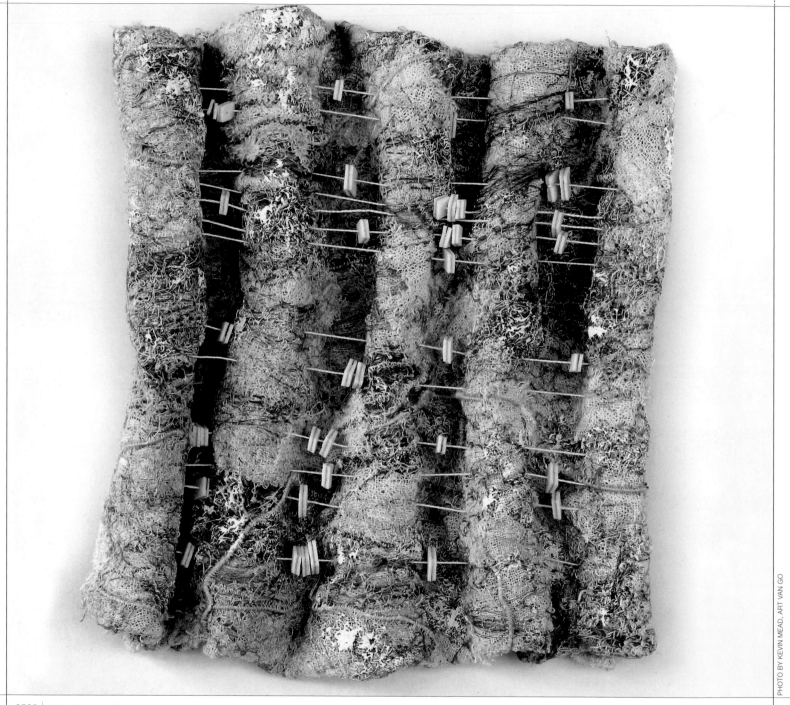

0532 | Pauline Verrinder, UK

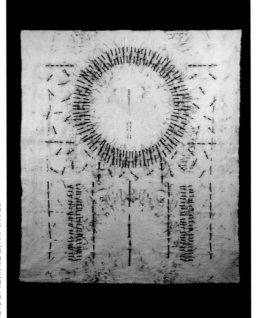

PHOTO BY KEVIN MEAD, ART VAN GO

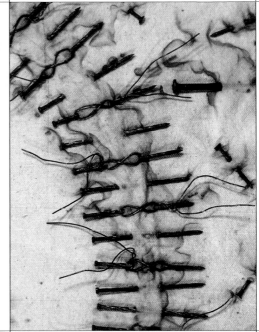

| 0533 | Pauline Verrinder, UK | 0534 | Jane Ogren, USA | 0535 | Jane Ogren, USA |

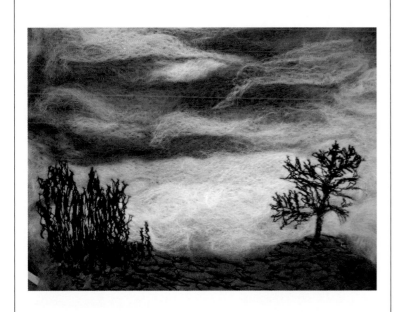

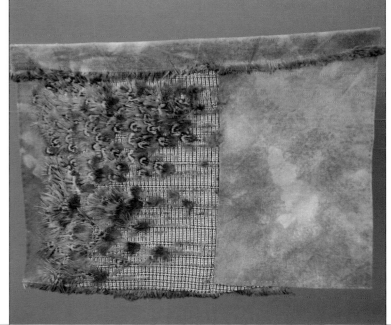

| 0536 | Sue Crook, UK | 0537 | Natalie Boyett, USA |

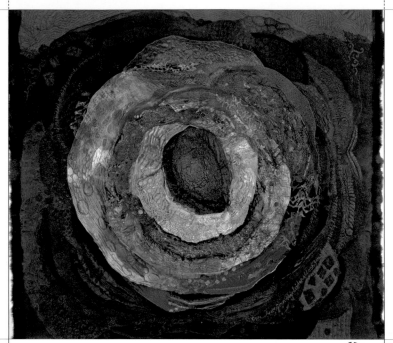

0538 | Saskia Weishut-Snapper, The Netherlands

0539 | Saskia Weishut-Snapper, The Netherlands

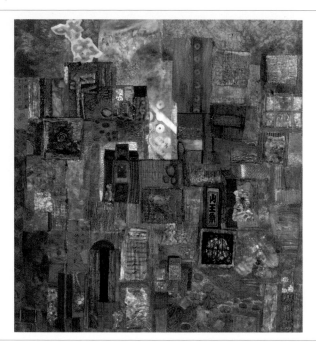

0540 | Saskia Weishut-Snapper, The Netherlands

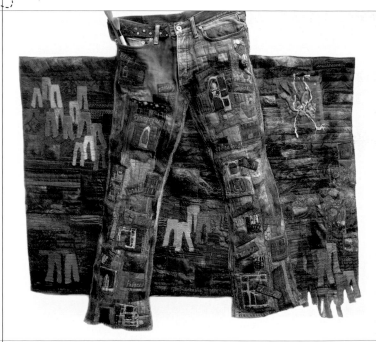

0541 | Saskia Weishut-Snapper, The Netherlands

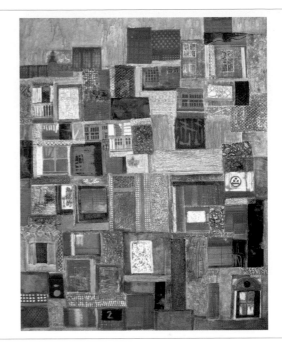

0542 | Saskia Weishut-Snapper, The Netherlands

0543 | Saskia Weishut-Snapper, The Netherlands

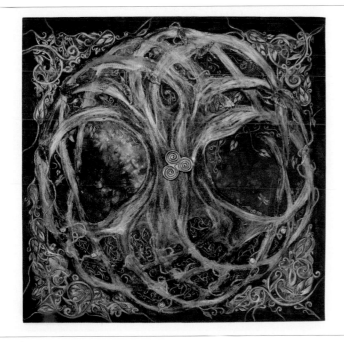

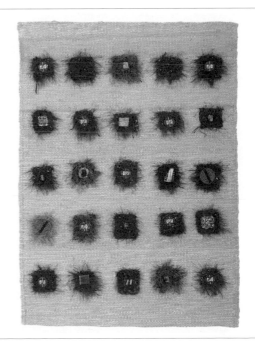

0544 | Jacqueline Lams, USA

0545 | Rowen Schussheim-Anderson, USA

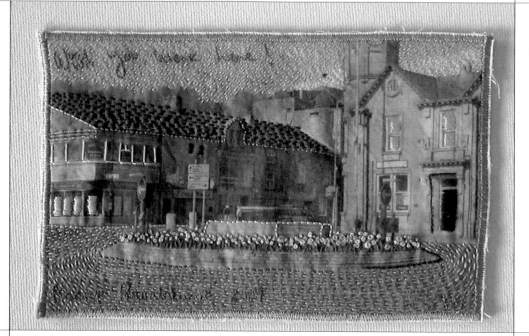

0546 | Sarah Louisa Whittle, UK

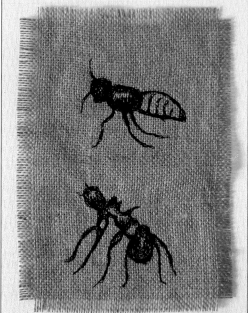

0547 | Sarah Louisa Whittle, UK

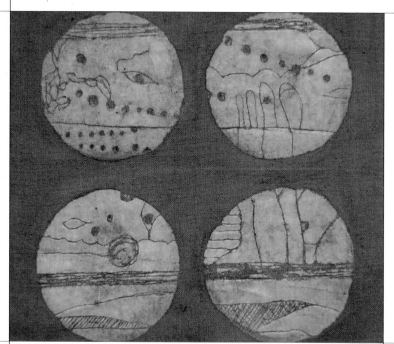

0548 | Amy DiPlacido, USA

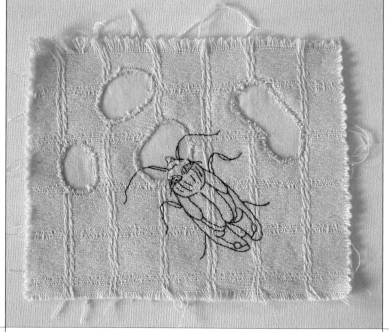

0549 | Sarah Louisa Whittle, UK

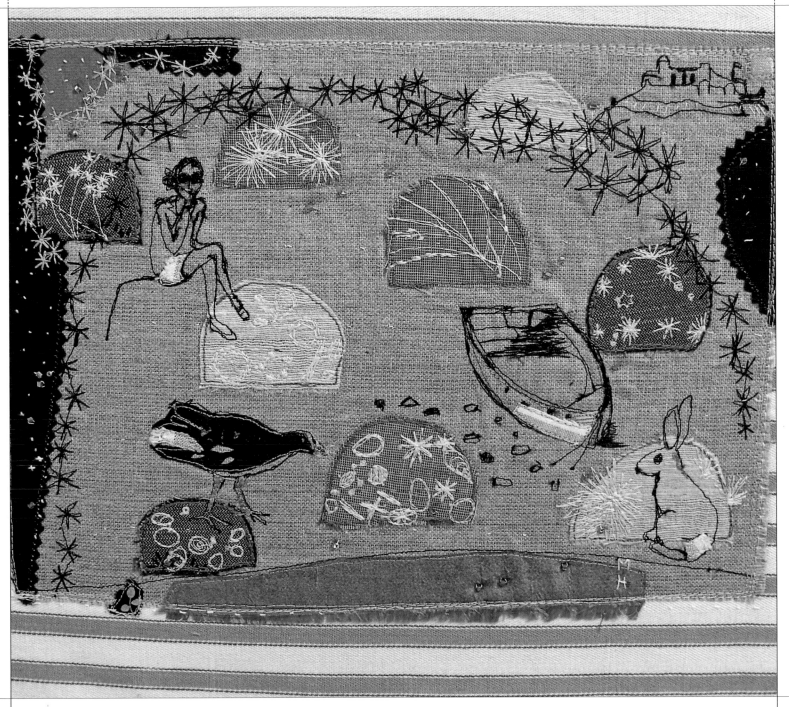

0550 | Michelle Holmes, UK

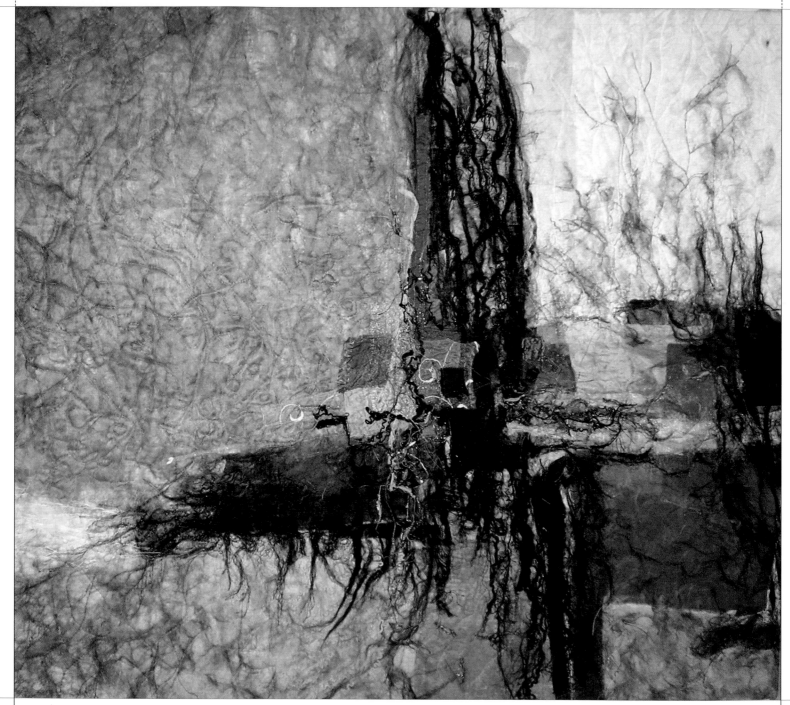

0551 | Debra A. Hartranft, USA

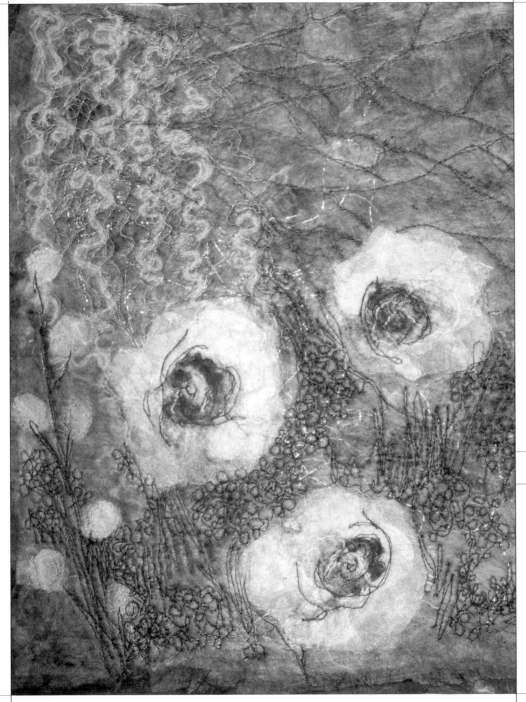

0552 | Debra A. Hartranft, USA

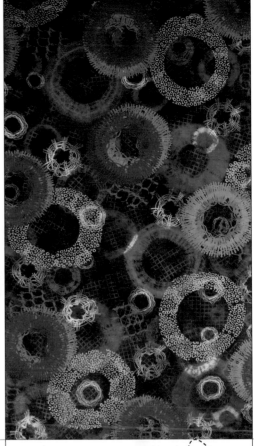

0553 | Susie Krage, USA

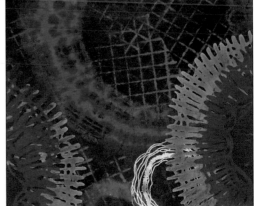

0554 | Susie Krage, USA

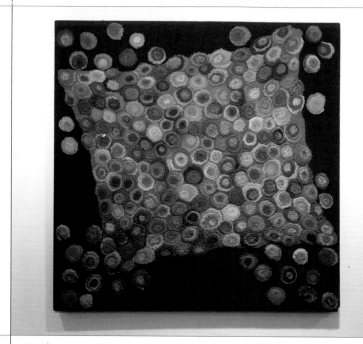

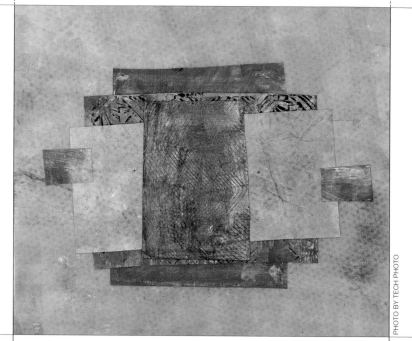

0555 | Elizabeth Armstrong, Australia

0556 | Miriam W. Jacobs, USA

PHOTO BY TECH PHOTO

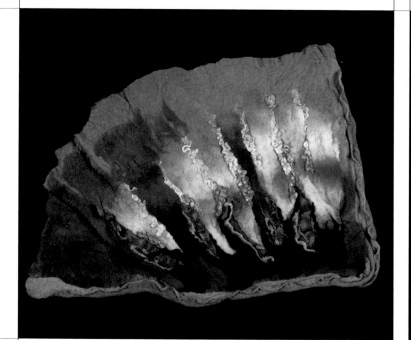

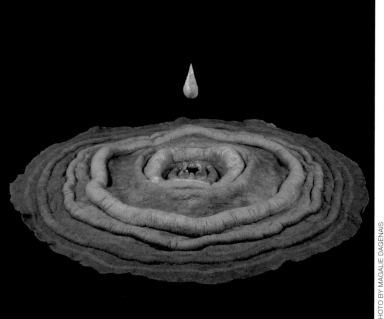

0557 | Sharron Parker, USA

0558 | Diane Gonthier, Canada

PHOTO BY MAGALIE DAGENAIS

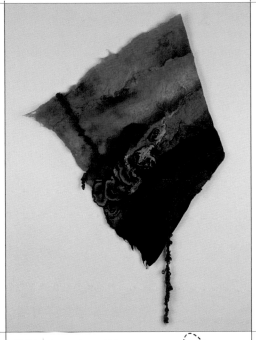

0559 | Sharron Parker, USA

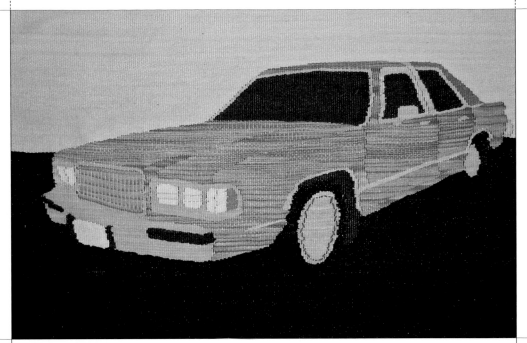

0560 | Erin M. Riley, USA

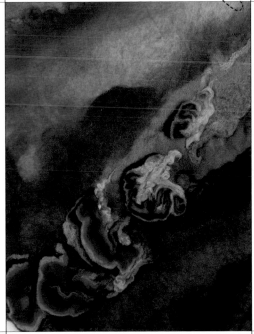

0561 | Sharron Parker, USA

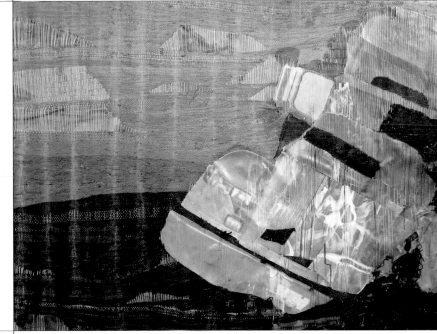

0562 | Erin M. Riley, USA

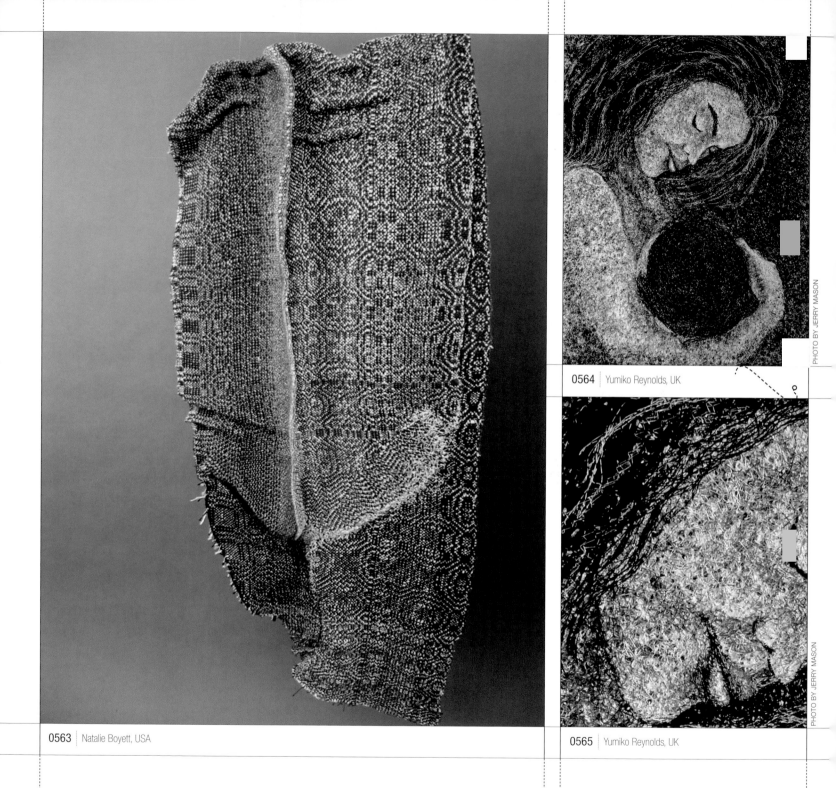

0563 | Natalie Boyett, USA

0564 | Yumiko Reynolds, UK

0565 | Yumiko Reynolds, UK

PHOTO BY JERRY MASON

PHOTO BY JERRY MASON

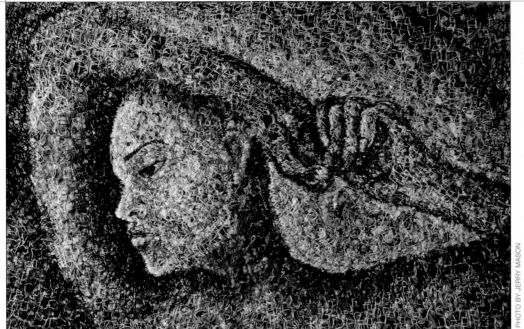

0566 | Yumiko Reynolds, UK

PHOTO BY JERRY MASON

⚲ 0567 | Yumiko Reynolds, UK

PHOTO BY JERRY MASON

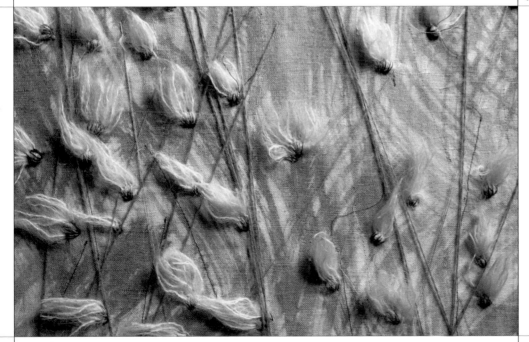

0568 | Christine Boyle, Northern Ireland

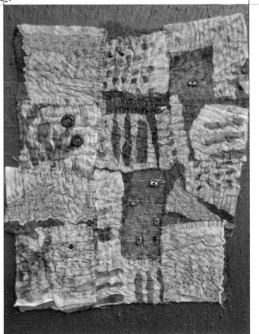

0569 | Linda Van Alstyne, USA

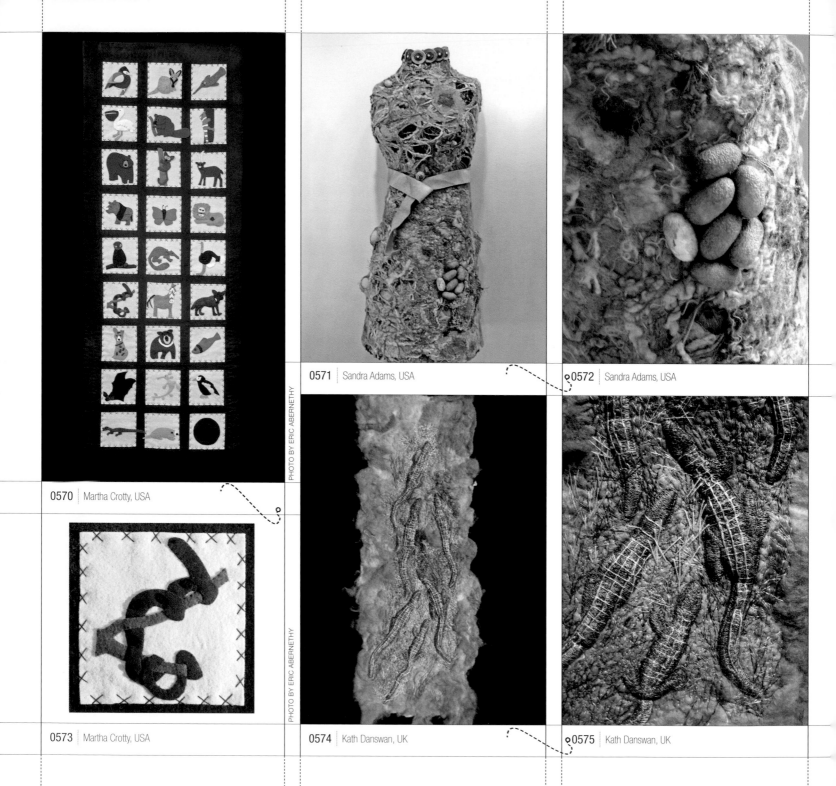

0571 | Sandra Adams, USA

0572 | Sandra Adams, USA

0570 | Martha Crotty, USA

0573 | Martha Crotty, USA

0574 | Kath Danswan, UK

0575 | Kath Danswan, UK

PHOTO BY ERIC ABERNETHY

PHOTO BY ERIC ABERNETHY

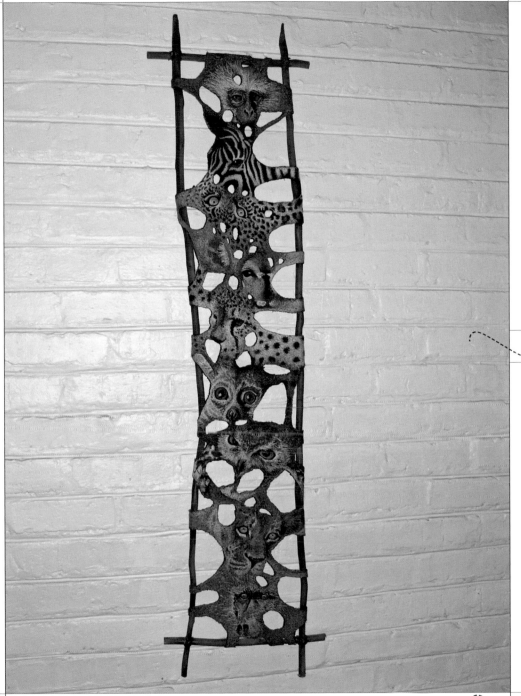

0576 | Kathryn Harmer, South Africa

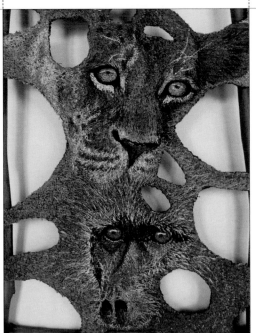

0577 | Kathryn Harmer, South Africa

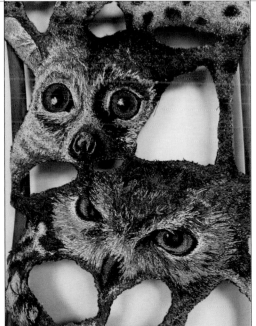

0578 | Kathryn Harmer, South Africa

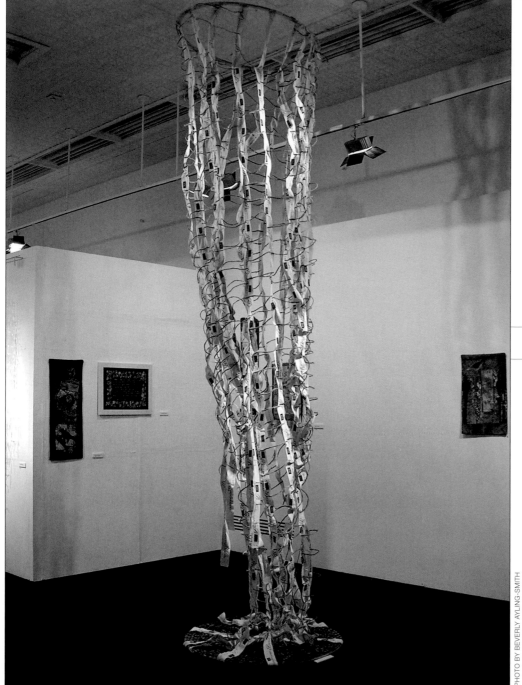

0579 | Maria-Theresa Fernandes, UK

PHOTO BY BEVERLY AYLING-SMITH

PHOTO BY SANDRA SALAMONY

0580 | Gina M. Brown, USA

♀0581 | Maria-Theresa Fernandes, UK

PHOTO BY BEVERLY AYLING-SMITH

0582 | Edwina Sutherland, Canada

0583 | Felted Style, USA

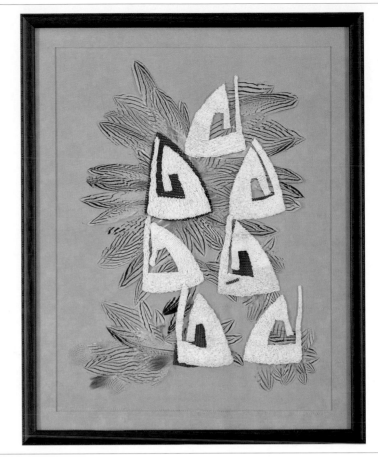

0584 | Rowen Schussheim-Anderson, USA

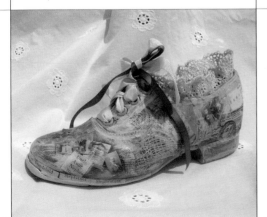

0585 | Nora Cannon, USA

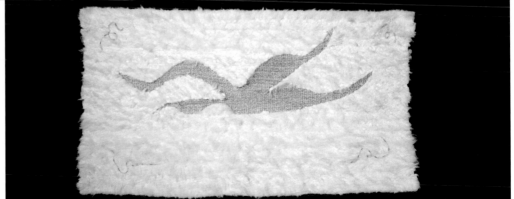

0586 | Jean Fortune Kaplan, USA

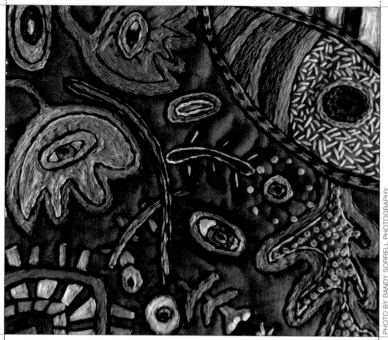

0587 | Susan R. Sorrell, USA

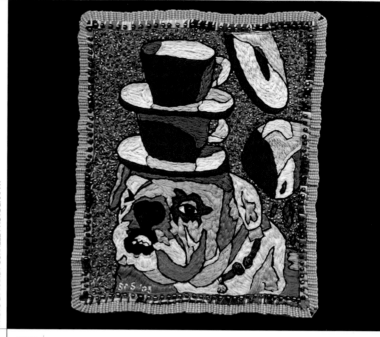

0588 | Susan R. Sorrell, USA

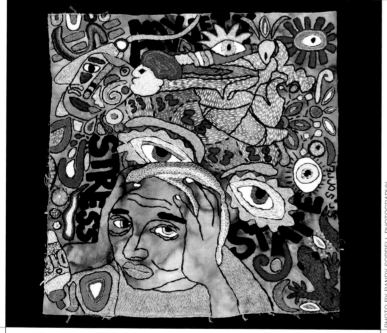

0589 | Susan R. Sorrell, USA

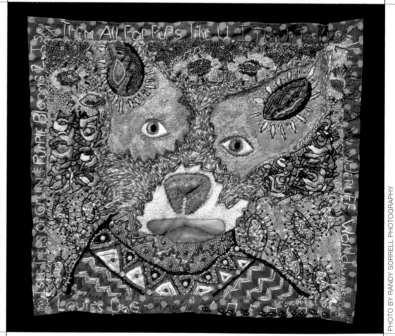

0590 | Susan R. Sorrell, USA

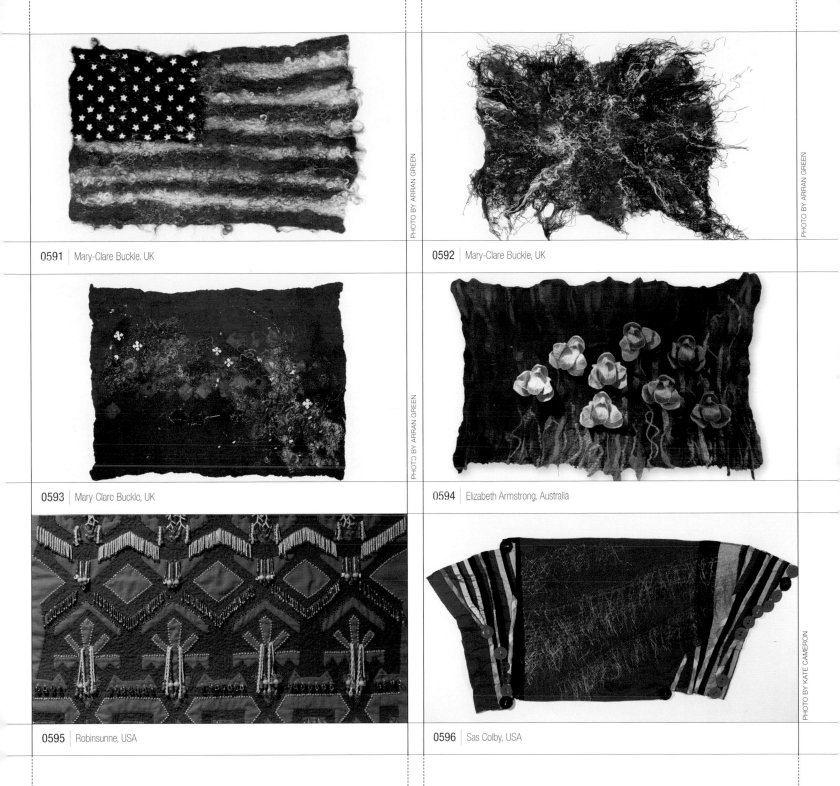

0591 | Mary-Clare Buckle, UK

0592 | Mary-Clare Buckle, UK

0593 | Mary-Clare Buckle, UK

0594 | Elizabeth Armstrong, Australia

0595 | Robinsunne, USA

0596 | Sas Colby, USA

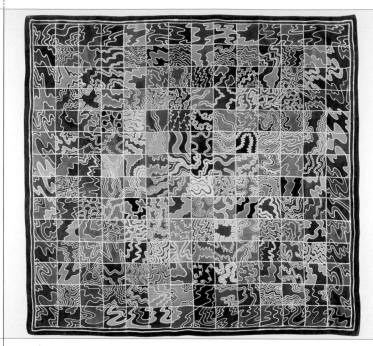

0597 | So Yoon Lym, USA

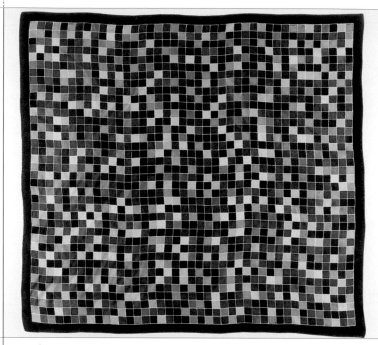

0598 | So Yoon Lym, USA

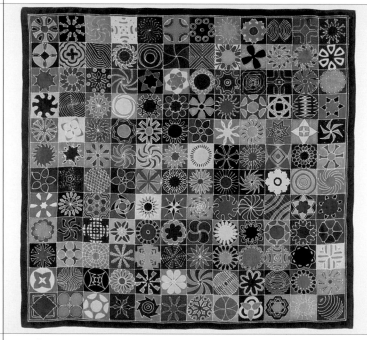

0599 | So Yoon Lym, USA

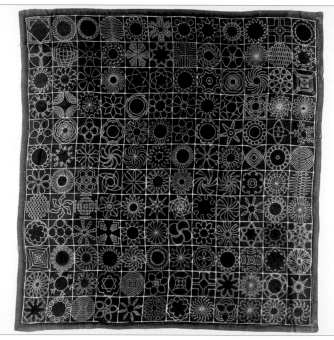

0600 | So Yoon Lym, USA

0601 | LisaLi Hertzi, USA

0602 | LisaLi Hertzi, USA

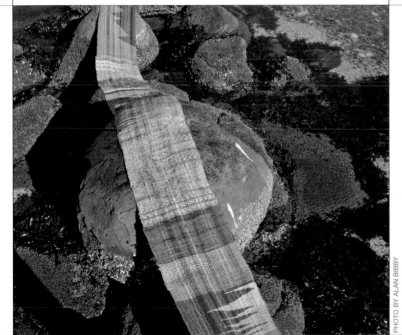

0603 | Terry Bibby, Canada

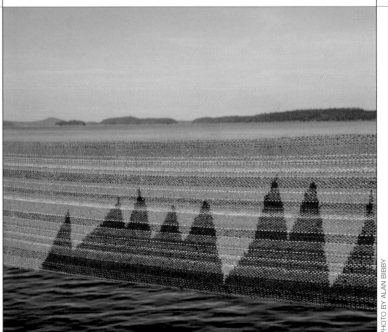

PHOTO BY ALAN BIBBY

0604 | Terry Bibby, Canada

PHOTO BY ALAN BIBBY

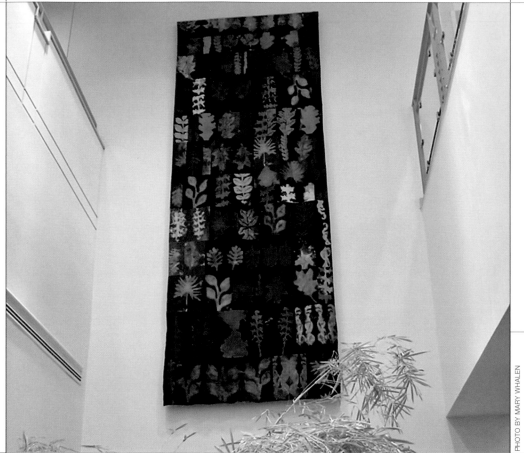

0605 | Carol LeBaron, USA

PHOTO BY MARY WHALEN

0606 | Carol LeBaron, USA

0607 | Carol LeBaron, USA

0608 | Carol LeBaron, USA

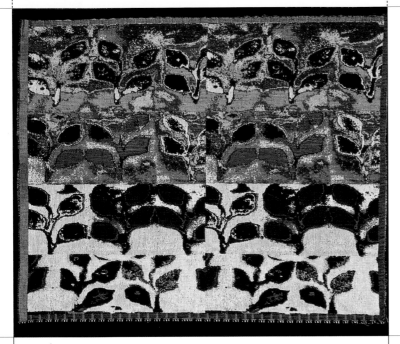

0609 | Carol LeBaron, USA

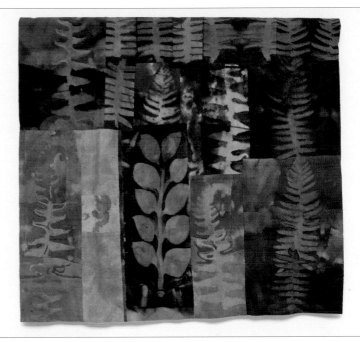

0610 | Carol LeBaron, USA

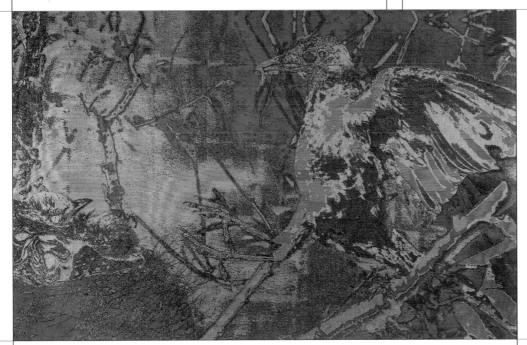

0611 | Carol LeBaron, USA

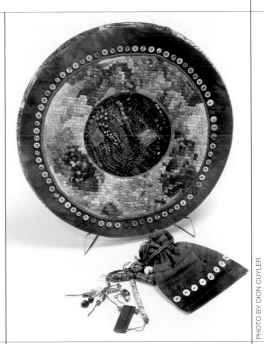

0612 | Jenny Hearn, South Africa

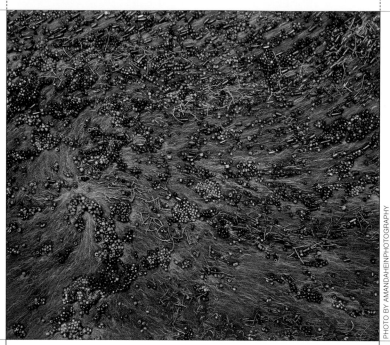

0613 Sharon L. Wright, USA

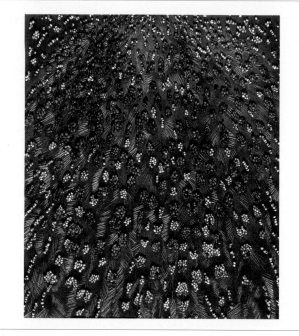

0614 Sharon L. Wright, USA

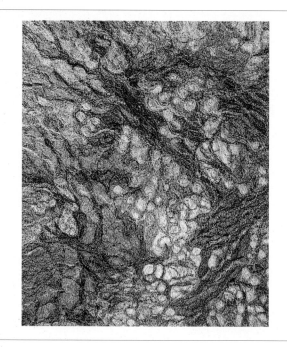

0615 Carol Coleman, UK

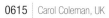**0616** Carol Coleman, UK

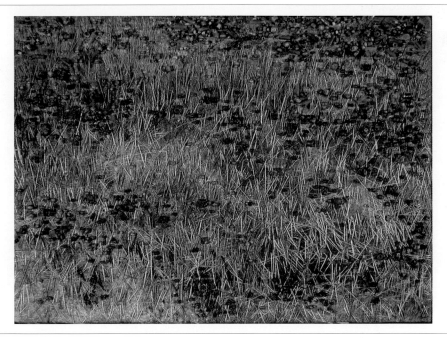

0617 | Sharon L. Wright, USA

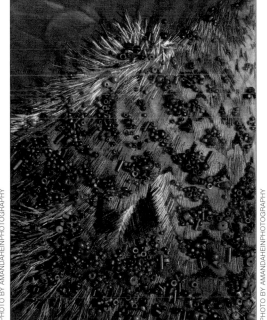

0618 | Sharon L. Wright, USA

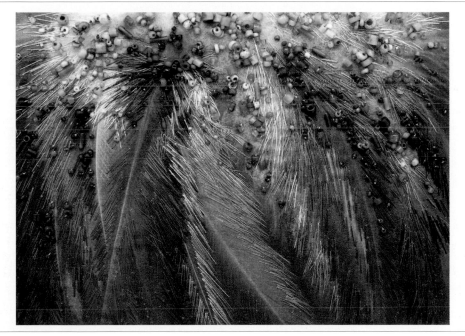

0619 | Sharon L. Wright, USA

0620 | Sharon L. Wright, USA

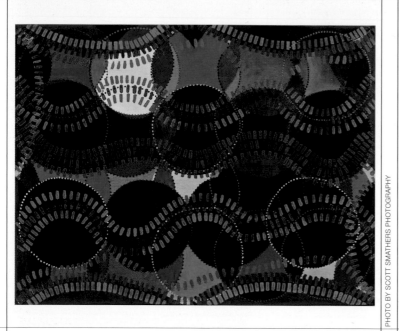

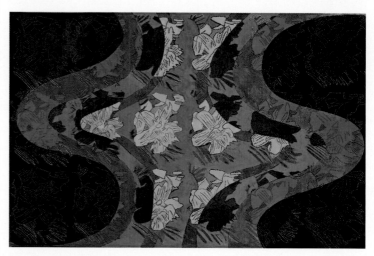

0621 | Hope Gelfand Alcorn, USA

0622 | Hope Gelfand Alcorn, USA

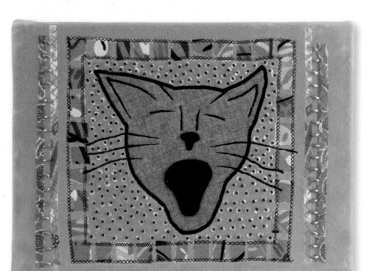

0623 | Patti Haskins, USA

0624 | Nancy Eha, USA

0625 | Hope Gelfand Alcorn, USA

0626 | Hope Gelfand Alcorn, USA

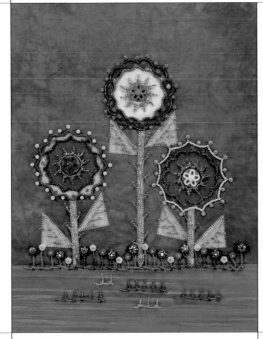

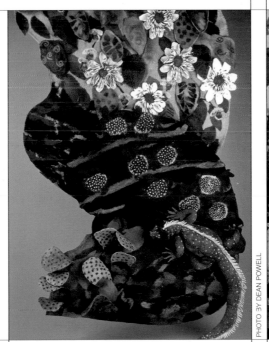

0627 | Nancy Eha, USA

0628 | Nicole Chazaud Telaar, Festive Fibers, USA

0629 | Hope Gelfand Alcorn, USA

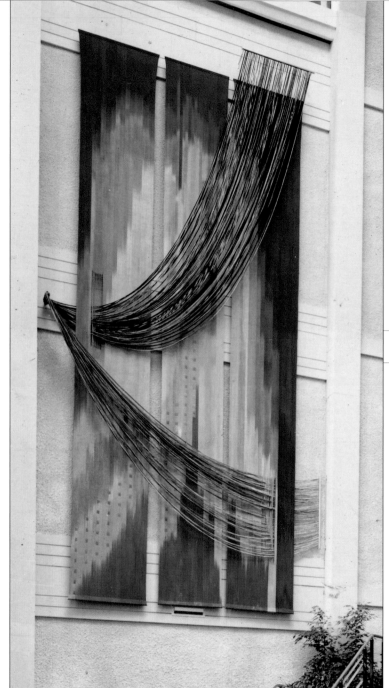

0631 | Heidi Lichterman, UK

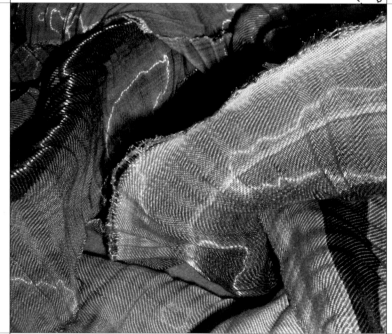

0630 | Heidi Lichterman, UK

0632 | Heidi Lichterman, UK

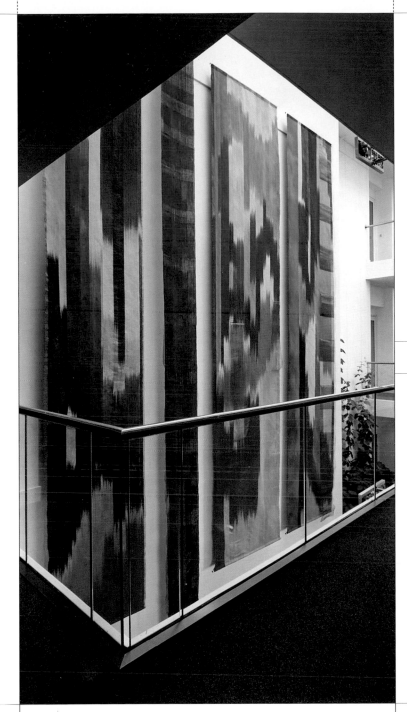

0633 | Heidi Lichterman, UK

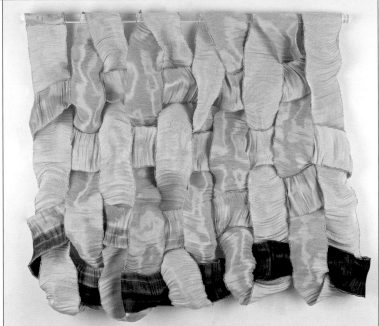

0634 | Heidi Lichterman, UK

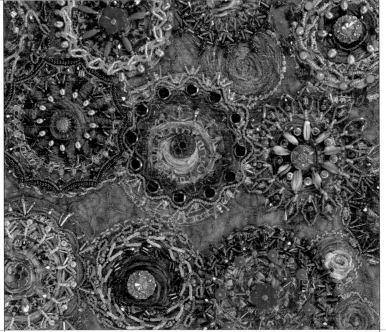

0635 | Nancy Eha, USA

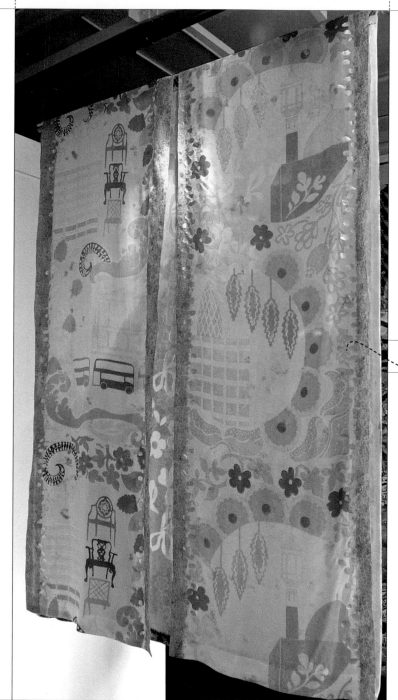

0636 | Gina Pierce, UK

0639 | Gina Pierce, UK

0640 | Gina Pierce, UK

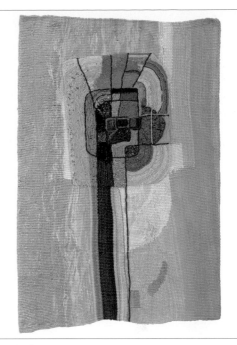

0641 | Rowen Schussheim-Anderson, USA

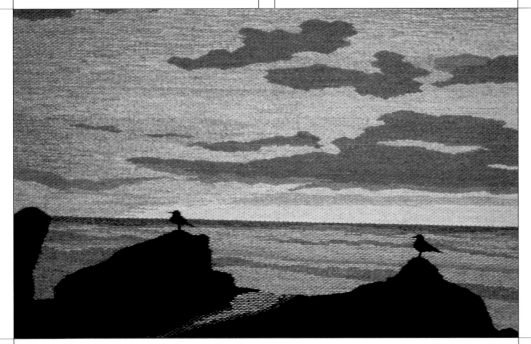

0642 | Janet Daniel, USA

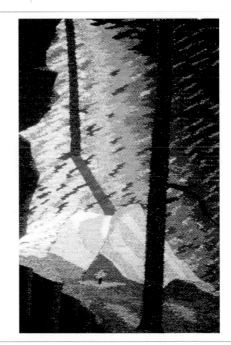

0643 | Janet Daniel, USA

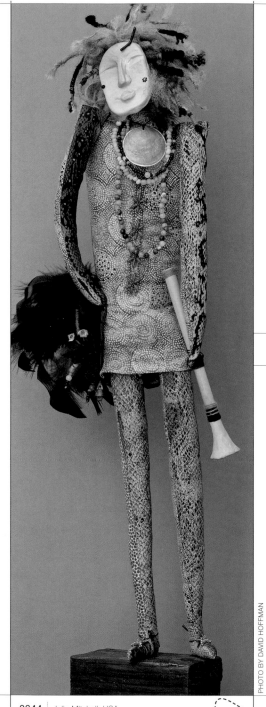

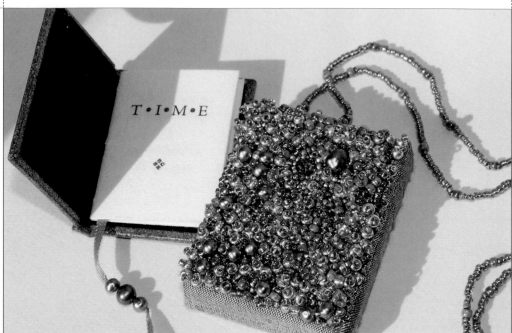

0645 | Madelyn Garrett, USA

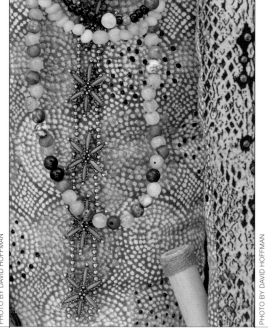

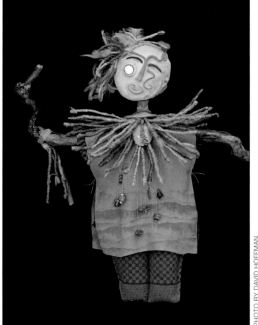

0644 | Julie Mitchell, USA

♀0646 | Julie Mitchell, USA

0647 | Julie Mitchell, USA

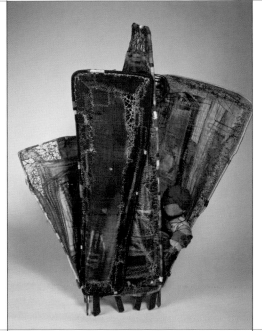

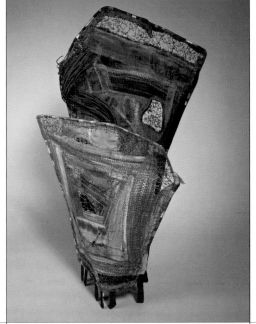

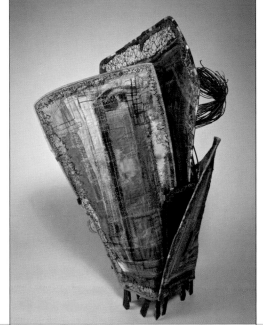

0648 | Peggy Sexton, USA

0649 | Peggy Sexton, USA

0650 | Peggy Sexton, USA

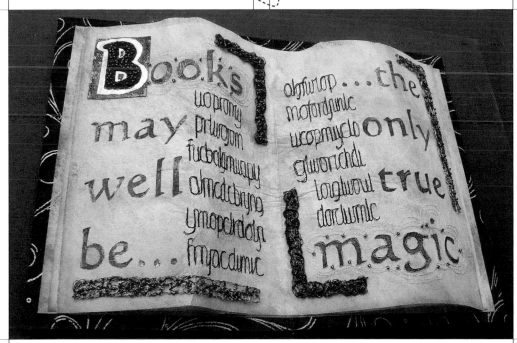

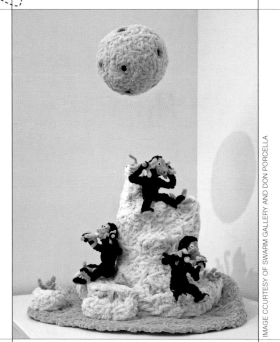

0651 | Di Schonhut, UK

0652 | Don Porcella, USA

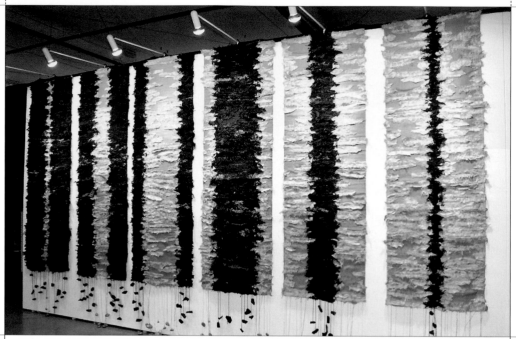

0653 | Brigitte Amarger, France

0654 | Kristin Rohr, Canada

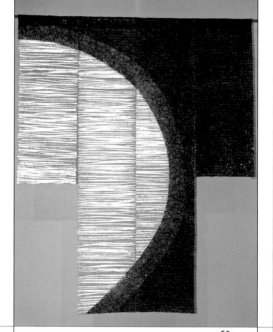

0655 | Brigitte Amarger, France

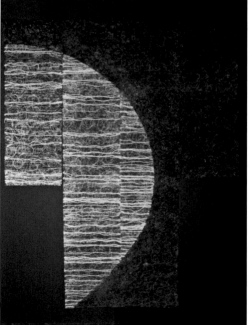

0656 | Brigitte Amarger, France

0657 | Kristin Rohr, Canada

0658 | Madelyn Garrett, USA

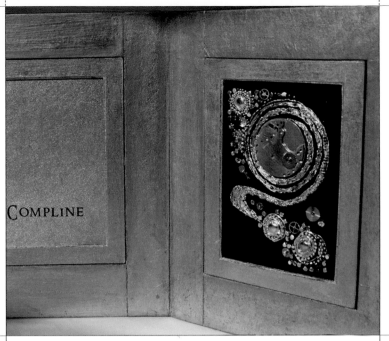

0659 | Madelyn Garrett, USA

0660 | Madelyn Garrett, USA

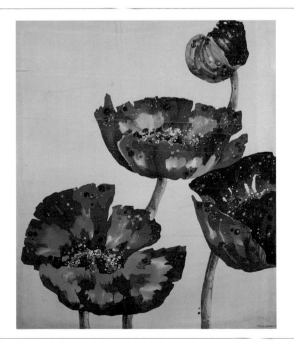

0661 | Elena Bondar, USA

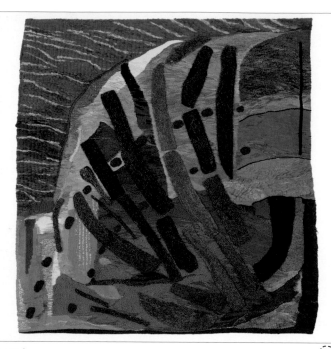

0662 | Rowen Schussheim-Anderson, USA

0663 | Rowen Schussheim-Anderson, USA

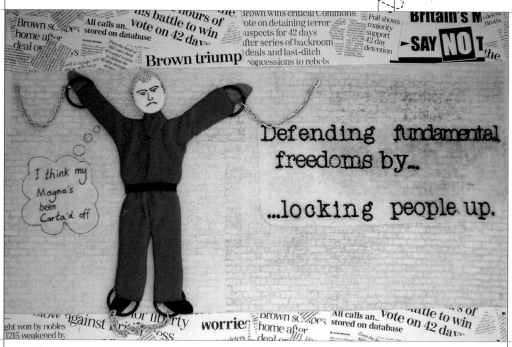

0664 | Di Schonhut, UK

0665 | Jennifer Krage, USA

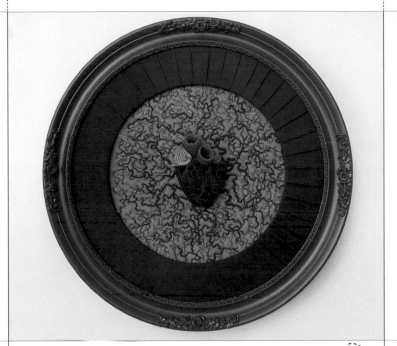

0666 | Kate Kretz, USA

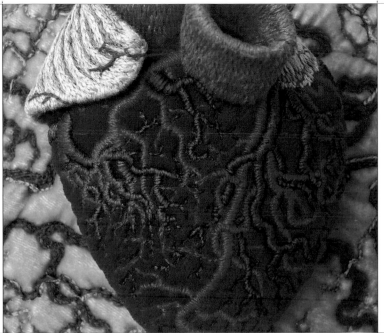

0667 | Kate Kretz, USA

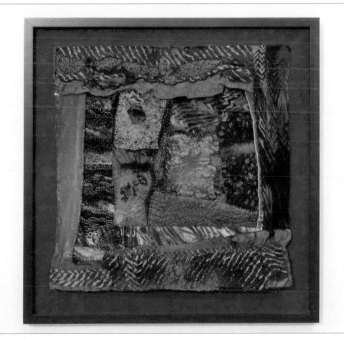

0668 | Anne Flora, USA

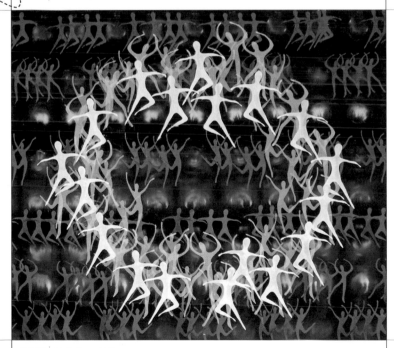

0669 | Susie Krage, USA

0671 | Jeri L. Flom, USA

0670 | Jeri L. Flom, USA

0672 | Jeri L. Flom, USA

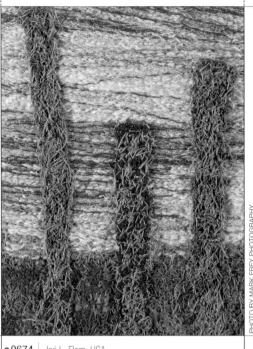

0673 | Jeri L. Flom, USA

0674 | Jeri L. Flom, USA

0675 | Sandra Adams, USA

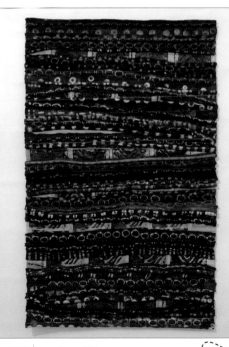

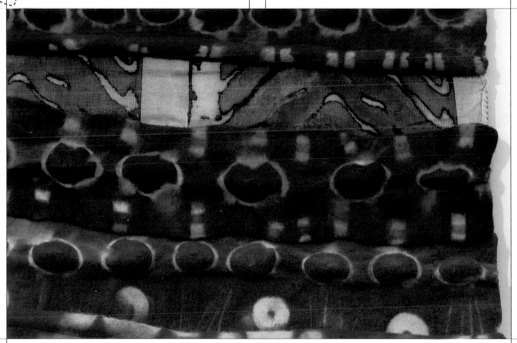

0676 | Anne Flora, USA

0677 | Anne Flora, USA

0678 | Fibredesign, USA

0679 | Fibredesign, USA

0680 | Fibredesign, USA

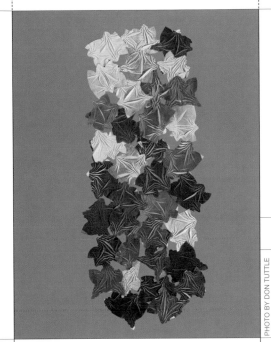

0681 | Ana Lisa Hedstrom, USA

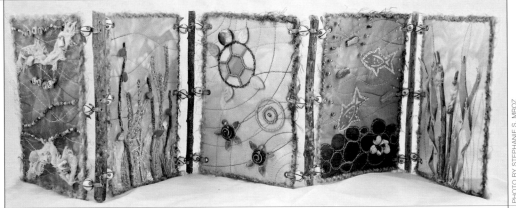

0682 | Sidney Savage Inch, USA

0000 | Artist Name

0683 | Lee Creswell, UK

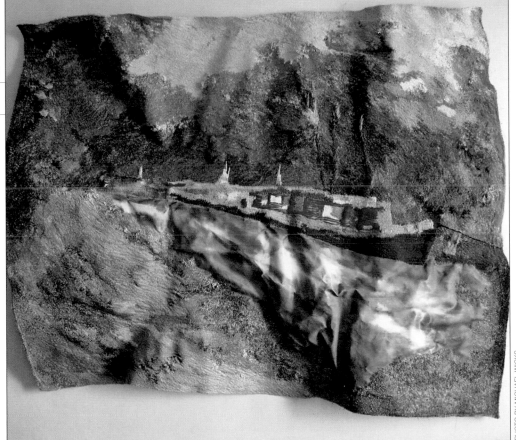

0684 | Maria-Theresa Fernandes, UK

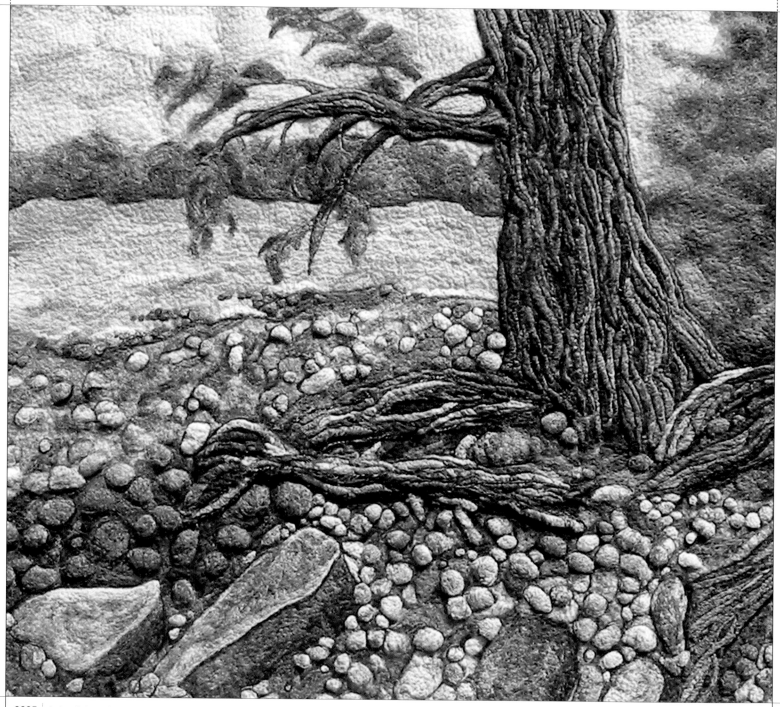

0685 | Andrea Graham, Canada

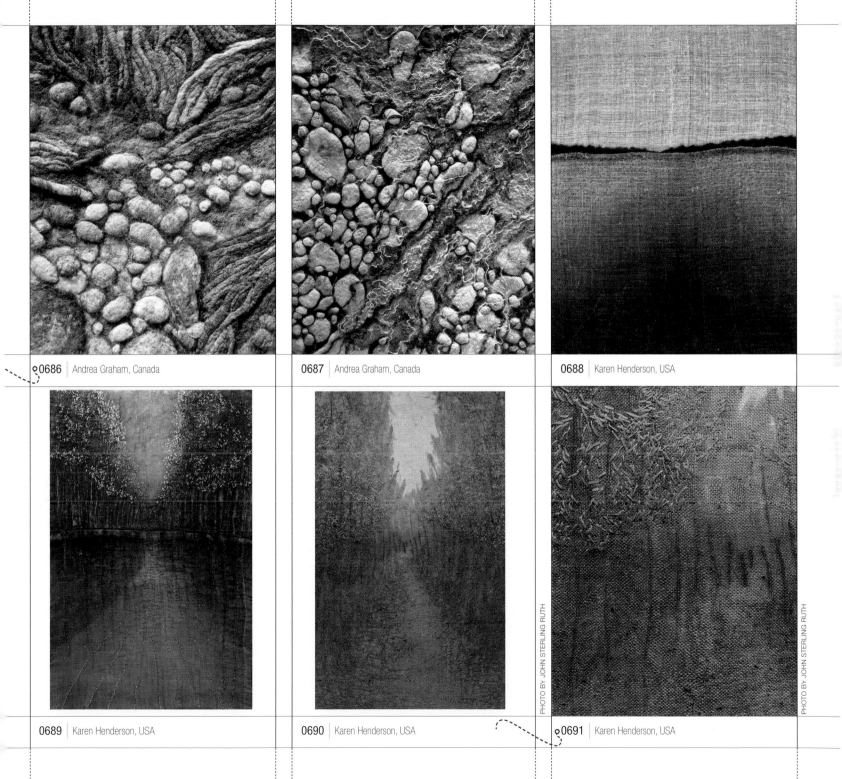

0686 | Andrea Graham, Canada

0687 | Andrea Graham, Canada

0688 | Karen Henderson, USA

0689 | Karen Henderson, USA

0690 | Karen Henderson, USA

0691 | Karen Henderson, USA

PHOTO BY JOHN STERLING RUTH

PHOTO BY JOHN STERLING RUTH

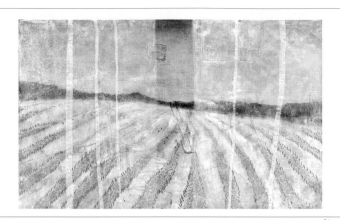

0692 | Karen Henderson, USA

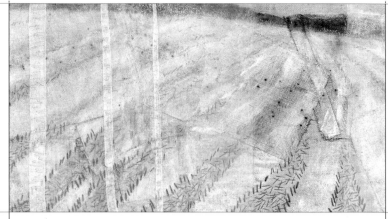

0693 | Karen Henderson, USA

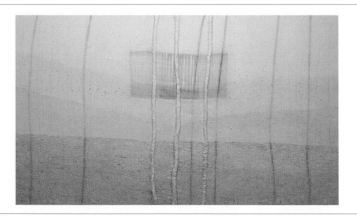

0694 | Karen Henderson, USA

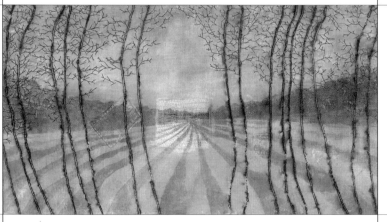

0695 | Karen Henderson, USA

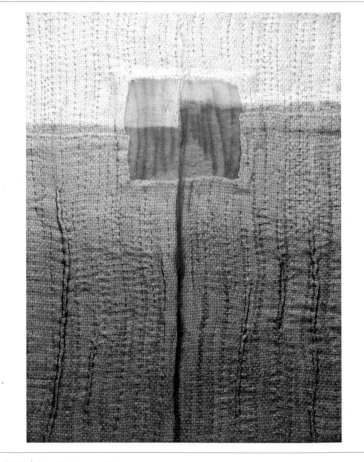

0696 | Karen Henderson, USA

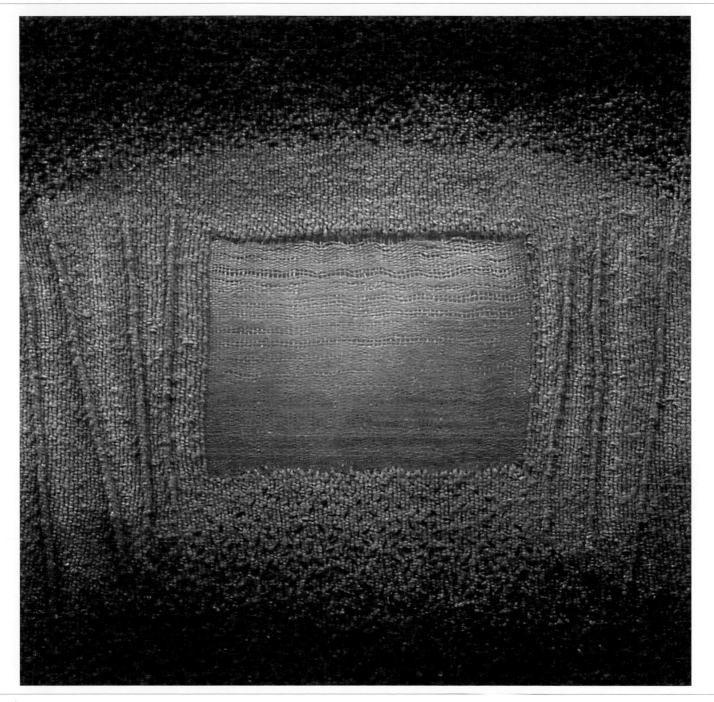

0697 | Karen Henderson, USA

ROW 1: IMAGE COURTESY OF DESIREE VAUGHN, IMAGE COURTESY OF
BETSY CANNON (PHOTO BY THE IMAGEMAKER); ROW 2: IMAGE 0776, IM-
AGE COURTESY OF FULVIA BORIANI LUCIANO; ROW 3: IMAGE COURTESY
OF NAOMI RENOUF, IMAGE 0698

Art Quilts

0698—1000

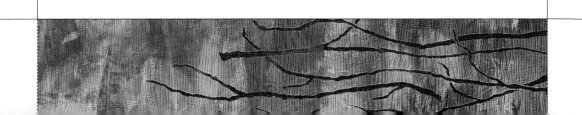

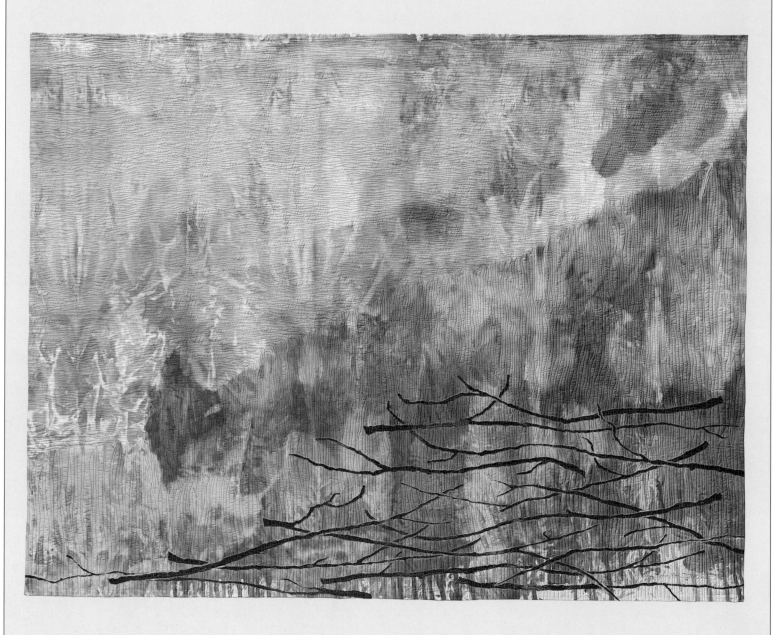

0698 | Ann Johnston, USA

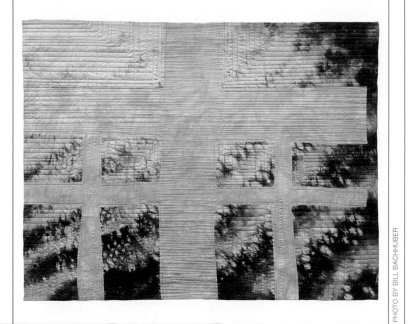

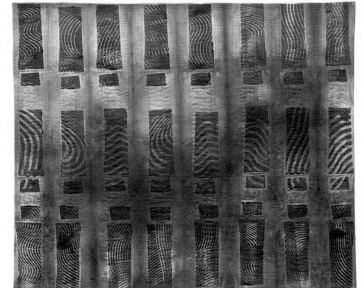

0699 | Ann Johnston, USA

0700 | Ann Johnston, USA

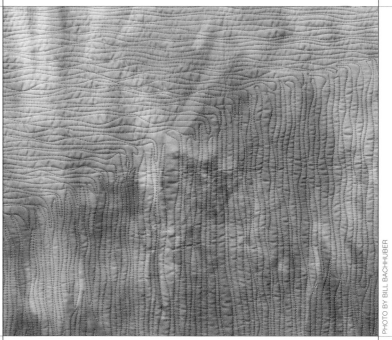

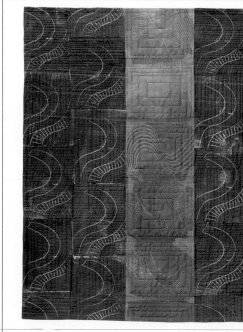

0701 | Ann Johnston, USA

0702 | Ann Johnston, USA

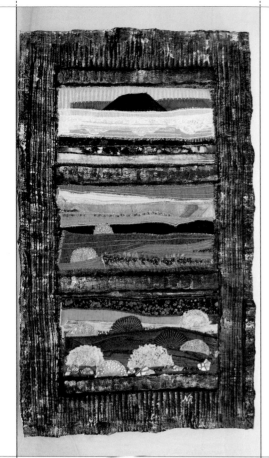

0703 | Naomi Renouf, UK

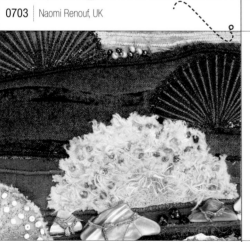

0704 | Naomi Renouf, UK

0705 | Ann Johnston, USA

0706 | Ann Johnston, USA

0707 | Ann Johnston, USA

0708 | Ann Johnston, USA

0709 | Ann Johnston, USA

0710 | Ann Johnston, USA

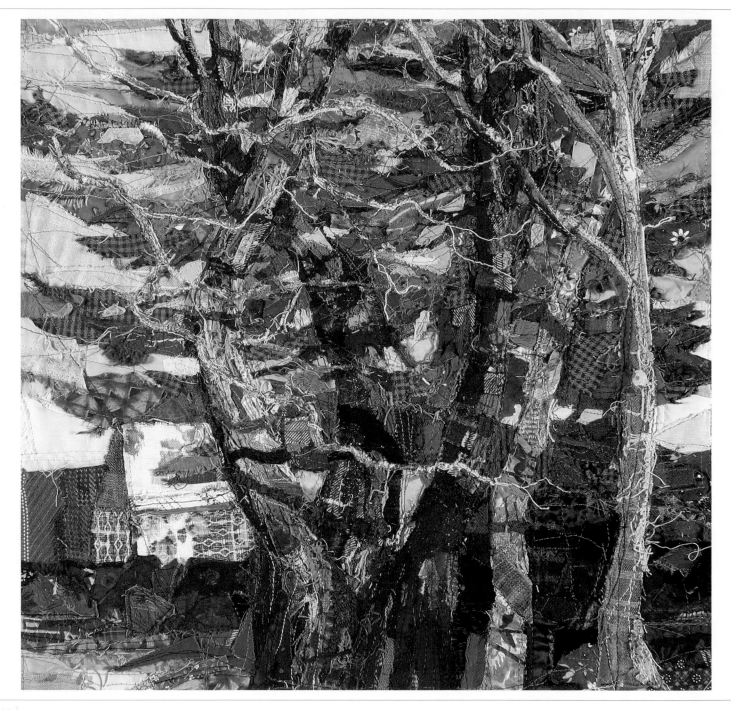

0712 | Ann Johnston, USA

0713 | Gail Pierce, USA

0714 | Gail Pierce, USA

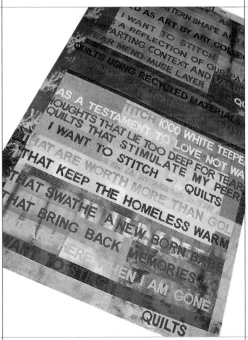

0715 | Michele C. Leavitt, USA

0716 | Bethan Ash, UK

0717 | Barbara Schneider, dipl. des., Germany

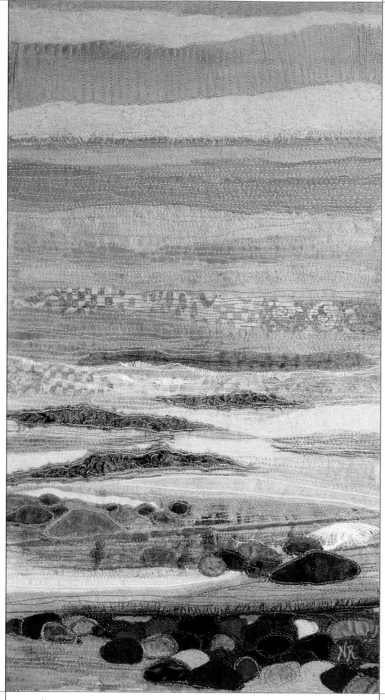

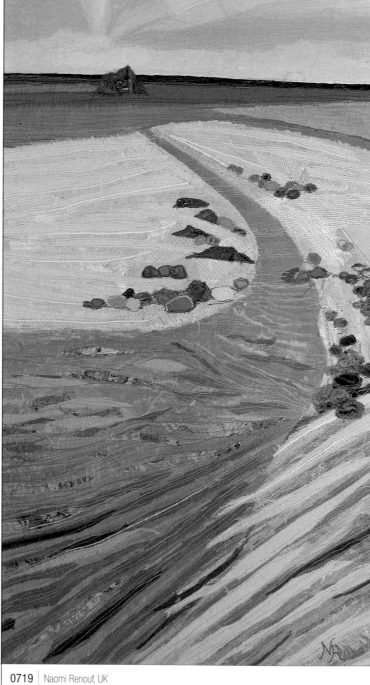

0718 | Naomi Renouf, UK

0719 | Naomi Renouf, UK

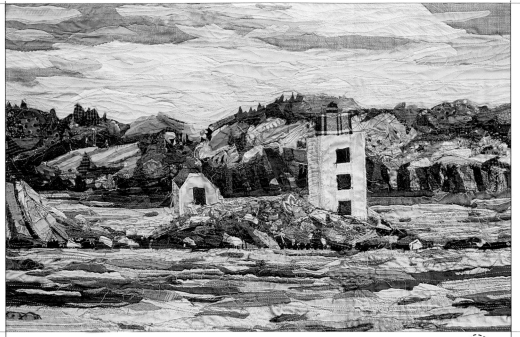

0720 | Michele C. Leavitt, USA

0721 | Michele C. Leavitt, USA

0722 | Naomi Renouf, UK

0723 | Julia Sermersheim, USA

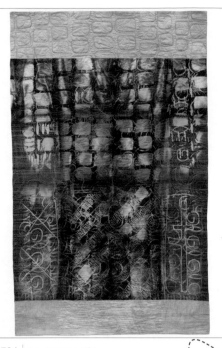

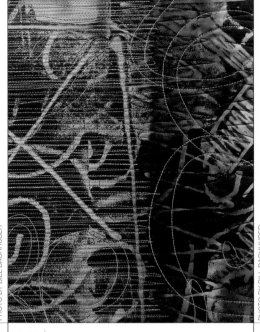

PHOTO BY BILL BACHHUBER

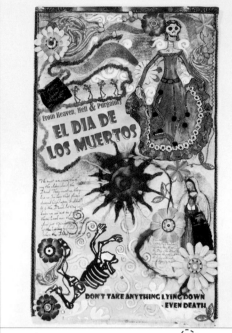

PHOTO BY BILL BACHHUBER

0724	Ann Johnston, USA
0725	Ann Johnston, USA
0726	Jacqueline Lams, USA

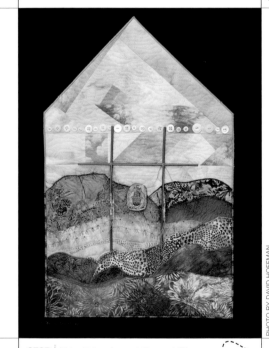

PHOTO BY DAVID HOFFMAN

PHOTO BY DAVID HOFFMAN

0727	Vivian Helena Aumond-Capone, USA
0728	Vivian Helena Aumond-Capone, USA
0729	Jacqueline Lams, USA

0730 | Desiree Vaughn, USA

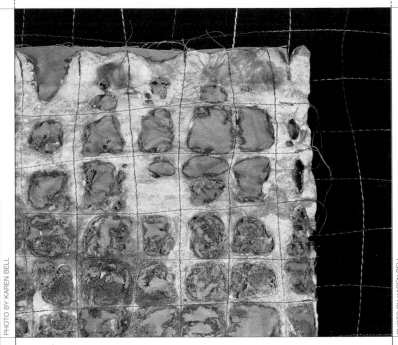

0731 | Desiree Vaughn, USA

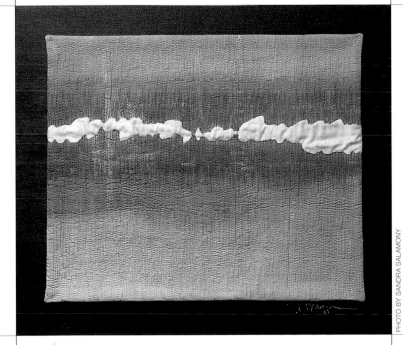

0732 | Desiree Vaughn, USA

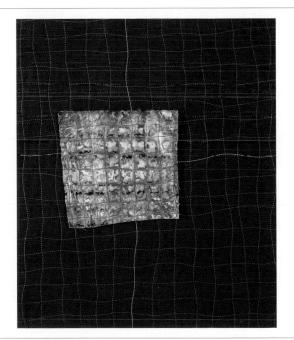

0733 | Desiree Vaughn, USA

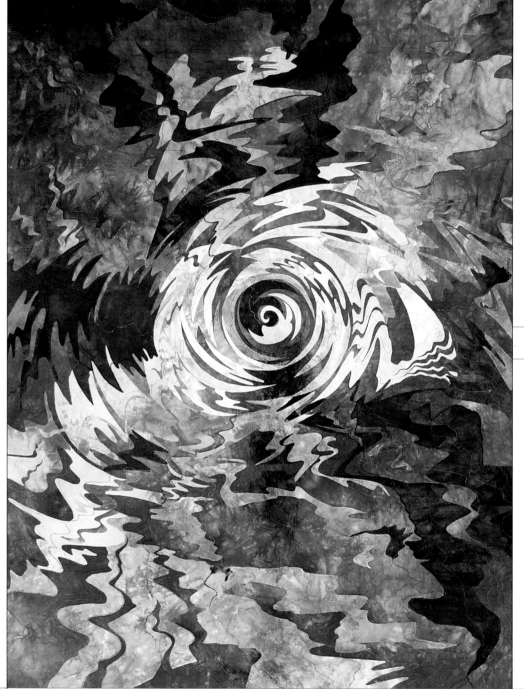

0734 | Barbara J. Schneider, USA

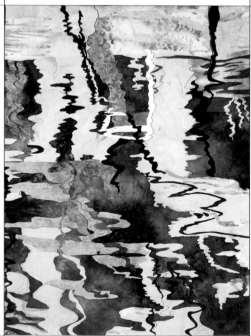

0735 | Barbara J. Schneider, USA

0736 | Barbara J. Schneider, USA

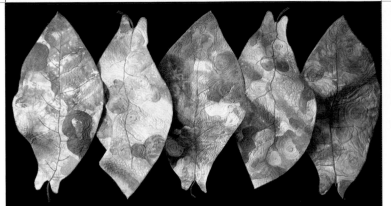

0737 | Barbara J. Schneider, USA

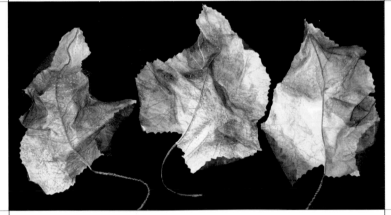

0738 | Barbara J. Schneider, USA

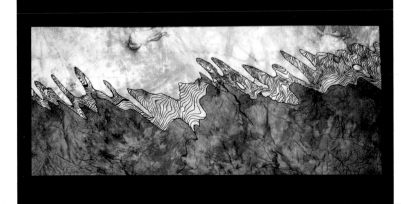

0739 | Barbara J. Schneider, USA

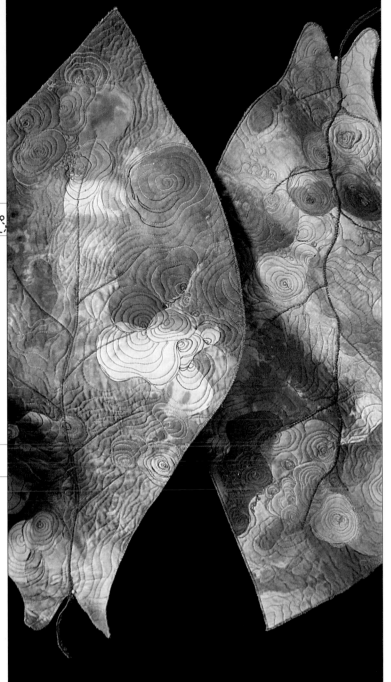

0740 | Barbara J. Schneider, USA

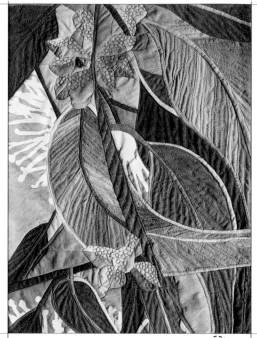

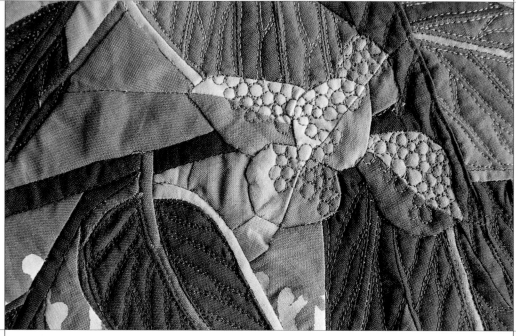

0741 | Ruth de Vos, Australia

0742 | Ruth de Vos, Australia

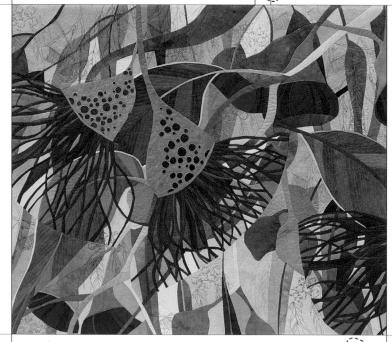

0743 | Ruth de Vos, Australia

0744 | Ruth de Vos, Australia

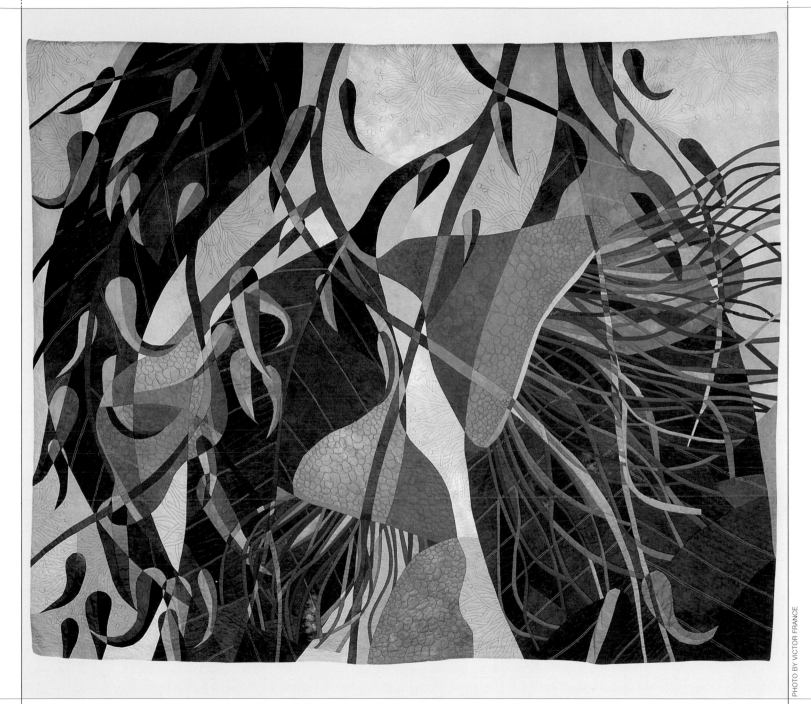

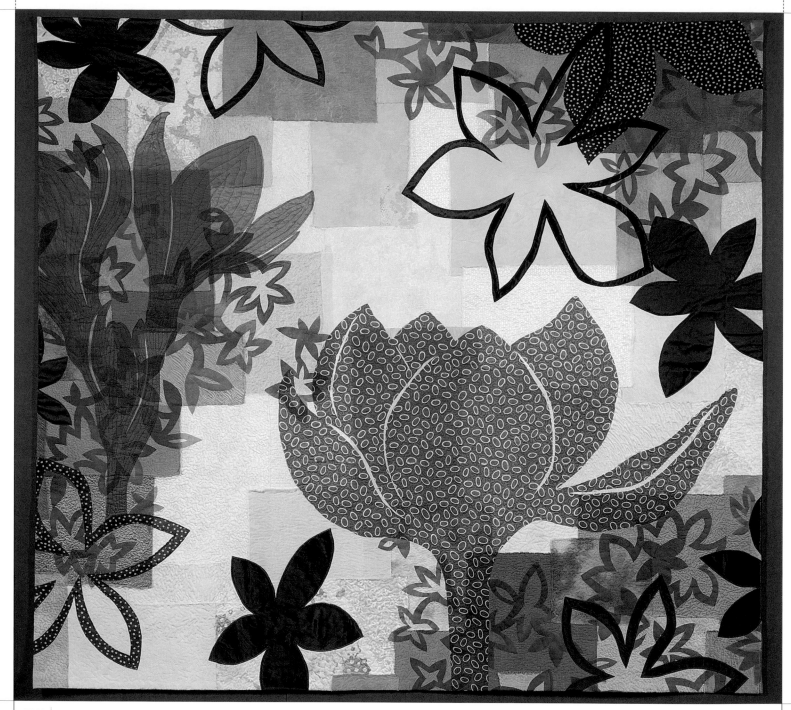

0746 | Maggie Weiss, USA

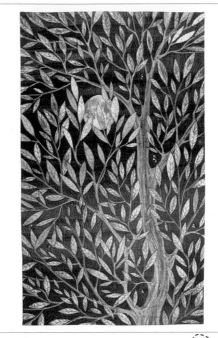

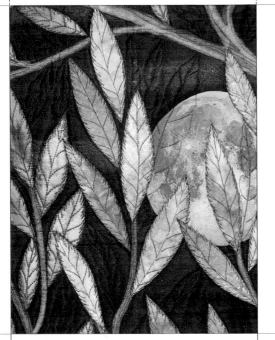

0747 | Kathleen Field, USA

0748 | Betty Busby, USA

⚲0749 | Betty Busby, USA

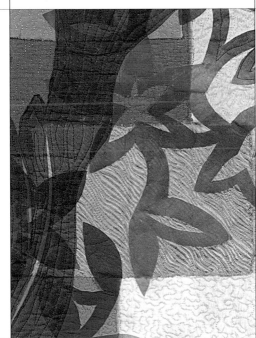

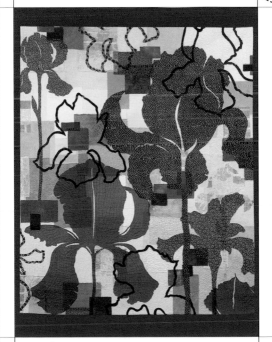

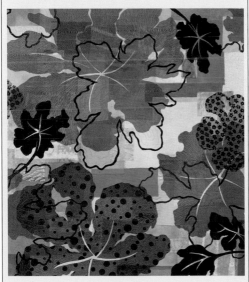

⚲0750 | Maggie Weiss, USA

0751 | Maggie Weiss, USA

0752 | Maggie Weiss, USA

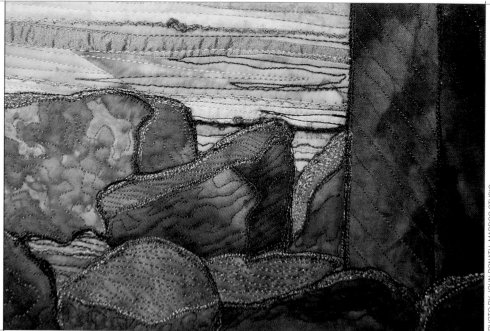

0753 | Denise Labadie, USA

0754 | Denise Labadie, USA

0755 | Denise Labadie, USA

0756 | Denise Labadie, USA

0757 | Denise Labadie, USA

0758 | Denise Labadie, USA

⚲0759 | Denise Labadie, USA

0760 | Denise Labadie, USA

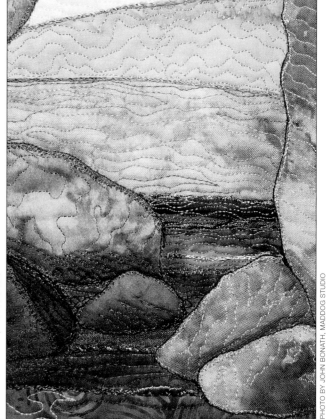

⚲0761 | Denise Labadie, USA

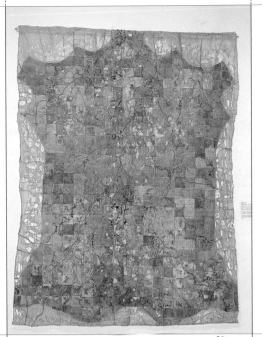

0762 | Sue Akerman, South Africa

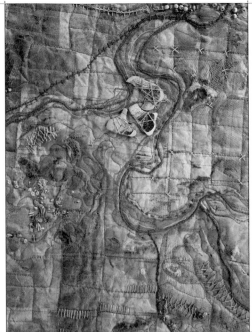

♀0763 | Sue Akerman, South Africa

♀0764 | Sue Akerman, South Africa

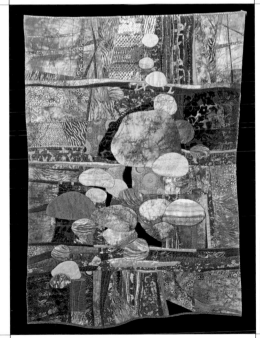

0765 | Rosalie Dace, South Africa

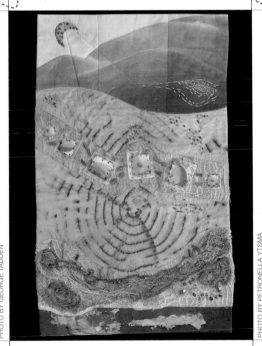

766 | Doroth Mayer, USA

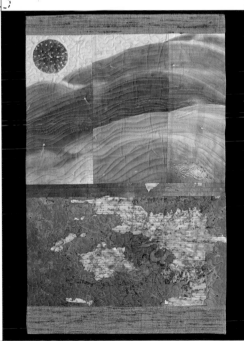

0767 | Doroth Mayer, USA

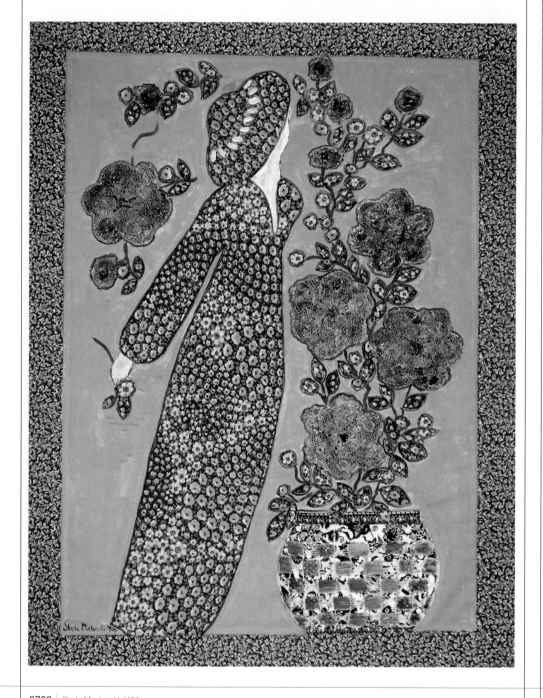

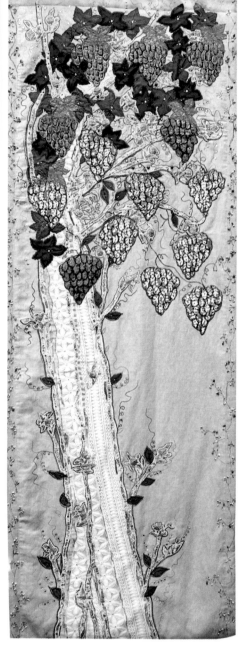

0768 | Shula Mustacchi, USA

0769 | Shula Mustacchi, USA

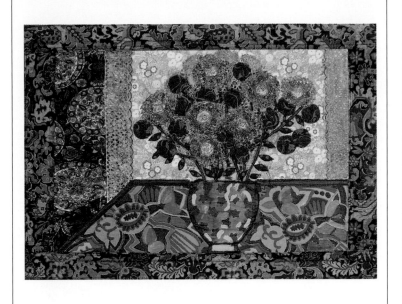

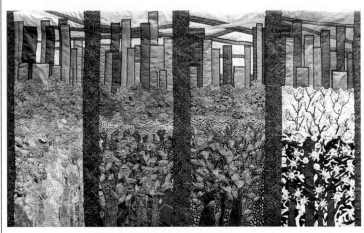

0770 | Shula Mustacchi, USA

0771 | Shula Mustacchi, USA

0772 | Terri Stegmiller, USA

0773 | Terri Stegmiller, USA

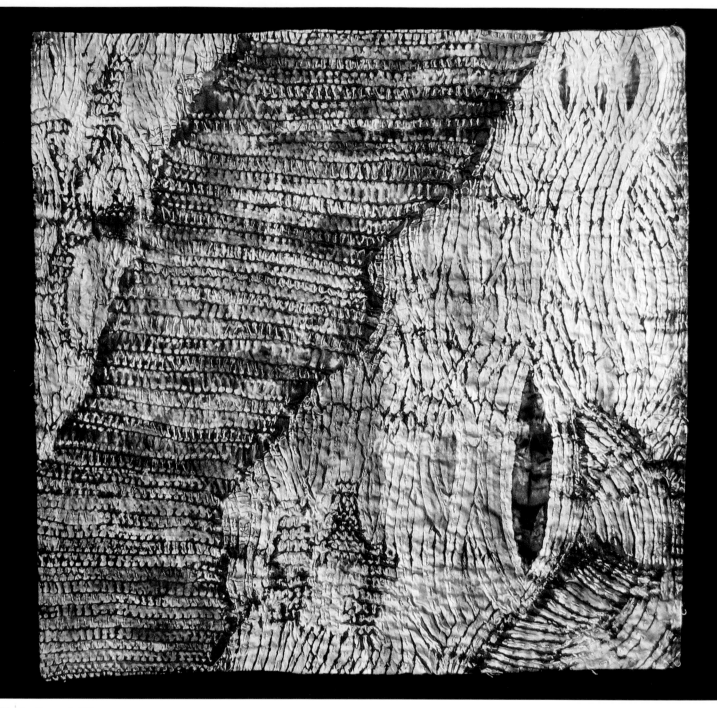

0775 | Sue Cavanaugh, USA

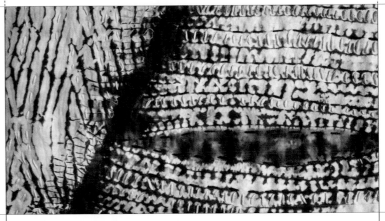

0776 | Sue Cavanaugh, USA

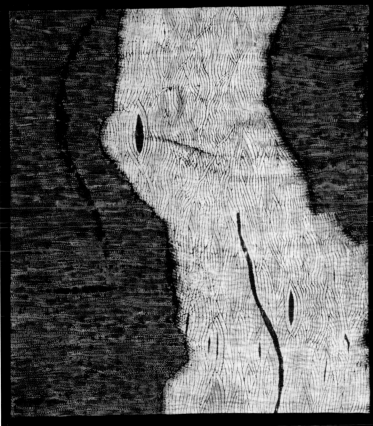

0777 | Sue Cavanaugh, USA

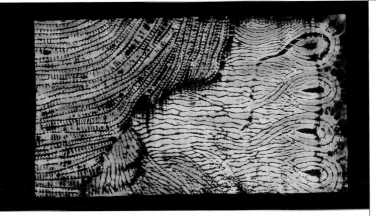

0778 | Sue Cavanaugh, USA

0779 | Sue Cavanaugh, USA

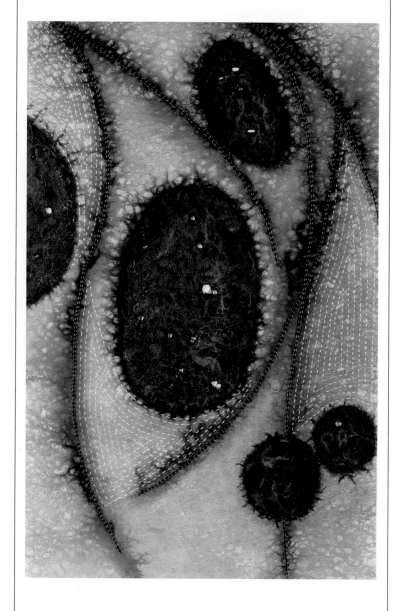

0780 | Marilyn Gillis, USA

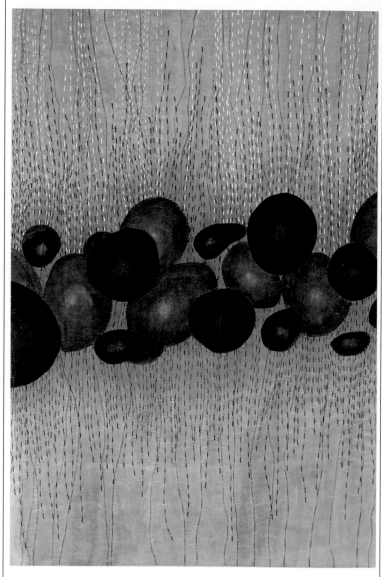

0781 | Marilyn Gillis, USA

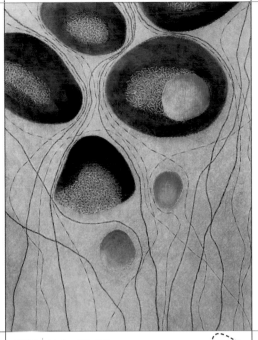

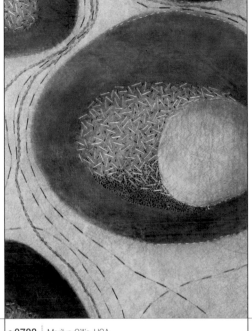

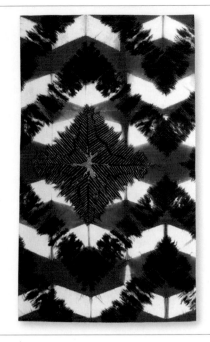

0782 | Marilyn Gillis, USA

0783 | Marilyn Gillis, USA

0784 | Marilyn Gillis, USA

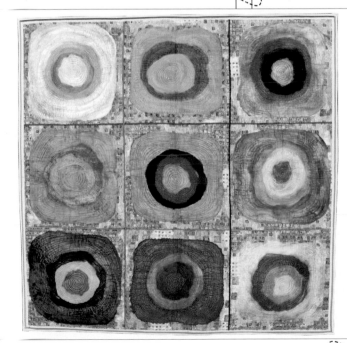

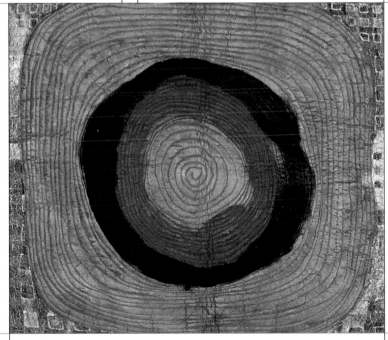

0785 | Marilyn Gillis, USA

0786 | Marilyn Gillis, USA

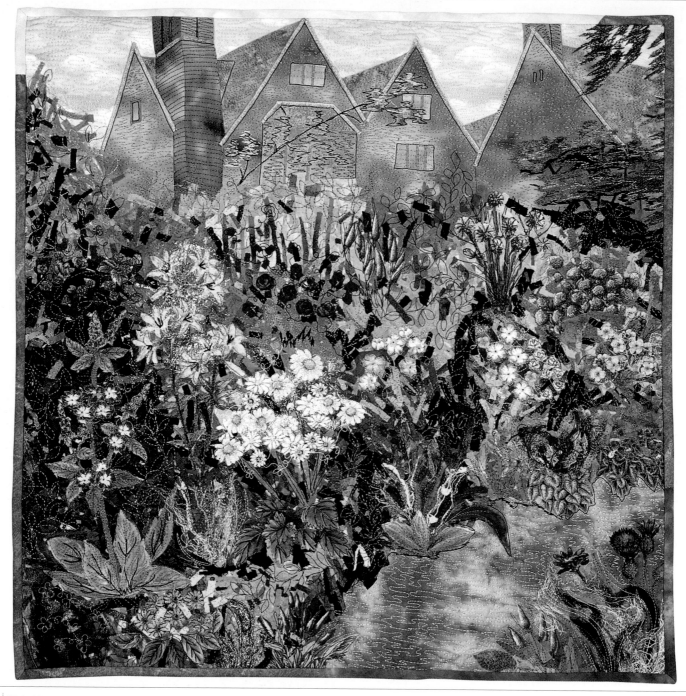

0787 | Hiroko Miyama, Japan

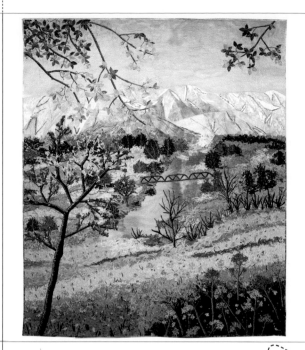

0788 | Hiroko Miyama, Japan

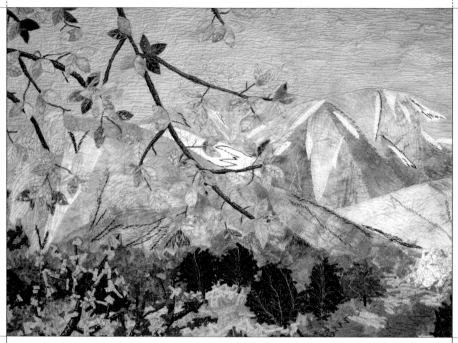

0789 | Hiroko Miyama, Japan

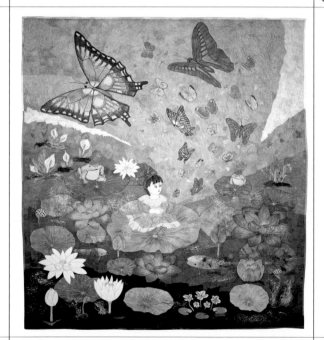

0790 | Hiroko Miyama, Japan

0791 | Hiroko Miyama, Japan

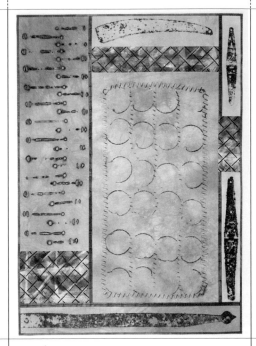

0792 | Marilyn Gillis, USA

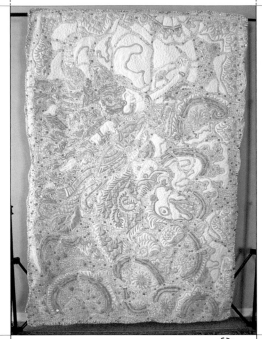

0793 | Susan Vassallo, USA

ᛩ0794 | Susan Vassallo, USA

0795 | Heike Gerbig, Germany

ᛩ0796 | Heike Gerbig, Germany

0797 | Heike Gerbig, Germany

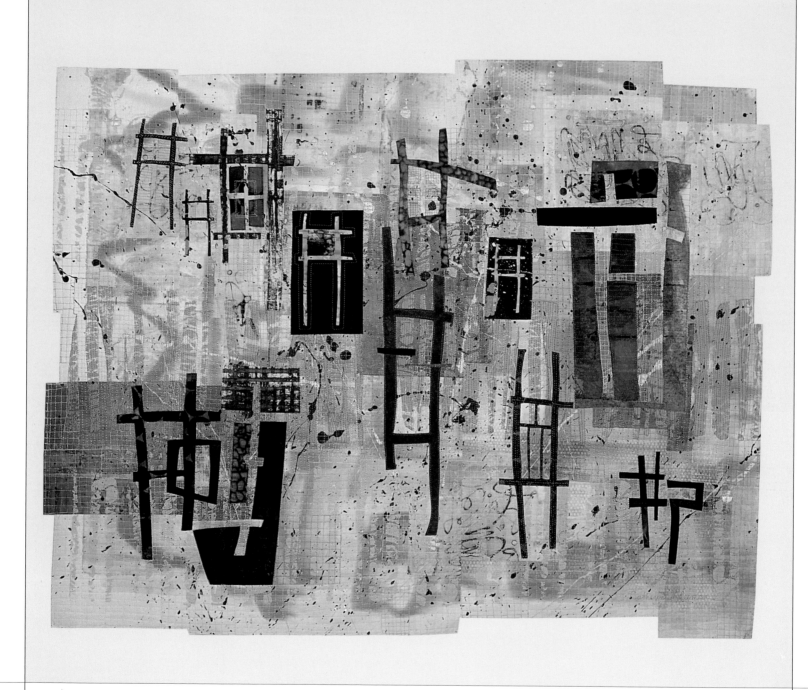

0798 | Catherine Kleeman, USA

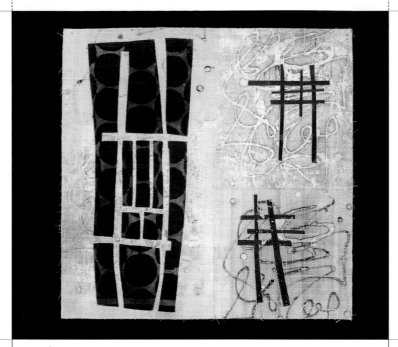

0799 | Catherine Kleeman, USA

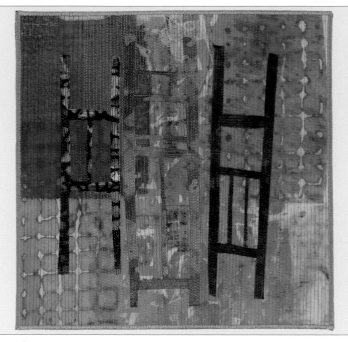

0800 | Catherine Kleeman, USA

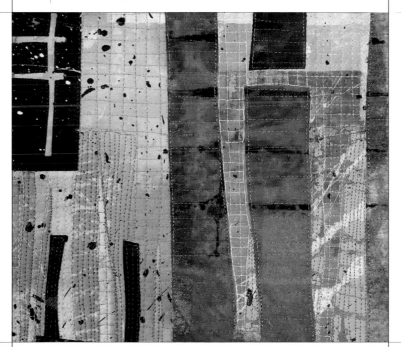

0801 | Catherine Kleeman, USA

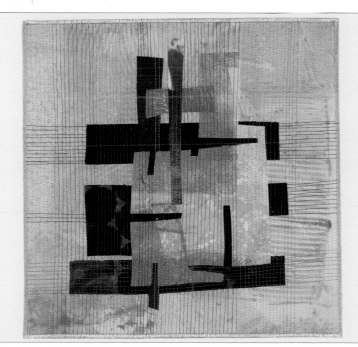

0802 | Catherine Kleeman, USA

0803 | Catherine Kleeman, USA

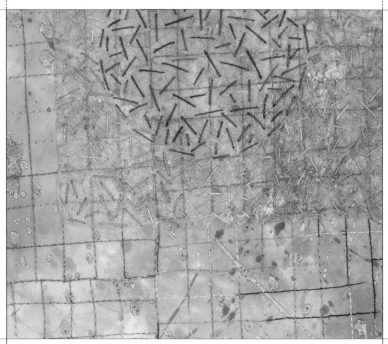

0804 | Catherine Kleeman, USA

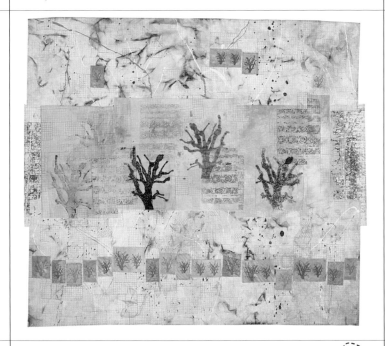

0805 | Catherine Kleeman, USA

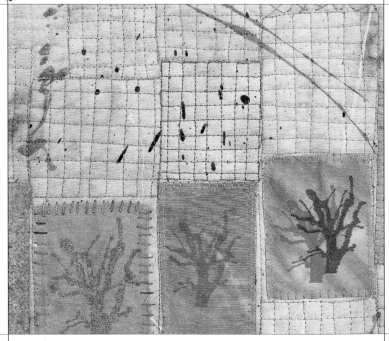

0806 | Catherine Kleeman, USA

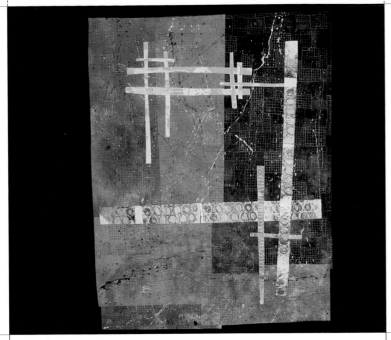

0807 | Catherine Kleeman, USA

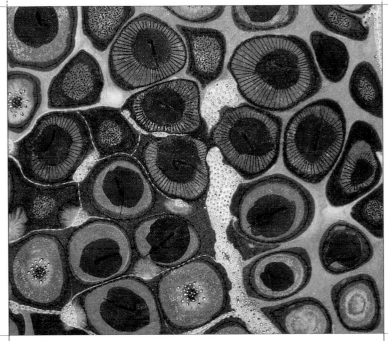

0808 | Marilyn Gillis, USA

0809 | Nysha Nelson, USA

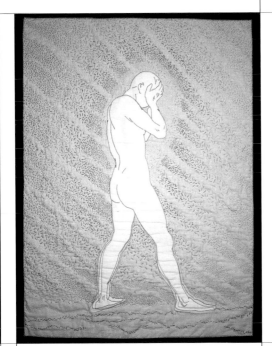

0810 | Nysha Nelson, USA

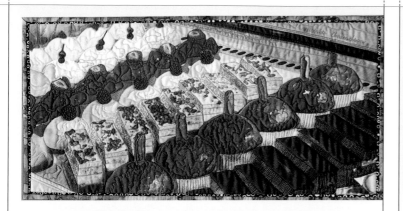

0811 | Marta Amundson, USA

0812 | Marta Amundson, USA

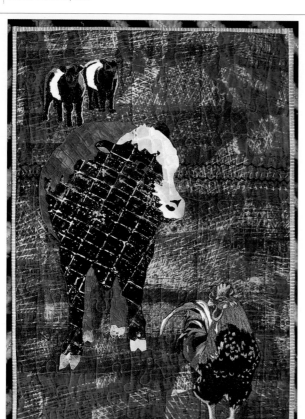

0813 | Marta Amundson, USA

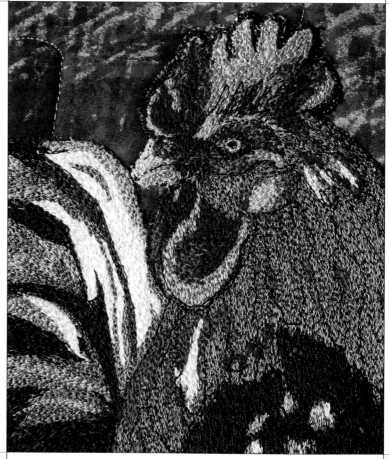

0814 | Marta Amundson, USA

0815 | Marta Amundson, USA

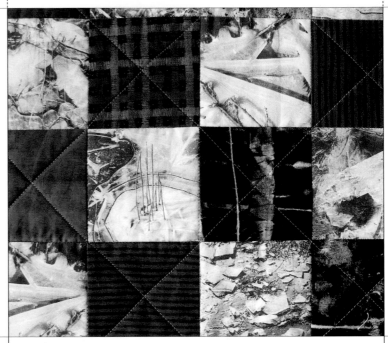

♀0816 | Marta Amundson, USA

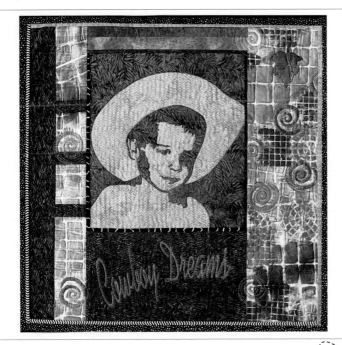

0817 | Marta Amundson, USA

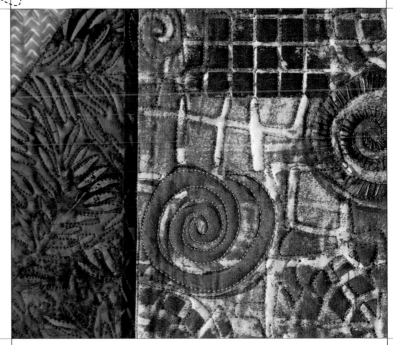

♀0818 | Marta Amundson, USA

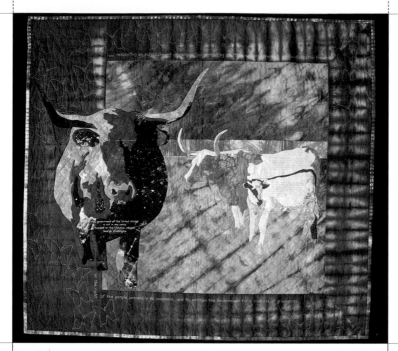

0819 | Marta Amundson, USA

0820 | Valerie P. Stiles, USA

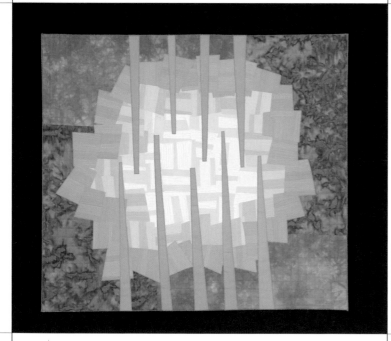

0821 | Carol Ann Waugh, USA

0822 | Marian Zielinski, USA

PHOTO BY MARSHA WARD

0823 | Meena Schaldenbrand, USA

0824 | Meena Schaldenbrand, USA

0825 | Meena Schaldenbrand, USA

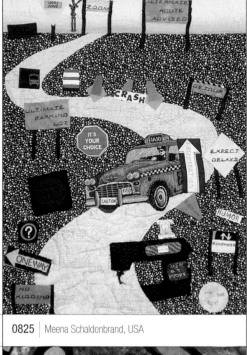

0826 | Betty Busby, USA

0827 | Betty Busby, USA

0828 | Betty Busby, USA

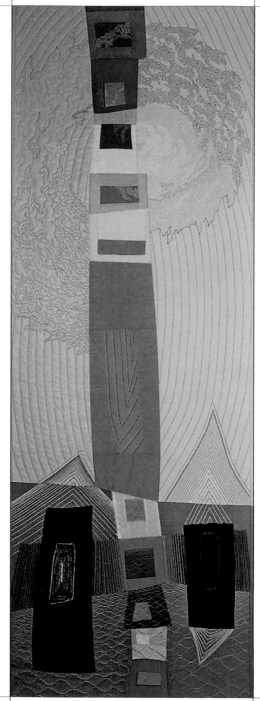

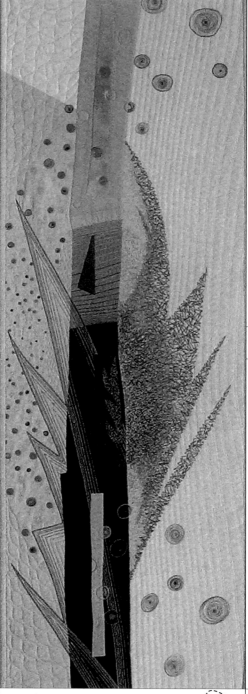

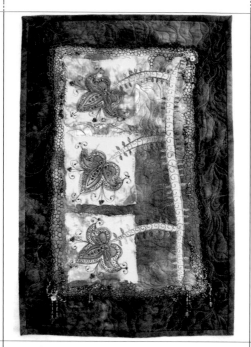

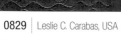

0833 | Leslie C. Carabas, USA

0834 | Carol Ann Waugh, USA

PHOTO BY KEN SANVILLE

0835 | Carol Ann Waugh, USA

PHOTO BY KEN SANVILLE

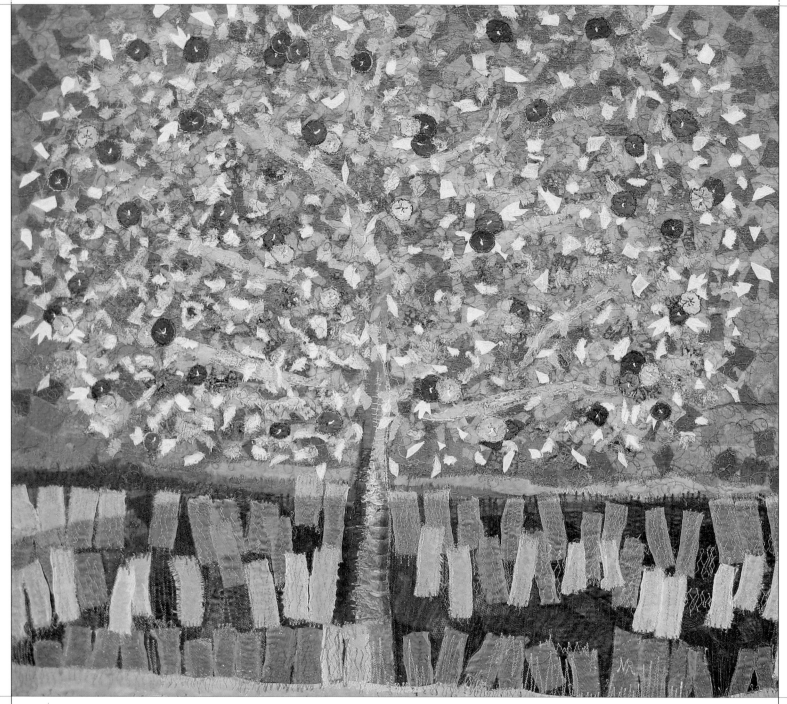

0836 | Naomi Renouf, UK

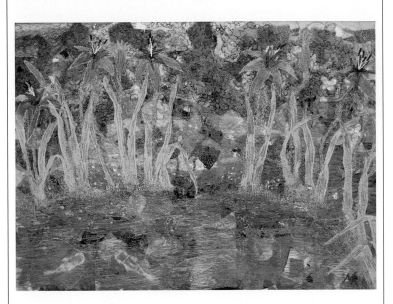

0837 | Naomi Renouf, UK

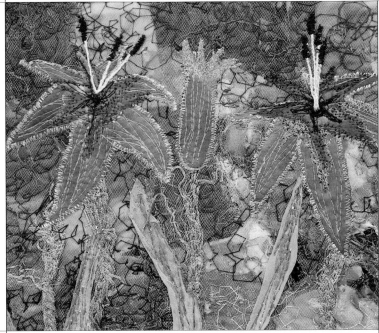

0838 | Naomi Renouf, UK

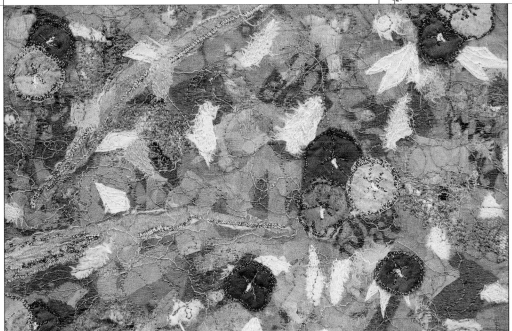

0839 | Naomi Renouf, UK

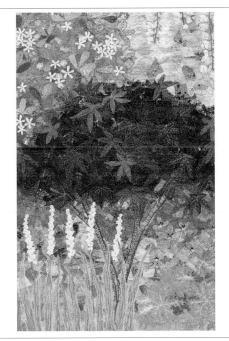

0840 | Naomi Renouf, UK

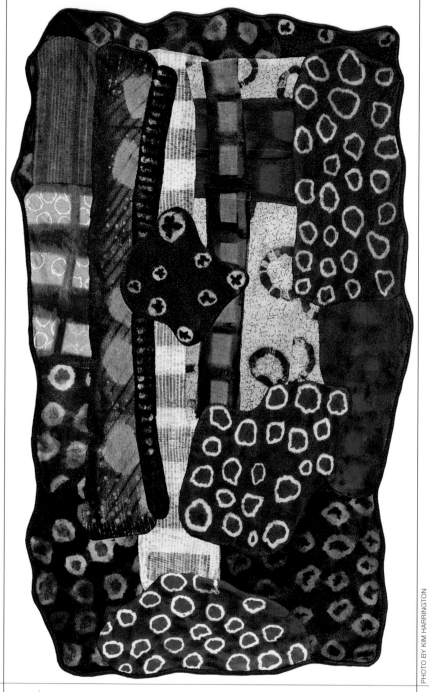

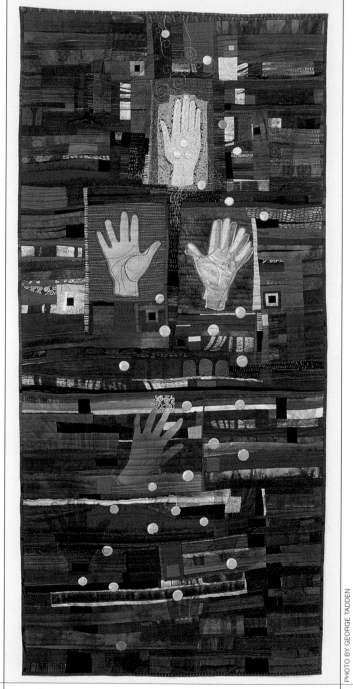

0841 | Bonnie Wells, Material Grace, USA

0842 | Rosalie Dace, South Africa

0843 | Rosalie Dace, South Africa

0844 | Sharron Shalekoff, Australia

0845 | Sharron Shalekoff, Australia

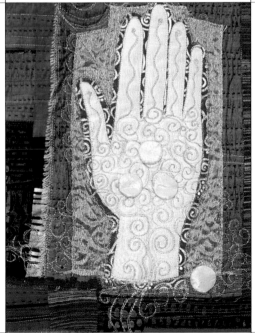

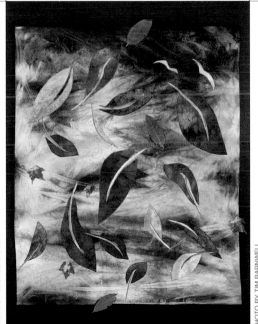

0846 | Rosalie Dace, South Africa

0847 | Norma Bradley, USA

0848 | Norma Bradley, USA

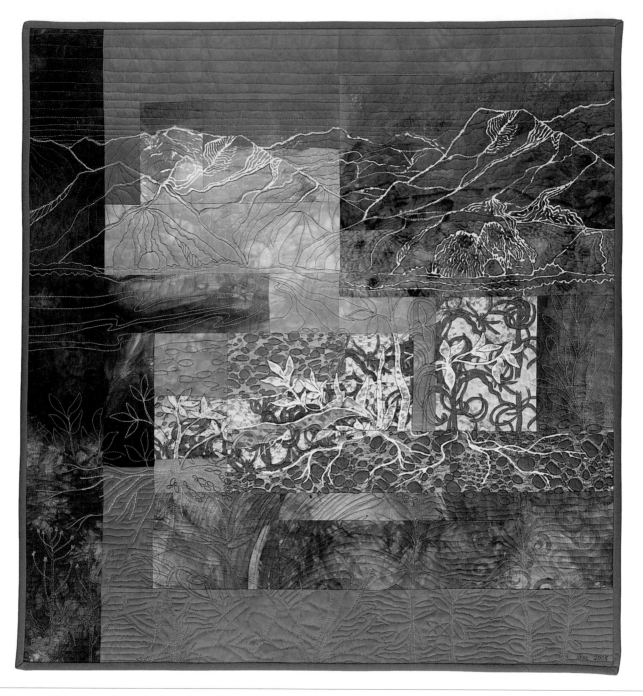

0849 | Ree Nancarrow, USA

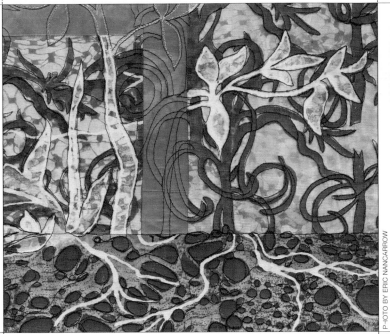

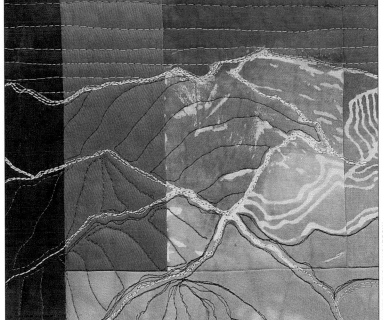

0850 | Ree Nancarrow, USA

0851 | Ree Nancarrow, USA

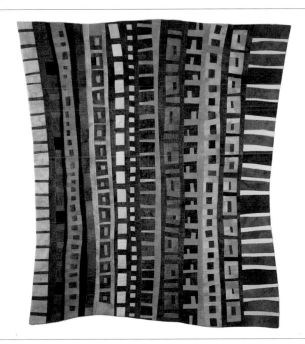

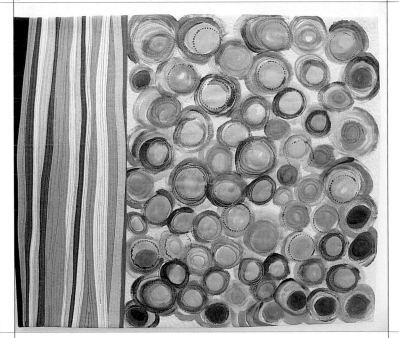

0852 | Brenda Gael Smith, Australia

0853 | Brenda Gael Smith, Australia

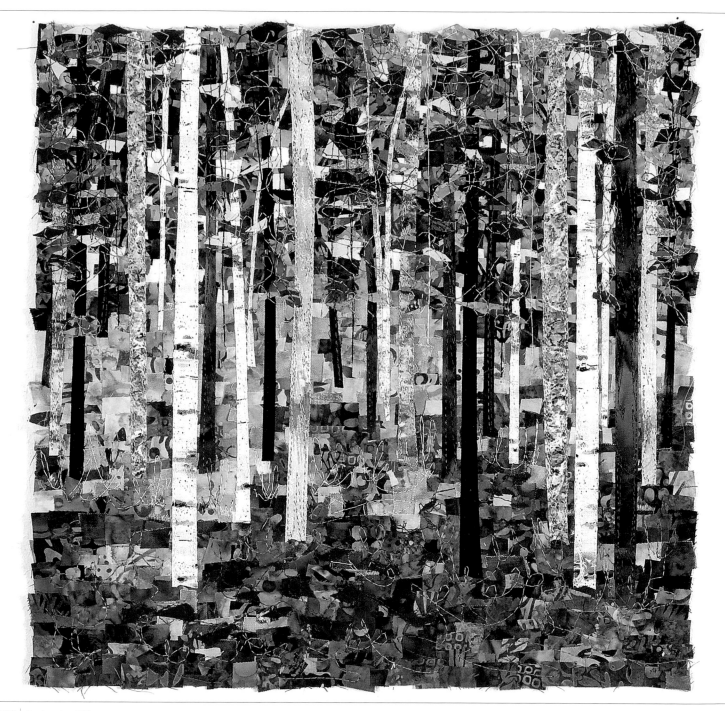

0854 | Ann Loveless, USA

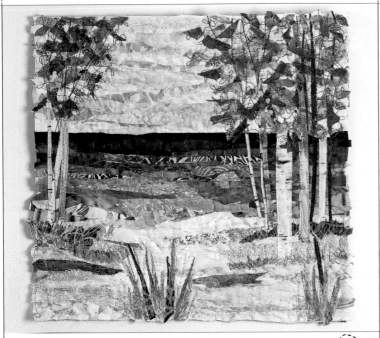

0855 | Ann Loveless, USA

0856 | Ann Loveless, USA

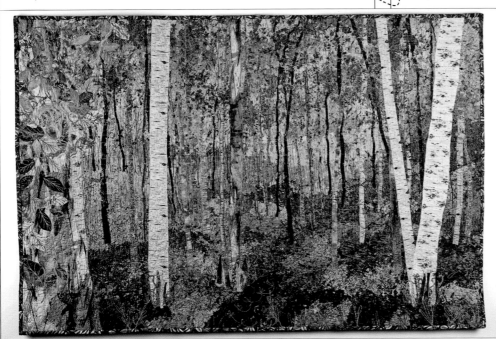

0857 | Ann Loveless, USA

0858 | Ann Loveless, USA

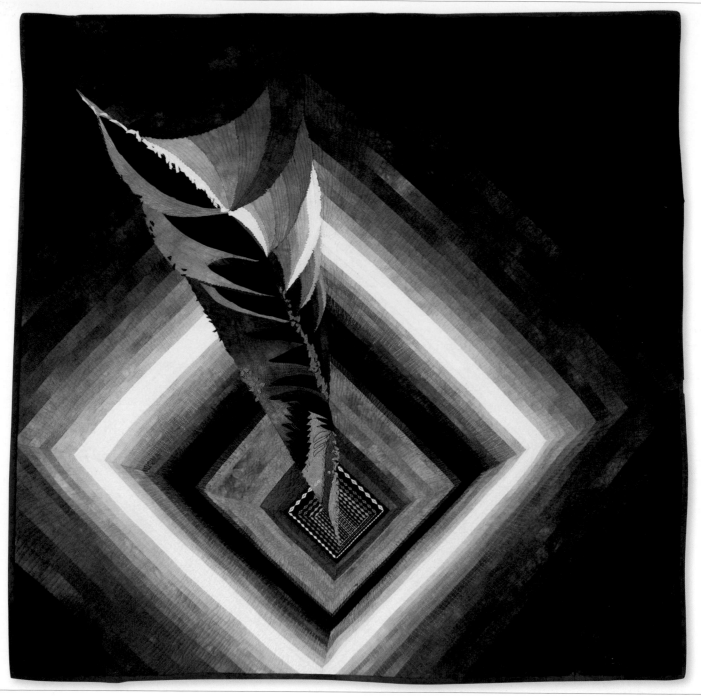

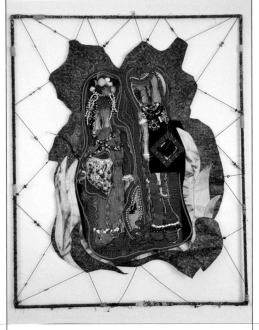

0860 | Helga Beaumont, South Africa

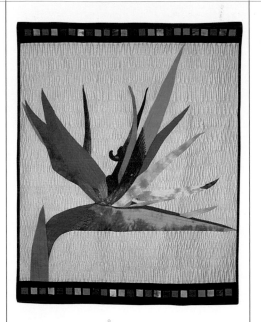

0861 | Jette Ford, Australia

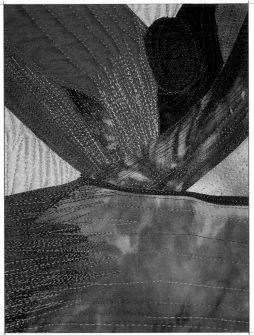

0862 | Jette Ford, Australia

0863 | Jette Ford, Australia

0864 | Jette Ford, Australia

0865 | Betsy Cannon, USA

0866 | Betsy Cannon, USA

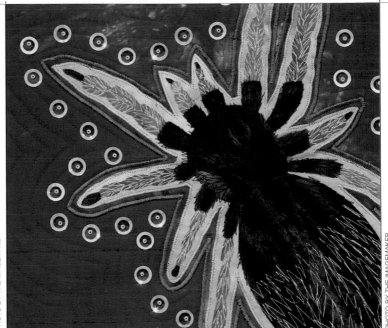

♀0867 | Betsy Cannon, USA

0868 | Betsy Cannon, USA

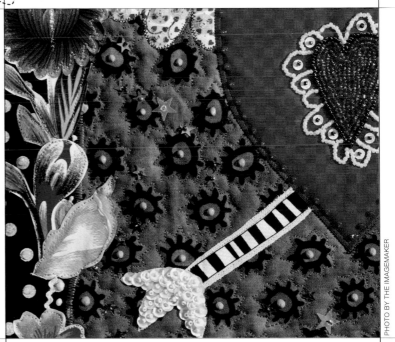

♀0869 | Betsy Cannon, USA

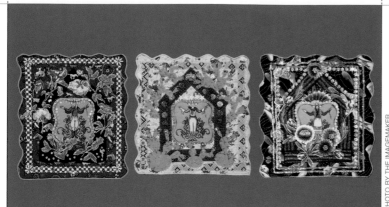

0870 | Betsy Cannon, USA

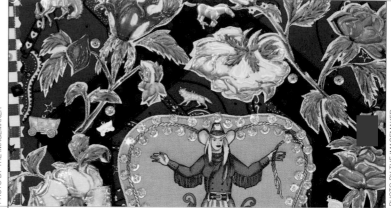

0871 | Betsy Cannon, USA

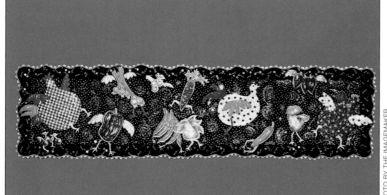

0872 | Betsy Cannon, USA

0873 | Betsy Cannon, USA

0874 | Betsy Cannon, USA

0875 | Betsy Cannon, USA

0876 | Lynn Krawczyk, USA

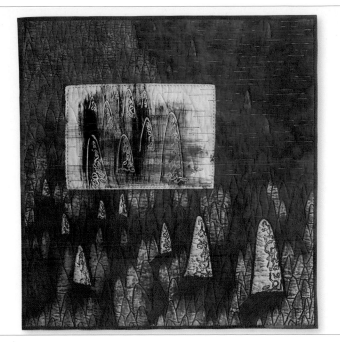

0877 | Sue Dennis, Australia

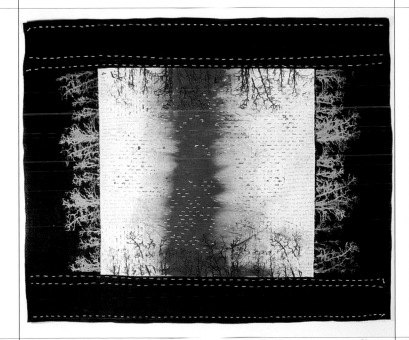

0878 | Lynn Krawczyk, USA

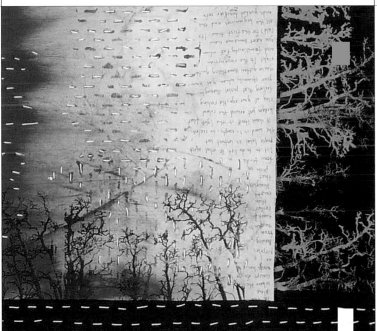

0879 | Lynn Krawczyk, USA

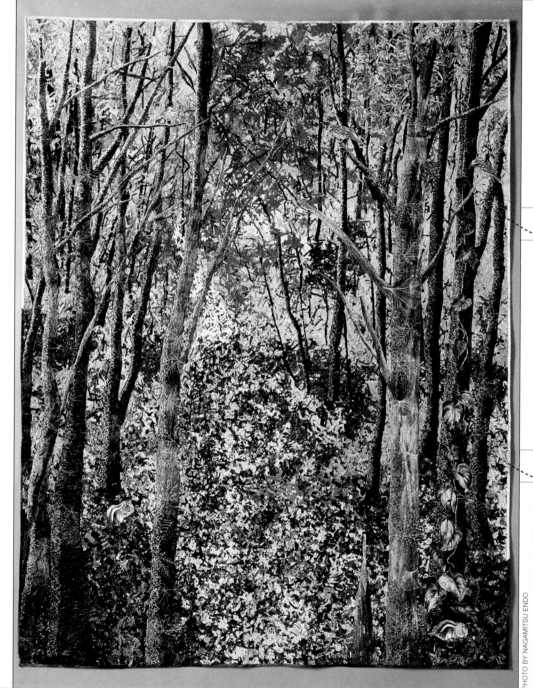

0880 | Noriko Endo, Japan

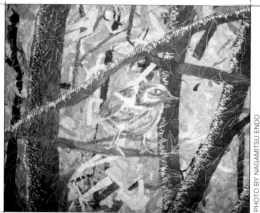

0881 | Noriko Endo, Japan

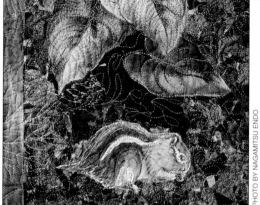

0882 | Noriko Endo, Japan

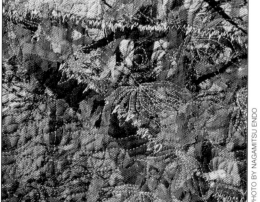

0883 | Noriko Endo, Japan

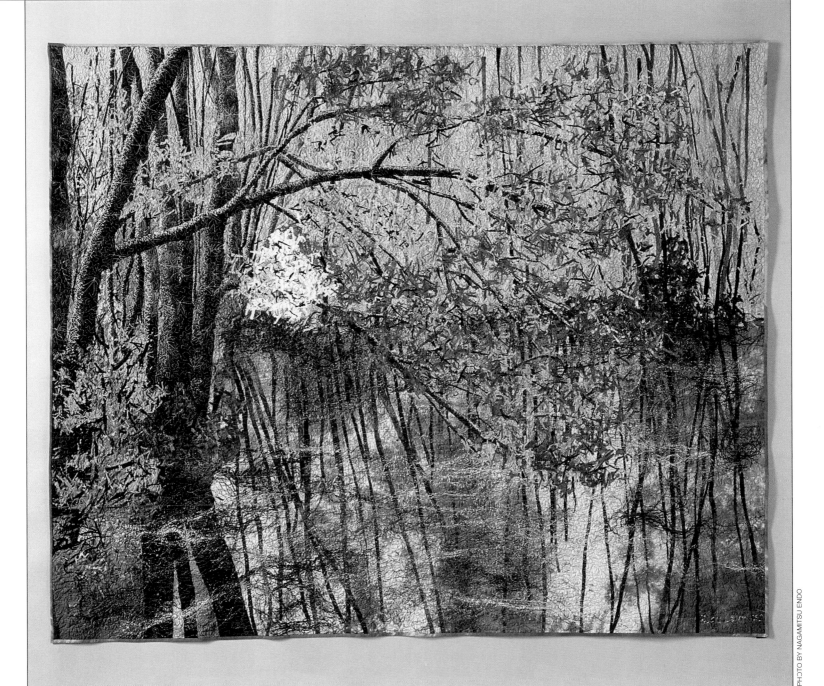

0884 | Noriko Endo, Japan

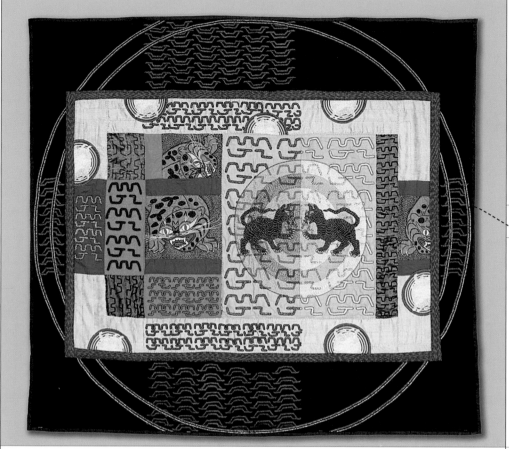

0886 | Ann Baddeley Keister, USA

0885 | Ann Baddeley Keister, USA

0887 | Ann Baddeley Keister, USA

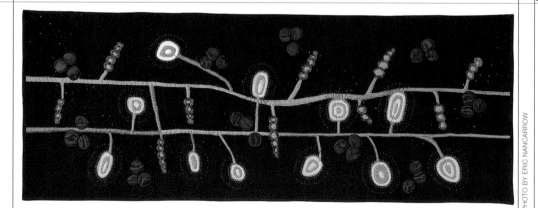

0888 | Charlotte Bird, USA

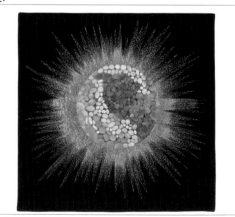

0889 | Charlotte Bird, USA

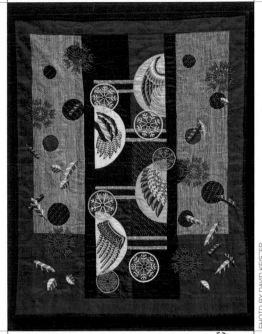

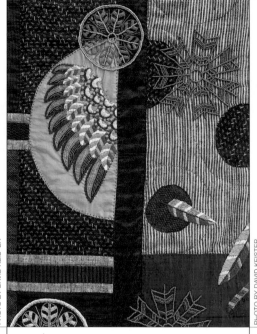

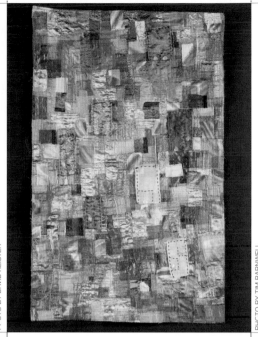

| 0890 | Ann Baddeley Keister, USA | 0891 | Ann Baddeley Keister, USA | 0892 | Norma Bradley, USA |

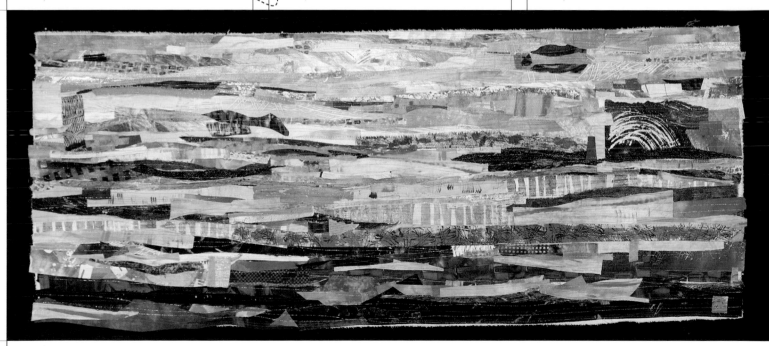

0893 | Deborah Fell, USA

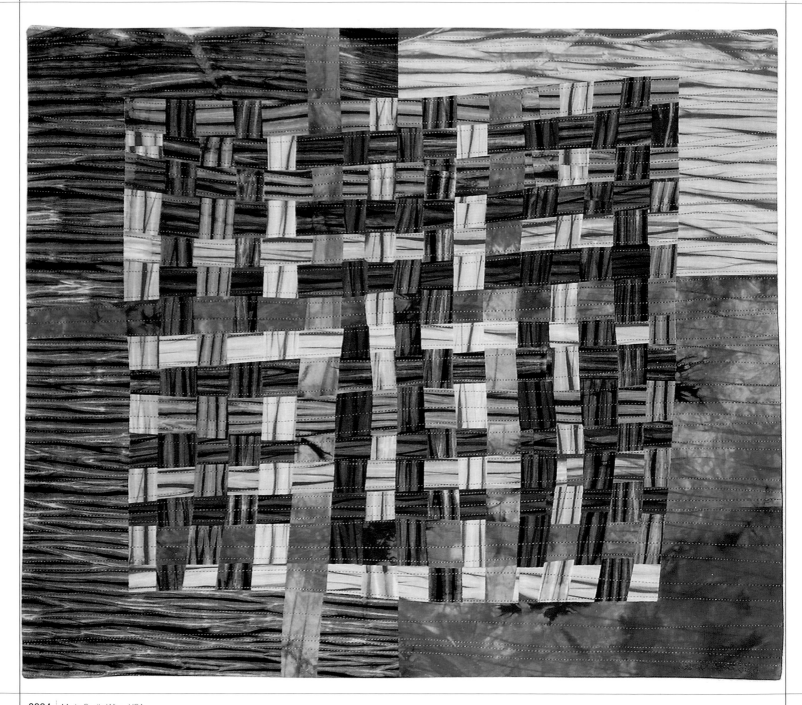

0894 | Marie Castle Wing, USA

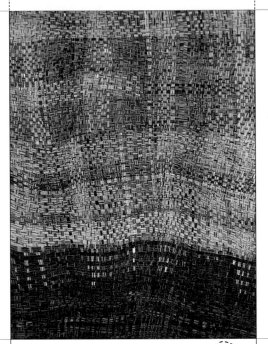

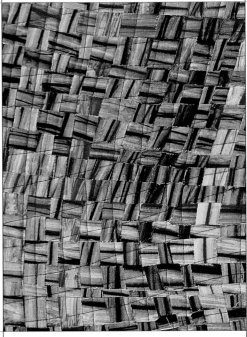

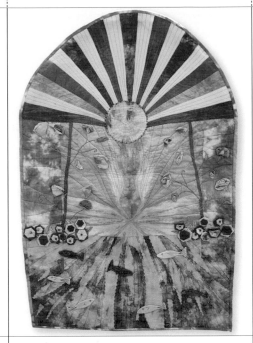

0895 | Marie Castle Wing, USA

0896 | Marie Castle Wing, USA

0897 | Natalie Isvarin-Love, USA

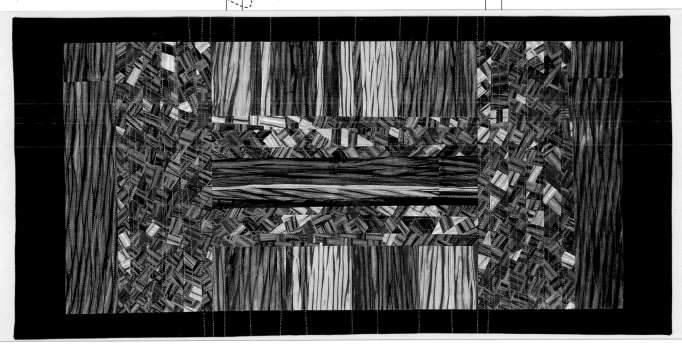

0898 | Marie Castle Wing, USA

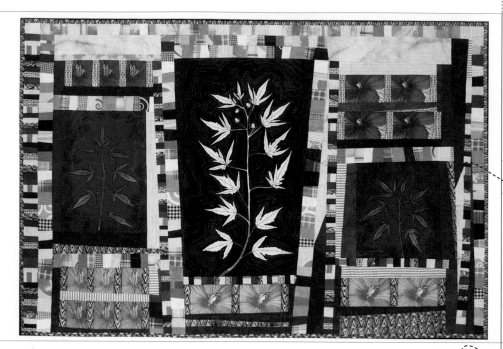

0900 | Sue Reno, USA

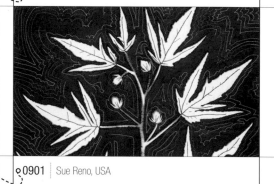

0899 | Sue Reno, USA

0901 | Sue Reno, USA

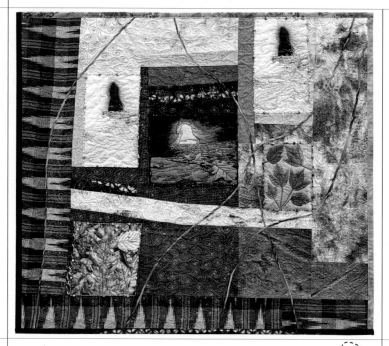

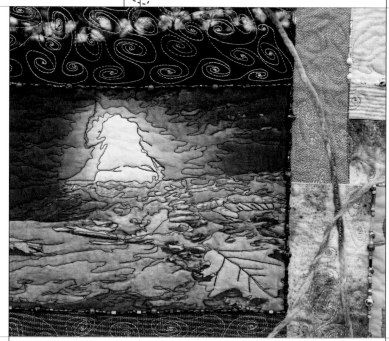

0902 | Sue Reno, USA

0903 | Sue Reno, USA

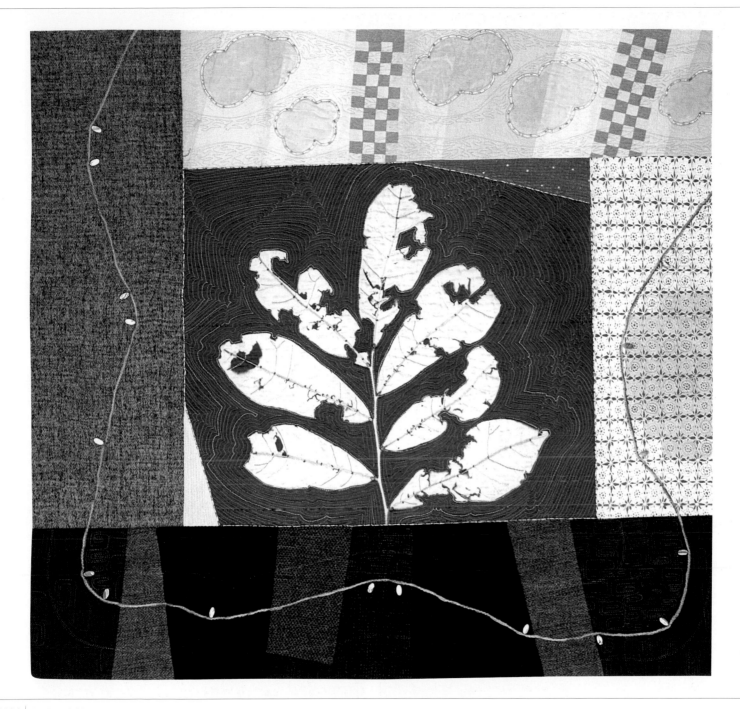

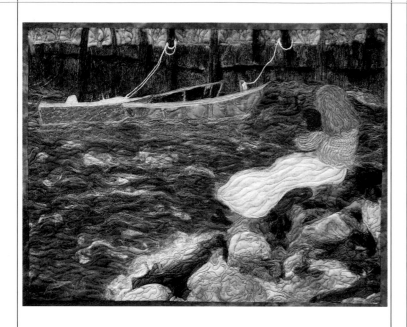

0905 | Shelley Brucar, USA

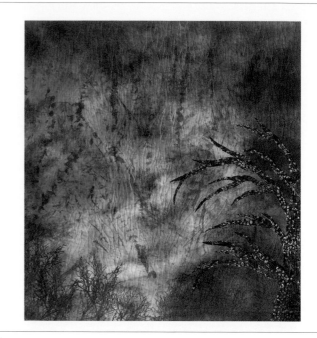

0906 | Shelley Brucar, USA

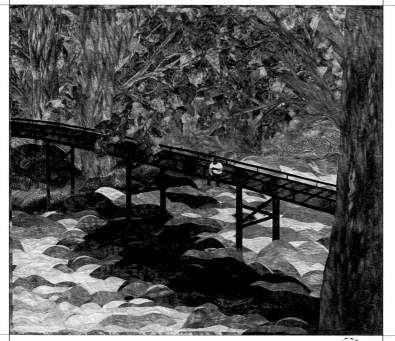

0907 | Shelley Brucar, USA

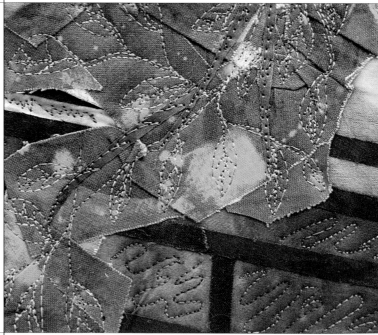

0908 | Shelley Brucar, USA

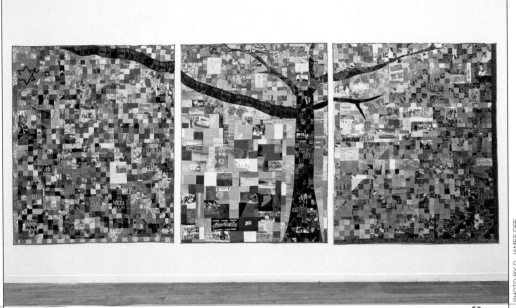

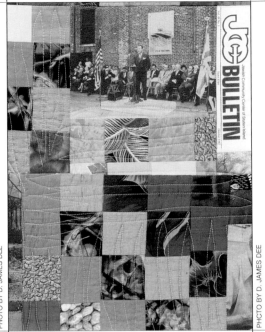

0909 | Adrienne Yorinks, USA

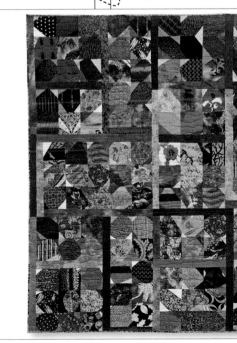

0910 | Adrienne Yorinks, USA

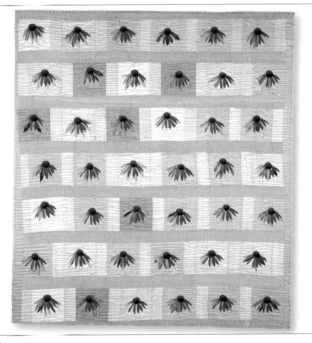

0911 | Adrienne Yorinks, USA

0912 | Adrienne Yorinks, USA

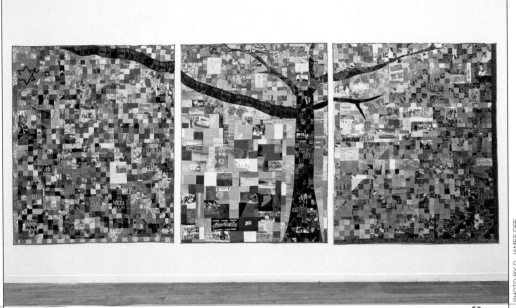

PHOTO BY D. JAMES DEE

PHOTO BY D. JAMES DEE

PHOTO BY KAREN BELL

PHOTO BY D. JAMES DEE

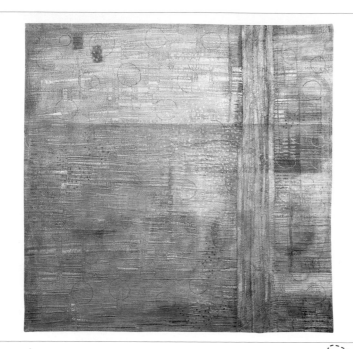

0913 | Deidre Adams, USA

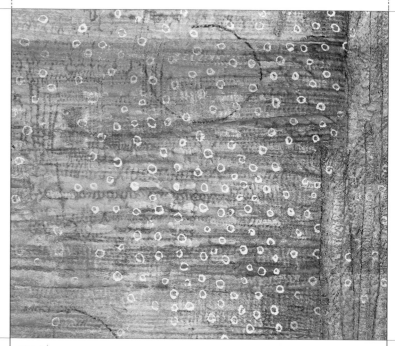

0914 | Deidre Adams, USA

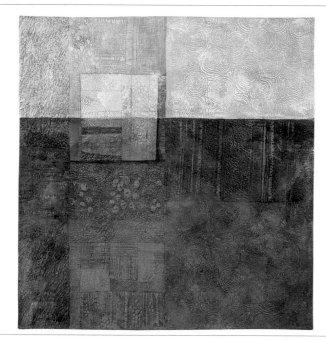

0915 | Deidre Adams, USA

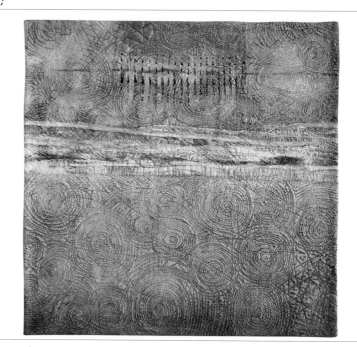

0916 | Deidre Adams, USA

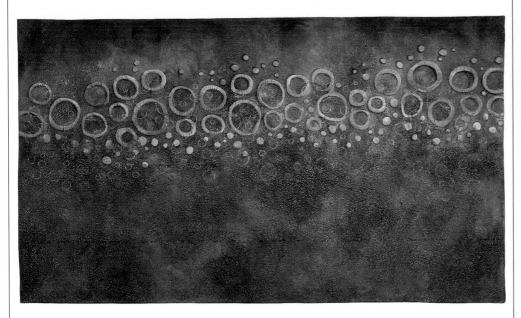

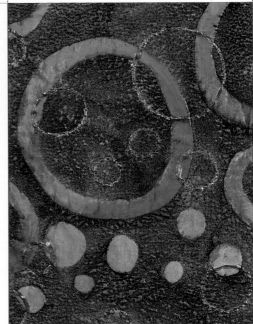

0917 | Deidre Adams, USA

○0918 | Deidre Adams, USA

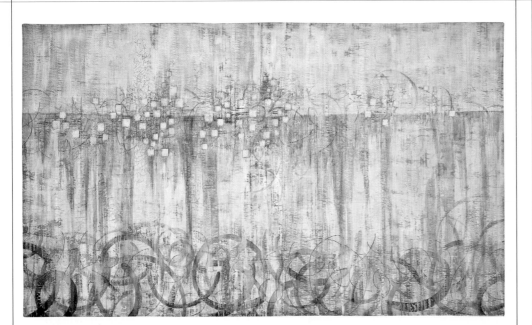

0919 | Deidre Adams, USA

○0920 | Deidre Adams, USA

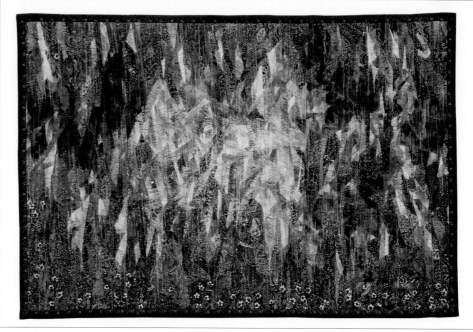

0921 | Virginia A. Spiegel, USA

0922 | Ludmila Aristova, USA

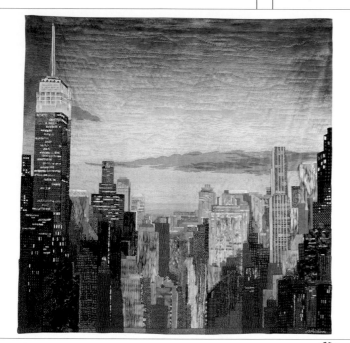

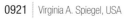

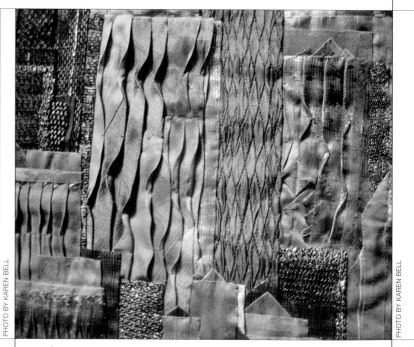

0923 | Ludmila Aristova, USA

0924 | Ludmila Aristova, USA

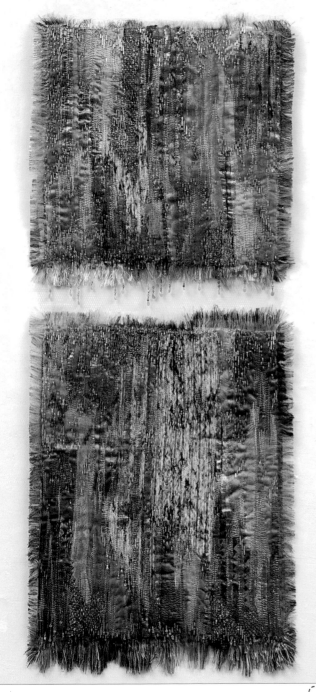

0925 | Ludmila Aristova, USA

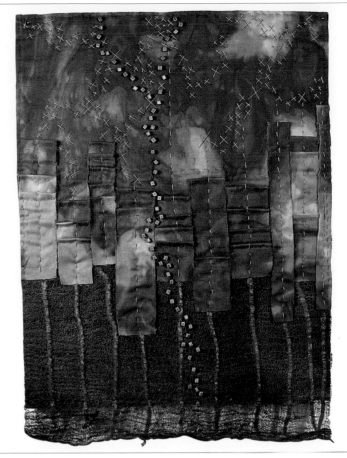

0926 | Lynn Krawczyk, USA

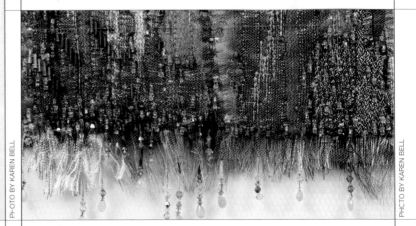

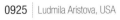

0927 | Ludmila Aristova, USA

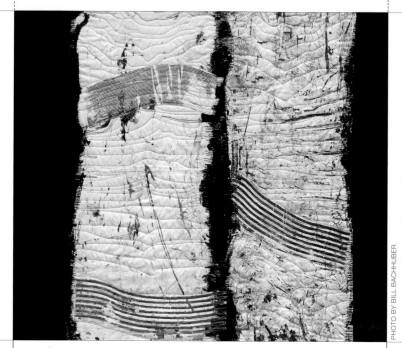

0928 | Ann Johnston, USA

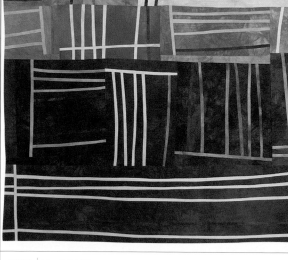

0929 | Lisa Call, USA

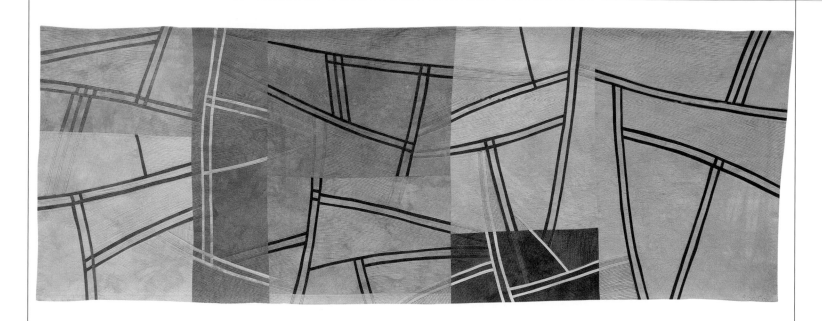

0930 | Lisa Call, USA

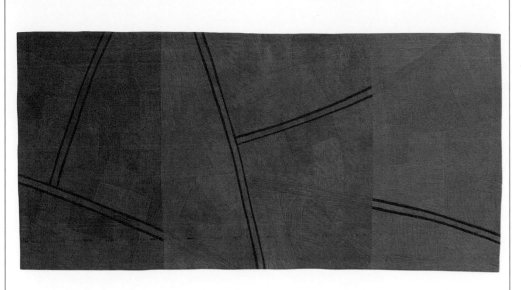

0931 | Lisa Call, USA

0932 | Lisa Call, USA

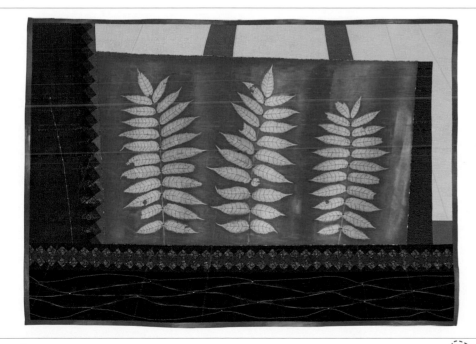

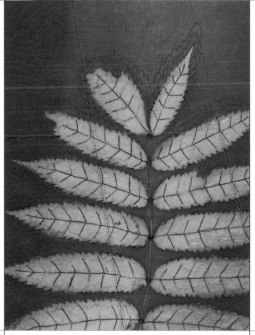

0933 | Sue Reno, USA

0934 | Sue Reno, USA

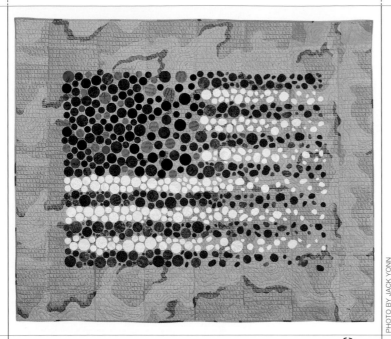

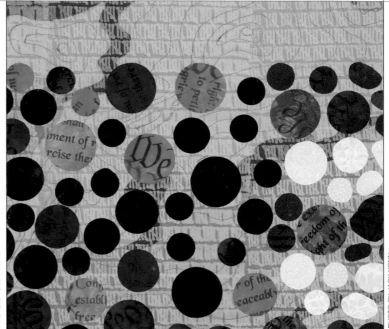

0935 | Charlotte Bird, USA

0936 | Charlotte Bird, USA

0937 | Charlotte Bird, USA

0938 | Charlotte Bird, USA

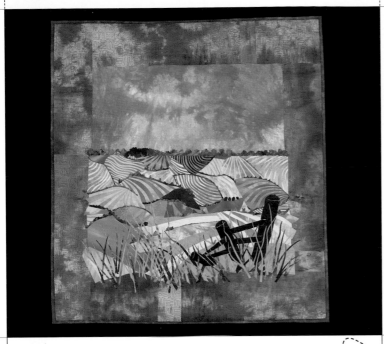

0939 | Laura Wailowski, USA

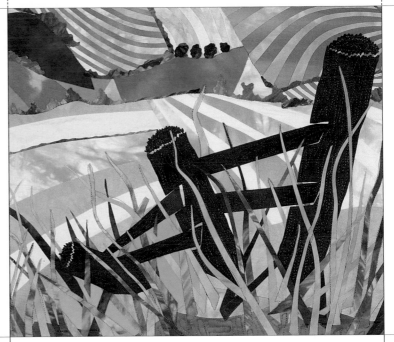

○ 0940 | Laura Wailowski, USA

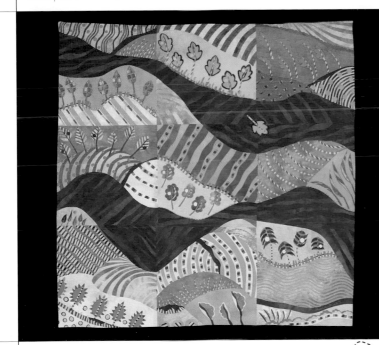

0941 | Laura Wailowski, USA

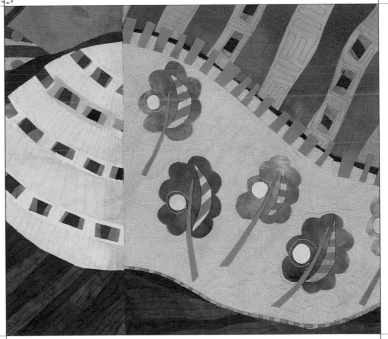

○ 0942 | Laura Wailowski, USA

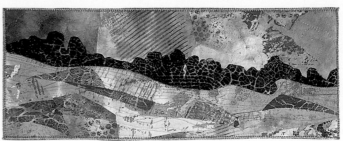

0943 | Patty Hawkins, USA

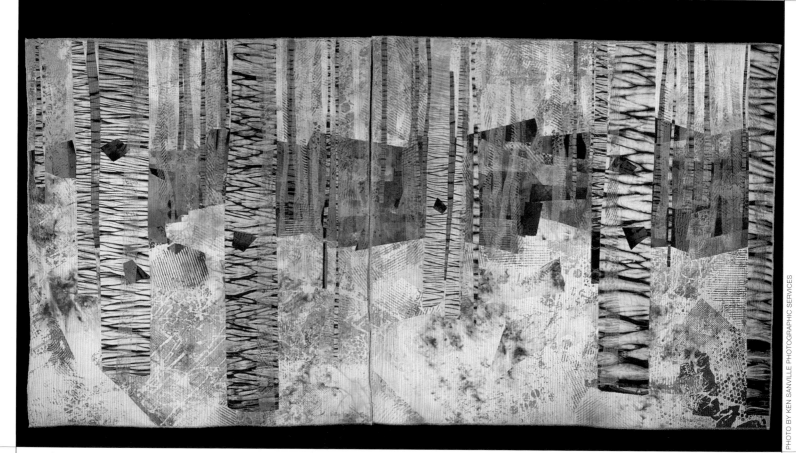

0944 | Patty Hawkins, USA

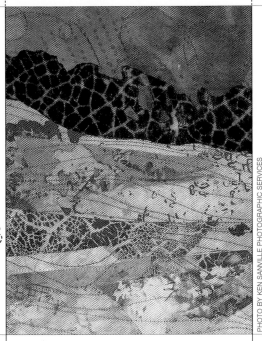

0945 | Patty Hawkins, USA

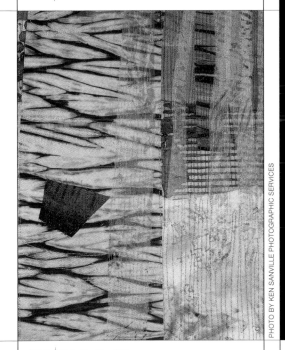

0946 | Patty Hawkins, USA

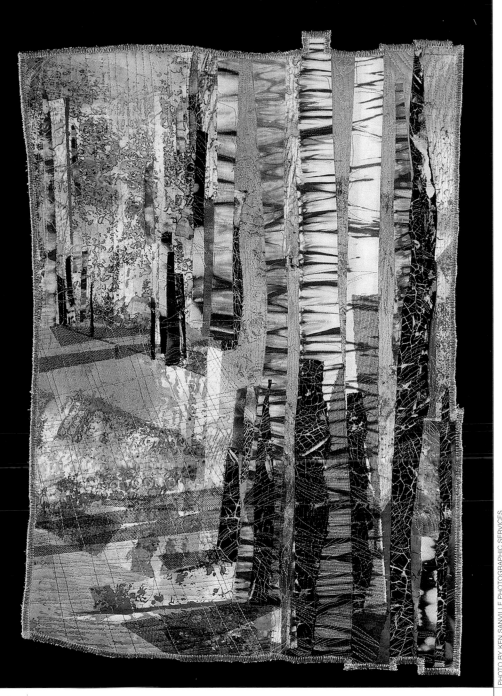

0947 | Patty Hawkins, USA

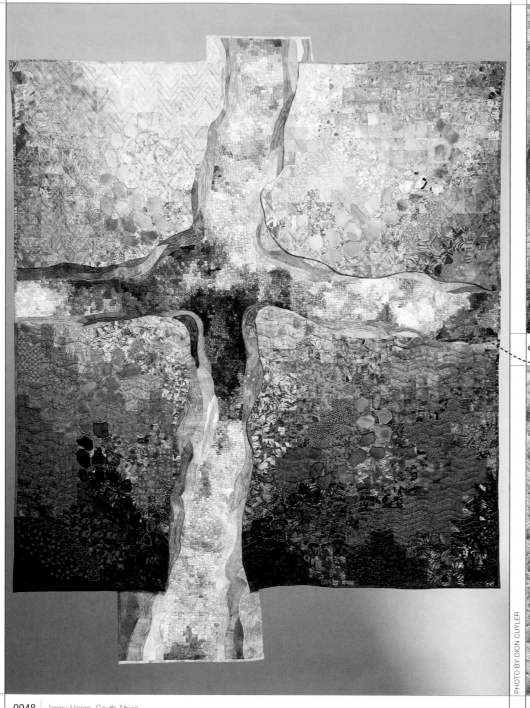

0948 | Jenny Hearn, South Africa

0949 | Jenny Hearn, South Africa

0950 | Jenny Hearn, South Africa

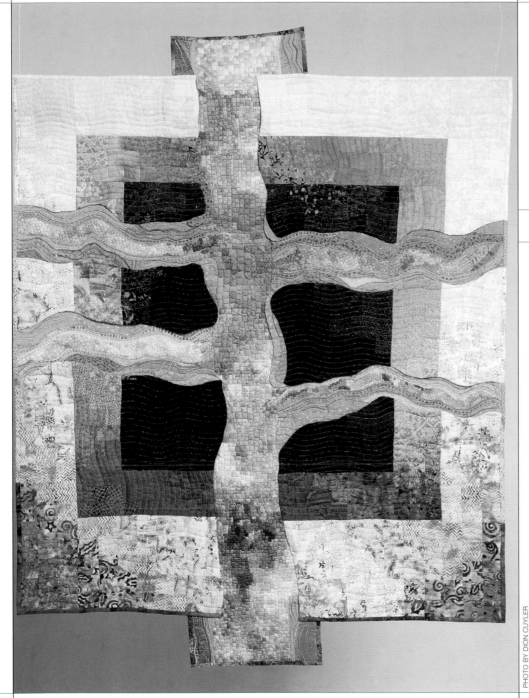

0952 | Barbara J. Schneider, USA

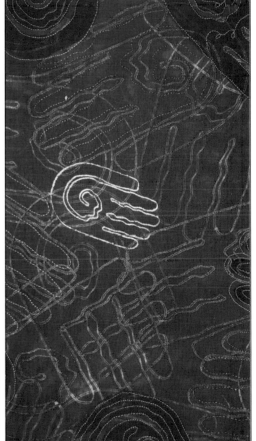

0951 | Jenny Hearn, South Africa

0953 | Barbara J. Schneider, USA

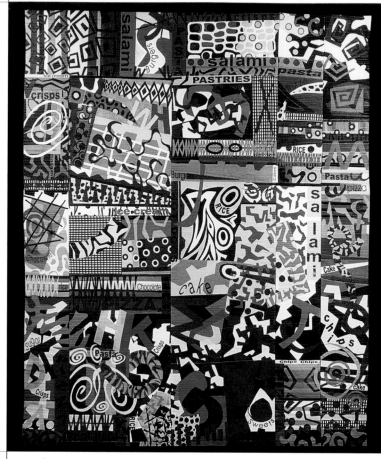

0954 | Bethan Ash, UK

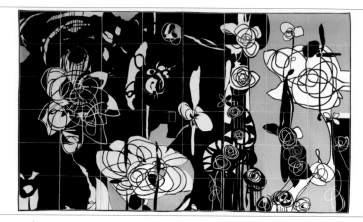

0955 | Bethan Ash, UK

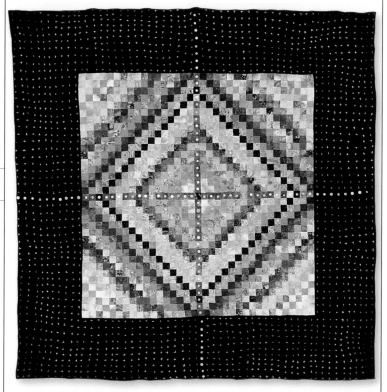

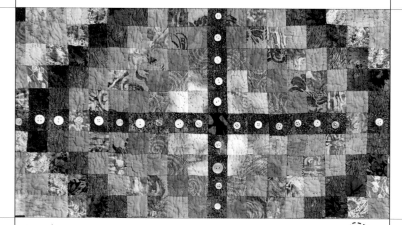

0956 | Judy Martin, Canada

0957 | Judy Martin, Canada

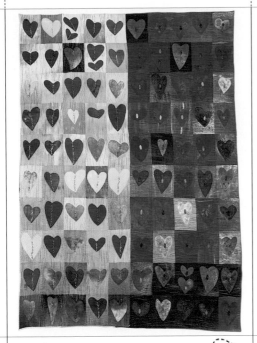

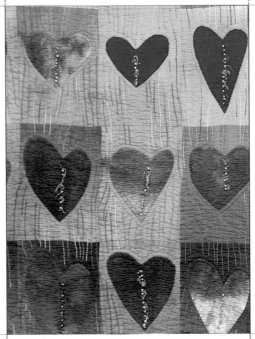

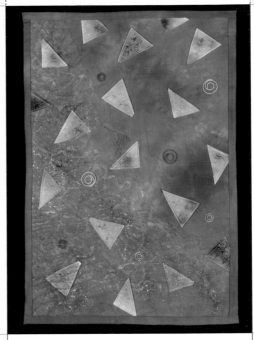

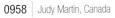

0958 | Judy Martin, Canada

0959 | Judy Martin, Canada

0960 | Tracy Borders, Squiggle Chick Designs, USA

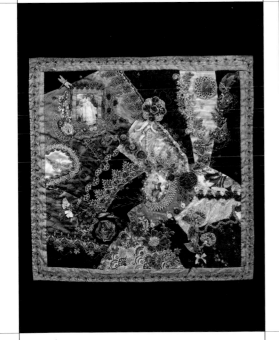

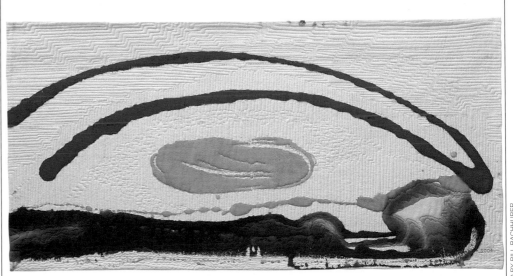

0961 | Nancy Eha, USA

0962 | Ann Johnston, USA

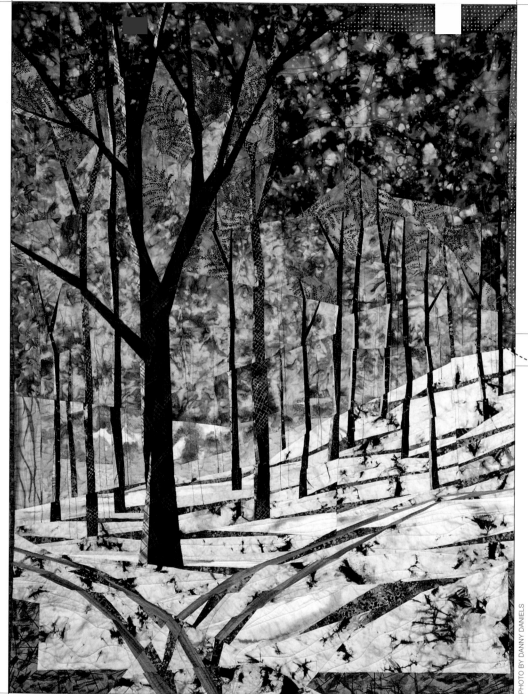

0963 | Linda Beach, USA

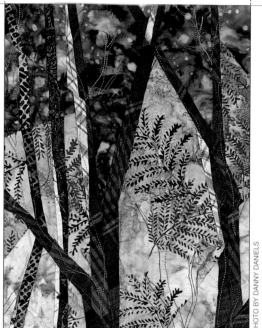

0964 | Linda Beach, USA

0965 | Linda Beach, USA

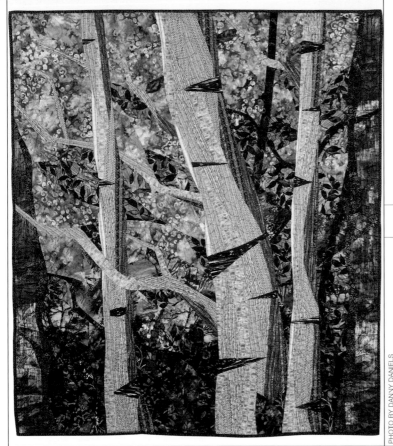

0966 | Linda Beach, USA

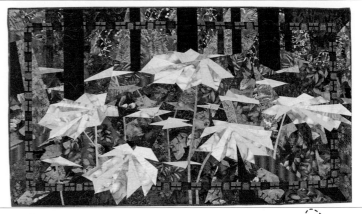

0967 | Linda Beach, USA

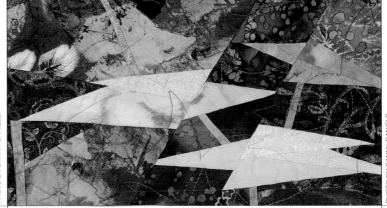

0968 | Linda Beach, USA

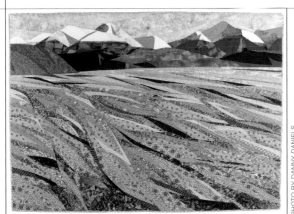

0969 | Linda Beach, USA

0970 | Linda Beach, USA

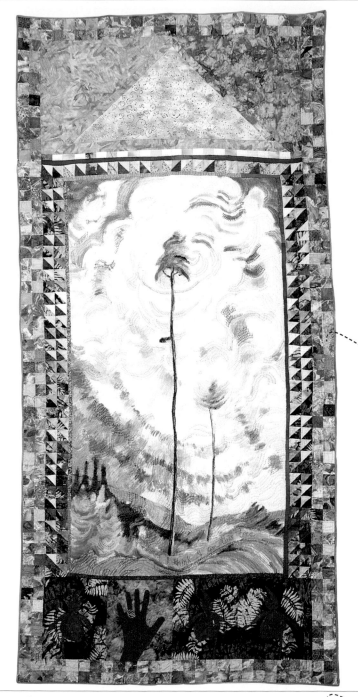

0971 | Judy Martin, Canada

0974 | Sylvia Naylor, Canada

0975 | Sylvia Naylor, Canada

0976 | Jacqueline Lams, USA

0977 | Jacqueline Lams, USA

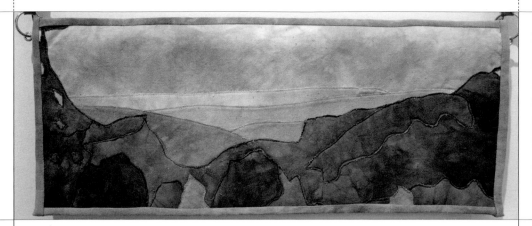

0978 | Natalie Isvarin-Love, USA

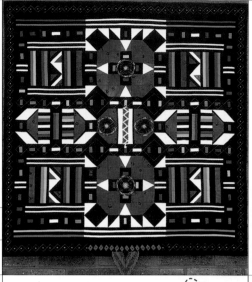

0979 | Paul Schutte, South Africa

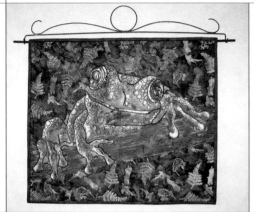

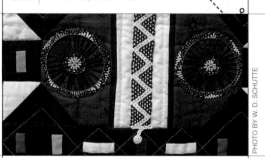

0980 | Toni Cavey, New Zealand

0981 | Toni Cavey, New Zealand

0982 | Paul Schutte, South Africa

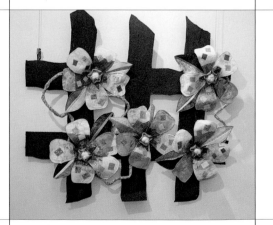

0983 | Julia Sermersheim, USA

0984 | Julia Sermersheim, USA

0985 | Sharon Markovic, USA

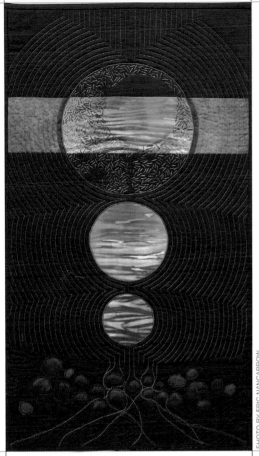

PHOTO BY ERIC NANCARROW

0986 | Charlotte Bird, USA

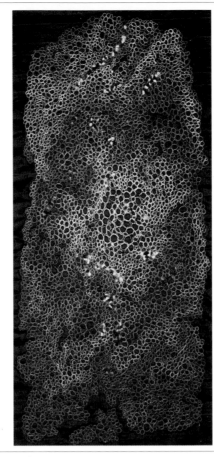

0987 | Nysha Nelson, USA

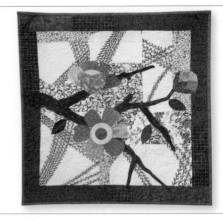

0988 | Sharon Markovic, USA

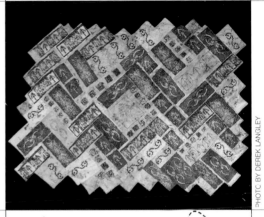

PHOTO BY DEREK LANGLEY

0989 | Jenny Langley, UK

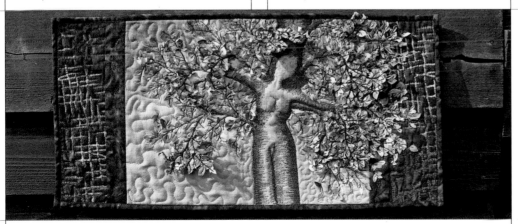

0990 | Corryna Janssen-Geers, The Netherlands

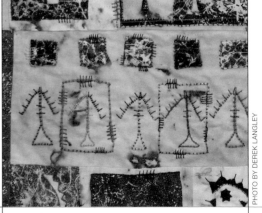

PHOTO BY DEREK LANGLEY

0991 | Jenny Langley, UK

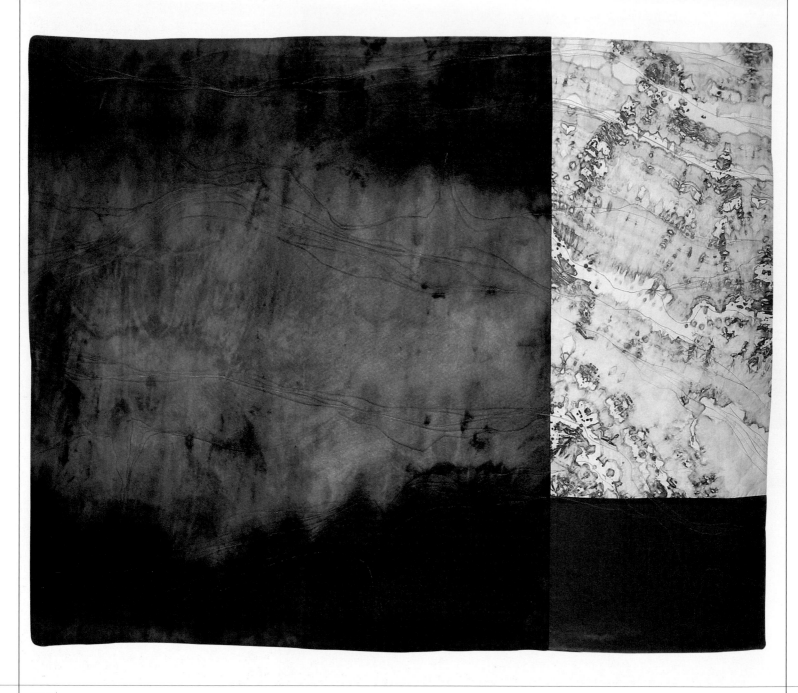

0992 | Fulvia Boriani Luciano, USA

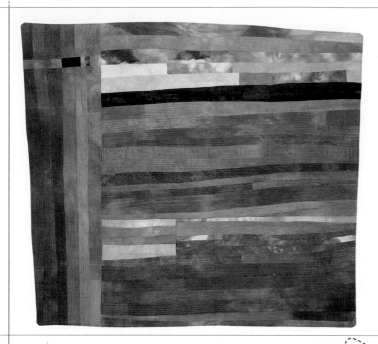

0993 | Fulvia Boriani Luciano, USA

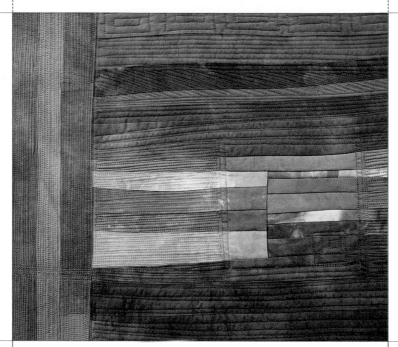

0994 | Fulvia Boriani Luciano, USA

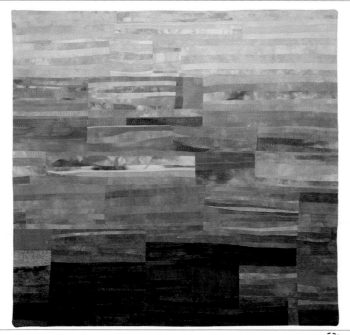

0995 | Fulvia Boriani Luciano, USA

0996 | Fulvia Boriani Luciano, USA

0997 | Fulvia Boriani Luciano, USA

0998 | Fulvia Boriani Luciano, USA

0999 | Fulvia Boriani Luciano, USA

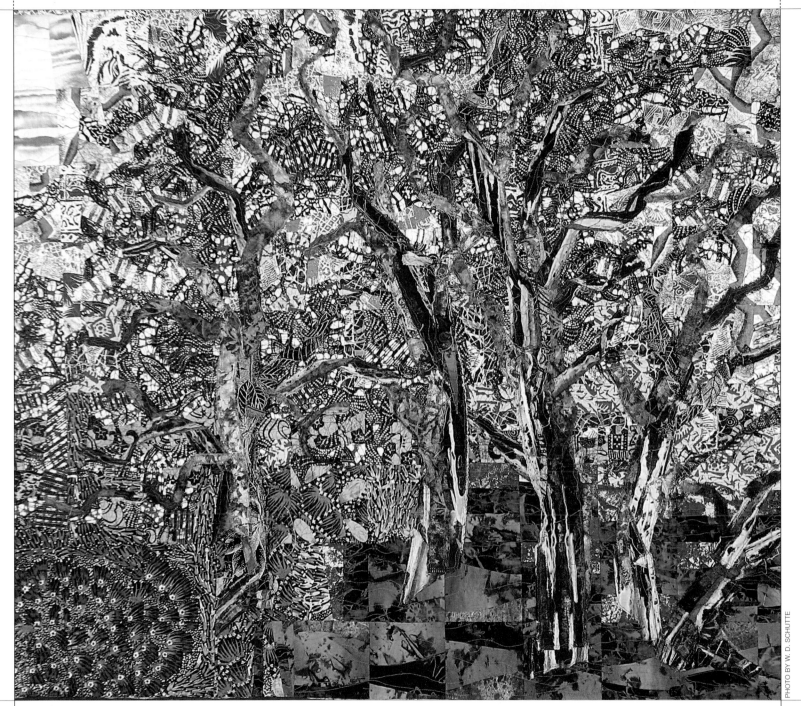

1000 | Paul Schutte, South Africa

Resources

Guilds/Organizations

AUSTRALIA

Australian Textile Arts and Surface Design Association
www.astasda.org.au

Ozquilt Network Inc.
www.ozquiltnetwork.org.au

EUROPE

craftscotland
www.craftscotland.org

Edge - Textile Artists Scotland
www.edge-textileartists-scotland.com

Embroiderers' Guild - UK
www.embroiderersguild.com

European Textile Network
www.etn-net.org

Fusion Textile Artists North East - UK
www.fusiontextileartists.co.uk

Gloucestershire Guild of Craftsmen
www.guildcrafts.org.uk

Moral Fibre
www.moralfibre.uk.com

The 62 Group of Textile Artists
www.62group.org.uk

Society of Designer Craftsmen
www.societyofdesignercraftsmen.org.uk

NORTH AMERICA

American Needlepoint Guild
www.needlepoint.org

American Sewing Guild
www.asg.org

American Tapestry Alliance
www.americantapestryalliance.org

Art Cloth Network
www.artclothnetwork.com

Baulines Craft Guild
www.baulinescraftguild.org

Brookfield Craft Center
www.brookfieldcraftcenter.org

Embroiderer's Guild of America
www.egausa.org

Fiber Arts/Mixed Media
www.fiberartsmixedmedia.ning.com

The Fiber Connection
www.thefiberconnection.com

Fiber Scene
www.fiberscene.com

Fiberarts Guild of Pittsburgh
www.fiberartspgh.org/guild/

Handweavers Guild of America, Inc.
www.weavespindye.org

Maine Fiberarts
www.mainefiberarts.org

Michigan League of Handweavers
www.mlhguild.org

Piedmont Craftsmen, Inc.
www.piedmontcraftsmen.org

Southern Highland Craft Guild
www.southernhighlandguild.org

Studio Art Quilt Associates
www.saqa.com

Studio Channel Islands Art Center
www.studiochannelislands.org

Surface Design BC
www.surfacedesignbc.org

Surface Design Organization
www.dev.surfacedesign.org

Textile Center
www.textilecentermn.org

Textile Study Group of New York
www.tsgny.org

SOUTH AFRICA

Fibre Works Art
www.fibreworksart.com

WORLD

Etsy
www.etsy.com

World Textile Art Organization
www.wta-online.org

Magazines

Belle Armoire Magazine
www.bellearmoire.com

Embroidery
http://embroidery.embroiderersguild.com

Fiberarts Magazine
www.fiberarts.com

Selvedge
www.selvedge.org

Threads
www.threadsmagazine.com

Image Directory

0001 Liz Clay Coat Fabric Produced for Stella McCartney A/W 08 Collection: traditional wet felting of merino wool using hand-rolled technique, hand-dyed with hand-cut motif, fibers carded and color-blended by artist

0002 Liz Clay Coat Fabric Produced for Stella McCartney A/W 08 Collection: traditional wet felting of merino wool using hand-rolled technique, hand-dyed with hand-cut motif, fibers carded and color-blended by artist

0003 Liz Clay Coat Fabric Produced for Stella McCartney A/W 08 Collection: traditional wet felting of merino wool using hand-rolled technique, hand-dyed with hand-cut motif, fibers carded and color-blended by artist

0004 front view of Mud Cloth Ruana

0005 Mud Cloth Ruana: hand-woven using various twill patterns and traditional mud cloth from Ghana

0006 Wrap: nuno-felted hand-dyed wool and silk

0007 Sunday at the Circus Coat: handwoven cotton houndstooth, stitched

0008 Aurora Dreaming the Sea: nuno-felted, hand-dyed silk saree mesh and merino wool

0009 Tunic: nuno-felted hand-dyed wool and silk

0010 Recycled Wedding Dress: silk dupioni dress, torn and restructured using wet and needle felting techniques, hand-dyed

0011 Floral Shirt: nuno felt of merino wool and silk, free-machine embroidery

0012 Untitled: silk dyed with cochineal, madder, onion skin, and logwood dyes, hand-knit and embroidered

0013 Untitled: silk and cotton chenille dyed with cochineal, madder, onion skin, and logwood dyes, hand-knit, mixed edging techniques

0014 SunRise / SunSet: nuno-felted, hand-dyed silk silk eyelet chiffon and merino wool

0015 another way to wear SunRise / SunSet

0016 another way to wear SunRise / SunSet

0017 Breast Fence: wool fleece, waxed linen; wet-felted, naturally dyed, hand- and machine-stitched

0018 Sundrenched: coat of handmade felt, wet-felted over a resist

0019 detail of Sundrenched

0020 Dress: hand-felted, hand-dyed merino on black cotton, felted in one piece with valances ending as "bird's tail"

0021 Dress: hand-felted, hand-dyed merio on hand-dyed silk chiffon, felted in one piece with valances standing out on both sides

0022 Keyhole Petal Dress and Pointelle Twist Fingerless Gloves: hand-loomed organic cotton and tencel, using partial kitting and manual-lifted tuck heart stitch, gloves hand-loomed of organic undyed wool using manual stitch transfer

0023 Draped Petal Cape: hand-loomed tencel and silk, partial knitted pleats, manual stitch transfer to create pointelle cable twist detail and cape edge trim

0024 Lichen Angels Yellow Loungewear: knitted silk and elastic, wracking

0025 Lichen Angels Nipple Shrug: 3D knitting technique

0026 Lichen Angels Blue Loungewear: knitted silk and elastic

0027 detail of Lichen Angels Blue Loungewear

0028 Jacket

0029 Shawl: wet felting

0030 Bender's PLUS Promotion Bag: reimagined and recycled plastic grocery bag, digital transfer print, appliqué, various materials

0031 back view of Bender's PLUS Promotion Bag

0032 Jacket: heat-fused plastic shopping bags

0033 Marmaid: crocheted and hand-stripped fabrics

0034 Patch-Work Sea-Blue Coat: wet felting, stitching, merino wool on cotton fabric, crochet work, sliced rolls of wool, uncombed wool, silk fiber

0035 Wind of Change, Story-telling Cape: wool felt with touch of hand-spun silk, mohair, corn fibers, cotton, beads

0036 Long Tunic: nuno-felted hand-dyed wool and silk

0037 Indigo Waistcoat: nuno-felted wool, silk fibers, texures silk and velvet, Indigo-dyeing, hand-stitching with silk threads and ribbons

0038 detail of Indigo Waistcoat

0039 Botanica: nuno felt of merino wool and silk

0040 The Countess Travels from St. Petersburg to Moscow: hand-dyed merino wool, prefelted wool shapes, yarn and silk fabric embellishments, needle-felted surface details

0041 back view of The Countess Travels from St. Petersburg to Moscow

0042 Autumn Wrap: hand-dyed merino and silk, yarn, silk chiffon

0043 Colors' Circular Dance: nuno felt of merino wool and silk

0044 Fiores del Sol Story Shawl: nuno felt of merino wool and silk

0045 Old Flame, New Flame II: nuno-felted, hand-dyed silk saree mesh and merino wool

0046 Nuno Felt Dress: wet-felted layered felt and fibers, rust dyed

0047 Gold Grains Wrap: nuno-felted wool and silk fibers in silk fabric

0048 Lascaux Wrap: nuno-felted wool and silk fibers in silk fabric

0049 Seamless Three-Quarter Top: nuno-felted, hand-dyed merino wool and China silk felted together on a resist, knitted lower sleeves, hand beading

0050 Deconstructed Wrap with Necklace: hand-dyed, wet-felted merino wool and silk organza, deconstructed and remade adding brown leather and silk

0051 Gosamer Spirit Coat: nuno felt of alpaca wool and silk

0052 Siberia Coat: hand-felted alpaca, moutain sheep wool, and raw wool

0053 Wrap Skirt: hand-felted merino wool, raw wool, silk, and peat fibers

0054 Windesprite Shawl: nuno felt of merino wool and silk

0055 Dress: hand-felted sand-colored merino on black silk pongé, felted in one piece with valances standing out on left side

0056 Zebra Wrap: nuno-felted wool and silk fibers in silk fabric

0057 Dark Wing Wrap: organza, gel medium, powdered mica pigments

0058 Costume: hand-felted and sculpted merino wool, hand-dyed, mounted on shibori-bleached denim

0059 Tsunami Warning: arashi shibori

0060 Tsunami Recovery: arashi shibori

0061 detail of Tsunami Recovery

0062 Shrink Wrapped: plastic wrap and soda can tabs, heat-fused, pleated and stitched

0063 back view of Shrink Wrapped

0064 Dress: hand-felted white merino on silk georgette, felted in one piece with valances ending up as the train

0065 detail of Dress

0066 Song of Willows: hand-woven natural-dyed silk shawl, network-drafted turned twill

0067 Shawl: nuno-felted merino wool, repurposed cardigan, shirt, jacket, basinet cover, and mesh top, free machine embroidery

0068 back view of Shawl

0069 Scarf: nuno felting

0070 Untitled: nuno-felted merino wool, silk, silk gauze

0071 Top and Bolero Jacket: nuno felting with sheep's wool, mohair, and silk

0072 Bolero Jacket: wet felting with sheep's wool, mohair, and silk

0073 Last Tango: nuno-felted, commercially dyed silver mesh and merino wool

0074 Mid-Length Vest: nuno-felted hand-dyed wool and silk

0075 detail of Mid-Length Vest

0076 Windowpane Scarf: nuno-felted hand-dyed wool and silk

0077 Untitled: hand-knitted commercial silk, hand beading

0078 Dots and Spots, half-scale gown: collaged fabrics, embroidered organza overskirt, mobile dot appliqué

0079 Holy Moly Skirt: hand-rolled nuno felt combining merino wool fiber and scraps of salvaged cotton, silk, and polyester fabrics

0080 detail of Holy Moly Skirt

0081 Kyoto: kimono of silk satin, silk chiffon, felted with merino wool, silk and flax fibers

0082 Shoulder Wrap: hand-folled felt collage combining woven silk and cotton fabrics with silk and wool fibers

0083 detail of Shoulder Wrap

0084 detail of Kyoto

0085 Seamless Shell: nuno-felted seamless shell of hand-dyed merino wool and silk felted together on a resist, hand-rolled neck and arms

0086 Turquoise Dream Coat: nuno felt of merino wool and silk

0087 Gossamer Spirit Coat in Greens: nuno felt of merino wool and silk

0088 Shawl: nuno-felting with sheep's wool, mohair and silk

0089 Woodland Elf Poncho: wet felting, stitching, merino wool on cotton fabric, crochet work, uncombed wool, flax fiber

0090 detail of Woodland Elf Poncho

0091 Forest Floor: assorted fibers, yarns, and fabric scraps, manipulated and embellished with free-motion embroidery

0092 detail of Forest Floor

0093 Collar: folded merino felt mounted into folded organza and organdy

0094 Top: nuno felting with sheep's wool, mohair, and silk

0095 Cherub Shawl: nuno-felted merino wool, repurposed cardigan and shirt

0096 back view of Cherub Shawl

0097 Dress: nuno-felting with sheep's wool, mohair and silk

0098 A Walk in the Forest: wearable art jacket, hand-dyed and felted Hanji papers, machine embroidery, shibori pleated paper

0099 detail of A Walk in the Forest

0100 Winter Wrap: hand-dyed merino and silk, yarn, silk chiffon

0101 My Moth for Shawl and Wall: nuno-felted hand-dyed merino wool and silk

0102 Starry, Starry Night Dancing Dress: shibori-dyed silk gauze, nuno-felted merino wool, hand-beading, glitter, Folkwear Patterns dress design

0103 Cape: hand-dyed, wet-felted silk and wool with crocheted edges

0104 Inlayed Shawl: hand-dyed, wet-felted merino wool with bamboo and silk motif

0105 Green Wrap: hand-dyed, wet-felted, merino wool and silk

0106 Look 'Round the Back, half-scale gown: collaged fabrics, hand beading, cartridge pleating

0107 back view of Look 'Round the Back

0108 Silk Jacket: hand-dyed and screen printed, original pattern

0109 Front Piece of a Costume: hand-felted and sculpted merino wool, hand-dyed, mounted in folded organza

0110 Front Piece of a Costume: hand-felted and sculpted merino wook, partly hand-dyed

0111 La Femme Wrap: nuno-felted wool and silk fibers in silk fabric

0112 Tree Wrap: nuno-felted wool and silk fibers in silk fabric

0113 For Empress Wu Zetian, half-scale gown: fabric collage, hand-beading, hand-applied bias tubing using couching technique

0114 Sedna's Cloak: nuno-felted, hand-dyed silk saree mesh, silk pongee, and merino wool

0115 Front Piece of a Costume: hand-felted and sculpted merino wook, partly hand-dyed

0116 Graphite Tunic: hand-dyed and silk-screened nylon waste hosiery, low-impact dyes, non-toxic water soluble pigments

0117 Crème Fraiche: undyed and silk-screened nylon waste hosiery, silk-screened organic cotton/bamboo knit, heat reactive print paste

0118 Aquatine Tea Dress: hand-dyed and silk-screened nylon waste hosiery, organic cotton/bamboo knit, low-impact dyes, non-toxic water soluble pigments

0119 Fuschia Tunic with Ebony Ballerina Wrap: hand-dyed and silk-screened nylon waste hosiery, low-impact dyes, non-toxic water soluble pigments

0120 Lavender Top and Skirt: hand-dyed and silk-screened nylon waste hosiery, organic cotton/bamboo knit, low-impact dyes, non-toxic water soluble pigments

0121 Bronze Tea Dress: hand-dyed and silk-screened nylon waste hosiery, organic cotton/bamboo knit, low-impact dyes, non-toxic water soluble pigments

0122 Pocahontas Sun: hand-dyed boiled wool, discharged, tied and over-dyed, hand-painted, fringed, machine-stitched

0123 Red & Black Arashi Evening Bag: boiled wool, shape resist discharged and dyed, clamp-dyed silk organza rose, clamp-dyed gunma silk trim, hand-stitched

0124 California Funk: hand-dyed, wet-felted merino wool, painted boiled wool, hand-dyed silk chiffon, quilted and hand-stitched

0125 Peach and Blue Magoo: hand-dyed boiled wool, silk chiffon poof, silk and wool needle-felted patch, clamp-dyed, hand-stitched

0126 Sweet 16: hand-dyed raw sillk, clamp-dyed gunma silk, and silk organza, hand-stitched

0127 Tentacles Scarf: hand-felted and clamp resist dyed merino wool

0128 Daily Defenses: wool fleece, waxed linen; naturally dyed wet-felted with partial felt appliqué, hand- and machine-stitched

0129 back view of Daily Defenses

0130 detail of Daily Defenses

0131 Untitled Bracelets: wool fleece, waxed linen, antique metal seed beads; naturally dyed, wet-felted, hand-stitched and -beaded

0132 Bubble Scarf: hand-dyed and discharged merino wool, arashi and clamp-dyed and tied

0133 Crocus Bag: free-hand machine embroidered using water soluble fabric

0134 Collar: felt, organza, Tyvek, paper, paint, machine embroidery

0135 Bobble Neckpiece: hand-felted with no sewing, bobbles individually created and attached to tubular neckpiece

0136 Mardi Gras Bag: cotton embroidery, woven strap

0137 Hair Pin: hand-felted and hand-modeled with merino wool and silk

0138 Shoe Flower: hand-dyed, wet-felted merino wool

0139 Nuno-felted Shrug: nuno-felted silk chiffon and hand-dyed merino wool, embellished with bombyx silk

0140 Acquarel Flowers Scarf: hand-felted merino wool, hand-beaded, machine-stitched

0141 detail of Acquarel Flowers Scarf

0142 Untitled Brooch: wool fleece, knit fabric, waxed linen; wet-felted, naturally dyed, hand- and machine-stitched

0143 Nuno-felted Scarf: merino wool fibers, two layers of silk fabrics

0144 Boa: merino wool felt, silk fiber, cotton cord

0145 Silk Scarf: Habotai silk painted with silk dyes, crumped, and left to dry for days

0146 Twisted: hand-felted, hand-dyed merino wool and tussah silk

0147 Untitled Brooch: wool fleece, waxed linen; wet-felted, naturally dyed, hand- and machine-stitched

0148 Sweet Pea Scarf: hand-felted wool, hand-stitched

0149 Prarie Point Crown: linen, cotton, velvet prairie points, stitching

0150 Button On!!! button: wet-felted merino wool applied to buttons

0151 Zeba Collar: hand-felted blend of merino and other wools, nuno-felted tencel fibers and fabric strips, buttons

0152 Crocheted Bag: inverted crocheted hat, button embellishment, woven leather belt strap

0153 Persephone Pendant: wool with nuno-felted lace and silk fiber accents, hand-formed flowers and beadwork added post-felting

0154 Route 66: silk chiffon, felled with merino wool, combined with flax fibers

0155 Indigo Handbag: nuno-felted wool, silk fibers, texured silk and velvet, indigo dyeing, hand stitching with silk threads and ribbons

0156 Scarf: hand-dyed merino wool wet felted into hand-dyed silk

0157 Ocean Handbag: wet felting, shibori felting, hand-dyeing, pearl and seed bead embroidery

0158 Feel Me, Too: handmade ring of melted silver and felt

0159 Purse: nuno-felted with silk and merino wool, adorned with mother of pearl and semi-precious beads

0160 Encircled: wool fleece and silk fiber blend, silk fabric, waxed linen, glass seed beads; wet felted, naturally dyed, hand and machine-stitched

0161 detail of Encircled

0162 Scarf: nuno-felted merino wool fiber with silk gauze, bi-color double layer border arrangement

0163 Tiled Print Scarf: nuno-felted hand-dyed wool and silk

0164 Wrap: nuno-felted merino wool, hand-dyed locks, silk, silk and merino mixtures, silk rods, bamboo fibers

0165 detail of Wrap

0166 Untitled Necklace: wool fleece, waxed linen, shell beads; wet felted, hand-stitched

0167 detail of Untitled Necklace

0168 Felt Purse: wet felted flowers and metal-smithing

0169 Hibiscus Rose Scarf: nuno-felted wool and silk fibers in silk fabric

0170 Two Brooches: hand-felted and hand-modeled with merino wool and mohair

0171 Pink Purse and Knitting Bag: wool and alpaca weaving with twill combination threading, hand-felted, embellished with felted flowers

0172 Scarf: nuno-felted with double-faced silk chiffon and double-colored wool border

0173 Rose Tendril Necklace: hand-felted and hand-modeled with merino wool

0174 Hollyhock Ring: hand-felted and hand-modeled with merino wool

0175 Scarf / Collar: nuno-felted merino wool fiber in silk chiffon

0176 Scarf: wet felted merino wool

0177 After Monet scarf: nuno-felted on hand-colored silk gauze, hand-mixed, hand-painted fibers

0178 Flower Tendril Necklace: hand-felted and hand-modeled with merino wool

0179 Handbag: wet and needle-felted bag, machine embroidery

0180 Indigo Flower: wet- and needle-felted merino wool, recycled silk yarn

0181 Bra Purse: bra, dyes, free-motion sewing, embroidery, hand-beading

0182 Evening Purse: fabric collage, rubber stamping and coloring, free-motion machine stitching, beading

0183 Art Nouveau Summer Shawl: wet felting, pearl and seed bead embroidery

0184 Ruffled Scarf: nuno-felted hand-dyed wool and silk

0185 Pansy Scarf: wool scarf with nuno-felted lace fringe, silk fiber accents, hand-felted pansy flowers, hand-stitched

0186 Purse: nuno felting, raku clay pin

0187 Porcelain Handbag: nuno felting, hand-painted Habotai silk, merino wool, silk tops, hand beading

0188 Wrist Warmers: hand-felted and hand-modeled with merino wool

0189 Flower: hand-dyed, wet-felted merino wool

0190 Rings: wet felting and silversmithing

0191 Scarf / Collar: nuno-felted merino wool fiber in silk chiffon

0192 Soy Silk Bag: hand-dyed handmade soy silk, machine- and hand-stitched

0193 Woldolomiet brooches: five layers of pre-shaped wool felt and silicon

0194 Brooch: embellished felt, shaped rebar

0195 Highland Heart: nuno-felted, hand-dyed silk pongee and merino wool

0196 detail of Highland Heart

0197 Wrapped in Gold: hand-felted marino wool, hand-spun and hand-dyed yarn, silk fibers, linen fibers

0198 detail of Wrapped in Gold

0199 Spiral Hat: merino wool and silks

0200 Obscurity: copper, fabric layers, hand-embroidery, gemstones

0201 Links: silver, plastic, fabric

0202 Untitled Earrings: wool fleece, amber cabochons, glass seed beads, hand-forged sterling silver hoops; naturally dyed, wet felted, hand-stitched and -beaded

0203 Three White Lilies on Green: wet- and needle-felted merino wool, wool locks, silk fibers, paper fibers

0204 Shellbrooch 2: sewn, sawed, and drilled foam, thread, anodized aluminum, shell

0205 Ladies' Pink Spotted Felt Hat: merino wool wet felted with black wool spots, ostrich feather

0430 Spare Parts 2, 20" x 4" x 7" (51 x 10 x 18 cm): twine and hardware

0431 Dia de Las Modelos, 22" x 18" (56 x 45.5 cm): cotton embroidery on muslin, appliqué

0432 Laundry Day of the Dead, 20" x 17" (51 x 43 cm): cotton embroidery on muslin, appliqué

0433 Devil Digit Finishing School, 20.5" x 16" (52 x 40.5 cm): cotton embroidery on muslin, appliqué

0434 Shopping Mall Day of the Dead, 20" x 16" (51 x 40.5 cm): cotton embroidery on muslin, appliqué

0435 Day of the Beachmaster, 12.5" x 14" (32 x 35.5 cm): metallic embroidery on muslin, appliquéd disks

0436 Boogie to the Bone, 12" x 12" (30.5 x 30.5 cm): cotton embroidery on muslin, appliqué

0437 Night House, 12" x 14" (30.5 x 35.5 cm): cotton embroidery on muslin

0438 Groundhog Day of the Dead, 13" x 15" (33 x 38 cm): cotton embroidery on muslin

0439 Floating, 6" x 6" (15 x 15 cm): entirely hand stitched

0440 Dust Storm, 6" x 16" (15 x 40.5 cm): entirely hand-stitched

0441 Spiral, 5" x 5" (12.5 x 12.5 cm): entirely hand-stitched

0442 Green Grey Leaf, 7" x 7" (18 x 18 cm): entirely hand-stitched

0443 Leaves, 15" x 15" (38 x 38 cm): entirely hand-stitched

0444 Island Reflections, 38" x 74" x 18" (96.5 cm x 1.88 m x 45.5 cm): balanced weave in strips, origami birds at weaving openings, infinity-shaped copper pipe

0445 Angels Do Listen, 12" x 12" (30.5 x 30.5 cm): hand-dyed and painted transfers and digital prints, stitched

0446 Inner Heart, 15" x 16" (38 x 40.5 cm): collaged digital prints and surface-designed textiles, stitched

0447 Hard Ball, 15" x 25" (38 x 63.5 cm): digital-printed cotton sateen, silk organza, and Belgian linen, stitched

0448 Unhinged, 19" x 25" (48.5 x 63.5 cm): digital-printed, hand-dyed, painted

0449 Trees Seen, Forest Remembered, 24" x 33" (61 x 84 cm): digital printing, fused on canvas with hand-painted and silk-screened fabric

0450 Kesa #6 Samskaras, 103" x 43" x 2" (2.615 m x 1.09 m x 5 cm): dye-sublimation on polyester organza

0451 Sky/Color/Void, 15' x 40" (4.57 x 1.015 m): heat-compression, digital imaging, dye-sublimation on polyester organza

0452 detail of Sky/Color/Void

0453 Origami #8, 12' x 40" x 8" (3.66 m x 1.015 m x 20.5 cm): heat-compression, dye-sublimation on polyester organza

0454 Sky/Sky, 103" x 40" (2.615 x 1.015 m): heat-compression, digital imaging, dye-sublimation on polyester organza

0455 Wallhanging: rayon chenille doubleweave on 16-harness loom

0456 Wallhanging: mercerized 5/2 cotton doubleweave on 16-harness loom

0457 Mark Making, 25.5" x 27" (65 x 69 cm): hand embroidery on linen

0458 detail of Mark Making

0459 Playground, 20" x 21.5" (51 x 55 cm): hand embroidery on linen

0460 detail of Playground

0461 On Color, 26" x 27.5" (66 x 70 cm): hand embroidery on linen

0462 Family Connections, 23.5" x 8" (60 x 20 cm): machine lace created on soluble fabric wound with painted elastic "barbed wire," wasp's nest contained inside

0463 detail of Family Connections

0464 Branching Series #1, 24" x 24" x 2" (61 x 61 x 5 cm): hand-sewn fabrics, couched yarns, hand-printed rice paper, acrylic pigment, acrylic medium

0465 Branching Series #2, 24" x 24" x 2" (61 x 61 x 5 cm): hand-sewn fabrics, couched yarns, hand-printed rice paper, acrylic pigment, acrylic medium

0466 Branching Series #3, 24" x 24" x 2" (61 x 61 x 5 cm): hand-sewn fabrics, couched yarns, hand-printed rice paper, acrylic pigment, acrylic medium

0467 detail of Branching Series #3

0468 Lost Northwood, 32" x 20" (81.5 x 51 cm): needle felting on cotton

0469 Mitakuye Oyasin, 12.5" x 14.75" (32 x 37.5 cm): hand embroidery, beads, pheasant feather, on linen and pigskin

0470 Spring Moon, 20" x 18" (51 x 45.5 cm): hand-felted, stitched, mixed media

0471 Summer Moon, 20" x 18" (51 x 45.5 cm): hand-felted, stitched, mixed media

0472 Autumn Moon, 20" x 18" (51 x 45.5 cm): hand-felted, stitched, mixed media

0473 Sleeping Cedar - Luminous Dreams #4, 10.25" x 11.25" (26 x 28.5 cm): hand embroidery with mixed media, silk paper fusion, hand-dyed silk chiffon, hand beading, stitching

0474 People of the South, 30" x 12" x 8" (76 x 30 x 20 cm): stitched, hand-embroidered, beaded

0475 Bamboo Ladder: machine- and hand-stitched

0476 Mark in Time, 10" x 10" (25.5 x 25.5 cm): stitched, machine-embroidered, colored with felt tip pens

0477 The Sun Spirit House, 8" x 6" x 2.25" (20.5 x 15 x 5.5 cm): reinforced fabrics and found objects, batik, hand beading, yarn trim, raw edge appliqué

0478 detail of Bamboo Ladder

0479 detail of Bamboo Ladder

0480 107 River St., 14" x 32" each (35.5 x 81.5 cm each): dyed gradation on cotton, silkscreen

0481 Between the Devil and the Deep Blue Sea, 45" x 68" (1.145 x 1.725 m): block weave on 9 harnesses

0482 Metalia, 2' x 3' (61 x 91.5 cm): woven tapestry based on 6-year-old granddaugher's artwork

0483 Blues, 51" x 39.5" (1.3 x 1 m): organza, tulle, paper, Tyvek, machine embroidery

0484 detail of Blues

0485 Nighttime Birds: machine couching, appliqué, hand embroidery, beading

0486 Boogie Woogie Blues, 3' x 5' (91.5 cm x 1.525 m): tapestry straight and on the diagonal

0487 A Midsummer Night's Dream, 29" x 50" (73.5 cm x 1.27 m): bound weave, twill threading

0488 Maze #2, 34" x 54" x 17" (86.5 cm x 1.37 m x 43 cm): colored rice paste resist printing (Nassen Katazome & Tsutsugaki) on silk and wool, hand-stitched

0489 Trace #1, 36" x 93" (91.5 x 236 cm): colored rice paste resist printing (Nassen Katazome & Tsutsugaki) on silk, hand-stitched

0490 Coexistence #2, 49" x 71" (1.245 x 1.805 m): colored rice paste resist printing (Nassen Katazome & Tsutsugaki) on silk, hand-stitched

0491 detail of Coexistence #2

0492 Painted Countenance 406, 25" x 25" (63.5 x 63.5 cm): mixed media fiber artwork

0493 Jefo 607-8, 8" x 8" (20.5 x 20.5 cm) (each piece): mirrors covered with hand-dyed, heat-set polyester fabric

0494 Jefo 609, 58" x 18" (1.475 m x 45.5 cm) (each panel): polyester sheer panels dyed with disperse dyes

0495 Mixed Media 219, 12" x 16" (30.5 x 40.5 cm): zippers glued to base, painted texture background

0496 Jefo 613, 58" x 43" (1.475 x 1.09 m): 99 holes dyed with disperse dyes, permanent heat-set shapes, mounted on faux suede

0497 Painted Countenance 402, 23" x 13" x 7" (58.5 x 33 x 18 cm): hand-painted, stitched, beaded

0498 Spirits on Cloth 517, 44" x 22" x 5" (1.12 m x 56 cm x 12.5 cm): silk dupioni raw-edged appliqué

0499 Coiled Maskhara 015, 24" x 22" (61 x 56 cm): intertwined fiber-covered coils

0500 Jefo 618, 18" x 18" (45.5 x 45.5 cm): multicolored polyester heat-set to form permanent bubbles, mounted on grid of colored circles

0501 Image, 13.5" x 15.5" (34 x 40 cm): digital transfer print, freestyle screen printing, stitching

0502 Ways of Seeing, from 27.5" (70 cm) compressed to 59" (150 cm) expanded: felting, embroidery, crochet, beading, decorated paper, acrylic ink

0503 Openings, 19" x 4.5" x 3" (48 x 11 x 8 cm): double weave using dissolvable yarn in sections of warp, together with linen, cotton, and fine wire in warp and weft

0504 Meanderings, 4.5" x 18" x 2.5" (11 x 46 x 7 cm): double weave using dissolvable yarn in sections of warp, together with linen, cotton, and fine wire in warp and weft

0505 Celebrations, 6.5" x 15.5" x 2" (17 x 39 x 5 cm): double weave using dissolvable yarn in sections of warp, together with linen, cotton, and fine wire in warp and weft

0506 detail of Celebrations

0507 Unplanned Obsolescence #2, 14" x 67" (35.5 cm x 1.7 m): handwoven double weave cloth, silk, cotton, and brocade plastic shopping bags, painted warp, applied embroidery and caution tape

0508 detail of Unplanned Obsolescence #2

0509 Unplanned Obsolescence #1, 55" x 28" (1.395 m x 71 cm): handwoven cloth of tencel, cotton, and brocade shopping bags, painted warp, applied embroidery

0510 Excess, 12" x 144" (30.5 cm x 3.66 m): handwoven double weave cloth, cotton warp, preused plastic shopping bags as weft

0511 detail of Excess

0512 Deep Forest Snow, 32" x 70" (81.5 cm x 1.78 m): deconstructed dresses, stitching, embroidery, fabric paint, digital printed photography and designs

0513 The State of the Union, 8" x 12" (20.5 x 30.5 cm): woven tapestry, silk, and cotton

0514 From Above & Below, 8" x 8" (20 x 20 cm): torn fabric, lace, dried botanicals, stitching, watercolors

0515 Color of Our Own, 6.5" x 6.5" (16.5 x 16.5 cm): muslin, acrylics, stitching

0516 Las Casitas de Macondo, 22" x 18" (56 x 46 cm): wet felting with handmade prefelts, merino wool

0517 Hidden, 8" x 8" (20.5 x 20.5 cm): fabric, paper, feathers, ribbons, yarns

0518 Turquoise Wall Hanging, 22" x 28.5" (56 x 73 cm): even warp, alternating weft, finger manipulated weaves

0519 Fire Flower, 13" x 8" (33 x 20 cm): hand-felted bergwool and merino wool layered with a blend of merino and silk, hand-dyed together, hand-dyed yarn and linen fibers

0520 Gossipers, 20" x 20.5" (51 x 52 cm): wet felting, needle felting, wools, silk fiber

0521 detail of Gossipers

0522 Small Wallhanging: machine appliqué, beading

0523 Snowdrop Shoe: freehand machine embroidered using water-soluble fabric

0524 From the Mountains and the Sun, 37" x 25" (94 cm x 63.5 cm): free machine stitching, paint, other embellishments

0525 Apples for Sale, 36" x 28" (91.5 x 71 cm): free machine stitching, paint, other embellishments

0526 From the Mountains and the Sun, 37" x 25" (94 x 63.5 cm): free-machine stitching, paint, other embellishments

0527 detail of Apples for Sale

0528 Eden Hanging, 2' x 8' (61 cm x 2.45 m): machine- and hand-stitched painted fabric

0529 Untitled, 8" x 15.5" x 1" (20 x 40 x 2.5 cm): hand and machine embroidery, photography

0530 NO!, 12" x 12" (30.5 x 30.5 cm): hand and machine embroidery

0531 Shabnam, 39.5" x 39.5" x 1" (1 m x 1 m x 2.5 cm): hand and machine embroidery, photography

0532 Undulating, 15.75" x 11.42" (40 x 29 cm): stitched and wired cheesecloth

0533 Climbing the Wall, 16.5" x 12.6" (42 x 32 cm): reverse appliqué on plain and hand-dyed calico

0534 Mixed Media 220, 39" x 34" (99 x 86.5 cm): rusted fabric created by inserting rusted nails into canvas

0535 detail of Mixed Media 220

0536 Stormy Night, 8" x 10" (20.5 x 25.5 cm): needle felting with free machine embroidery

0537 Untitled, 15" x 11" (38 x 28 cm): woven cloth with weft feathers, hand-dyed canvas

0538 Espoir et Gloire, 46" x 48" x 3" (1.17 m x 1.22 m x 7.5 cm): appliquéd fabrics, heat-manipulated Tyvek, machine embroidery

0539 detail of Espoir et Gloire

0540 Passé Décomposé, 42" x 39" (1.065 m x 99 cm): appliquéd fabrics, heat-manipulated Tyvek, machine embroidery

0541 Wherever I Go, 44" x 39" x 3" (1.12 m x 99 cm x 7.5 cm): appliquéd fabrics, heat-manipulated Tyvek, machine embroidery

0542 Wedding Canopy, four friezes of 88" x 12" each (2.235 m x 30.5 cm each): appliquéd fabrics, heat-manipulated Tyvek, machine embroidery

0543 Escapade, 35" x 47" (89 cm x 1.195 m): appliquéd fabrics, heat-manipulated Tyvek, machine embroidery

0544 Life Entwined, 24" x 24" (61 x 61 cm): hand-dyed and commercial fabrics, soy silk fibers and various natural rovings used in felting (hand and machine), fabric paint, acrylic paint, oil sticks, other media

0545 Gridlocket, 31.5" x 23" (80 x 58.5 cm): woven tapestry with bead embroidery

0546 Wish You Were Here, 6" x 4" (15 x 10 cm): inkjet-printed cotton, hand embroidery, machine-stitched

0547 Ants, 5.5" x 8" (14 x 20.5 cm): free machine embroidery on hessian fabric

0548 How I Remember Hanoi, 10" x 14" (25.5 x 35.5 cm): etched wax on dyed cotton

0549 Cutwork Moth, 6.5" x 5.5" (16.5 x 14 cm): hand embroidery, cut-away areas

0550 Watching the Moorhen, 15.75" x 11.75" (40 x 30 cm): free machine embroidery onto linen, hand-dyed silk and cotton, appliqué, beading, hand stitching

0551 Forest Edge, 32" x 44" (81.5 cm x 1.12 m): machine needle felting, machine quilting

0552 The Tastes of Summer, 18.5" x 14" (47 x 35.5 cm): machine-needle felting, machine stitching

0553 Running in Circles, 44" x 78" (1.12 x 1.98 m): manipulated hand-dyed, discharged, multiple silk screens

0554 detail of Running in Circles

0555 Breakaway, 35.5" x 35.5" (90 x 90 cm): hand-dyed merino wool

0556 Delaware River Path, 18.75" x 17.75" (47.5 x 45 cm): monoprint on polyester with disperse dyes

0557 Daybreak, 30" x 42" x 3" (76 cm x 1.065 m x 7.5 cm): wet felting and additional stitching

0558 A Life, in Homage to Marlette Rousseau-Vermette: hand-felted rug

0559 A Gift of Fire, 56" x 36" x 2" (1.42 m x 91.5 cm x 5 cm): wet felting and additional stitching

0560 1988 Silver Mercury Grand Marquis, 45" x 29" (1.14 m x 74 cm): woven tapestry of hand-dyed cotton and wool

0561 detail of A Gift of Fire

0562 Portrait of a Father, 91" x 96" (2.31 x 2.44 m): hand-woven tapestry, laser-printed image on canvas, hand-dyed wool, cotton, and other mixed media

0563 Untitled, 39" x 17" (99 x 43 cm): woven cloth, cut, pleated, painted, bleached, and stitched

0564 Mother and Child, 22" x 30" (56 x 76.7 cm): free machine stitching of thread and fleece

0565 detail of Mother and Child

0566 Woman, 18" x 14" (46 x 35 cm): free machine stitching of thread and fleece

0567 detail of Woman

0568 Wild Bog Cotton, 19.5" x 15.5" x 1.5" (50 x 40 x 3.5 cm): Irish linen painted with dye of red onion skins, tufted mohair yarn, linen thread stitching

0569 Through the Door, 8" x 10" (20.5 x 25.5 cm): laminated felt, fingerprinted cotton organza, hand-stitched, bead-embellished, stitched collage

0570 Endangered Animals A–Z #7, 23" x 59" (58.5 x 1.5 m): cut wool felt pieces, hand-stitched, lined with muslin

0571 Feminine Qualities: Felted Figure: wet-felted, free-lace, mixed wool and silk fibers over metal armature

0572 detail of Feminine Qualities

0573 detail of Endangered Animals A–Z #7

0574 Alligator Wallow, 9" x 26" (23 x 66 cm): hand-dyed felt from merino and jacobs fleece and silk tops, free machine embroidery, machine and hand stitching

0575 detail of Alligator Wallow

0576 Africa Skinned, 122.5" x 14" (3.11 m x 36 cm): free machine embroidery

0577 detail of Africa Skinned

0578 detail of Africa Skinned

0579 Keep Britain Tidy, 9' x 3' diameter (2.745 m x 91.5 cm diameter): mixed media

0580 Twisted, 11.25" x 13" (28.5 x 33 cm): plain weave with rethreaded warp

0581 detail of Keep Britain Tidy

0582 The Gossip, 13" x 14" (33 x 35.5 cm): needle-felted wool sculpture on wet-felted base

0583 Wall Art, 20" x 30" (51 x 76 cm): wet and needle felting of natural Karakul wool

0584 First Flight, 27" x 21.5" (68.5 x 54.5 cm): collage with bead embroidery

0585 Vintage Tap Shoe: collage of photos, material, and book pages

0586 Blue Bird, 25" x 17" (63.5 x 43 cm): hand-spun angora, hand-dyed silk, glass beads

0587 Eye-Land 2, 5" x 5" (12.5 x 12.5 cm): hand embroidery, printing on fabric

0588 Tea Cup Bulldog, 8.5" x 7" (21.5 x 18 cm): hand embroidery and beading

0589 My Aching Head, 10" x 10" (25.5 x 25.5 cm): hand embroidery and hand-dyed fabric

0590 Louis's Dog-Jazz, 13.75" x 12.25" (34.5 x 31 cm): hand embroidery, hand beading, painting of fabric, mixed media

0591 Sam, 20.5" x 14.5" (52 x 37 cm): felted fibers, hand stitching

0592 Jack, 19.5" x 14.5" (50 x 37 cm): felted fibers

0593 For Katherine, 25" x 18.5" (63 x 47 cm): felted mixed fibers and prefelts

0594 Golden Orchids, 55" x 31.5" (1.4 m x 80 cm): hand-dyed merino wool, silk and soy fibers, hand embroidery

0595 A Reason to Live, 18" x 16" (45.5 x 40.5 cm): cotton cloth over felt, hand reverse appliquéd, machine-stitched, embellished with glass, wood, and clay beads

0596 Money, 5' wide (1.525 m wide): machine-stitched and padded silk with buttons, stitched text by Gertrude Stein

0597 Aqua Blues, 36" x 36" (91.5 x 91.5 cm): gutta resist lines with aniline dyes on steam-set habotai silk

0598 1558 Squares, 36" x 36" (91.5 x 91.5 cm): gutta resist lines with aniline and tinfix dyes on steam-set habotai silk

0599 144 Starbursts, 36" x 36" (91.5 cm x 91.5 cm): gutta resist lines with aniline dyes on steam-set habotai silk

0600 144 Blue Starbursts, 35" x 36" (89 cm x 91.5 cm): gutta resist lines with aniline dyes on steam-set habotai silk

0601 Movement, 7.5" x 6" (19 x 15 cm): thread painting self portrait

0602 Lake Above Boulder, 7" x 6.75" (18 x 17 cm): painted and stitched landscape

0603 Waterfall, 15" x 20' (38 cm x 6.095 m): Saori freestyle weaving, clasped weft, added thrums, incorporating ribbons, unspun fleece, and other materials.

0604 detail of Waterfall

0605 Falling Leaves, 14' x 4' (4.265 x 1.22 m): wool, acid dye, clamp resist, hand-stitched

0606 Blackbirds, 72" x 56" (1.83 x 1.42 m): cotton jacquard tapestry

0607 Virtual Water, 20" x 56" (51 cm x 1.42 m): cotton jacquard tapestry

0608 ReUse, 30" x 22" (76 x 56 cm): wool, acid dye, clamp resist, reverse appliqué, hand-stitched

0609 Drought Begins, 22" x 36" (56 x 91.5 cm): cotton jacquard tapestry

0610 The Last Plant 3: wool, acid dye, clamp resist, monoprint, hand-stitched

0611 Mother Giving a Worm, 48" x 56" (1.22 x 1.42 m): cotton jacquard tapestry

0612 Divination IV 14.5" in diameter (36.8 cm in diameter): hand-embroidered fabric, embellished with beads

0613 Casting a Memory, 9.5" x 10.5" (24 x 16.5 cm): antique trade beads, contemporary beads, hand embroidery, waxed linen, colored pencil, and acrylic paint

0614 Silent Shade of Fallen Wings, 12" x 10" (30.5 x 25.5 cm): antique trade beads, contemporary beads, hand embroidery, colored pencil, and acrylic paint

0615 Cascade, 8" x 9.5" (20 x 24 cm): free-machine embroidery on cotton fabric

0616 detail of Cascade

0617 September Keepsake, 6.75" x 9.25" (17 x 23.5 cm): antique trade beads, contemporary beads, hand embroidery, colored pencil and acrylic paint

0618 Ruffled Features, 6.25" x 4.5" (16 x 11.5 cm): antique trade beads, contemporary beads, hand embroidery, colored pencil, and acrylic paint

0619 Delicate Balance, 4.5" x 6.25" (11.5 x 16 cm): antique trade beads, contemporary beads, hand embroidery, wool roving, colored pencil, and acrylic paint

0620 Beat of the Wing, 6.25" x 4.5" (16 x 11.5 cm): antique trade beads, contemporary beads, hand embroidery, colored pencil, and acrylic paint

0621 Fuzzy Caterpiller, 48" x 36" (1.22 m x 91.5 cm): acrylic on industrial wool, negative transfer process with hand-cut stencils

0622 Lilies, 48" x 72" (1.22 x 1.83 m): acrylic on industrial wool, negative transfer process with hand-cut stencils

0623 Meow Yawn, 9" x 12" (23 x 30.5 cm): machine embroidery, machine appliqué, hand beading, hand embroidery, original drawing transfer

0624 Crazy Beading Sampler, 8.5" x 11" (21.5 x 28 cm): silk fabric machine-stitched, hand-beaded with a variety of "crazy beading" techniques developed by the artist

0625 Eccinachea at Twelve O'Clock, 30" x 47.25" (76.2 x 120 cm): acrylic on industrial wool, negative transfer process with hand-cut stencils

0626 detail of Eccinachea at Twelve O'Clock

0627 Button Hole Flowers, 13" x 11" (33 x 28 cm): cotton fabric fused and machine-stitched, hand-beaded with beaded buttonhole stitch

0628 Galapagos, 5' x 10' (1.525 m x 3.05 m): hand-dyed wool fiber, wet felting, layered resists, hand stitching

0629 Migration Down Waterfall Number One, 36" x 48" (91.5 cm x 1.22 m): acrylic on industrial wool negative transfer process with hand-cut stencils

0630 After the Storms, 30' x 12' x 15" (9.145 m x 3.66 m x 38 cm): ikat and dip-dyed silk, plain weave and sprang

0631 Earth Line, 3' x 5' (91.5 cm x 1.525 m): ikat-dyed silk and copper wire, 3/1 twill weave 80 feet (24 m) long woven back on itself

0632 detail of Earth Line

0633 The Journey, 28' x 18' (8.535 x 5.485 m): ikat and dip-dyed silk and wire, doubleweave silk warp and copper wire weft

0634 Ice Line, 3' x 3' (91.5 x 91.5 cm): ikat dyed silk warp and stainless steel wire weft, 3/1 single piece woven then woven back on itself to hang freely

0635 Cryptic Crop Circles #2, 17" x 22" (43 x 56 cm): overlay of sheer fabric machine-stitched, fibers couched with metallic thread, hand-beaded

0636 New Spitalfields Silk, 47" x 59" (1.2 x 1.5 m): digital print on silk habotai, hand-printed foils

0637 detail of New Spitalfields Silk

0638 detail of New Spitalfields Silk

0639 Peeling Paint Terracotta, 88.5" x 29.5" (2.25 m x 75 cm): digital print on cotton satin

0640 History Maps, 31.5" x 67" (80 cm x 1.7 m): digital and hand-printed pigments on cotton satin

0641 Lineage, 23.5" x 15.5" (59.5 x 39.5 cm): woven tapestry with bead embroidery

0642 Sundown for Seagulls, 26" x 42" (66 cm x 1.065 m): modified Moorman technique: wool yarn laid under black thread tiedown warp and over cotton/linen background warp

0643 Light in the Valley of Shadow: modified Moorman technique: wool yarn laid under black thread tiedown warp and over cotton/linen background warp

0644 The Music Man, 29" x 10" (73.5 x 25.5 cm): fabric-stuffed body on wood armature, painted fabric, wood and clay face, coiled yarn, medicine pouch, bead embellishments

0645 A Time for Small Things, 1.75" x 1.35" x .5" (4.5 x 3.5 x 1.25 cm): hand-beaded pearls, crystal, glass, and antique metal beads on silk

0646 The Music Man, 29" x 10" (73.5 x 25.5 cm): fabric-stuffed body on wood armature, painted fabric, paper clay face, roiled yarn, bead embellishments

0647 The Shaman, 22" x 19" (56 x 48 cm): fabric-stuffed body on wood armature, painted fabric, paper clay face, coiled yarn, bead embellishments

0648 Peek-a-Boo, 26" x 14" x 18" (66 x 35.5 x 45.5 cm): hand-dyed cloth with machine embroidery stitched on wire frame

0649 detail of Peek-a-Boo

0650 detail of Peek-a-Boo

0651 The Magic of Books, 17" x 12" (43 x 30.5 cm): machine embroidery, embellishments

0652 Going Bananas, 25" x 25" x 25" (63.5 x 63.5 x 63.5 cm): pipe cleaners

0653 SO AM I: from darkness to light, 98.5" x 35.5" (2.5 x .65 m) per panel: weaving of vegetal fibers, lurex threads, paint, charcoal, pebbles, brass wire

0654 Old Red Sandstone, 18" x 52" (45.5 cm x 1.32 m): painted and hand-dyed fabrics, pieced, machine embroidered

0655 Water Light Kimonos: various opaque, transparent, translucent, iridescent fabrics, micro balls of glass, phosphorescent threads and pigments, iridescent acrylic paints

0656 black light view of Water Light Kimonos

0657 detail of Old Red Sandstone

0658 A Book of Hours, 7" x 5" x 1.5" (18 x 12.5 x 4 cm): hand-beaded pearls, crystals, antique beads, and semi-precious stones on velvet, silver and gold leaf, wristwatch parts

0659 additional page from A Book of Hours

0660 additional page from A Book of Hours

0661 Glorious Poppies, 35" x 42" (89 cm x 1.065 m): hot wax resist and fabric dyes on silk

0662 Monarchy, 69" x 67" (1.755 x 1.7 m): woven tapestry with off-loom woven detailing and beadwork

0663 detail of Monarchy

0664 Freedom Fighter, 17" x 12" (43 x 30.5 cm): machine lettering, stump work figure, image transfer, embellishments

0665 Reflections, 9.5" x 16.25" (24 x 41.5 cm): digital prints on cotton, collaged, stitched

0666 Heart Center, 21" diameter (53.5 cm diameter): hand-dyed velvet, hand embroidery

0667 detail of Heart Center

0668 Fiber Music Series: A Small Symphony, 19" x 19" (48.5 x 48.5 cm): collage of nuno-felted fabric, hand-dyed velvet, and other fabrics, hand stitching, hand beading

0669 Dancers in the Moonlight, 41" x 36" (1.04 m x 91.5 cm): hand-dyed, multiple silk screens

0670 Cow Trail, 30.5" x 21" (77.5 x 53.3 cm): freeform machine embroidery over a single layer of tulle with wool and silk roving

0671 Wheatfield, 32.5" x 19" (82.5 x 48.5 cm): freeform machine embroidery over a single layer of tulle with wool and silk roving, with hand embroidery

0672 detail of Wheatfield

0673 Landscape with Lines, 21" x 12" (53.5 x 30.5 cm): freeform machine embroidery over a single layer of tulle with wool and silk roving

0674 detail of Landscape with Lines

0675 LUSH Tapestry 3.5' x 30" (1.065 m x 76 cm): hand-dyed, wet-felted merino and finn wool with silk and found organic objects

0676 Remembering Tangiers, 37" x 60" (94 cm x 1.525 m): shirbori-dyed strips of felt, hand-dyed strips of silk-screened linen, hand-sewn

0677 detail of Remembering Tangiers

0678 North Carolina Arboretum Screen Tapestry, 5' x 5.5' (1.525 m x 1.675 m): stretched and framed weft face tapestry with embroidery overlay

0679 Mt. Batchelor in Oregon, 40" x 70" (1.015 m x 1.78 m): stretched and framed weft face tapestry with embroidery overlay

0680 Wanzer's Woodlands, 33" x 72" (84 cm x 1.83 m): stretched and framed weft face tapestry with embroidery overlay

0681 Verdure, 82" x 34" (2.085 m x 86.5 cm): dye sublimation transfer print on hand-manipulated synthetic felt

0682 The Lake, 6" x 24" (15 x 61 cm): reinforced fabrics and found objects, hand-dyed fabrics, yarn trim, hard-carved stamps, hand beading

0683 Up Stream, 15" x 22" (38 x 56 cm): batik on Habotai silk, hand and machine embroidery

0684 Canal Basin, Derbyshire 2008, 39.5" x 39.5" x 1" (1 m x 1 m x 2.5 cm): hand and machine embroidery, paint

0685 Lemoine's Point, 36" x 30" (91.5 x 76 cm): wet-felted wool fiber with needle-felted detail

0686 detail of Lemoine's Point

0687 Lemoine's Point 2, 28" x 24" (71 x 61 cm): wet-felted wool fiber with needle-felted detail

0688 Butterfly's Journey, 16" x 20" (40.5 x 51 cm): hemp fabrics, dye and discharge, stitching, with raw silk

0689 Persistence, 11" x 19" (28 x 48.5 cm): hand-woven linen and silk, batik, dye and discharge, with silk organza and stitching

0690 Path, 16" x 26" (40.5 x 66 cm): hand-woven linen, batik, gradation dye, dye paint, rust print, stitching

0691 detail of Path

0692 Early Winter, 32.125" x 20.25" (81.5 x 51.5 cm): collage of mended vintage linen, painted with dyes and acrylic, with silk gauze and stitching

0693 detail of Early Winter

0694 Accept, 61" x 30" (1.55 m x 76 cm): hand-woven silk, paper, rayon paper with silk, batik, dye paint, discharge, cotton and silks, with stitching, paint, and silver foil

0695 Early Autumn, 31.375" x 17.5" (79.5 cm x 44.5 cm): collage of mended vintage linen, painted with dyes and acrylic, with silk organza and stitching

0696 Departure, 13.5" x 18.25" (34.5 x 46.5 cm): hand-woven cotton, paper, linen, rust print, dyed, with silk organza and stitching

0697 Dusk Gathers, 14.75" x 15.25" (37.5 x 38.5 cm): hand-woven linen and cotton, shibori and batik dyed, hand stitching

0698 Fallen, 51" x 65" (1.295 x 1.65 m): mono printed dye on cotton sateen, machine-reverse appliqué, machine-quilted

0699 Double Crossing, 34" x 43" (86.5 cm x 1.09 m): bound immersion dyed cotton sateen, hand-appliquéd, machine-quilted

0700 Game Pieces, 34" x 41" (86.5 cm x 1.04 m): hand printed and painted with dye and resists on cotton, whole cloth, machine-quilted

0701 detail of Fallen

0702 Is It a Game? 41" x 44" (1.04 x 1.12 m): monoprinted and block printed with dyes, immersion-dyed cotton sateen, machine quilted

0703 El Teide, 26" x 12" (66 x 30 cm): painted fabric, machine-stitched, machine and hand embroidery, hand beading

0704 detail of El Teide

0705 Earth Lines, 52" x 35" (1.32 m x 89 cm): potato dextrin resist on cotton sateen, hand-painted with dye, whole cloth, machine-quilted

0706 Twisted, 31" x 53" (78.5 cm x 1.345 m): iron-stained silk, whole cloth, machine- and hand-quilted

0707 detail of Twisted

0708 detail of Earth Lines

0709 Balance #30: In Between, 33" x 23" (84 x 58.5 cm): iron-stained silk, whole cloth, machine- and hand-quilted

0710 detail of Balance #30

0711 Katrina's Barn, 20" x 20" (51 x 51 cm): frazzled appliqué, machine- and hand-stitched textile scraps

0712 Madrid (arches 2), 18" x 15" (45.5 x 38 cm): monoprinted dye on silk noil, whole cloth, machine-quilted

0713 Mini-Quilt #30, 5" x 7" (12.5 x 18 cm): painted muslin stamped with hand-made stamp, machine stitched

0714 Mini-Quilt #31, 4" x 6" (10 x 15 cm): stamped with hand-made stamps, machine-stitched

0715 detail of Katrina's Barn

0716 I Want to Stitch, 56.5" x 31.5" (1.44 m x 80 cm): improvisational cut and fused; cut and fused wording applied to hand-, resist-, and discharge-dyed cotton; machine-stitched and -quilted

0717 Drawing on Canvas, 10.5" x 9" (27 x 23 cm): digital transfer print, appliqué, free machine embroidery, additional media and techniques

0718 Red Stones, Green Sea, 17" x 8.5" (43 x 22 cm): hand-painted, layered fabric and organza, machine-stitched

0719 Chasing the Tide, 16.5" x 28" (42 x 71.5 cm): hand-painted, layered fabric and organza, machine-stitched

0720 Summer on Dutch Island, 15.5" x 19.5" (39.5 x 49.5 cm): frazzled appliqué, machine- and hand-stitched textile scraps

0721 detail of Summer on Dutch Island

0722 Sea and Stones, 11.5" x 12" (29 x 30 cm): hand-painted, layered fabric and organza, machine-stitched

0723 Abel Tasman Sea Kayak Trip, 48.75" x 43" (1.24 x 1.09 m): commercial and hand-dyed fabrics, hand- and machine-stitched, bonded fabrics

0724 Lost Crosses, 56" x 35" (1.42 m x 89 cm): immersion dyed and hand-printed and painted with dye and corn dextrin resist on cotton, machine-quilted

0725 detail of Lost Crosses

0726 Family Reunion, 15" x 25" (38 x 63.5 cm): fabric paints and markers, beading, image transfers, hand and machine stitching, various yarns, threads, angelina fibers, felt, other embellishments

0727 Shrine to Land and Sky, 26.25" x 17" (66.5 x 43 cm): hand-dyed fabrics, batiks and organza, hand and machine quilting, hand embroidery, beads, buttons, yarns, hand-dyed threads, clay, paint, wood, photo transfer

0728 detail of Shrine to Land and Sky

0729 detail of Family Reunion

0730 Square One, 36" x 35" (91.5 x 89 cm): commercial and hand-dyed cotton, Tyvek, machine quilting

0731 detail of Square One

0732 Reflections, 20" x 24" (51 x 61 cm): hand-painted cotton, machine quilting

0733 Winter Forest, 20" x 17" (51 x 43 cm): commercial cotton, discharged, Tyvek, machine quilting

0734 Reflections, Burano, Variation 2, 41" x 51" (1.04 x 1.295 m): hand-dyed, overdyed, fused, machine-stitched

0735 Oak Leaf Cluster, Variation 1, 18" x 24" (45.5 x 61 cm): hand-dyed and commercial fabrics, fused, stitched, shaped into dimensional piece, assembled

0736 Reflections, Burano, Variation 1, 32" x 49" (81.5 cm x 1.245 m): hand-dyed, overdyed, commercial fabrics, fused, printed, machine-stitched

0737 Leaf Fall, Variation 1, 56" x 32" (1.42 m x 81.5 cm): hand-dyed and commercial fabrics, fused, stitched, shaped into dimensional piece, assembled

0738 Summer's End, Prairie Dock Leaves, 44" x 24" (1.12 m x 61 cm): hand-dyed and commercial fabrics, fused, stitched, shaped into dimensional piece, assembled

0739 Reflections, Burano, Variation 11, 85" x 37" (2.16 m x 94 cm): hand-dyed, overdyed, organza overlay, painted, fused, machine-stitched

0740 Leaf Fall, Variation 1, 56" x 32" (1.42 m x 81.5 cm): hand-dyed and commercial fabrics fused, stitched, shaped into dimensional piece, assembled

0741 Overleaf I, 12.5" x 18" (32 x 46 cm): hand-dyed, screen-printed, machine-pieced, machine-quilted

0742 detail of Overleaf I

0743 In Good Company, 67.5" x 56.5" (1.72 x 1.43 m): hand-dyed, machine-pieced, some reverse appliqué, machine-quilted

0744 detail of In Good Company

0745 Not Even Solomon . . ., 71" x 58" (1.8 x 1.47 m): hand-dyed, machine-pieced, machine-quilted

0746 Crocus, 56" x 60" (1.42 x 1.52 m): collage of hand-dyed silk and cotton, commercial silk, machine quilting

0747 One Flew Over Cambodia, 32" x 42" (81.5 cm x 1.065 m): artist-created paper collage, transferred to fabric, quilted

0748 Blue Moon 2, 60" x 36" (1.525 m x 91.5 cm): silk, silk painting, paintstick, stitching

0749 detail of Blue Moon 2

0750 detail of Crocus

0751 Iris, 60" x 72" (1.52 x 1.83 m): collage of hand-dyed silk and cotton, commercial silk, machine quilting

0752 Canopy, 48" x 52" (1.22 x 1.32 m): collage of hand-dyed silk and cotton, commercial silk, machine quilting

0753 Monastic Cross II, 49" x 41" (1.245 x 1.04 m): hand-painted fabric, machine-pieced, appliquéd and quilted, couched yarn

0754 detail of Monastic Cross II

0755 St. Kevin's Monastery II, 66" x 55" (1.675 x 1.395 m): hand-painted fabric, machine-pieced, appliquéd, and quilted

0756 detail of St. Kevin's Monastery II

0757 Dun Aengus Stone Fort, 71" x 63" (1.805 x 1.6 m): hand-painted fabric, machine-pieced, appliquéd and quilted

0758 Poulnabrone Dolmen, 32" x 63" (81.5 cm x 1.6 m): hand-painted fabric, machine-pieced, appliquéd and quilted, couched yarn

0759 detail of Poulnabrone Dolmen

0760 Eightercua Stone Row, 39" x 40" (99 cm x 1.015 m): hand-painted fabric, machine-pieced, appliquéd and quilted, couched yarn

0761 detail of Eightercua Stone Row

0762 Africa Scarified: used teabags, organza, stitched, burnt, embroidered

0763 detail of Africa Scarified

0764 detail of Africa Scarified

0765 Elements 1: Earth, 28" x 40.5" (70.5 cm x 1.03 m): hand-dyed and commercial cotton, silk, velvet, other fabrics, machine-pieced, hand-appliquéd, machine- and hand-quilted

0766 Hills and Valleys, 18" x 30" (45.5 x 76 cm): original cyanotypes on silk rust printing, stencil, couched yarn and bead embellishing, hand quilting

0767 Threat, 20" x 31" (51 x 78.5 cm): original cyanotypes on organza, rust printing, stencil, bead embellishing, machine quilting

0768 Pink Lady, 48" x 37" (1.22 m x 94 cm): silks, cottons, velvets, brocades, etc., backed with fusing, cut freehand, and sewn

0769 Green Grapes, 84" x 39" (2.135 m x 99 cm): silks, cottons, velvets, brocades, etc., backed with fusing, cut freehand, and sewn

0770 Still Life, 30" x 40" (76 cm x 1.015 m): silks, cottons, velvets, brocades, etc., backed with fusing, cut freehand, and sewn

0771 N.Y.C. Seasons, 36" x 60" (91.5 cm x 1.525 m): silks, cottons, velvets, brocades, etc., backed with fusing, cut freehand, and sewn

0772 Pink Petals, 13.75" x 11.75" (35 x 30 cm): raw-edge, fused appliqué; machine-quilted, painted

0773 Here's a Pretty One, 12" x 12" (30.5 x 30.5 cm): raw-edge, fused appliqué; painted facial features; painted highlights and shadows; free-motion quilting

0774 Ori-Kume #5, 18" x 18" (45.5 x 45.5 cm): stitch-resisted shibori patterning (mokume and ori-nui), hand-dyed, hand-quilted, hand-stitched

0775 Ori-Kume #4, 56.5" x 36.5" (1.435 m x 92.5 cm): stitch-resisted shibori patterning (mokume and ori-nui), hand-dyed, hand-quilted, hand-stitched

0776 detail of Ori-Kume #4

0777 Ori-Kume #3, 46" x 40.5" (1.17 x 1.03 m): stitch-resisted shibori patterning (mokume and ori-nui), hand-dyed, hand-quilted, hand-stitched

0778 Ori-Kume #2, 27.5" x 15" (70 x 38 cm): stitch-resisted shibori patterning (mokume and ori-nui), hand-dyed, hand-quilted, hand-stitched

0779 detail of Ori-Kume #3

0780 Inner Voice 4, 24" x 36" (61 x 91.5 cm): hand-painted silk organza and lace paper, hand-quilted

0781 Inner Voice 3, 24" x 36" (61 x 91.5 cm): hand-painted silk organza, hand-quilted

0782 Inner Voice 1, 24" x 36" (61 x 91.5 cm): hand-painted silk organza, hand-quilted

0783 detail of Inner Voice 1

0784 Sedona III, 24" x 42" (61 cm x 1.065 m): shibori-dyed fabric, machine-quilted, hand-beaded

0785 Molti Colori, 51" x 51" (1.295 x 1.295 m): artist-made silk paper, machine-quilted

0786 detail of Molti Colori

0787 Fascinating Garden, 19" x 19" (48.5 x 48.5 cm): machine-quilted, machine-appliquéd, confetti

0788 Bright Spring, 52" x 65" (1.32 x 1.65 m): machine-quilted, machine-appliquéd, confetti, hand painting, thread painting

0789 detail of Bright Spring

0790 Red Carpet, 50" x 41" (1.27 x 1.04 m): machine-quilted, machine-appliquéd, confetti, hand painting, thread painting

0791 detail of Red Carpet

0792 Remnants from the Farmstead, 30" x 42" (76 cm x 1.065 m): rust-printed fabric, deconstructed screen print, machine-quilted

0793 Pearls of Wisdom, 62" x 100" (1.575 x 2.54 m): whole cloth quilt, cut up and appliquéd onto another whole cloth, painted, embellished with genuine pearls

0794 detail of Pearls of Wisdom

0795 Labyrinth, 13.5" x 13.5" (34 x 34 cm): hand-embroidered, hand-quilted, cotton and silk

0796 detail of Labyrinth

0797 Calmer, 4" (10 cm) in diameter each: cotton, linen, crochet, vintage buttons, paper, hand and machine stitching

0798 Family Reunion, 31.5" x 40" (80 cm x 1.02 m): hand-dyed and -painted cotton fabrics, multiple surface design techniques, layered, and machine-stitched

0799 Ventanas 9, 12" x 12" (30.5 x 30.5 cm): hand-dyed and -painted cotton fabrics, multiple surface design techniques, layered, machine-stitched

0800 Ventanas 16, 12" x 12" (30.5 x 30.5 cm): hand-dyed and -painted cotton fabrics, multiple surface design techniques, layered and machine-stitched

0801 detail of Family Reunion

0802 Ventanas 17, 12" x 12" (30.5 x 30.5 cm): hand-dyed and -painted cotton fabrics, multiple surface design techniques, layered and machine-stitched

0803 Moss Gold, 45" x 58" (1.14 x 1.47 m): hand-dyed and -painted cotton fabrics, multiple surface design techniques, layered, machine- and hand-stitched

0804 detail of Moss Gold

0805 Winter Song, 39.5" x 44.5" (1 x 1.13 m): hand-dyed and -painted cotton fabrics, multiple surface design techniques, layered, machine- and hand-stitched

0806 detail of Winter Song

0807 Blue Moon, 44.5" x 34.5" (1.13 m x 87.5 cm): hand-dyed and -painted cotton fabrics, layered and machine-stitched

0808 Bougainvillea III, 12" x 12" (30.5 x 30.5 cm): marbled silk organza, trapped bougainvillea petals, hand-quilted, burned

0809 Sky's Aura, 22" x 17" (56 x 43 cm): fabric paint, quilting

0810 On Shaky Ground, 22" x 30" (56 x 76 cm): machine trapunto, hand embroidery, hand quilting

0811 Earthly Delights: Paris, 25" x 13" (63.5 x 33 cm): artist-altered digital image printed on fabric with archival ink, machine-quilted

0812 Earthly Delights: Stockholm, 25" x 13" (63.5 x 33 cm): artist-altered digital image printed on fabric with archival ink, machine-quilted

0813 Cock and Bull Story, 24" x 36" (61 x 91.5 cm): dye-printed fabric, discharge, machine and hand embroidery, machine quilting

0814 detail of Cock and Bull Story

0815 Ice Nine Revisited, 42" x 39" (1.065 m x 99 cm): discharge, dye-printed fabric, machine-quilted

0816 detail of Ice Nine Revisited

0817 Cowboy Dreams, 24" x 24" (61 x 61 cm): dye-printed, fabric paint, machine appliqué, hand embroidery

0818 detail of Cowboy Dreams

0819 Sacred Cows, 51" x 53" (1.295 x 1.345 m): hand-dyed fabric, discharge, machine-quilted

0820 Water Colors 3, 17" x 18.5" (43 x 47 cm): cotton painted with water-soluble wax pastels, commercial cotton fabric, machine-appliquéd, over-painted, machine-quilted

0821 Yellow Submarine, 25" x 28" (63.5 x 71 cm): fused hand-dyed cotton, machine-stitched, flakes

0822 Riches of Age, 22" x 24" (56 x 61 cm): heliographic resist, quilting

0823 Celebrating The Model T Era, 38" x 31" (96.5 x 78.5 cm): hardware (door hinge, washers, lock washers), appliqué

0824 detail of Celebrating The Model T Era

0825 Pothole Patchwork, 16" x 24" (40.5 x 61 cm): stitching with metal soda cans, paper cord, sewing machine needle, other mixed media

0826 Monstera, 70" x 63" (1.78 x 1.6 m): silk, silk painting, appliqué

0827 detail of Monstera

0828 detail of Monstera

0829 Rainbow Tower, 52" x 18" (1.32 m x 45.5 cm): machine-pieced and -quilted

0830 Salient, 52" x 18" (1.32 m x 45.5 cm): machine-pieced and -quilted

0831 Art Quilt, 21" x 14" (53.5 x 35.5 cm): fusible appliqué on free-motion quilting background, free-motion embroidery, hand-beaded embellishment

0832 detail of Salient

0833 Samurai, 18" x 52" (45.5 cm x 1.32 m): machine-pieced and -quilted

0834 New Urbanism, 27" x 37" (68.5 x 94 cm): fused hand-dyed cotton, machine-stitched, flakes

0835 detail of New Urbanism

0836 Celebrating Summer, 35" x 35" (89 x 89 cm): layered fabric and organza, machine stitching, machine-appliquéd

0837 Lily Pool, 20.5" x 28.5" (52 x 72 cm): layered fabric and organza, machine stitching, machine-appliquéd

0838 detail of Lily Pool

0839 detail of Celebrating Summer

0840 Florescence, 20" x 34.5" (51 x 87 cm): layered fabric and organza, machine stitching, machine-appliquéd

0841 Falling Together, 61" x 38" (1.55 m x 96.5 cm): shape resist dyed, air-brushed, screen-printed, painted with discharge paste, over-dyed fabrics, hand-dyed wool, acid dyes, hand-pieced and constructed

0842 Handwork, 20.5" x 28.5" (52 x 72.5 cm): hand-dyed and commercial cotton, silk, taffeta, other fabrics, machine-pieced and -appliquéd, hand- and machine-quilted

0843 Petals and Pollen, 25" x 25.5" (63.5 x 65 cm): hand-dyed and commercial cotton and silk, synthetics, machine-pieced, hand-appliquéd, machine- and hand-quilted

0844 Rainforest Dance, 28.5" x 24" (73 x 61 cm): hand-dyed cotton, silk paper, silk, machine-pieced, free machine quilted

0845 detail of Rainforest Dance

0846 detail of Handwork

0847 Leaf Dance, 34.5" x 42" (87.5 cm x 1.065 m): hand-dyed, freehand-cut forms, painted, machine-appliquéd, free-motion embroidery

0848 detail of Leaf Dance

0849 Mountains with Willows, 32" x 30" (81.5 x 76 cm): silk-screened, dye-painted, stamped, immersion-dyed, machine-pieced, machine-quilted

0850 detail of Mountains with Willows

0851 detail of Mountains with Willows

0852 Magic Carpet 50.5" x 42.5" (1.28 x 1.08 m): free cutting, machine-pieced and -quilted, hand-dyed cottons

0853 Acacia Bloom, 18" x 22" (46 x 55 cm): free cutting, hand-painted and -stamped cottons, machine-pieced and -quilted

0854 Autumn Confetti, 12" x 12" (30.5 x 30.5 cm): raw-edge fusible appliqué, free-motion machine quilting

0855 Lake Collage, 12" x 12" (30.5 x 30.5 cm): raw-edge fusible appliqué with untraditional quilting fabrics, free-motion machine quilting

0856 detail of Lake Collage

0857 White Birch Forest, 24" x 20" (61 x 51 cm): fabrics layered under black polyester tulle, free-motion quilting

0858 detail of White Birch Forest

0859 The Pen Is.....: machine-pieced and -quilted, dyed, machine embroidery, raw edge appliqué

0860 Leather Dye Vats in Morocco, 9.8" x 9.8" (25 x 25 cm): hand-dyed fabrics such as cotton, silk pieces, and chamois leather, hand-dyed threads and wool, machine-couched and -stitched

0861 Bird of Paradise: raw edge appliqué, machine-quilted and -dyed

0862 detail of Bird of Paradise

0863 detail of The Pen Is.....

0864 Broken Fence: machine-pieced and -quilted, dyed, painted, felted

0865 Our Town, 34" x 38" (86.5 x 96.5 cm): cotton, oilcloth, appliqué, painting, machine quilting, machine embroidery, bead and sequin embellishment

0866 Totally Tarantula, 24" x 24" (61 x 61 cm): cotton, oilcloth, sequins, bottle caps, beads, machine embroidery, machine appliqué, machine quilting

0867 detail of Totally Tarantula

0868 Do the Chicken Dance, 15" x 14" (38 x 35.5 cm): cotton, oilcloth, beads, sequins, paint, buttons, machine appliqué, machine quilting

0869 detail of Do the Chicken Dance

0870 The Giddyup Girls, 15" x 14" (38 x 35.5 cm): cotton, oilcloth, sequins, beads, paint, machine appliqué, machine quilting

0871 detail of The Giddyup Girls

0872 The Hoedown, 16" x 59" (40.5 cm x 1.5 m): appliqué, painting, machine quilting, bead and sequin embellishment

0873 detail of The Hoedown

0874 Yangtze Fantasy, 31" x 43" (78.5 cm x 1.09 m): cotton, oilcloth, paint, sequins, beads, hand embroidery, machine quilting

0875 detail of Yangtze Fantasy

0876 Talk to Me 2, 13" x 13" (33 x 33 cm): coffee-dyed fabric, monoprinting, image transfer, handwriting, hand stitching

0877 Anthills: Study in Gold, 30" x 31.25" (76 x 79.5 cm): hand dyed cotton, hand rusted, monoprinted, hand-stitched, machine-quilted, hand-painted

0878 Talk to Me 8, 30.5" x 37" (77.5 x 94 cm): coffee-dyed fabric, painting, screen printing, handwriting, hand-stitched

0879 detail of Talk to Me 8

0880 Autumn Enchantment, 67" x 89" (1.7 x 2.26 m): small pieces and painted objects covered with tulle, machine-embroidered and -quilted

0881 detail of Autumn Enchantment

0882 detail of Autumn Enchantment

0883 detail of Radiant Reflections

0884 Radiant Reflections, 80" x 66" (2.03 x 1.675 m): small pieces and painted objects covered with tulle, machine-embroidered and -quilted

0885 Tooth and Nail, 53" x 58" (1.345 x 1.475 m): machine-pieced, hand-quilted, embroidered, beaded, machine appliqué, digital printing

0886 detail of Tooth and Nail

0887 detail of Tooth and Nail

0888 Deep Vent Garden, 50.5" x 19" (1.285 m x 48.5 cm): hand-dyed and commercial cotton, hand-cut and fuse-appliquéd, machine-appliquéd, hand-embroidered, beaded, machine-quilted

0889 Last Clear Chance, 18" x 18" (45.5 x 45.5 cm): hand-dyed, hand-painted, and commercial cotton, hand-dyed thread, hand-cut and fuse-appliquéd, hand-embroidered, machine-quilted

0890 Wings and Arrows, 53" x 42" (1.345 x 1.065 m): machine piecing, hand quilting, embroidery, beading, reverse appliqué

0891 detail of Wings and Arrows

0892 Alchemy, 18" x 30" (45.5 x 76 cm): repurposed, collected, painted and dyed cloth, polished stones, machine- and hand-stitched

0893 Reclamation Earth Statement, 24" x 59" (61 cm x 1.5 m): scraps of commercial and hand-dyed material, selvages, painted fabric, Bounce dryer sheets, fruit and vegetable packaging, old clothing, Starbucks coffee huggers, dryer lint, and other mixed media

0894 Weavings #22, 26.5" x 22" (67.5 x 56 cm): shibori-dyed cotton fabrics, fused, machine-stitched

0895 Weavings #20 Red/Black, 66" x 48" (1.675 x 1.22 m): shibori-dyed cotton fabrics, fused, machine-stitched

0896 detail of Weavings #20 Red/Black

0897 Sunrise: hand-dyed and commercial fabrics, fabric folded flowers, embroidery, beading, and machine quilting

0898 Weavings #24, 20" x 30.5" (51 x 77.5 cm): shibori-dyed cotton fabrics, fused, machine-stitched

0899 Fireball, 50" x 76" (1.27 x 1.93 m): cyanotypes on cotton and silk, heliographic prints on silk, digital prints on cotton and silk, commercial and hand-painted fabrics, hand embroidery, machine stitching

0900 detail of Fireball

0901 detail of Fireball

0902 Cold Cave, 34" x 38" (86.5 x 96.5 cm): digital prints on silk and cotton, commercial and hand-painted fabrics, couched threads, machine stitching, hand beading

0903 detail of Cold Cave

0904 November PawPaw, 40" x 42" (1.015 x 1.065 m): cyanotype on silk, vintage crochet work, commercial and hand-painted silks, wools, and corduroy, machine stitching, hand beading

0905 Lady of the Lake, 21" x 28" (53.5 x 71 cm): photo transfer, needle felting, machine stitching

0906 Wildfires II, 30" x 28" (76 x 71 cm): hand-dyed, hand-screened fabric, raw-edge appliqué, machine stitching

0907 Bridge I, 44" x 52" (1.12 x 1.32 m): hand-dyed fabric, raw-edge appliqué, machine stitching

0908 detail of Bridge I

0909 Behold, 15' x 71" (4.57 x 1.8 m): photo-transfers, hand-dyed fabric, machine-pieced and -quilted

0910 detail of Behold

0911 Cone Flowers, 46" x 62" (1.17 x 1.575 m): photo-transfers, hand-dyed fabric, machine-pieced and -quilted

0912 Dichotomies in Brown, 70" x 78" (1.78 x 1.98 m): photo-transfers, various new and vintage fabrics, machine-pieced and -quilted

0913 Composition IX, 46" x 48" (1.17 x 1.23 m): stitched textile with acrylic paint

0914 detail of Composition IX

0915 Composition VIII, 39" x 39" (99 x 99 cm): stitched textile with acrylic paint

0916 Horizon IV, 24" x 24" (61 x 61 cm): stitched textile with acrylic paint

0917 Façade V, 39" x 66" (99 cm x 1.68 m): stitched textile with acrylic paint

0918 detail of Façade V

0919 Façade II, 40" x 66" (1 x 1.68 m): stitched textile with acrylic paint

0920 detail of Façade II

0921 Boundary Waters 31 (North), 10.25" x 8.75" (26 x 22 cm): upholstery fabric, white cotton cloth, paint felt, organza, copper wire mesh, painted, burned, stitched

0922 Summer Rain, 28" x 40" (71 cm x 1.015 m): machine piecing, hand and machine quilting

0923 Dusk, 36" x 36" (91.5 x 91.5 cm): hand and maching piecing, hand and machine quilting, appliqué, prairie points, fabric painting

0924 detail of Dusk

0925 Sounds of Music #2 / Chopin, 35" x 14" (89 x 35.5 cm): hand piecing, machine quilting, beading, embellishment

0926 Fragile 1, 15" x 12" (38 x 30.5 cm): hand-dyed fabric, hand stitching, beading

0927 detail of Sounds of Music #2 / Chopin

0928 Two Trunks, 32" x 39" (81.5 x 99 cm): potato dextrin resist on cotton, hand-painted with dye and immersion dyed fabric, machine-quilted

0929 Structures #99, 33" x 39" (84 x 99 cm): hand-dyed fabric, freehand cut, pieced, machine-quilted

0930 Structures #60, 33" x 89" (84 cm x 2.26 m): hand-dyed fabric, freehand cut, pieced, machine quilted

0931 Structures #57, 33" x 66" (84 cm x 1.675 m): hand-dyed fabric, freehand cut, pieced, machine-quilted

0932 detail of Structures #57

0933 Sumac, 40" x 56" (1.015 x 1.42 m): helio-graphic prints on cotton and silk fabrics, seminole patchwork, machine stitching, hand beading

0934 detail of Sumac

0935 Dulce et Decorum Est, 49" x 53.5" (1.245 x 1.36 m): hand-dyed, screen-printed, and commercial cotton, hand-cut, die-cut, fuse-appliquéd, hand-embroidered, machine-quilted

0936 detail of Dulce et Decorum Est

0937 Labyrinth 3: A Lifetime of Learning, 56" x 56" x 2.5" (1.42 m x 1.42 m x 6.5 cm): hand-dyed, hand-screenprinted, and commercial cotton, electric rice lights, hand-cut, die-cut, fuse-appliquéd, machine-quilted, lighting on transformers so lights flicker in

0938 detail of Labyrinth 3

0939 Blue Fence, 40" x 45" (1.015 x 1.145 m): hand-dyed fabric, fused appliqué, machine-quilted

0940 detail of Blue Fence

0941 Orchards, Fields, and Streams, 47" x 47" (1.195 x 1.195 m): hand-dyed fabric, fused appliqué, machine-quilted

0942 detail of Orchards, Fields, and Streams

0943 Devil's Backbone, 53" x 10" (1.345 m x 25.5 cm): potato dextrin and bleach/monogum application, screen printing (deconstruction/abstract/break-down), fused fabric collage, machine stitching

0944 Aspen Solace, 76" x 40" (1.93 x 1.015 m): screen printing (deconstruction/abstract/break-down), shibori dying, fused fabric collage, machine stitching

0945 detail of Devil's Backbone

0946 detail of Aspen Solace

0947 Road to Endo Valley, 18" x 28" (45.5 x 71 cm): screen printing (deconstruction/abstract/breakdown), shibori dying, fused fabric collage, machine stitching

0948 On Thin Ice, 71" x 56" (1.805 x 1.42 cm): machine-pieced fabrics, hand embroidery, machine appliqué and quilting

0949 detail of On Thin Ice

0950 detail of Egoli—Place of Gold

0951 Egoli—Place of Gold, 39.5" x 35.5" (1 m x 90 cm): machine-pieced and -appliquéd, hand-embroidered, and machine-quilted

0952 In Good Hands, 51" x 51" (1.295 x 1.295 m): hand-dyed, overdyed, printed, discharged, stitched, assembled

0953 detail of In Good Hands

0954 Cutting the Carbs—Shedding the Lbs., 71" x 56.5" (1.8 x 1.44 m): improvisational cut and fused, digital transfer wording

0955 Rhosyn Du (Black Rose), 57" x 91" (1.45 x 2.31 m): improvisational cut, layered, fused, machine-stitched and -quilted

0956 detail of Twenty Four Hour Care

0957 Twenty Four Hour Care, 72" x 72" (1.83 x 1.83 m): variety of fabrics including hand-dyed and tapestry, machine- and hand-pieced, hand-stitched with St. George Crosses

0958 Husband and Wife, 64" x 92" (1.625 x 2.335 m): spray-dyed cotton, entirely hand-sewn, hand appliqué and beading, quilted with hand-embroidered chain stitch

0959 detail of Husband and Wife

0960 Green Apple Martini, 13" by 20" (33 x 51 cm): hand-dyed bamboo poplin, fused angelina fibers, hand-dyed cheesecloth, mixed media, thread painting, and machine quilting

0961 Olde Fashion Romance, 20" x 20" (51 x 51 cm): machine-pieced silks and other fabrics, paint, hand embroidery, lace made of beads, hand-beaded

0962 Fingerprints, 21" x 41" (53.5 cm x 1.04 m): monoprinted dye on silk noil, whole cloth, machine-quilted

0963 Home Before Dark, 50.5" x 39" (1.285 m x 99 cm): machine-pieced and -quilted cottons

0964 detail of Home Before Dark

0965 detail of Home Before Dark

0966 Through the Woods at Dusk, 48" x 41.5" (1.22 x 1.055 m): machine-pieced and -quilted cottons

0967 Along the Winner Creek Trail, 39" x 68" (99 cm x 1.725 m): machine-pieced and -quilted cottons

0968 detail of Along the Winner Creek Trail

0969 Threading Through the Gravel Bars, East Fork of the Toklat, 48.5" x 67.5" (1.23 x 1.715 m): machine-pieced and -quilted cottons

0970 detail of Threading Through the Gravel Bars, East Fork of the Toklat

0971 Emily Carr Visited Me, 27" x 73" (68.5 cm x 1.855 m): hand-painted rayon, machine piecework, hand appliqué and beadwork, quilted with hand-embroidered blanket stitch

0972 detail of Emily Carr Visited Me

0973 detail of Emily Carr Visited Me

0974 Purple House, 12" x 12" (30.5 x 30.5 cm): free-motion machine embroidery with fused appliqué and beads

0975 A Place of Refuge Beneath a Starry Sky, 12" x 12" (30.5 x 30.5 cm): free-motion machine embroidery with fused appliqué

0976 Pipedreams, 20" x 20.25" (51 x 51.5 cm): fabric paints and markers, beading, hand and machine stitching, various yarns and threads, hardware, other embellishments

0977 detail of Pipedreams

0978 West Virginia Vista: hand-dyed fabric, fusible webbing, maching quilting

0979 Celebrating Isiphephetu (Womanhood): machine-pieced and -quilted, embellished with Zulu womens' handmade bead artifacts and own bead embellishments

0980 Tree Frog, 21.5" x 19" (54 x 48 cm): appliquéd, stitched, acrylic paint, burnout

0981 detail of Tree Frog

0982 detail of Celebrating Isiphephetu (Womanhood)

0983 Saragasso Sea, 61.5" x 52.5" (1.56 m x 1.335 m): commercial fabrics, flour paste resist, textile and acrylic paints, monoprinted, hand- and machine-stitched, hand beading

0984 detail of Saragasso Sea

0985 Signs of Summer, 44" x 44" (1.12 x 1.12 m): commercial fabric, roofer's felt, polymer clay, embellishments, machine and hand stitching

0986 Zen Moon, 25" x 14" (63.5 x 35.5 cm): hand-dyed and commercial cotton, hand-cut and fuse-appliquéd, machine-appliquéd, oil stick shading, hand-embroidered, machine-quilted

0987 Constellation 1, 10" x 22" (25.5 x 56 cm): cottons with cotton quilting thread, wool embroidery thread, Swarovski crystals, quilted, embroidery, beading

0988 Signs of Spring, 36" x 36" (91.5 x 91.5 cm): commercial fabric, kimono fabric, embellishments, machine stitching

0989 Berber-design-inspired Quilt / Wrap, 64" x 50" (1.625 x 1.27 m): space-dyed cotton, stained with rust, then screen-printed, hand embroidered

0990 Mother Tree, 10" x 20" (25 x 51 cm): commercial and hand-dyed cotton and linen, threads, oil paint sticks, water-soluble fabric, hand quilting

0991 detail of Berber-design-inspired Quilt / Wrap

0992 Google Earth: Orinoco Delta, 39" x 49" (99 cm x 1.245 m): dyed, painted, printed, and stitched cloth

0993 Angel Falls, 27" x 31" (68.5 x 78.5 cm): dyed, painted, printed, and stitched cloth

0994 detail of Angel Falls

0995 Venezuelan Symphony, 37" x 39" (94 x 99 cm): dyed, painted, printed, and stitched cloth

0996 detail of Venezuelan Symphony

0997 Chinatown, 18" x 34" (45.5 x 86.5 cm): dyed, painted, printed, and stitched cloth

0998 Urban Grit, 35" x 39" (89 x 99 cm): dyed, painted, printed, and stitched cloth

0999 detail of Urban Grit

1000 Winter: Burnt Trees, 60" x 45" (1.525 x 1.145 m): machine-pieced and -quilted, raw edge appliquéd, commercial- and hand-dyed fabrics, machine-embellished

Artist Directory

A

Deidre Adams, USA
deidre@deidreadams.com
www.deidreadams.com
0913, 0914, 0915, 0916, 0917,
0918, 0919, 0920

**Sandra Adams, The Nature of
Things,** USA
sandyadams@mac.com
www.thenatureofthingsonline.com
0050, 0103, 0104, 0105, 0246,
0271, 0334, 0381, 0388, 0571,
0572, 0675

Sue Akerman, South Africa
hakerman@iafrica.com
www.fibreworksart.com
0762, 0763, 0764

**Hope Gelfand Alcorn, Joyful
Noise Studio,** USA
halcorn@aol.com
www.joyfulnoisestudio.com
0621, 0622, 0625, 0626, 0629

Brigitte Amarger, France
brigitte.amarger@gmail.com
0282, 0653, 0655, 0656

Marta Amundson
USA
artquilter@wyoming.com
www.artistsregister.com
0811, 0812, 0813, 0814, 0815,
0816, 0817, 0818, 0819

Ludmila Aristova, USA
ludmila.aristova@mac.com
www.ludmilaaristova.com
0922, 0923, 0924, 0925, 0927

Elizabeth Armstrong, Australia
elizaclaire@optusnet.com.au
www.frostfair.com
0042, 0100, 0555, 0594

Bethan Ash, UK
0716, 0954, 0955

Vivian Helena Aumond-Capone,
USA
vivianhelena@sti.net
www.vivianhelena.com
0727, 0728

Rosalind Aylmer, Canada
rosaqed@shaw.ca
0098, 0099

B

Joei Bassett, Art That's Felt, USA
ejaglady@cox.net
www.ArtthatsFelt.blogspot.com
0349, 0376, 0377

Linda Beach, USA
lbeach@gci.net
www.lindabeachartquilts.com
0963, 0964, 0965, 0966, 0967,
0968, 0969, 0970

Helga Beaumont, South Africa
helga@adoptimise.com
www.fibreworksart.com
0860

**Ulrieke Benner, Art You Wear in
Felt & Silk,** Canada
ulrieke@ulriekebenner.com
www.ulriekebenner.com
0039, 0043, 0044, 0051, 0054,
0086, 0087, 0199

Patty Benson, Papaver Vert, USA
papaververt@gmail.com
www.papaververt.com
0325, 0337, 0360

Terry Bibby, Saori Salt Spring,
Canada
saltspringweaving@gmail.com
www.saorisaltspring.com
0603, 0604

Dana Biddle, South Africa
biddles@telkomsa.net
www.fibreworksart.com
0226, 0474, 0476

Charlotte Bird, USA
cbird2400@aol.com
www.birdworks-fiberarts.com
0888, 0889, 0935, 0936, 0937,
0938, 0986

Sue Bleiweiss, USA
suebleiweiss@yahoo.com
www.suebleiweiss.com
0145, 0351

Saundra Stavis Bohl, USA
ssbohl@aol.com
0285

**Annette Boncek, LIfe Scenes,
Ltd.,** USA
annette@TextileArtStudio.com
www.TextileArtStudio.com
0308

Elena Bondar, USA
yvbondar@gmail.com
www.elenabondar.com
0148, 0151, 0153, 0185, 0661

**Tracy Borders, Squiggle Chick
Designs,** USA
tracy@squigglechickdesigns.com
www.squigglechickdesigns.com
0960

Claire Boulat, USA
claireboulat@gmail.com
0171, 0231

**Natalie Boyett, The Chicago
Weaving School,** USA
natalieboyett@me.com
www.chicagoweavingschool.com
0313, 0537, 0563

Christine Boyle, Northern Ireland
christineboyle140@googlemail.com
0152, 0568

Norma Bradley, USA
normabradley@mindspring.com
www.normabradley.com
0847, 0848, 0892

Evelyne Alioc Bridier, France
evelyne.bridier@orange.fr
www.barokbazar.canalblog.com
0070

Gill Brooks, Australia
gilbrooks@smartchat.net.au
www.handmadefelt.com.au
0143, 0219, 0259, 0310, 0375

Ali Brown, Heart Felt Art, UK
alison@heartfeltart.co.uk
www.heartfeltart.co.uk
0416, 0417

Gina M. Brown, USA
thebrownsupnorth@sbcglobal.net
0306, 0307, 0363, 0580

Shelley Brucar, USA
shelley@handmade-memories.com
www.handmade-memories.com
0905, 0906, 0907, 0908

Mary-Clare Buckle, UK
mary-clare.buckle@1-art-1.com
www.1-art-1.com
0591, 0592, 0593

Betty Busby, USA
fbusby3@comcast.net
www.home.comcast
.net/~bbusbyarts
0748, 0749, 0826, 0827, 0828

Joemy Buschur, USA
joemybuschur@mac.com
www.joemybuschur.com
0234

C

Lisa Call, USA
lisa@lisacall.com
www.lisacall.com
0929, 0930, 0931, 0932

Betsy Cannon, USA
BetsyHCannon@comcast.net
www.BetsyCannon.com
0865, 0866, 0867, 0868, 0869,
0870, 0871, 0872, 0873, 0874,
0875

Nora Cannon, Cannon Fine Arts,
USA
www.cannonfinearts.com
0372, 0585

Leslie C. Carabas, USA
lmail@carabas.org
www.leslie.carabas.org
0829, 0830, 0832, 0833

Rachel Castle, UK
rhcastle@blueyonder.co.uk
0037, 0038, 0155, 0357

Sue Cavanaugh, USA
scavanau@columbus.rr.com
www.suecavanaughart.com
0774, 0775, 0776, 0777, 0778,
0779

Toni Cavey, New Zealand
caveyz@ihug.co.nz
0980, 0981

Mariana Ciliberto, Florcita, The
Netherlands
mariana.ciliberto@kpnplanet.nl
www.florcita.eu
0140, 0141, 0164, 0165, 0197,
0198, 0220, 0221, 0516, 0519

**Liz Clay coat fabric produced for
Stella McCartney,** UK
liz@lizclay.co.uk
www.lizclay.co.uk
0001, 0002, 0003

Akemi Nakano Cohn, USA
jackemi@rcn.com
www.akemistudio.com
0488, 0489, 0490, 0491

Sas Colby, USA
sas@sascolby.com
www.sascolby.com
0596

Carol Coleman, UK
carol@fibredance.co.uk
www.fibredance.com
0272, 0615, 0616

Katherine L. Colwell, USA
imaginerivendell@tds.net
www.ImagineRivendell.com
0469, 0473

**Sharon Costello, Black Sheep
Designs,** USA
sharon@blacksheepdesigns.com
www.blacksheepdesigns.com
0335, 0384, 0385, 0386, 0387

**Kim Crayton, Queen Heron Cre-
ations,** USA
queenheroncreations@gmail.com
www.queenheroncreations.etsy.com
0336

**Creative Textile + Quilting Arts,
Linda Matthews,** USA
linda@creative-textile-and-quilting-
arts.com
www.creative-textile-and-quilting-
arts.com
0370, 0371, 0831

Lee Creswell, UK
cnlcreswell1@gmail.com
www.saa.co.uk/art/LeeCreswell
0683

Sue Crook, UK
sulphursue@yahoo.co.uk
www.frayededges.co.uk
0536

Rebecca Cross, USA
rebcross@gmail.com
www.rebeccastextiles.com
0409, 0410, 0411, 0412, 0413,
0414, 0415

Heather Crossley, Australia
mkhc@powerup.com.au
http://homepage.powerup.com
.au/~mkhc
0212

Martha Crotty, USA
crottymartha@yahoo.com
0570, 0573

**Patti Medaris Culea, PMC
Designs,** USA
patti@pmcdesigns.com
www.pmcdesigns.com
0182

D

Brigit Daamen, The Netherlands
info@brigitdaamen.nl
www.brigitdaamen.nl
0150, 0193

Rosalie Dace, South Africa
rdace@iafrica.com
www.rosaliedace.co.za
0765, 0842, 0843, 0846

Caroline Marcum Dahl, USA
cdahlplay@earthlink.net
www.carolinedahl.net
0136, 0431, 0432, 0433, 0434,
0435, 0436, 0437, 0438

**Marjolein Dallinga, Bloomfelt.
com,** Canada
marjolein@bloomfelt.com
www.Bloomfelt.com
0058, 0093, 0109, 0110, 0115,
0233

Janet Daniel, USA
jdweaving@pobox.com
www.jdweaving.com
0642, 0643

**Kath Danswan, Danswan
Designs,** UK
kath@danswandesigns.co.uk
www.danswandesigns.co.uk
0253, 0254, 0574, 0575

Victoria J. Davis, Canada
ddavis1@shaw.ca
www.periwinkleartstudios.com
0181

Ruth de Vos, Australia
ruth@ruthdevos.com
www.ruthdevos.com
0741, 0742, 0743, 0744, 0745

Della Lana, The Netherlands
info@dellalana.com
www.dellalana.com
0081, 0084, 0154, 0158, 0238,
0239, 0240, 0268, 0269, 0274,
0378, 0380

Sue Dennis, Australia
info@suedennis.com
www.suedennis.com
0877

Amy DiPlacido, USA
amydiplacido@yahoo.com
www.amydiplacido.com
0480, 0548

Kristie Carlisle Duncan, USA
klcarlisle@hotmail.com
www.thefamilychicken.blogspot.com
0419, 0420, 0421, 0422, 0423

E

**Penny Eamer, Teamwork Handi-
crafts,** Australia
kryssleigh@optusner.com.au
www.teamworkhandcrafts.com.au
0267

Dawn Edwards, Felt So Right,
USA
dawn@feltsoright.com
www.feltsoright.com
0139, 0213, 0214

Nancy Eha, USA
nancyeha@beadcreative.com
www.beadcreative.com
0624, 0627, 0635, 0961

Eleanornadimi.com, UK
ele.nadimi@hotmail.co.uk
www.eleanornadimi.com
0366, 0367, 0368

Noriko Endo, Japan
norikoendojp@yahoo.co.jp
0880, 0881, 0882, 0883, 0884

F

Susan Fecho, USA
0512

**Emily Felderman, Emily Felder-
man, LLC,** USA
emily@emilyfelderman.com
www.emilyfelderman.com
0439, 0440, 0441, 0442, 0443

**Deborah Fell, Deborah Fell Art
Quilts,** USA
art@deborahfell.com
www.deborahfell.com
0893

Felted Chicken, Christine Prusha,
USA
feltedchicken@live.com
www.feltedchicken.etsy.com
0346, 0347

Felted Style, Karen Hewig, USA
info@feltedstyle.com
www.feltedstyle.com
0314, 0354, 0355, 0356, 0358,
0390, 0393, 0395, 0583

Maria-Theresa Fernandes, UK
mariatheresafernandes@yahoo.co.uk
www.mariatheresafernandes.org
0529, 0530, 0531, 0579, 0581,
0684

Fibredesign, Saundra K. Adair,
USA
fibredesign@charter.net
www.craftguild.org;
www.fibredesignsandyadair.com;
www.fiberdesignsandyadair.com
0678, 0679, 0680

Kathleen Field, USA
kdfield1@gmail.com
www.kathleenfield.com
0747

Jeri L. Flom, USA
jeriflom@comcast.net
0263, 0428, 0429, 0430, 0670,
0671, 0672, 0673, 0674

Anne Flora, FloraWorks, USA
aflora@umich.edu
www.floraworks.org

0040, 0041, 0102, 0270, 0668,
0676, 0677

Jette Ford, Australia
ford@brightontown.com.au
0859, 0861, 0862, 0863, 0864

Heather Forman, USA
h2formans@bellsouth.net
www.heatherforman.com
0108, 0348, 0382

Maggie French, USA
maggiemay1973@hotmail.com
www.maggiefrench.net
www.sweetmaggiemay.blogspot.com
0215

**Sandra Yasmin Fuchshofen, Elf-
enzARTes und Verwunschenes,**
Germany
info@elfenzartes.de
www.elfenzartes.de
0137, 0170, 0173, 0174, 0178,
0188, 0237, 0264

G

Debora Galaz, Lana de Flor, USA
lanadeflor@yahoo.com
www.lanadeflor.etsy.com
0176, 0218, 0281, 0283

Madelyn Garrett, USA
madega@comcast.net
0645, 0658, 0659, 0660

Heike Gerbig, Germany
hgerbig@gmail.com
gerdiary.blogspot.com
0795, 0796, 0797

**Jenne Giles, Harlequin Felt-
works,** USA
jenne@harlequinfeltworks.com
www.harlequinfeltworks.com
0047, 0048, 0056, 0111, 0112,
0169

Marilyn Gillis, USA
marilyngillis@gmail.com
0780, 0781, 0782, 0783, 0784,
0785, 0786, 0792, 0808

**Diane Gonthier, Les Ateliers D'un
Pas Feutré,** Canada
info@savoir-faire-textile.com
www.savoir-faire-textile.com
0035, 0342, 0343, 0558

Andrea Graham, Canada
graham_andrea@cogeco.ca
www.andrea-graham.com
0685, 0686, 0687

Heidi Greb, Filz-Kleider-Kunst,
Germany
heidi_greb@gmx.de
0052, 0053

Erika Sojkova Grime, UK
sojkova1@gmail.com
sojkova1.googlepages.com
0503, 0504, 0505, 0506

H

Robin L. Haller, USA
rhaller@kent.edu
0262

Anne J. Hand, USA
handa@philau.edu
faculty.philau.edu/handa
0078, 0106, 0107, 0113

Kathryn Harmer, South Africa
kathryn.kathy@telkom.sa.net
0576, 0577, 0578

Debra A. Hartranft, USA
dahart1@ptd.net
www.dahartranft.com
0318, 0321, 0350, 0392, 0551,
0552

Patti Haskins, USA
phaskins@swbell.net
www.pattihaskins.com
0623

Abby Hathaway, USA
abbyhathaway@live.com
www.abbyhathaway.etsy.com;
ww.abbyhathaway.carbonmade.com
0200, 0201, 0258, 0287, 0288

Patty Hawkins, USA
hawknestpw@gmail.com
www.pattyhawkins.com
0943, 0944, 0945, 0946, 0947

Jenny Hearn, Just The Ticket,
South Africa
kabewhy@iafrica.com
0612, 0948, 0949, 0950, 0951

Ana Lisa Hedstrom, USA
hedstorms@earthlink.net
0681

Heloise, UK
0255, 0284

Karen Henderson, USA
karenhendersonfiber@yahoo.com
www.karenhendersonfiber.com
0688, 0689, 0690, 0691, 0692,
0693, 0694, 0695, 0696, 0697

**LisaLi Hertzi, LisaLi Hertzi
Design,** USA
lihertzi@lihertzidesign.com
www.lihertzidesign.com;
www.artdolladventures.com
0601, 0602

Michelle Holmes, UK
michelle@archangelstudio.co.uk
www.archangelstudio.co.uk
0550

Ginny Huber, USA
ginny@ginnyhuber.com
www.ginnyhuber.com
0180, 0203

Anni Hunt, Canada
annihunt@me.com
www.annihunt.com
0338, 0339, 0462, 0463

**Marylin Huskamp, Marilyn's
Nouvelle Collection,** USA
marylinsnouvelle@yahoo.com
marylinsnouvelle.blogspot.com
0517

**Tracie Lyn Huskamp, The Red
Door Studio,** USA
TheRedDoorStudio@yahoo.com
www.TheRedDoor-Studio.blogspot
.com
0514, 0515

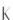

Sidney Savage Inch, USA
savagefiberarts@sbcglobal.net
www.savagefiberarts.com
0477, 0682

Carol Ingram, USA
carol@kiadvertising.com
0241, 0303, 0361, 0374

Ema Ishii, USA
emaishii@hotmail.com
www.emaishii.com
0033

Natalie Isvarin-Love, USA
natalieisvarin_love@hotmail.com
0897, 0978

J

Miriam W. Jacobs, USA
veggiemert@verizon.net
www.merteltheturtlefabricarts.com
0247, 0556

JANCIA, Jan McMillan, UK
janmcmillan@hotmail.com
0012, 0013, 0077

Corryna Janssen-Geers, The
Netherlands
corryna@home.nl
www.corryna.blogspot.com
0990

Ann Johnston, USA
aj@annjohnston.net
www.annjohnston.net
0698, 0699, 0700, 0701, 0702,
0705, 0706, 0707, 0708, 0709,
0710, 0712, 0724, 0725, 0928,
0962

K

Lotta-Pia Kallio, Finland
lotta-pia.kallio@hotmail.com
www.flickr.com/photos/45996764@
N00/
0424, 0425, 0426, 0427

Jean Fortune Kaplan, USA
jeankaplan@bellsouth.net
0444, 0586

Bonnie J. Kay, USA
bjkay@umich.edu
0455, 0456

Olga Kazanskaya, KOKOON,
Germany
kazans123@hotmail.com
www.kokonok.etsy.com
0157, 0183, 0187, 0211, 0242,
0260, 0261, 0275

Ann Baddeley Keister, USA
keistera@gvsu.edu
www.annbkeister.com
0885, 0886, 0887, 0890, 0891

**LaVerne Kemp Handwovens,
LaVerne Kemp,** USA
gypsygal5@aol.com
www.thewarpedweaver.blogspot.com
0004, 0005, 0248

**Heather Kerner, Spiralworks
Fiber Studio,** USA
info@spiralworksfelt.com
www.spiralworksfelt.com
0266, 0273, 0280

Barbara G. Kile, USA
barbara@bkdd.com; kilebar@
rice.edu
www.bkdd.com
0168, 0190, 0216, 0327, 0345,
0394, 0397

Linda Kittmer, Canada
lkittmer@cogeco.ca
0522

Catherine Kleeman, USA
cathy@cathyquilts.com
www.cathyquilts.com
0798, 0799, 0800, 0801, 0802,
0803, 0804, 0805, 0806, 0807

Jennifer Krage, USA
skrage2@att.net
0665

Susie Krage, USA
skrage2@att.net
0553, 0554, 0669

Susan Krahn, USA
sekrahn@hotmail.com
www.feltingsbysusan.blogspot.com
0468

Lynn Krawczyk, USA
FibraArtysta@earthlink.net
www.FibraArtysta.com
0876, 0878, 0879, 0926

Kate Kretz, USA
kkretz4art@aol.com
www.katekretz.com
0666, 0667

L

Denise Labadie, USA
denise@labadiefiberart.com
www.labadiefiberart.com
0753, 0754, 0755, 0756, 0757,
0758, 0759, 0760, 0761

**Sarah Harrington Lajoie, Attitude
Hats,** USA
attitudehats@comcast.net
www.AttitudeHats.com
0205, 0206, 0207, 0208, 0243

**Jacqueline Lams, Studio Lams,
LLC,** USA
jackie@studiolams.com
www.studiolams.com
0316, 0317, 0544, 0726, 0729,
0976, 0977

**Jody Pearl Lange, Sew Outside
the Lines,** Australia
jodypearl@westnet.com.au
www.jodypearl.com
0011, 0067, 0068, 0095, 0096

Jenny Langley, UK
jenny@darknessandlight.co.uk
www.fibrefusion.org.uk
0989, 0991

Janice M. Lawrence, UK
janicemlawrence@gmail.com
0528

Michele C. Leavitt, USA
leavitt25@cox.net
www.michelecleavitt.com
0711, 0715, 0720, 0721

**Carol LeBaron, Carol LeBaron
Fine Art Textiles,** USA
clebaron@embarqmail.com
www.carollebaron.com
0605, 0606, 0607, 0608, 0609,
0610, 0611

Debra M. Lee, USA
0217

Erica Licea-Kane, USA
erica.licea-kane@comcast.net
www.licea-kane.com
0464, 0465, 0466, 0467

Heidi Lichterman, UK
info@heidilichterman.co.uk
www.heidilichterman.co.uk
0630, 0631, 0632, 0633, 0634

**Lillian Jackson Textile Design,
Jacqueline Kilmartin,** USA
jkilmart@gmail.com
www.lillianjackson.com
0022, 0023

Ann Loveless, Quilts by Ann, USA
annlove@charter.net
www.QuiltsbyAnn.com
0854, 0855, 0856, 0857, 0858

**KC Lowe, Aurora Dreams,
Nunofelt Originals,** USA
kc@kclowe.com
www.kclowe.com
0008, 0014, 0015, 0016, 0045,
0073, 0101, 0114, 0146, 0195,
0196

Fulvia Boriani Luciano, USA
fulvialuciano@yahoo.com
www.fulviastudio.blogspot.com
0992, 0993, 0994, 0995, 0996,
0997, 0998, 0999

So Yoon Lym, USA
so.yoon.lym@gmail.com
www.soyoonlym.com
0597, 0598, 0599, 0600

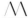

Julia Manitius, Canada
julia@urbanity.ca
www.raacollection.com
0326

Sharon Markovic, USA
sewaquilt01@gmail.com
0985, 0988

Judy Martin, Canada
njmartin@vianet.on.ca
www.judithmartin.info
0956, 0957, 0958, 0959, 0971,
0972, 0973

Doroth Mayer, USA
doroth@earthlink.net
0766, 0767

Carol McGill, Australia
mcsparg@bigpond.net.au
www.libode.blogspot.com
0277, 0278

Ben K. Mickus, Mickus Projects,
USA
ben@mprojects.com
www.mickusprojects.com
0311, 0312

Julie Mitchell, USA
JulieMitchell_art@sti.net
www.JulieMitchell.EBSQART.com
0644, 0646, 0647

Hiroko Miyama, Japan
attractive-yuri@bd.wakwak.com
0787, 0788, 0789, 0790, 0791

Maj-Britt Mobrand, USA
mmobrand@yahoo.com
0481, 0482, 0486, 0487

Ann Morton, USA
annmorton@mac.com
0304, 0305, 0352, 0353, 0507,
0508, 0509, 0510, 0511

Shula Mustacchi, USA
shulamust@optonline.net
0768, 0769, 0770, 0771

N

Ree Nancarrow, USA
reenan@mtaonline.net
0849, 0850, 0851

Sylvia Naylor, Canada
sylvia.naylor@sympatico.ca
www.sylvianaylor.com
0974, 0975

Nysha Nelson, Studio Nysha, USA
nyshao@comcast.net
www.studionysha.blogspot.com
0809, 0810, 0987

Niki Newkirk, USA
nnewkirk@charter.net
0223, 0224, 0225

Nicole Alexis Nydza, USA
nicole.nydza@gmail.com
www.nnydza.tumblr.com
0333

O

Lynn Ocone, USA
lynnocone@aol.com
0079, 0080, 0082, 0083, 0302,
0328

Jane Ogren, USA
janeogren@verizon.net
www.janeogren.com
0383, 0492, 0493, 0494, 0495,
0496, 0497, 0498, 0499, 0500,
0534, 0535

Yoriko Oki, Canada
www.woventhreads.ca
0066, 0235, 0236

Lorraine Oller, USA
loller02@yahoo.com
0331

P

Sharron Parker, USA
sharron@sharronparker.com
www.sharronparker.com
0557, 0559, 0561

Gail Perrone, Catfish Studio, USA
www.catfishstudiofelt.com
0194, 0249

Martine Peters, USA
mpwoven@fastmail.com.au;
martinepeters.com.au;
www.mpwoven.com.au
0324, 0404, 0405, 0406, 0407

Gail Pierce, USA
mizriley2003@yahoo.com
www.ExpressionStudio.blogspot.com
0713, 0714

Gina Pierce, Gina Pierce Design,
UK
info@ginapiercedesign.co.uk
www.ginapiercedesign.co.uk
0309, 0636, 0637, 0638, 0639,
0640

**Junco Sato Pollack, JuncoSato-
Pollack.com,** USA
junco@juncosatopollack.com
www.juncosatopollack.com
0450, 0451, 0452, 0453, 0454

Don Porcella, USA
svea@swarmgallery.com
www.swarmgallery.com;
www.donporcella.com
0652

R

**Ceres M. Rangos, The Woven
Vessel,** USA
ceres1art@yahoo.com
0398, 0399, 0400, 0401, 0402,
0403

Rayela Art, USA
rayela@comcast.net
www.fiberfocus.blogspot.com
0149

Wen Redmond, USA
wenreddy@yahoo.com
www.wenredmond.com
0445, 0446, 0447, 0448, 0449

Regina Moss Designs, USA
rseam29@yahoo.com
0029, 0069, 0159, 0186, 0340,
0369

Sue Reno, USA
sue@suereno.com
www.suereno.com
0899, 0900, 0901, 0902, 0903,
0904, 0933, 0934

Naomi Renouf, UK
textileart@naomirenouf.co.uk
www.naomirenouf.co.uk
0359, 0703, 0704, 0718, 0719,
0722, 0836, 0837, 0838, 0839,
0840

Yumiko Reynolds, UK
yumikoreynolds@tiscali.co.uk
www.hapticart.com
0564, 0565, 0566, 0567

LeBrie Rich, PenFelt, USA
LeBrie.Rich@gmail.com
www.PenFelt.com
0028, 0032, 0138, 0189, 0265,
0279

Erin M. Riley, USA
erin@erinmriley.com
www.erinmriley.com
0560, 0562

**Sherri Roberts, Galil Thread-
works,** USA
sherripitt1@yahoo.com
www.galilthreadworks.com
0485

Robinsunne, USA
robinsunne@robinsunne.com
www.robinsunne.com
0595

**Breanna Rockstad-Kincaid, felt
good fibers,** USA
breanna@feltgoodfibers.com
www.feltgoodfibers.com
0127, 0135, 0250, 0252

Kristin Rohr, Canada
0654, 0657

S

Scarlett O, Kelly O'Toole, USA
0289

Meena Schaldenbrand, USA
meenas@comcast.net
community.webshots.com/user/
pratibha130
0823, 0824, 0825

Barbara Schneider, dipl. des.,
Germany
sbarbara415@aol.com
www.artmarketing.com/gallery/
schneider
0030, 0031, 0344, 0501, 0717

Barbara J. Schneider, USA
bjsco@comcast.net
www.barbaraschneider-artist.com
0734, 0735, 0736, 0737, 0738,
0739, 0740, 0952, 0953

Di Schonhut, UK
di.schonhut@gmx.co.uk
sites.google.com/site/dschonhut/
0651, 0664

Rowen Schussheim-Anderson,
USA
tapestryart@gmail.com; rowen-
schussheim@augustana.edu
www.tapestryart.com
0408, 0545, 0584, 0641, 0662,
0663

Paul Schutte, South Africa
paul.schutte@nwu.ac.za
0979, 0982, 1000

**NE Schwab, eneeFabric Design
and Nunofelt,** USA
schwabne@earthlink.net
www.nunofelt.1000markets.com;
www.zibbet.com/nunofelt
0177, 0251

Tilleke Schwarz, The Netherlands
info@tillekeschwarz.com
www.tillekeschwarz.com
0457, 0458, 0459, 0460, 0461

Susanne C. Scott, USA
infotectives@comcast.net
0322, 0323, 0373, 0391

Elena Sempels, Belgium
elena.sempels@telenet.be
0071, 0072, 0088, 0094, 0097,
0244, 0341, 0379

Linda Senechal, USA
StudioTessere@aol.com
0227, 0228, 0229, 0230

Helena Sergeyeva, Yozhyk's Felt,
Sweden
helena.sergeyeva@gmail.com
http://yozhyks-felt.livejournal.com
0034, 0089, 0090, 0222, 0520,
0521

Julia Sermersheim, USA
juliasermer@hotmail.com
www.justjulia.com
0723, 0983, 0984

Peggy Sexton, USA
peggysexton@earthlink.net
www.PeggySexton.com
0648, 0649, 0650

Sharron Shalekoff, Australia
shalekof@satlink.com.au
0844, 0845

Brenda Gael Smith, Australia
brendagaelsmith@gmail.com
www.brendagaelsmith.com
0852, 0853

Riny Smits, The Netherlands
rftsmits@hotmail.com
www.rinysmits.exto.nl
0134, 0483 0484

Tricia Smout, Australia
smout@uqconnect.net
www.triciasmout.com.au
0502

**Susan R. Sorrell, Creative Chick
Studios,** USA
sorrell@creativechick.com
www.creativechick.com
0587, 0588, 0589, 0590

Katherine Soucie, Canada
katherinesoucie@gmail.com
www.sanssoucie.ca
0116, 0117, 0118, 0119, 0120,
0121

**Tori Sparks & Darren Kucera,
softelbow,** USA
softelbow.store@gmail.com
www.softelbow.etsy.com;
www.facebook.com/pages/
softelbow/66360176557
0332

Virginia A. Spiegel, USA
virginia@virginiaspiegel.com
www.virginiaspiegel.com
0921